Rot Red

Therese Hilbert

Die Neue Sammlung – The Design Museum

arnoldsche ART PUBLISHERS

ROT

Therese Hilbert
Schmuck
1966 –

Die Neue
Sammlung

arnoldsche
ART PUBLISHERS

RED

Therese Hilbert
Jewelry
2020

The Design
Museum

arnoldsche
ART PUBLISHERS

Inhalt

63

1

84

In der Zeit 1980–1984

10

Vorwort —
Angelika Nollert

64

Zürich und Bern
1966–1972

116

Dornenkrone —
Rainer Weiss

16

Therese Hilbert. ROT —
Petra Hölscher

68

Aufbruch in München
1972–1979

118

Insert 1985

34

Therese Hilbert.
(Ein) Schmuck – Leben —
Ellen Maurer Zilioli

80

Intermezzo 1973

128

Unmut und Widerstand
1985–1989

Inhalt

154 Dolor 1989

158 Kern 1989

162 Emotionen 1990–1994

170 Geheime Orte 1985–2003

188 Wölkchen 1999

190 Das Vertraute 2001–2005

201

2

203 Die wohldosierte Ferne Schmuck und Vulkanismus bei Therese Hilbert — Pravu Mazumdar

222 Nea Kameni 1995–1997

232 Glut 2004–2009

233 Eugène Ionesco

252 Die Freiheit des Vulkans — Heike Endter

Inhalt

260 Yali 2008–2009

274 Erwandern — Therese Hilbert

278 Durch den Sinn gefahren 2010–2013

290 Schwarze Berge 2015–2018

296 Rūaumoko, hörst du mich? — Warwik Freeman

302 Aus der Tiefe 2014–2019

318 Funke 2019–2020

326 Wenn der Berg vom Feuer träumt — Otto Künzli

332 Biografie

334 Anerkennungen und Preise

Arbeiten in öffentlichen Sammlungen

336 Ausstellungen

Literaturverzeichnis

356 Ich danke

Impressum

Contents

1

13 Foreword — Angelika Nollert

25 Therese Hilbert. RED — Petra Hölscher

48 Therese Hilbert. (A) Life of Jewelry — Ellen Maurer Zilioli

63

64 Zurich and Bern 1966–1972

68 New Start in Munich 1972–1979

80 Intermezzo 1973

84 Those Days 1980–1984

116 Crown of Thorns — Rainer Weiss

118 Insert 1985

128 Anger and Resistance 1985–1989

Contents

154 Dolor 1989

158 Core 1989

162 Emotions 1990–1994

170 Secret Places 1995–2003

188 Cloudlet 1999

190 Familiar 2001–2005

2012

212 Well-measured distance. Volcanism in Therese Hilbert's jewelry — Pravu Mazumdar

222 Nea Kameni 1995–1997

232 Glow 2004–2009

233 Eugène Ionesco

256 The volcano's freedom — Heike Endter

Contents

260 Yali 2008–2009

277 Exploring by foot — Therese Hilbert

278 Flashed through the Mind 2010–2013

290 Black Mountains 2015–2018

299 Can you hear me Rūaumoko? — Warwik Freeman

302 From the Depth 2014–2019

318 Spark 2019–2020

329 When the mountain dreams of fire — Otto Künzli

332 Biography

334 Awards and Prizes

Works in Public Collections

337 Exhibitions

Selected Bibliography

356 Thank you

Imprint

Vorwort

Mit der Ausstellung Therese Hilbert. ROT widmet Die Neue Sammlung der in München lebenden international bedeutenden Schmuckkünstlerin eine große Übersichtsschau.

Über 250 Objekte aus über 50 Jahren repräsentieren ein künstlerisches Werk, das sich durch inhaltliche Auseinandersetzung und technische Perfektion ebenso auszeichnet wie durch eine stringente Entwicklung von Motiven, deren Klarheit und Schärfe in der Ausgestaltung eine symbolhafte Pointierung erlangen.

Therese Hilbert begann ihr Studium an der Kunstgewerbeschule Zürich, bevor sie nach München zog und ihr Studium an der Akademie der Bildenden Künste in München bei dem Schmuckkünstler Hermann Jünger fortsetzte – wie ihr Schweizer Lehrer Max Fröhlich einer der Väter des internationalen Autorenschmucks. Seither lebt und arbeitet Therese Hilbert in München. Bereits 1974 erhielt sie den renommierten Herbert-Hofmann-Preis. 1978 folgte das Diplom an der Akademie, 1986 der Förderpreis der Stadt München. 2001 wurde ihr der Bayerische Staatspreis verliehen.

In München stellte Therese Hilbert 1996 zum ersten Mal ihre Arbeiten mit Vulkanen aus. Seit Anfang der 90er-Jahre ist ihr Werk untrennbar mit dem Thema Vulkan verbunden.

Die Farbe Rot prägt viele der Schmuckarbeiten von Therese Hilbert. Rot ist die Farbe des Feuers und des Eros. Die Rottöne erscheinen als Lack oder auch im Material der Koralle. Seltener wird mit Lack oder durch das Material Vulkanit die Farbe Gelb eingesetzt. Gelb ist die Farbe des Lichts und lässt auch Assoziationen mit Schwefel zu. Rot und Gelb treten nicht in Kombination auf. Weitere Farben sind die der verwendeten Materialien, vor allem auch vielfach geschwärztes Silber. Die unbunte Farbe Schwarz nimmt im Laufe der Jahre zu, auch weil zunehmend Obsidiane und andere dunkle Lavasteine Verwendung finden, die vielfach auf Reisen gesucht und gefunden wurden.

Therese Hilbert macht keine Unterscheidung zwischen Fassung und Gefasstem. Ihre Schmuckarbeiten sind in ihrer Gesamtheit Objekte: Objekte, die ihre Ausmaße und Volumina betonen, die in Form von durchbrochenen Gehäusen ihr gleichwertiges Inneres offenbaren sowie deren eingesetzte Materialien und begrenzte Farbigkeit integral sind. Therese Hilbert arbeitet aus dem Material heraus, es sind skulpturale Formen im kleinen Format.

Die Formensprache der Schmuckobjekte ist insgesamt ungewöhnlich, komplex und vereint scheinbare Gegensätze. Geometrische elegante Körper, durch Material verfremdete Naturzitate sowie organische Formen und Natursteine prägen die Arbeiten von Therese Hilbert. Es herrscht höchste Präzision, ein reduzierter Einsatz von Material und Farbe, eine Strenge und Radikalität der Formen. Die Objekte besitzen eine sehr starke Präsenz und prägen sich ein. Sie lassen nicht unberührt.

Ihre Werke erscheinen wie die Materialisierung des philosophischen Begriffes der Polarität. Es geht um sich gegenseitig bedingende Größen, um das komplementäre Verhältnis von Prinzipien, die in ihrer Existenz abhängig sind und immer eine Einheit bilden.
 Fläche und Körper, Innen und Außen, Schmuck und Waffe, Kalt und Warm, Natur und Kultur, Geheimnis und Offenbarung, Abgründigkeit und Erhabenheit, Leben und Tod sind die den Arbeiten von Therese Hilbert inhärenten Pole, die auch Spiegel des Lebens sind.

Mit Therese Hilbert stellt Die Neue Sammlung erneut eine herausragende Persönlichkeit der Schmuckkunst vor und setzt damit ihre Tradition von Ausstellungen und Publikationen zu internationalen Künstler*innen im Autorenschmuck fort.
 In der Danner-Rotunde werden Werke aus dem reichen und bedeutenden Fundus der Danner-Stiftung und der Neuen Sammlung präsentiert, in dem sich ebenfalls zahlreiche wichtige Arbeiten von Therese Hilbert befinden.
 Wir danken den internationalen Leihgebern für die vertrauensvolle Zurverfügungstellung der ausgezeichneten Exponate.
 Ein herzlicher Dank geht an die Konservatorin Dr. Petra Hölscher, die in enger Zusammenarbeit mit Therese Hilbert für Ausstellung und Katalog verantwortlich zeichnet, sowie bei allen Mitarbeiter*innen, die deren Realisierung unterstützten.
 Ich bedanke mich bei den Autor*innen des Kataloges, die das Werk von Therese Hilbert seit langen Jahren kenntnisreich begleiten. Heike Endtner, Warwick Freeman, Petra Hölscher, Otto Künzli, Ellen Maurer Zilioli sowie Pravu Mazumdar haben sich in ihren Texten dem komplexen Werk von Therese Hilbert aus sehr unterschiedlichen Perspektiven genähert und damit einen wichtigen Beitrag zur Kenntnis und Erörterung der künstlerischen Arbeiten geleistet.

Ein großer Dank geht an Frederik Linke für die wunderbare grafische Umsetzung. In guter Tradition erscheint auch dieses Buch erneut bei arnoldsche Art Publishers; ein herzlicher Dank an Dirk Allgaier für die bewährte Verlagstätigkeit.

Vorwort Angelika Nollert

Für die großzügige Unterstützung der Publikation sagen wir der Danner-Stiftung sehr großen Dank!

Ein ganz besonderer Dank geht an Therese Hilbert, die sich mit Begeisterung auf die Einladung der Neuen Sammlung eingelassen und Ausstellung und begleitende Monografie eindrucksvoll konzipiert hat.
 Wir freuen uns sehr, dass Therese Hilbert eines ihrer frühesten Werke von 1973, von dem sie die einzelnen Teile bewahrt hatte, für die Ausstellung nach rund 50 Jahren zusammengefügt hat. Es handelt sich um den Kettenanhänger in Form eines halbierten Apfels in Originalgröße, der nach der Ausstellung dankenswerter Weise seinen Platz in unserer Schmucksammlung finden wird. Dieser Apfel, Symbol für Macht und weibliche Kraft, aber auch Mahnung des «Memento mori», präsentiert sein Kerngehäuse und verweist auf sein Inneres.

Therese Hilbert hat mit ihren Werken Sinnbilder für den Zustand der Welt und der Menschen sowie für das Verborgene und nicht (Er-)Fassbare geschaffen.
 Ihre Stringenz in der künstlerischen Haltung entspricht einer Weisheit im Denken.

Foreword

Angelika Nollert

In the form of the «Therese Hilbert. RED» exhibition Die Neue Sammlung is dedicating a large survey to the major international jewelry artist who is based in Munich.

More than 250 objects that straddle over 50 years represent an artistic oeuvre that is characterized by both its substantive focus and technical perfection as well as a stringent development of themes, whose clarity and precision are symbolically heightened in the formgiving.

Therese Hilbert began her studies at the Zurich School of Applied Arts before moving to Munich and continuing her studies at the Academy of Fine Arts in Munich under jewelry artist Hermann Jünger – like her Swiss teacher Max Fröhlich, one of the founders of international studio jewelry. Since then, Therese Hilbert has lived and worked in Munich. As early as 1974, she was awarded the prestigious Herbert Hofmann Prize. In 1978, she received her diploma from the Academy, and in 1986 she was awarded the Förderpreis of the City of Munich. In 2001, she was awarded the Bavarian State Prize.

Therese Hilbert exhibited her work with volcanoes for the first time in Munich in 1996. Since the early 1990s, her work has been inextricably linked with the theme of volcanoes.

The color red characterizes many of Therese Hilbert's jewelry pieces. Red is the color of fire and Eros. The shades of red appear as lacquer or also in the material of coral. More rarely, the color yellow features as lacquer or through the material vulcanite. Yellow is the color of light and also allows associations with sulfur. Red and yellow do not appear in combination. Other colors are those of the materials she uses, in particular silver, which in many cases has been blackened repeatedly. She has come to use the achromatic color black more over the years, one reason being that she increasingly employs obsidian and other dark lava stones in her work many of which she looked for and found on journeys.

Foreword

Therese Hilbert makes no distinction between the setting and what is set. She treats her jewelry pieces as objects in their entirety: Objects that emphasize their dimensions and volumes, that in the shape of openwork settings reveal an interior which is of equal value and where the materials and limited coloration play an integral part. Therese Hilbert takes the material as her starting point and works from that; what she creates are sculptural shapes in miniature.

The formal language of the jewelry objects is altogether unusual, complex, and combines apparent opposites. Geometric elegant bodies, quotes from nature alienated by material but also organic forms and natural stones characterize the works of Therese Hilbert. The pieces feature the highest precision, a reduced use of material and color, as well as an austerity and radicality of form. The objects have a very strong presence and imprint themselves in our memories. They will not leave you unaffected.

Hilbert's oeuvre seems like the materialization of the philosophical concept of polarity. It is about mutually dependent quantities, about the complementary relationship of principles that are dependent on one another for their existence and always form a unity.
 Surface and body, inside and outside, jewelry and weapon, cold and warm, nature and culture, mystery and revelation, abysmal and sublime, life and death are the poles inherent in the works of Therese Hilbert, which are also mirrors of life.

In the person of Therese Hilbert Die Neue Sammlung is once again presenting an outstanding figure in jewelry and in doing so continues its tradition of exhibitions and publications on international artists of studio jewelry.
 The Danner Rotunde provides a perfect backdrop for showcasing works from the richly-facetted and important collections of the Danner Foundation and Die Neue Sammlung which also includes numerous major works by Therese Hilbert.
 We would like to extend our thanks to all those around the world who loaned us works – for their confidence in entrusting us with such excellent exhibits.
 A warm thanks goes to curator Dr. Petra Hölscher who in close collaboration with Therese Hilbert was in charge of realizing the exhibition and the catalog, and to all the staff members who assisted in the process.
 I would also like to thank the authors of the catalog who for many years have accompanied the work of Therese Hilbert with their vast knowledge. In their texts, Heike Endtner, Warwick Freeman, Petra Hölscher, Otto Künzli, Ellen Maurer Zilioli, and Pravu Mazumdar have approached Therese Hilbert's complex oeuvre from very different perspectives and in doing so made an important contribution to our discussion and understanding of her works.

Big thanks also go to Frederik Linke for his wonderful graphic design. In keeping with an established tradition this book will once again be published by arnoldsche Art Publishers; warm thanks to Dirk Allgaier for the accustomed excellent publishing work.

For its generous support of the publication, we say a very big thank you to the Danner Foundation!

And naturally special thanks go to Therese Hilbert who responded with such enthusiasm to the invitation by Die Neue Sammlung and conceived the exhibition and accompanying monograph so impressively.

We are delighted that Therese Hilbert provided us with one of her earliest works from 1973, a pendant comprising several pieces that she reassembled for the presentation some fifty years later. Shaped like half an apple and in the original size the pendant will be included in our jewelry collection thanks to the artist's generosity. This apple, a symbol of power and female strength but also a reminder of the «memento mori», presents its core and refers to its inner life.

With her works Therese Hilbert has created symbols for the state of the world and its inhabitants but also for what is hidden and those things we cannot grasp.

The stringency in her artistic attitude corresponds to a wisdom in her thinking.

Therese Hilbert. ROT

Jede Farbe hat ihre Geschichten … auch ROT*

1 TH, OK und PH sitzen nicht weit entfernt von einem Münchner Auktionshauses an einem milden Frühsommerabend bei einem Glas Wein beisammen. Thema ist die mögliche Erwerbung eines Kieselstein-Rings von Naum Slutzky. Das Für und Wider wird diskutiert. Nach einer Weile ist man sich einig – die Qualität des Rings überzeugend, man verlässt das Thema. Der richtige Moment scheint gekommen, eine diffizile Frage zu stellen. Der gewählte Titel für THs geplante Ausstellung in der Neuen Sammlung, der im Deutschen wie Englischen vier prägnante Buchstaben aufweist, ist seit Wochen in den Köpfen der Beteiligten präsent. Doch bei Überprüfung von www und Social Media erweist sich die Verwendung des Vier-Buchstaben-Wortes als schwierig. Gibt es vielleicht noch einen anderen Titel für die Ausstellung?

Die Frage ist gestellt. TH verstummt. Über Schwabing entlädt sich das erste frühsommerliche Gewitter. Regen prasselt auf die Straßen. Die Äste der Bäume biegen sich im Wind. Menschen kämpfen mit ihren Regenschirmen. Tageszeitungen über den Köpfen knicken ein unter den Wassermassen. TH schaut aus dem Fenster. Wie wird sie reagieren? Ist Schweigen ihre Antwort? Minuten fühlen sich an wie Stunden. Dann plötzlich kommt es in einem munteren Staccato aus ihrem Mund: «Ich hab's — kein Problem — aber ich sag's Dir noch nicht — es ist wieder nur ein Wort — lass mich noch ein bisschen d'rüber schlafen — es hat noch weniger Buchstaben — ich sag's Dir bald.» Wir sitzen noch eine ganze Weile beisammen. Es hat aufgehört zu regnen.

Der Juni verging, es wurde bald Juli. Von TH war nichts zu hören.

Dann, an einem dieser Dienstage, an dem die Woche gerade begonnen, aber noch nicht wirklich ihren Rhythmus gefunden hat, ein Anruf von TH. Der erste Satz eine blanke Katastrophe: «Du bist schuld!»

Also doch: Es war falsch, die Frage ausgesprochen zu haben. Der Adrenalinspiegel steigt in Sekundenschnelle. Ruhe bewahren! Es wird eine Lösung geben. Dann THs bekanntes, warmes Lachen am anderen Ende der Telefonleitung: «Du bist schuld … und ich find' den neuen Titel toll. – Toll und viel besser als den alten. Es ist ROT.»

2 Therese Hilbert. ROT

3 ROT. — Nicht Schwarz. — Nicht Silber. — Nicht Gelb.
Auch sie gehören zum Farbspektrum von TH, zu ihren Broschen und Anhängern.

Per definitionem sind Schwarz und Weiß keine Farben. Silber ist – streng genommen – die Bezeichnung für ein Edelmetall. Die Pythagoreer, Angehörige der Schule des Pythagoras im 6. Jahrhundert v. Chr., bezeichneten nach Goethe die Oberfläche der Körper als Farbe.[1] Silber also doch eine Farbe? 2540 Jahre später hat sich diese Auffassung mehr oder weniger durchgesetzt.

* Eine kleine, assoziativ zusammengestellte Schrift zur Farbe ROT.
1 Johann Wolfgang Goethe, Gedenkausgabe der Werke, Briefe und Gespräche, Bd. 1–24 und Erg.-Bde 1–3, Bd. 16, Zürich 1948, S. 255.

Von den Alten Ägyptern sind zwei Bezeichnungen für Silber bekannt. Da wäre einmal der Begriff Mondmetall. In vielen Kulturen repräsentiert der Mond den weiblichen, die Sonne den männlichen Aspekt. Der französische König Ludwig XIV. und der ihm später so nacheifernde August der Starke in Sachsen stellten dies eindrucksvoll mit ihrem majestätischen Sonnenkult unter Beweis.[2] Heute fast in Vergessenheit geraten, weist das Christentum Silber und Mond der Jungfrau Maria zu. Früh entstand der Typus der Mondsichelmadonna.[3]

Die schon einmal herangezogenen Alten Ägypter benutzten für Silber auch den Begriff «Weißes Metall». Aus der Scheidekammer kommendes, gereinigtes Silber zeigt die höchsten Reflexionseigenschaften aller bekannten Metalle. Es reflektiert 95% des sichtbaren Lichts und gilt deshalb als «weißestes» aller Gebrauchsmetalle.[4] Im Gegensatz dazu entsteht eine schwarze Oberfläche, wenn es – umgangssprachlich – «anläuft». Das Metall entwickelt einen Silbersulfid-Belag. Der Annex Sulfid verrät den Bestandteil von Schwefel, der bei Silber in Verbindung mit Sauerstoff als meist dunkler Belag auf dem Metall entsteht. Als 16. Element im Periodensystem wird Schwefel – Zimmertemperatur vorausgesetzt – mit zitronengelber Farbigkeit beschrieben.

Gelb. Den Themenkreis von THs Vulkan-Arbeiten durchbrechen immer wieder Arbeiten mit einem hellen Gelbton. In den Augen eines mit der Tätigkeit von Vulkanen vertrauten Menschen gehören ROT und Gelb wie auch Schwarz untrennbar zusammen. Geschmolzenes Gestein aus dem Erdinneren – Magma – tritt als rotglühende Lava an die Erdoberfläche. Langsam nimmt sie während ihres Erkaltungsprozesses die Farbe Schwarz an. Kühlt die Lava hingegen rasch ab, kann daraus unter bestimmten chemischen Bedingungen tief schwarzes, vulkanisches Glasgestein – Obsidian – entstehen. «Obsidian», und hier kommt TH nun selbst zu Wort, ist «ein hartes, schwarzes, glasähnliches Material, das sich dank seiner scharfen Abbruchkanten hervorragend für die Herstellung von Werkzeugen, Pfeilspitzen etc. eignete […] Wenn ich auf Obsidiansuche gehen kann, bin ich sehr zielstrebig und aufgeregt. Meine Augen sind gesenkt … der Himmel existiert nicht mehr, es gibt nur den Erdboden, ein Unten.»[5]

Setzt der Abkühlungsprozess sehr viele Gase frei, kommt es zu einem wahren Aufschäumen oder Aufgasen der Lava, an dessen Ende der poröse, mal weißlichgraue, dann bräunliche, manchmal auch schwarze Bimsstein entstanden ist. Mit Bimsmehl bearbeitet TH die Oberfläche ihrer Silberarbeiten. So erhalten sie ihre charakteristische, fast möchte man sagen, weiche Textur.

Nach diesen Außenbetrachtungen ergibt auf einmal alles im Werk von TH einen Sinn – das Material Silber, die eingesetzte Farbigkeit von Schwarz und Gelb und ihre Entscheidung für: Therese Hilbert. ROT.

2 Ausst.-Kat. «Eine gute Figur machen.» Kostüm und Fest am Dresdner Hof. Hrsg. v. Claudia Schnitze.

3 «Bild der Maria mit den Zügen des apokalyptischen Weibes, der vom Drachen verfolgten Frau, die das Kind zur Welt bringt, das der Erzengel Michael rettet, und die, von der Sonne bekleidet, von den Sternen bekrönt, auf dem Mond steht (Offb.12,1f.). Der biblischen Beschreibung entsprechend, trägt die Mondsichelmadonna eine Krone aus 12 Sternen, ist von Sonnenstrahlen umgeben und steht auf dem Mond.», in: H. Sachs, E. Badstübner, H. Neumann, Erklärendes Wörterbuch zur Christlichen Kunst, Hanau, o.A., Stichwort «Mondsichelmadonna».

4 http://de.wikipedia.org/wiki/Silber, aufgerufen am 28.08.2020.

5 Begleitheft zur Ausstellung «&: Hilbert & Künzli» Gestalten im Dialog: Therese Hilbert & Otto Künzli, Gewerbemuseum Winterthur 2016, Nr. 56 und 57.

Therese Hilbert. ROT

4 ROT.
Wohl eine der ältesten und ersten Bezeichnungen für eine Farbe überhaupt.[6]

ROT ausgemalt sind die schwarz gezeichneten Umrisse von urzeitlichen Stieren in den Höhlen von Altamira (Spanien) und Lascaux (Frankreich). Diese ersten rötlichen Farben wurden aus Hämatit gewonnen, dem sogenannten Roteisenerz. Sie enthielten manchmal ein Bindemittel aus zerriebenem Bernstein.[7]

Spätestens seit dem 2. Jahrhundert v. Chr. wird in Teilen Südamerikas aus den trächtigen weiblichen Cochenilleschildläusen roter Farbstoff hergestellt, das sogenannte Karmin. Bis ins 20. Jahrhundert wurde auf der Kanareninsel La Isla de San Miguel de La Palma dieses Cochenille gewonnen, u.a. für die Herstellung von Kosmetika und noch heute von rotem Lippenstift.[8]

Das Wissen um sehr frühe, rötlich-braune Körperbemalung verdanken wir dem Auffinden antiker Mumien. Die getrockneten und zermahlenen Blätter des Hennastrauchs lieferten den Farbstoff. Schauspielerinnen wie Demi Moore, Sängerinnen wie Madonna und Gwen Stefani von der US-amerikanischen Rockband No Doubt entfachten in den 1990er-Jahren einen wahren Kult um diese Art des Körperschmucks im Stil der indischen Mehndis.[9] Zunehmend zum Mode-Accessoire geworden, hat er später nichts mehr gemein mit den Vermählungs- und Begräbnisriten indigener Kulturen.

5 ROT. Bei Länderflaggen ist es die am häufigsten eingesetzte Farbe. Der gerade gegründete Bundesstaat der Schweiz, Therese Hilbert ist in Zürich geboren und macht hier ihre ersten Schritte zur Goldschmiedin, setzte 1848 ein weißes Kreuz mittig auf quadratisch (!) roten Flaggengrund, nicht zu verwechseln mit dem längsrechteckigen dänischen Dannebrog. Bis zum Ende des Zweiten Weltkriegs galt ROT als männlich und als Farbe der Stärke. Erst danach wurde ROT durch das Blau der Marine-Uniformen abgelöst. Unter den flaggenartigen Erkennungs- und Verständigungsmitteln gibt es in Umkehrung zur Schweizer Flagge das rote Kreuz auf weißem Grund. Es ist Namensgeber für das 1876 gegründete Internationale Komitee vom Roten Kreuz, das auf Ideen des Schweizer Geschäftsmanns Jean-Henry Dunant und des Generals Guillaume Henri Dufour zurückgeht.

6 ROT. Als Signalfarbe findet es sich im öffentlichen Leben, denkt man an Verkehrsschilder, Ampelmännchen oder gelb-rot aufgemalte Pop-up-Fahrradwege zu Zeiten von COVID-19. Fahrzeuge in einem roten Lackoutfit galten lange als besser verkäuflich. Wie das Racing Green für immer mit dem Jaguar E-Type verbunden sein wird, gehört das positive (Fahr-)Emotionen versprechende Blau-ROT zum Fiat Nuovo Cinquecento und zur sportlicheren Giulietta von Alfa Romeo. Ferrari-ROT steht für begehrenswerte Sport-Boliden made in Italy und den Traum von Geschwindigkeit.

6 https://de.wikipedia.org/wiki/rot, aufgerufen am 30.08.2020.

7 Stefan Muntwyler, «Die ersten Farben der Menschheit. Schwarz. Rot. Gelb. Weiss», in: Gewerbemuseum Winterthur (Hrsg.), Farbpigmente. Farbstoffe. Farbgeschichten. Winterthur 2010, S.152–153.

8 Marietta Rohner, «Karminrot», in: Gewerbemuseum Winterthur (Hrsg.), Farbpigmente. Farbstoffe. Farbgeschichten. Winterthur 2010, S. 222.

9 https://de.wikipedia.org/wiki/Mehndi und www.mehndiskart.com/henna-artificial.htm, beide aufgerufen am 30.08.2020.

Durchscheinendes ROT zwischen Autofelgen spricht nicht nur für das Understatement eines deutschen Sportwagenherstellers, sondern auch für die Sicherheit seiner Bremsanlagen. ROT – eine Farbe der Gegensätze.

ROT. In all seinen Schattierungen ist es eine von Gestaltern und Industrial Designern gern eingesetzte Farbe.

Der Schriftzug der 1925 gegründeten Neuen Sammlung, ihre CI, ist seit langer Zeit ROT angelegt, mag das ROT in seiner Zeit auch Trends und Vorlieben unterliegen. ROT gehört in die Kultur der 1920er-Jahre: zur Neuen Architektur von Max und Bruno Taut oder der Brüder Hans und Wassily Luckhardt wie auch zum Roten Wien und seinen genossenschaftlichen Wohnanlagen. ROT assoziiert man mit der Neuen Typographie aus der Hand von Jan Tschichold und Johannes Molzahn wie mit dem Deutschen Werkbund, dem Münchner Bund und der «Roten Gruppe» – der Vereinigung kommunistischer Künstler in Deutschland, angeführt von George Grosz und John Heartfield. In den 1980er-Jahren wählt der Münchner Grafiker Pierre Mendell Japan-Rot, eine Art Zinnoberrot, als Farbe für den Schriftzug der Neuen Sammlung. Mirko Borsche, bekannt durch das Erscheinungsbild des SZ- und später des Zeit-Magazins, erhöht rund 35 Jahre danach im Re-Fresh noch einmal den Gelbanteil im Schriftzug der Neuen Sammlung.

ROT. Einen wahren Boom erlebte die Farbe Ende der 1960er-, Anfang der 1970er-Jahre, als das Einfärben von Kunststoff im Industrial Design vieles möglich machte wie das Telefon «Grillo» von Siemens Italia und das Radiogerät «RR127» von Brionvega, beide 1965 entworfen von Richard Sapper und Marco Zanuso. Wer kennt sie nicht, die Kofferschreibmaschine «Valentine», die Ettore Sottsass 1969 gemeinsam mit Olivetti umsetzte. In ROT ausgeführt erhält die Legende darauf geschriebener Liebesbriefe ihren emotionalen Background – wie blass wirkt sie dagegen in einem gebrochenen, warmen Weiß. Passt da nicht auch, dass 2006 erstmals der Band «Rote Gedichte» in Reclams Universal-Bibliothek unter der Nr. 18926 erschien?[10] Nach dem Vorbild der verheißungsvollen «Ruby-Lips» von Salvadore Dali (1936) entwirft Studio 65 das rote Lippensofa «Bocca» (1971), Hersteller Gufram. Und aus der Hand Gaetano Pesces entsteht nicht nur das Sitzobjekt «La Mamma» (1969) in ROT für B & B Italia, sondern auch das Modulsofa «Tramonto a New York» (1980) für Cassina. Eine rote Abendsonne über den Skyscrapern der amerikanischen Metropole lädt sein Gegenüber zum romantischen Sun-Downer ein.

ROT also eine Lieblingsfarbe der Menschen? Laut einer Studie des Instituts für Demoskopie Allensbach aus dem Jahr 2014, durchgeführt mit 1000 Erwachsenen im Alter von 16 bis 75 Jahren, nimmt nicht ROT, sondern Blau den ersten Platz mit 40% bei den Befragten ein, erst dann gefolgt von ROT mit 19% und Grün mit 18%.[11] Schon 2007 kam eine statistische Erhebung mit 171 Briten der Universität

10 Hrsg. v. Evelyne Polt-Heinzl u. Christine Schmidjell.

11 Pressemeldung, Deutsches Lackinstitut, www.lacke-und-farben.de, aufgerufen am 28.08.2020. Aufgeschlüsselt nach Geschlechtern lag die Prozentverteilung bei den ersten drei Farben bei den weiblichen Probanden bei Blau 36%, Rot 20% und Grün 12% bei den männlichen bei Blau 40%, Rot 20% und Grün 12%.

Therese Hilbert. ROT

Newcastle zu ähnlichen Ergebnissen unter zusätzlicher Berücksichtigung von 37 erst kurzzeitig in Großbritannien lebenden Chinesen.[12] THs Lieblingsfarbe ist ROT. Ihre Kleidung meist schwarz. ROT ist nur ihr Lippenstift.

10 Eine von THs frühen Arbeiten ist ein Ohrschmuck bestehend aus zwei Paar Kirschen. Jedes Paar besteht aus einer roten und einer durchsichtigen Kirsche. Man hängt sich – wie Kinder es gerne tun – je eins der Kirschpaare über die Ohrmuscheln, das eine rechts, das andere links. Deshalb fehlt auch ein Befestigungsmechanismus, sei es Stecker, Clip oder Schraube, er ist unnötig. Dem hellen ROT nach sind es eher Sauer- als Süßkirschen, was hier aber eigentlich nichts zur Sache tut. Es sei denn, dass sich in den Kirschen das ROT erstmals in der Nuance zeigt, die der Künstlerin die liebste ist.

Eine weitere Arbeit entsteht: Ein halbierter Apfel, als Anhänger zu tragen, scheint mit seinem vermeintlich roten Fruchtfleisch und dem eingegossenen Kerngehäuse eines realen Apfels eine nicht essbare, pomologische Rarität. Eine dünnwandige, rote Kunststoffschicht bildet die Außenhaut der angeschnittenen Apfelhälfte. In sie hinein bettet TH das vom Fruchtfleisch freigelegte Kerngehäuse, um die Apfelhälfte anschließend mit transparentem Kunststoff auszugießen. Das ROT der Außenhaut scheint durch den transparenten Kunststoff durch.

Kirschen wie Apfel entstanden 1973 in Zusammenhang mit einem Modeschmuck-Wettbewerb in Neugablonz. TH reichte nur die «Apfel-Hälfte […] mit eingeschmolzenem natürlichem Apfelkernhaus» ein.[13] Dafür wurde sie mit dem ersten Preis ausgezeichnet. Nur ein Jahr, nachdem sie das Studium in der Schmuckklasse von Hermann Jünger an der Münchner Akademie der Bildenden Künste begonnen hatte – Jünger war zu dieser Zeit Berater der Fachschule für Glas und Bijouterie in Kaufbeuren-Neugablonz. Kurz zuvor hatte Bussi Buhs ihre Berufung als Dozentin für künstlerische Kunststofftechnik erhalten (1971) und leitete die neu eingerichtete Studienwerkstatt für Kunststoff an der Münchner Akademie. Hier experimentierte TH mit dem neue Möglichkeiten offerierenden künstlichen, synthetischen Material. Der «schreckliche Geruch» des flüssigen Kunststoffs ließ sie letztendlich Abstand davon nehmen.[14]

Äpfel und Kirschen gehören botanisch gesehen zur Familie der Rosengewächse. Im Volksglauben steht der Kirschbaum für Kraft und Fruchtbarkeit. Seine weißen Blüten symbolisieren Reinheit und Schönheit. Der Volksglaube besagt auch, dass im Dezember, am Barbara-Tag, geschnittene Kirschzweige mit ihrem Aufblühen zu Weihnachten der Frau, die sie geschnitten hat, von der bevorstehenden Hochzeit künden. Seit den 1950er-Jahren gehören Kirschen als Symbol der süßen Verlockung zum Repertoire modischer Accessoires bei Petticoat und Rock 'n' Roll.
Im Gegensatz dazu gehört der Apfel mit Krone und Zepter zur Trias königlicher Machtsymbole. Die Bibel überliefert den Apfel als unheilbringende Frucht vom

12 «Blau ist Lieblingsfarbe – Frauen stehen auf Rot», in: Handelsblatt, 21.08.2007, Rubrik «Wissenschaft».

13 «Blumen eines Sommers. Modeschmuckwettbewerb 1973 des Arbeitskreises Form + Farbe», in: Goldschmiedezeitung 1973, Nr. 8, S. 30-32, und Ausst.-Kat. «Modeschmuck 1973», hrsg. v. Arbeitskreis für Form und Farbe, Kaufbeuren 1973, o.S.

14 Mündliche Mitteilung von Therese Hilbert, 21.09.2020.

Baum der Erkenntnis im Paradies. In Dürers berühmtem Gemälde «Adam und Eva» von 1507 hält Adam den Apfel bereits in Händen. 450 Jahre danach hat sich das Bild gewandelt: Auf einer Fotografie trägt eine junge ROT-blonde Frau mit lasziv geöffneten, ROT-geschminkten Lippen THs Apfelhälfte an einer silbernen Kette. Der Apfel hängt mittig über dem Ansatz ihrer Brüste, die gerade noch durch die weit geöffnete, rosa-farbene Bluse verdeckt sind.

Es ist das Statement von Regina Relang (1906–1989), gefeierte deutsche Modefotografin mit Titelblättern für «Die Dame», «Film und Frau» oder die deutsche «Madame». Mit den Mitteln der damals aktuellen Modefotografie vermittelt die zu dieser Zeit 67-Jährige hier scheinbar ein noch immer aktuelles Thema der 68er-Frauenbewegung.[15] Das Resultat ist weit mehr als nur eine Modefotografie. Relang dechiffriert die Apfelhälfte im Bildzusammenhang als weibliche Vulva und stellt den Apfel-Anhänger von TH bildlich in einen erotischen Zusammenhang.

Zurück zu ROT. Das Wiki-basierte freie Wörterbuch «Wiktionary» listet 66 Unterbezeichnungen von ROT auf: von Amarantrot, Blaurot über Dunkelrot, Erdbeerrot, Falunrot, Gelbrot, Hellrot, Indianerrot, Karmesinrot, Mohnrot, Ochsenrot, Pinkrot bis zu Weinrot und Zinnoberrot.[16] Wohl jeder kann noch eine weitere Variante hinzufügen … Jaipurrot, Korallenrot, Orangerot, Terracotta-Rot, Tizianrot etc. In der Pantone-Systematik sind es «… Nr. 2035 oder Nr. 2347»[17], die sich dem Lieblings-ROT-Ton von TH annähern. Der Einband des vorliegenden Buches gibt eine Vorstellung davon.

Als Kunsthistorikerin kommt PH nur schwer an den Granden der europäischen Kultur- und Kunstgeschichte vorbei: Angefangen bei Giotto, der im 14. Jahrhundert die Farbe Weiß als ungebrochenes Licht verstand, über Leonardo da Vinci, der ein Saeculum später versuchte, Farben zu systematisieren, zu Isaac Newton, der im 18. Jahrhundert daran anknüpfte. Mittels eines Prismas benannte er die Grundfarben ROT, Grün und Blau. Die Summe aus ihnen ergab Weiß oder genauer gesagt weißes Licht, womit wir wieder bei Giotto wären. Im Übergang zum 19. Jahrhundert erweiterte Johann Wolfgang von Goethe mit Purpur, Rotgelb, Gelb, Grün, Blau und Rotblau den Kanon auf sechs Grundfarben, die er zu einem Farbkreis zusammensetzte. Im Farbkreis bildet Purpur den Übergang der Bereiche «Phantasie» und «Vernunft». Goethe gibt diesem Farbbereich das Attribut «schön». Rotgelb charakterisiert er mit «edel». Mit «gut» und reinem Gelb bedachte Goethe den Bereich «Verstand».

Heute verbindet die Allgemeinheit mit ROT laut Wikipedia Wärme und Energie. Verknüpft wird es mit der Farbe des Blutes, und deshalb gleichgesetzt mit Leben. ROT steht laut der hier zitierten digitalen Plattform für Freude, Leidenschaft, Liebe sowie Erotik, aber auch für Aggression und Zorn. Wikipedia schließt den Eintrag mit dem Hinweis: Glut ist ROT.[18] (Womit an dieser Stelle auch das Geheimnis um den zuerst angedachten Titel der Ausstellung «Glut. Glow» gelüftet wäre.) «In vielen

15 Mitglied der Jury ist Anni Schaad (geb. Lang), Inhaberin der Firma Langani in Stuttgart und Schwester von Regina Relang; Ausst.-Kat. Die elegante Welt der Regina Relang. Mode- und Reportagefotografin, hrsg. v. Esther Ruelfs u. Ulrich Pohlmann. Ostfildern-Ruit 2005, S. 25.

16 https://de.wiktionary.org/wiki/wiktionary:Rot, aufgerufen am 28.08.2020.

17 Email v. Therese Hilbert an die Verfasserin, 04.09.2020.

18 http://de.wikipedia.org/wiki/rot, aufgerufen am 30.08.2020.

Kulturen versinnbildlicht die Farbe ROT sowohl den Tod als auch das Leben – ein schönes und zugleich schreckliches Paradox. In unserer modernen Sprache gilt ROT als Metapher für Feuer, für stürmische Gefühle des Herzens, für Liebe, für den Kriegsgott [Mars] und für die Macht.» Und weiter heißt es im selben Artikel: «Bei den Komantschen bedeutet ein und dasselbe Wort – ‹ekapi› – Farbe, Kreis, Rot. Was den Schluss nahelegt, dass der Begriff in der indianischen Kultur als etwas Fundamentales angesehen wurde, der alles einschloss.»[19] Vielleicht meinte Goethe genau das, als er schrieb: «Die vollendeteste Farbe ist das roth ...»[20]

13 Eine langstielige rote Rose gilt als höchste Vollendung in der Pflanzenwelt. Oft wird sie zu Geburts- und Muttertagen als Liebessymbol verschenkt. Hildegard Knef, eine im Nachkriegsdeutschland gefeierte Chanson-Sängerin, wünschte sich 1968 zum ersten Mal und dreißig Jahre später gleich noch einmal gemeinsam mit der Rockband Extrabreit, es solle «Rote Rosen» für sie regnen. Bei TH ist die Rose nicht ROT, sondern aus dünnem Silberblech geformt, dann montiert und als Brosche zu tragen (1989). Sie ist geschwärzt, die Dornen wurden ihr von TH genommen. Die in voller Pracht stehenden Blütenblätter wirken im Gegensatz zu ihren Artgenossinnen aus der Natur schutzlos.

Schwarz, diese Nichtfarbe, hat – wie sollte es auch anders sein – ihre eigene Symbolik. Auf der Plattform «Designer in Action» findet man unter der Rubrik «Design-Wissen» den Beitrag «Die Bedeutung der Farben». Über die Farbe Schwarz erfährt man dort, dass «in vielen Kulturkreisen Schwarz für Kultiviertheit und Formalität [steht], aber auch für negative Aspekte Tod, Trauer, Krankheit, Pech, Geheimnisse und mehr (...).» In Afrika, so heißt es weiter, steht Schwarz «als Synonym für Männlichkeit».[21] TH zerteilte den Rosenstiel in mehrere Stücke, ließ ihm seine Dornen und goss alles in Silber ab. Anschließend fügte sie die einzelnen Stücke in Form einer langen Kette wieder zusammen. Beim Tragen drücken sich die Dornen ein-drucksvoll in den Hals der Trägerin.

14 Kehren wir zurück zu ROT. Für den britischen Filmregisseur Derek Jarman, der sich immer wieder sehr intensiv mit Farben auseinandersetzte, ist keine andere Farbe so territorial wie ROT. Nach seinen Worten «steckt es sein Revier ab.»[22] In der Natur passiert das bei einem Vulkanausbruch, wenn sich das Magma seinen eigenen Weg bahnt und zur Vergrößerung von Inseln beiträgt oder Häuser, Dörfer und Städte unter sich begräbt. In der von Menschenhand geprägten Welt stellt das Rote Rathaus in Berlin in seiner roten Ziegelsteinoptik solch eine nach Jarman bestimmende Architektur dar. 1869/70 markant ins Stadtbild implantiert, steht das Rathaus mit seiner Rundbogenthematik breit und selbstherrlich im Stadtraum. Ein Turm betont seine axiale Symmetrie. Herrschaftlicher hätte die Fassade nicht ausgeführt, hätte politische Architektur nicht demonstriert sein können.

19 Victoria Finlay, Das Geheimnis der Farben. Eine Kulturgeschichte. Aus dem Englischen von Charlotte Breuer und Norbert Möllemann. Berlin 2019 (engl. Erstausgabe 2002, dt. Erstausgabe 2005), S. 166ff.
20 http://de.wikipedia.org/wiki/rot, aufgerufen am 30.08.2020.
21 www.designerinaction.de/Bedeutung, aufgerufen am 20.09.2020.
22 «Architektur in Rot», in: Zeitmagazin 14.01.2019.

In Deutschland soll es laut Wikipedia²³ allein fünfzehn Rote Türme geben bzw. gegeben haben – ihrer Funktion nach oft Stadttore. Im bayerischen Wasserburg steht seit 1415 ein solch roter Turm als Teil der mittelalterlichen Ringmauer. Früher gab es auch einen in München. Heute erinnert nur noch der «Rote-Turm-Platz» im Münchner Stadtteil Sendling an ihn. Warum dieser Exkurs? Am 10. August 2020 schickte TH via WhatsApp Fotos eines ochsenblutroten Turms aus den Schweizer Alpen an PH. In der Vertikalen rhythmisieren acht konkave Abschnitte den temporären Theaterturm aus Holz, in der Horizontalen sind es vier übereinanderliegende Reihen von Rundbögen. Mal spiegelt sich in ihren Verglasungen die Berglandschaft, dann das unendliche Blau des Himmels, ein anderes Mal ist die Glasfläche tief schwarz und voller geheimnisvoller Dunkelheit. Der in seiner Archaik an spätantik-byzantinische Bauten wie San Vitale in Ravenna erinnernde Turm steht seit 2005 auf dem 2300 Meter hohen Julierpass im Kanton Graubünden und ist Spielstätte des Origen Festival Cultural.²⁴

1983 stellte TH im «Schaufenster Nr. 34» in der noblen Münchner Maximilianstraße aus. Gabi Dziuba und Annette Rössle, ehemalige Studentinnen der Münchner Akademie, organisierten dort von 1982 bis 1983 Ausstellungen zeitgenössischen Schmucks, besser gesagt Autorenschmucks. Das Ganze eine Idee Münchner Künstler*innen.²⁵

15

Von 1971 bis 1974 hatten schon Hermann Jünger und Hubertus von Skal mit der Galerie Cardillac in der Innenstadt (Ecke Residenz- und Maximilianstraße) versucht, Münchner*innen mit außergewöhnlichen Schaufensterinszenierungen für ihren Schmuck zu begeistern. Von Skals «Schaufenster» werden noch einmal, in ganz anderem Zusammenhang, in der Öffentlichkeit gezeigt: 1975 dienen sie der Neuen Sammlung, seine Arbeiten in der Ausstellung «Hubertus von Skal. Goldschmiedearbeiten» zu präsentieren.

Die Maximilianstraße – dieser Prachtboulevard aus der Mitte des 19. Jahrhunderts nach Entwürfen des Architekten Georg Friedrich Christian Bürklein – war von 1983 bis 2003 Heimat der legendären Schumanns Bar, die heute ihr Domizil am Odeonsplatz hat. In der Etage darüber gründete der Kunsthändler Richard Grimm das erste Jüdische Museum in München. Der Journalist und Autor Karl Stankiewitz beschrieb 2011 sehr bildhaft die vergangene Atmosphäre der Prachtstraße, weshalb an dieser Stelle ein längerer Auszug davon wiedergegeben sein soll: «Im ‹Nacht-Cabaret Intermezzo› tanzten die Pariser Lido-Girls, trillerte ein Londoner Skandalgirl, musizierten Baby-Elefanten. Vis-à-vis leitete Trude Kollmann die ‹Kleine Freiheit›, die mit Texten von Friedrich Holländer, Erich Kästner und Martin Morlock zur führenden Kleinkunstbühne der Stadt, vielleicht sogar der Republik wurde. Dieter Hildebrandt ließ sich hier als Platzanweiser zu eigenen Kabarettplänen anregen. An der Ecke lockte ‹Das Roma› bildhübsche Mädchen, Besucher und Akteure umliegender Theater und Galerien, Touristen, Bohemiens und notorische Boulevard-Bummler. Jahrzehntelang inszenierte sich da eine Kultur-Schickeria, vorzugsweise in der blauen Stunde vor Sonnenuntergang. Außerdem konzentrierte

23 http://de.wikipedia.org/wiki/Roter_Turm, aufgerufen am 13.09.2020.

24 «Kultur in der Natur. Temporärer Theaterturm in den Schweizer Alpen»,
 www.baunetz.de/meldungen/Meldungen-Temporaerer_Theaterturm_in_den_Schweizer_Alpen, aufgerufen am 12.09.2020.

25 Mündliche Mitteilung von Therese Hilbert, 28.09.2020.

sich hier immer mehr das Geschäft mit der Kunst. Zeitweise bis zu 20 Läden und Beletage-Galerien boten vorwiegend der Gegenwartskunst ein international beachtetes Schaufenster. So hat der junge Heiner Friedrich die ‹junge heftige Malerei› (Baselitz und einige Beuys-Schüler, aber auch amerikanische Pop Art) hierzulande erst richtig bekannt gemacht. Eine Vorreiterrolle spielten auch Otto van de Loo oder die Galerie Art in Progress von Ingvild Götz, die eher als die Museen einen Andy Warhol entdeckte. Dreizehn Galeristen veranstalteten einmal wöchentlich am Donnerstag eine ‹lange Nacht der Kunst›.»[26] Die Galerien eröffneten zusammen am ersten Donnerstag im Monat ihre Ausstellungen,[27] gaben in der Zeit von 1976 bis 1980 einmal im Jahr eine gemeinsame Publikation zu einem gesonderten Thema heraus.[28] Die letzte dieser Publikationen ist 1980 dem Thema Farbe gewidmet. Der Einband ist ROT.

16 Damit zurück in das Jahr 1983, als TH in der «Schaufenstervitrine Nr. 34» ausstellt. Es war die letzte Ausstellung an diesem außergewöhnlichen Ort.[29] TH kleidete das Schaufenster ganz in ROT. Sie präsentierte «Die Dornenkrone», Halsschmuck, 1983, PVC, Stahl, Messing, Dm. 450 mm. Das Metall ist lackiert, das PVC eingefärbt: in ROT.[30] Eines der wenigen Objekte in ihrem Werk mit einem Titel. Und auch wenn das Kulturelle Wissen andere Assoziationen bei einem ROT in Szene gesetzten (Schau-)Fenster evoziert, sind es rein ästhetische Überlegungen, dieses reizvolle Moment von ROT auf ROT, die TH diese besondere Präsentationsform wählen lassen.[31] Es ist ihre erste rote Präsentation. Auf sie folgt nun «Therese Hilbert. ROT».

26 Karl Stankiewitz, «Boulevard der Dämmerung: Die letzten Altmünchner Läden der Maximilianstraße geben auf, eine Kulturmeile ist am Ende.» https://kultur-vollzug.de/article-20432/2011/11/19/boulevard-der-dammerung-die-letzten-altmunchner-laden-der-maximilianstrase-geben-auf-eine-kulturmeile-ist-am-ende/, aufgerufen am 03.10.2020. – Galerien in der Maximilianstraße nach aufsteigenden Hausnummern ohne Gewähr auf Vollständigkeit: Maximilinstraße Nr. 10: Galerie Alfred Gunzenhauser, Galerie Fred Jahn (1.OG) — Nr. 12: Galerie Biedermann und Galerie Schellmann & Klüser — Nr. 13: Galerie Heseler — Nr. 15: Galerie Friedrich und Dahlem, später Galerie Six Friedrich — Nr. 16: Galerie Karl Pfefferle — Nr. 20: Galerie Orny — Nr. 22: Galerie Rieder, Galerie von Abercron — Nr. 25: Galerie Raimund Thomas (3. OG), Galerie Art in Progress von Ingvild Götz — Nr. 27: Galerie Otto van de Loo — Nr. 29: American Contemporary Art Gallery von Kirstin und Otto Hübner, Galerie Godula Buchholz, Galerie Klewe — Nr. 30: Schaufenstervitrine 30 — Nr. 34 (Passage): Schaufenstervitrine 34 — Nr. 36: Galerie Arnold-Livie — Nr. 38 Maximiliansforum (früher Kunstforum München und ZKMax) — Nr. 42: Galerie der Künstler — Nr. 45 Galerie TANIT von Naila Kettaneh-Kunigk und Stefan Kunigk (5. OG) — Maximilianstraße/ Ecke Residenzstrasse/ Max-Joseph-Platz: Galerie Cardillac — ohne genaue Verortung: Galerie Sabine Knust — und auch noch in der Maximilianstraße Nr. 17: Hotel Vier Jahreszeiten — Nr. 26–28: Münchner Kammerspiele im Schauspielhaus — Nr. 39: Regierung von Oberbayern — Nr. 42 Bayerisches Nationalmuseum, seit 1954 Museum für Völkerkunde, jetzt Museum Fünf Kontinente — und in direkter Nähe: Am Platzl 4: Kabarett «Die Kleine Freiheit» und Galerie Hermanns.

27 Gudrun Spielvogel über 30 Jahre Münchner Open Art, deren Anfänge und das aktuelle Galerien-Wochenende. «Da war Aufbruchstimmung!» Das Gespräch führte Simone Dattenberger, 08.09.2018. www.ovb-online.de/weltspiegel/kultur-tv/aufbruch-stimmung-10223274.html, aufgerufen am 03.10.2020.

28 «Handzeichnungen». Gemeinsame Ausstellung der Galerien in der Maximilianstraße, München, April 1976 | «Menschenbild». Gemeinsame Ausstellung der Galerien in der Maximilianstraße, München, 1. April 1977 | «Architektur Räume Projekte». Gemeinsame Ausstellung der Galerien in der Maximilianstraße, München, 1. April 1978 | «Zum Thema Skulptur». Gemeinsame Ausstellung der Galerien in der Maximilianstraße, München, 1. April 1979 | «Farbe». Gemeinsame Ausstellung der Galerien in der Maximilianstraße, München, 30. März 1980.

29 Erst mit der Schaufenstervitrine Nr. 30 bot sich einige Jahre später wieder eine ähnliche Möglichkeit.

30 Franz G. Gold, «Interview mit Therese Hilbert und Otto Künzli», in: Ausst.-Kat. Fragments. Therese Hilbert und Otto Künzli. Jewellery 1976–1986. Helen W. Drutt English Gallery, Philadelphia 1986, S. 19 (Archiv Therese Hilbert).

31 Mündliche Mitteilung von Therese Hilbert, 28.09.2020.

Therese Hilbert. RED

Petra Hölscher

Every color has its stories … including RED*

1

Not far from a Munich auction house, TH, OK and PH sit together over a glass of wine on a mild early summer evening. The topic of the day: the possible acquisition of one of Naum Slutzky's «Pebble Rings». The pros and cons are discussed. After a while, the group agrees – the ring's quality is convincing, the issue thus concluded. Now seems like a good moment for asking a delicate question. The title TH has chosen for her planned exhibition at Die Neue Sammlung, made up of four letters and forming a word both in German and English, has been on the mind of all three present for weeks. Yet upon consultation of the world wide web and social media, the use of the four-letter word turns out to be somewhat problematic. Is there maybe a different title that could be used for the exhibition?

The question has been asked. TH falls silent. The first early summer thunderstorm breaks over Schwabing. Rain pelts down on the streets. The branches of the trees bend in the wind. People struggle with their umbrellas. Newspapers used for makeshift protection buckle under the masses of water. TH looks out of the window. How will she react? Is silence her answer? Minutes start to feel like hours. Then she begins speaking in a lively staccato voice: «I've got it — no problem — but I'm not going to tell you yet — it's just a single word again — let me sleep on it a little while though — it has even fewer letters — I'll tell you soon.» We sit together a little while longer. It's stopped raining.

June passed, soon it was July. TH hadn't been in touch.

Then, on one of those Tuesdays on which the week has just kicked off, but not yet found its rhythm, a call from TH. Her first sentence, an utter disaster: «It's your fault!» So it had been wrong to ask the question after all. My adrenaline level shot through the roof in a mere few seconds. Stay calm, I told myself. There will be a solution. Then TH laughed her famous warm laugh at the other end of the line: «It's your fault … and I think the new title is great. – Great and much better than the old one. It is: RED.»

Therese Hilbert. RED

2

RED. — Not black. — Not silver. — Not yellow.
These of course also belong to TH's color spectrum, to her brooches and pendants.

3

Per definition, black and white are not really colors. And silver – strictly speaking – is the term used to describe a precious metal. According to Goethe, the Pythagoreans, members of the school of Pythagoras in the 6th century BCE, described the surface of solids as color.[1] So is silver a color after all? 2540 years later this notion has become more or less established.

* A short, associatively written piece on the color RED.
1 Johann Wolfgang Goethe, Gedenkausgabe der Werke, Briefe und Gespräche, volumes. 1-24 and supplamantary volumes 1-3, vol. 16, Zurich 1948, p. 255.

Therese Hilbert. RED

We know of two terms used for silver in ancient Egypt. One is: moon metal. In many cultures the moon represents the female and the sun the male aspect. The French king Louis XIV and later also Augustus II the Strong of Saxony, seeking to emulate the French role model, impressively demonstrated this with their majestic sun cult.[2] A now almost forgotten fact is that in Christianity silver and the moon used to be associated with the Virgin Mary. The depiction of the Mother of God as the Woman of the Apocalypse frequently showed her with the moon under her feet.[3]

The other word used for silver in ancient Egypt translates as «white metal». Purified silver coming out of the separating chamber has the highest reflective properties of all known metals. It reflects 95% of visible light and is thus regarded to be the «whitest» of all the metals we use.[4] In contrast to this, its surface becomes black when it becomes «tarnished». The metal develops a film of silver sulfide. The annex sulfide describes the sulfur component which in combination with oxygen forms as a usually dark coating on the metal. As the 16th element in the periodic table, sulfur is described as having a lemon-yellow color at room temperature.

Yellow. TH's body of works on the theme of the volcano are frequently interspersed by pieces that feature a light-yellow hue. In the eyes of someone familiar with volcanic activity, RED, yellow and black are intrinsically linked. Molten stone from the center of the earth – magma – emerges from the earth's surface as glowing-red lava. As this slowly cools off it turns black in color. However, when cooled rapidly under certain chemical conditions inky black, volcanic glass – called obsidian – may be produced. «Obsidian», TH explains, is a «hard, black, glass-like material that creates very sharp edges when fractured, which is why in the past it was very well suited to making tools, such as arrowheads […] When I go looking for obsidian, I am very focused and excited. My eyes are lowered … the sky no longer exists, only the ground, what is below.»[5]

If a lot of gases are released during the cooling process, the lava foams and bubbles up such that the end result is the porous, sometimes whiteish-grey, brownish or at times black pumicite. TH uses pumice powder to treat the surfaces of her silver pieces. This gives them their characteristic texture, which appears almost soft.

Having considered these outward perspectives, everything in TH's oeuvre suddenly makes sense: her use of silver as a material, the black and yellow hues she employs, and her decision for: Therese Hilbert. RED.

2 Exh. cat., Eine gute Figur machen. Kostüm und Fest am Dresdner Hof. Ed. by Claudia Schnitzer and Petra Hölscher, Dresden 2000.

3 «Image of Mary with the features of the Woman of the Apocalypse, of the woman pursued by the dragon that births the child saved by the archangel Michael and stands on the moon, clothed by the sun, crowned by the stars (Rev.12,1f.). According to the biblical description, Our Lady of the Crescent Moon wears a crown of 12 stars, is surrounded by rays of the sun and stands on the moon.», in: H. Sachs, E. Badstübner, H. Neumann, Erklärendes Wörterbuch zur Christlichen Kunst, Hanau, unpaginated, keyword «Mondsichelmadonna».

4 https://en.wikipedia.org/wiki/Silver, last retrieved August 28, 2020.

5 Booklet accompanying the exhibition «&: Hilbert & Künzli» Gestalten im Dialog: Therese Hilbert & Otto Künzli, (Gewerbemuseum Winterthur, 2016), nos. 56 and 57.

RED. 4
It may well be one of the oldest and first appellations for a color that we know.[6]
 RED was the color used to fill the black outlines of prehistoric bulls in the Caves of Altamira (Spain) and Lascaux (France). These first reddish pigments were extracted from hematite, a red iron oxide. At times this was mixed with ground pumice stone as a binding agent.[7]
From at least the 2nd century BCE onwards, red dye, the so-called carmine, was produced from the pregnant female cochineal insects in parts of South America. Up until the 20th century, this cochineal was produced on the Canary Island of La Isla San Miguel de La Palma, to be used among other things for the production of cosmetics. It is still used for red lipstick to date.[8]

We know of very early reddish-brown body painting thanks to the finds of ancient mummies. Dried and ground-up leaves of the henna plant provided the coloring for these. In the 1990s, actors such as Demi Moore, singers like Madonna and Gwen Stefani of the American rock band No Doubt sparked a veritable cult following for this type of bodily adornment in the style of the Indian mehndi.[9] Its later increased use as a fashion accessory had little to do with the marital and funeral rites of indigenous cultures.

RED. The color most often used in national flags. Therese Hilbert was born in Zurich 5
in the newly founded federal state of Switzerland, where she also took her first steps towards becoming a goldsmith. In 1848, the state placed a white cross in the center of a square (!) red flag as a background – not to be confused with the lengthwise rectangular Dannebrog flag of Denmark. Up until the end of World War II, RED was seen as having male connotations and as the color of strength. It was only then that RED was succeeded by blue in the marine uniforms. Among the flag-like means of recognition and communication there exists the inverse composition of the Swiss flag as the red cross on a white ground. It is the name giver of the international committee of the Red Cross, founded in 1876 based on the ideas of the Swiss businessman Jean-Henry Dunant and the general Guillaume Henri Dufour.

RED. Used in the public sphere as a signal color for example in traffic signs, walking 6
figures on pedestrian traffic lights, or yellow-red pop-up cycle lanes painted onto roads in times of COVID-19. RED cars were long seen as easier to sell. Just as Racing Green will always be associated with the Jaguar E-Type, positive (driving) emotions were associated with the promising blue-RED of the Fiat Nuovo Cinquecento and

6 https://en.wikipedia.org/wiki/Red, last retrieved August 30, 2020.

7 Stefan Muntwyler, «Die ersten Farben der Menschheit. Schwarz. Rot. Gelb. Weiss», in: Gewerbemuseum Winterthur (ed.), Farbpigmente. Farbstoffe. Farbgeschichten, (Winterthur, 2010), pp.152–3.

8 Marietta Rohner, «Karminrot», in: Gewerbemuseum Winterthur (ed.), Farbpigmente. Farbstoffe. Farbgeschichten, (Winterthur, 2010), p. 222.

9 https://en.wikipedia.org/wiki/Mehndi and www.mehndiskart.com/henna-artificial.htm, both last retrieved August 30, 2020.

the more sporty Giulietta by Alfa Romeo. Ferrari-RED stands for desirable sports bolides made in Italy and the dream of speed. RED showing through the car rims not only stands for the understatement of a German sports car manufacturer, but also for the safety offered by its brake systems. RED – a color of opposites.

7 RED. Creatives and industrial designers like to use all shades of the color.

The logo, or corporate identity, of Die Neue Sammlung, founded in 1925, has used RED for a long time. Yet RED may also be subject to trends and preferences specific to an era. RED is part of the culture of the 1920s: of Max and Bruno Taut's New Architecture or that of the brothers Hans and Wassily Luckhardt, but also of Red Vienna and its cooperative housing complexes. RED is associated with the New Typography by Jan Tschichold and Johannes Molzahn as well as with the German Werkbund, the Munich Bund and the «Rote Gruppe» – the union of Communist artists in Germany led by George Grosz and John Heartfield. In the 1980s the Munich based graphic artist Pierre Mendell chose Japanese red, a type of vermillion, as the color for the logo of Die Neue Sammlung. Around 35 years later Mirko Borsche, who also created the graphic layout for the renowned Süddeutsche Zeitung Magazine as well as later that of the Magazine of the weekly Die Zeit, upped the proportion of yellow in the Die Neue Sammlung logo.

8 RED. The color enjoyed a veritable boom in the late 1960s / early 1970s when industrially dyed plastic made things such as the telephone «Grillo» by Siemens Italia and the radio receiver «RR127» by Brionvega possible, both designed in 1965 by Richard Sapper and Marco Zanuso. Who doesn't know the portable typewriter «Valentine» created by Ettore Sottsass in 1969 together with Olivetti. Executed in RED, it provides the emotional background to legendary love letters said to have been written on this machine – how pale does the same machine look in a broken warm white in comparison. Is it not fitting, then, that the volume «Rote Gedichte» was first published by Reclam's Universal Bibliothek under the number 18926 in 2006?[10]

Based on the seductive «Ruby-Lips» by Salvadore Dali (1936), Studio 65 designed the red lip sofa «Bocca» (1971), produced by Gufram. And Gaetano Pesce not only penned the seating object «La Mamma» (1969) in RED for B & B Italia, but also the module sofa «Tramonto a New York» (1980) for Cassina. A red setting sun above the skyscrapers of the American metropolis invites its counterpart to partake in a romantic sun downer.

9 Can we surmise that RED is one of the human race's favorite colors? According to a 2014 study by the Institut für Demoskopie Allensbach conducted with 1000 adults aged 16 to 75, blue (40% of respondents) beat RED (19%) to the top spot, followed by green (18%).[11] A statistical survey carried out in 2007 with 171 British subjects at

[10] Edited by Evelyne Polt-Heinzl & Christine Schmidjell.

[11] Press Release, Deutsches Lackinstitut, www.lacke-und-farben.de, last retrieved August 28, 2020. Broken down by gender, female respondents preferred blue 36%, red 20% and green 12%, while male respondents preferred blue 40%, red 20% and green 12%.

Newcastle University had already produced similar findings while taking into account 37 Chinese nationals who had only relocated to Great Britain a short while earlier.[12] TH's favorite color is RED. She mostly dresses in black. It's only her lipstick that is RED.

One of TH's early pieces is a set of ear jewelry consisting of two pairs of cherries. Each pair is made up of a red and a translucent cherry. You hang them – as kids like to do – over your outer ear, one left and one right. This is also why they have no kind of fastening mechanism, no clip, no clutch, no screw system – there is no need for one. Based on the light RED color used, they look more like sour cherries than the sweet variety, but that doesn't really matter here, if only that the cherries feature the nuance of RED that the artist loves the most.

A further piece is created around the same time: A halved apple, to be worn as a pendant, appears as an inedible, pomological rarity with its seemingly red flesh and the cast-in real apple core. A thin red layer of plastic forms the outer skin of the cut-open half of the fruit. Encased in this in a bed of transparent plastic this is the core, freed of the fruit flesh. The RED of the outer skin shines through the transparent plastic.

TH created the cherries and apple in connection with a fashion jewelry competition in Neugablonz in 1973. She submitted only the «apple half […] with a cast-in natural apple core».[13] It won her the first prize. She had only started studying in the Jewelry class of Hermann Jünger at the Academy of Fine Arts in Munich one year earlier – at the time, Jünger was the advisor of the technical college Fachschule für Glas und Bijouterie in Kaufbeuren-Neugablonz. Bussi Buhs had been appointed to a lectureship for Artistic Plastics Engineering a short while earlier in 1971 and was heading the newly established study workshop for plastics at the Munich Academy. It was here that TH experimented with the artificial, synthetic material that offered a range of new possibilities. However, the «horrible smell» of liquid plastic caused her to stop utilizing the material in the end.[14]

From a botanical point of view, apples and cherries belong to the family of rosaceous plants. In popular belief the cherry tree stands for strength and fertility. Its white flowers symbolize purity and beauty. Popular belief also states that if cherry branches cut on Saint Barbara Day the 4th of December flower at Christmas this predicts that the woman who cut them will marry soon. Since the 1950s cherries as the symbol of sweet seduction have belonged to the repertoire of fashion accessories of petticoat and Rock'n'roll.

By contrast, the apple forms part of the triad of royal power symbols together with the crown and scepter. The bible features the apple as a fruit from the tree of knowledge carrying the curse that sees the first people ejected from paradise. In Durer's famous 1507 painting «Adam and Eve» Adam is already holding the apple in his hands. 450 years later the image has changed: On a photograph a young

12 «Blau ist Lieblingsfarbe – Frauen stehen auf Rot», in: Handelsblatt, August 21, 2007, «Wissenschaft» (science) section.

13 «Blumen eines Sommers. Modeschmuckwettbewerb 1973 des Arbeitskreises Form + Farbe», in: Goldschmiedezeitung, 1973, no. 8, pp. 30–32 and exh. cat. Modeschmuck 1973, ed. by the Arbeitskreis für Form und Farbe, (Kaufbeuren, 1973), unpaginated.

14 As told by Therese Hilbert, September 21, 2020.

strawberry blonde woman with lasciviously opened lips painted in RED lipstick wears TH's apple half on a silver chain. The apple hangs in the middle of her décolleté, her breasts only just covered by a pink shirt unbuttoned down to her chest.

The statement image was produced by Regina Relang (1906–1989), the celebrated German fashion photographer who produced cover shots for «Die Dame», «Film und Frau» and the German «Madame». Using the tools of fashion photography current to her era, the then 67-year-old conveyed a theme of the feminist movement of 1968 that appears to still hold currency.[15] The result is much more than mere fashion photography. In the image context, Relang deciphered the apple half as the female vulva and thus placed TH's apple pendant in a visual-erotic context.

11 Back to RED. The wiki-based dictionary «Wiktionary» lists 66 derived terms for RED as an adjective: from Amaranth red, red-blue via dark red, strawberry red, Falun red, red yellow, bright red, indian red and crimson red to poppy red and ox blood red as well as pink-red to wine-red and vermillion.[16] Everyone can add another variant including Jaipur red, coral red, orange red, Pompeian red, Titian red etc. In the Pantone system, it is the numbers «2035 or 2347»[17] that most closely resemble TH's favorite RED hue. The sleeve of this volume provides an idea of the color in question.

12 For art historian PH it would be difficult to circumvent the greats of European cultural and art history, beginning with Giotto, who in the 14th century understood white as unfractured light, to Leonardo da Vinci, who a century later attempted to create a system of colors, to Isaac Newton, who built on the former's system in the 18th century. Using a prism, Newton characterized the basic colors as RED, green and blue. In their sum they created white, or to be more precise white light, which brings us back to Giotto. At the turn of the 19th century Johann Wolfgang von Goethe expanded the canon to six basic colors, namely purple, red-yellow, yellow, green, blue and red-blue, with which he formed a color wheel. In the color wheel, purple forms the transition between the areas of «fantasy» and «prudence». Goethe gave this color section the attribute «beautiful». He characterized red-yellow as «noble». Pure yellow stood for the realm of «reason».

Nowadays, according to the German Wikipedia entry on the subject, we associate RED with warmth and energy. It is linked to the color of blood and thus equated with life. According to the here cited digital platform RED stands for joy, passion, love and eroticism, but also for aggression and anger. The entry closes with the pointer: embers are red.[18] (At which point I can also reveal the first proposed title of the exhibition as having been «Glut. Glow».) «In many cultures the red symbolizes both life and death – it is a beautiful and at the same time terrible paradox. In our modern language RED is a metaphor for fire, wilde and stormy feelings, for love …

15 Anni Schaad (née Lang) was a member of the jury. She owned the Langani company (fashion jewelry) in Stuttgart and was Regina Relang's sister; exh. cat. Die elegante Welt der Regina Relang. Mode- und Reportagefotografin, ed. by Esther Ruelfs & Ulrich Pohlmann, (Ostfildern-Ruit, 2005), p. 25.

16 https://en.wiktionary.org/wiki/red, last retrieved August 28, 2020.

17 Email from Therese Hilbert to the author, September 4, 2020.

18 https://en.wiktionary.org/wiki/red, last retrieved August 30, 2020.

is standing for [Mars] the God of War and power.» And the same article states further «The Comanche use the same word – ‹ekapi› – for color, circle and red. Which suggests that the Native-American peoples regarded the concept to be something fundamental that comprised everything else.»[19] Maybe Goethe referred to exactly this when he wrote: «The most perfect color is red …»[20]

A long-stemmed red rose is seen as the pinnacle of perfection in the plant world. It is often given as a present symbolic of love on birthdays and Mother's Day. Hildegard Knef, a chanson singer feted in post-war Germany, sang for the first time in 1968 – as well as together with Rock band Extrabreit thirty years later – that she wished «Rote Rosen» (red roses) would rain down on her. In TH's oeuvre, the rose is not RED but formed from thin sheet silver, then mounted and worn as a brooch (1989). It is blackened, TH has taken away its thorns. The petals in their full splendor thus seem defenseless in comparison to those of the other members of its species.

The noncolor black has – how could things be any different – its own symbolism. On the platform «Designer in Action» under the heading «Design-Wissen» (design knowledge) you can find the contribution «Die Bedeutung der Farben» (The meaning of colors). About the color black you can read there that «in many cultural milieus, black stands for sophistication and formality, but also for negative aspects such as death, mourning, illness, bad luck, secrets and more (…).» In Africa, the text goes on to say, black is seen as «synonymous with masculinity».[21] TH broke the stem of a rose into several pieces, leaving it its thorns, and cast the pieces in silver. Afterwards she reassembled the pieces to form a long chain. When worn, the thorns impress themselves into the wearer's neck.

Let's return to RED. The British film director Derek Jarman, who examined the subject of colors closely and repeatedly, saw no other color as being as territorial as RED. In his words it «stakes out its territory.»[22] In nature, this occurs when a volcano erupts, when magma breaks its way and enlarges islands or buries houses, villages and cities. In the world shaped by the human hand, according to Jarman the town hall of Berlin, called the Rotes Rathaus, with its red brick façade, stands for an architecture that is defining in the above sense. Implanted into the townscape in 1869/70, the striking town house with its characteristic round arches provides a wide and domineering sight in the urban space. A tower further emphasizes its axial symmetry. The façade could hardly have been implemented in a grander way, political architecture could hardly be more demonstratively imposing.

19 Victoria Finlay, Color: A Natural History of the Palette, (Random House. New York, 2003).
20 https://en.wiktionary.org/wiki/red, last retrieved August 30, 2020.
21 www.designerinaction.de/Bedeutung, last retrieved September 20, 2020.
22 «Architektur in Rot,» in: Zeitmagazin, Januar 14, 2019.

According to Wikipedia[23], Germany has or had fifteen Red Towers alone – their function usually forming a part of city gates. One such tower has stood in the Bavarian town of Wasserburg as part of the medieval curtain wall since 1415. There used to also be one in Munich. Nowadays, the only thing left of the latter is the «Rote-Turm» -plaza named after the structure in the Sendling district of Munich. Why this excursus? On August the 10th, TH sent PH a photograph of an ox blood red tower in the Swiss Alps via WhatsApp. Vertically, the temporary wooden theatre tower is rhythmized by eight concave sections, horizontally it is four rows of round arches above each other. At times, their windows reflect the mountain landscape, at others the endless blue of the sky, at yet others the glass surface is a deep black and filled with a mysterious darkness. With its archaic look the tower is reminiscent of late antique-Byzantine structures such as San Vitale in Ravenna. It was built in 2005 as the venue of the Origen Festival Cultural on the 2300-meter high Julier Pass in the Swiss canton of Graubünden.[24]

15 In 1983 TH exhibited her work at «Schaufenster Nr. 34» in the poshy Maximilianstraße in Munich. Gabi Dziuba and Annette Rössle, former students at the Munich Academy, organized exhibitions of contemporary jewelry, or rather, studio jewelry, there from 1982 through to 1983. The idea had come from Munich-based artists.[25]

From 1971 through to 1974, Hermann Jünger and Hubertus von Skal had already attempted to capture the interest of Munich citizens with exceptional window display stagings with their Galerie Cardillac in the center of town (on the corner of Residenzstraße and Maximilianstraße). Von Skal's «Schaufenster» installations were shown once more publicly in an entirely different context: In 1975, they served as a backdrop to his work in the exhibition «Hubertus von Skal. Goldschmiedearbeiten» held at Die Neue Sammlung.

The Maximilianstraße – that grand boulevard built in the mid-19th century according to the ideas by Georg Friedrich Christian Bürklein – was the home of the legendary Schumanns Bar, which is now domiciled on the Odeonsplatz, from 1983 to 2003. On the floor above it, the art dealer Richard Grimm founded the first Jewish Museum in Munich. In 2011, the journalist and author Karl Stankiewitz vividly described the atmosphere of the Prachtstraße. The following long excerpt is lifted from his description: «Lido girls from Paris danced in the ‹Nacht-Cabaret Intermezzo›, while a London scandal girl sang, and baby elephants made music. Vis-à-vis Trude Kollmann was in charge of the ‹Kleine Freiheit›, which turned into the leading cabaret stage of the city, and maybe even the country, with texts by Friedrich Holländer, Erich Kästner and Martin Morlock. His work here as an usher inspired Dieter Hildebrandt to implement his own cabaret plans. On the corner, the ‹Das Roma› attracted beautiful girls, visitors and protagonists of the nearby theatres and galleries, tourists, bohemians and notorious boulevard flaneurs. For many decades it was a hotspot to see and be seen for a ‹Schickeria› (cultural in-crowd), with the

23 http://de.wikipedia.org/wiki/Roter_Turm, last retrieved September 13, 2020.

24 «Kultur in der Natur. Temporärer Theaterturm in den Schweizer Alpen», www.baunetz.de/meldungen/Meldungen-Temporaerer_Theaterturm_in_den_Schweizer_Alpen, last retrieved September 12, 2020.

25 As told by Therese Hilbert, September 28, 2020.

blue hour before sunset the preferred hour for a visit. What's more, art business was increasingly conducted in the area. At times there were up to 20 shops and bel étage galleries that offered an internationally noted display window primarily for contemporary art. The young Heiner Friedrich popularized the ‹young vehement painting› here (Baselitz and some Beuys students, as well as American Pop Art). Otto van de Loo or the gallery Art in Progress by Ingvild Götz also played a pioneering role, discovering Andy Warhol before the museums did. Thirteen gallerists held a ‹long night of the arts› here every Thursday.»[26] The galleries all inaugurated their exhibitions on the first Thursday of the month[27] and in the time from 1976 to 1980 issued a shared publication on a special topic.[28] The last of these publications looked at color. Its sleeve was RED.

Let us look back to the year 1983 in which TH exhibited her work at «Schaufenstervitrine Nr. 34». It was the last exhibition in this exceptional space.[29] TH dressed the entire window in RED. She presented her «Die Dornenkrone» neck jewelry, created in 1983 using PVC, steel, brass, and which had a diameter of 450 mm. The metal has been varnished, the PVC dyed: in RED.[30] It is one of the few objects in her oeuvre with a title. And even though our cultural knowledge evokes other associations when it comes to a (display) window staged all in RED, TH chose the special form of presentation, the alluring RED on RED, for purely aesthetic reasons.[31] It was her first presentation using the color. This is now followed by «Therese Hilbert. RED».

26 Karl Stankiewitz, «Boulevard der Dämmerung: Die letzten Altmünchner Läden der Maximilianstraße geben auf, eine Kulturmeile ist am Ende,» https://kultur-vollzug.de/article-20432/2011/11/19/boulevard-der-dammerung-die-letzten-altmunchner-laden-der-maximilianstrase-geben-auf-eine-kulturmeile-ist-am-ende/, last retrieved on October 3, 2020. – Galleries on Maximilianstraße by rising house numbers, with no guarantee of completeness: Maximilinstrasse no. 10: Galerie Alfred Gunzenhauser, Galerie Fred Jahn (2nd floor) — no. 12: Galerie Biedermann and Galerie Schellmann & Klüser — no. 13: Galerie Heseler — no. 15: Galerie Friedrich and Dahlem, later Galerie Six Friedrich — no. 16: Galerie Karl Pfefferle — no. 20: Galerie Orny — no. 22: Galerie Rieder, Galerie von Abercron — no. 25: Galerie Raimund Thomas (4th floor), Galerie Art in Progress by Ingvild Götz — no. 27: Galerie Otto van de Loo — no. 29: American Contemporary Art Gallery by Kirstin and Otto Hübner, Galerie Godula Buchholz, Galerie Klewe — no. 30: Schaufenstervitrine 30 — no. 34 (passage): Schaufenstervitrine 34 — no. 36: Galerie Arnold-Livie — no. 38 Maximiliansforum (previously Kunstforum München and ZKMax) — no. 42: Galerie der Künstler — no. 45 Galerie TANIT by Naila Kettaneh-Kunigk and Stefan Kunigk (6th floor) — Maximilianstraße/ corner of Residenzstrasse/ Max-Joseph-Platz: Galerie Cardillac — without precise location: Galerie Sabine Knust — and further on Maximilianstraße no. 17: Hotel Vier Jahreszeiten — no. 26–28: Münchner Kammerspiele in the Schauspielhaus — no. 39: Regierung von Oberbayern — no. 42 Bayerisches Nationalmuseum, since 1954 Museum für Völkerkunde, now Museum Fünf Kontinente — and in the immediate vicinity: Am Platzl 4: Kabarett «Die Kleine Freiheit» and Galerie Hermanns.

27 Gudrun Spielvogel on 30 years of Münchner Open Art, its beginnings and the current gallery weekend. «Da war Aufbruchstimmung!» The interview was conducted by Simone Dattenberger, September 8, 2018. www.ovb-online.de/weltspiegel/kultur-tv/aufbruchstimmung-10223274.html, last retrieved October 3, 2020.

28 «Handzeichnungen». Gemeinsame Ausstellung der Galerien in der Maximilianstraße, Munich, April 1976 | «Menschenbild». Gemeinsame Ausstellung der Galerien in der Maximilianstraße, Munich, April 1, 1977 | «Architektur Räume Projekte». Gemeinsame Ausstellung der Galerien in der Maximilianstraße, Munich, April 1, 1978 | «Zum Thema Skulptur». Gemeinsame Ausstellung der Galerien in der Maximilianstraße, Munich, April 1, 1979 | «Farbe». Gemeinsame Ausstellung der Galerien in der Maximilianstraße, Munich, March 30, 1980.

29 Only a few years later did a similar opportunity arise again with the shop window No. 30.

30 Franz G. Gold, interview with Therese Hilbert and Otto Künzli, in: exh. cat. Fragments. Therese Hilbert and Otto Künzli. Jewellery 1976–1986, (Helen W. Drutt English Gallery: Philadelphia, 1986), p. 19 (archive of Therese Hilbert).

31 As told by Therese Hilbert, September 28, 2020.

Therese Hilbert. (EIN) SCHMUCK – LEBEN

Therese Hilbert
(EIN) SCHMUCK – LEBEN

«Bei Kunst geht es nicht um Kunst.
Bei Kunst geht es um das Leben
und das fasst es zusammen.»
(Louise Bourgeois)[1]

«Ich versuche, mich zu äußern, zu
formulieren über meinen Schmuck.
Es sind Reaktionen und Reflektionen
meines Lebens … Meine ‹Worte›
sind meine Broschen, Anhänger, Ringe.»
(Therese Hilbert)[2]

Die Aussage von Louise Bourgeois verrät einen künstlerischen Blickwinkel, der sich auch bei Therese Hilbert beobachten lässt, verborgen und transkribiert in der ausdrucksvollen Gestalt ihres Schmucks. Es geht dabei nie um konkrete autobiographische Erlebnisse oder narrative Inhalte, sondern um ein generelles Temperament, eine Haltung, eine innere Überzeugung, welche die Arbeit der Goldschmiedin fundamental prägen.

Auftakt und Annäherung

Frühe Stimmen zum Werk geben uns für eine erste Annäherung Parameter an die Hand. Wolfgang Wunderlich etwa, der 1979 – ein Jahr nach dem Diplom Hilberts bei Hermann Jünger an der Akademie der Bildenden Künste München – ihren erstmals im Schmuckmuseum Pforzheim ausgestellten Objekten «ein ambivalentes Verhältnis von innen und außen, Verborgenem und Sichtbarem» attestiert. Die Schmuckstücke, vorwiegend in Silber, seien Dokumente einer autonomen Sprache, die vom «Prinzip des Durchbruchs, der Durchdringung …», von «Zerstörung», «Verletzung», von einer quasi aggressiven, triebhaften, vegetativ wirkenden Organik zeugen.[3] Gemeint sind Broschen, Ringe, Anhänger von geometrischem Zuschnitt – wesentlich Quadrat, Zylinder, Kreis –, dabei von glatter oder fein punzierter, leicht welliger Oberflächenstruktur und bis fast zum Äußersten ins Material getriebenen warzenartigen Erhebungen gekennzeichnet. Winzige silberne oder vereinzelt

1 Donald Kuspit, An interview with Louise Bourgois. New York 1988; zit. n. Henry Meyric Hughes, «La casa», in: Ausst.-Kat. «La casa, il corpo, il cuore». Konstruktionen der Identitäten, hrsg. v. Lóránd Hegyi. Museum moderner Kunst Stiftung Ludwig. 20er Haus, Wien 1999. S.55–63; S. 55.

2 Therese Hilbert, unveröffentlichtes Manuskript, Jahr 2001.

3 Wolfgang Wunderlich in: Ausst.-Kat. Therese Hilbert. Schmuckmuseum Pforzheim 1979, Deutsches Goldschmiedehaus Hanau, Galerie Alberstraße Graz und Loft Wien 1980, S. 2 (Einzelausstellung zusammen mit Otto Künzli).

goldene Kügelchen sitzen auf diesen Nippeln, kaum wahrnehmbare goldene Reifen und zarte Intarsien akzentuieren «weiche, matte Stofflichkeit»[4]. Kapselartige, perforierte Anhänger repräsentieren Behältnisse en miniature. Sie erinnern an zarte Pomander und Duft-Ampullen der Viktorianischen Epoche. Andere Broschen tragen wulst- oder lippenartige Auf- und Einsätze, die sich aus dem sonst glatten, diskusförmigen Plateau herausschälen oder in dieses einnisten.

Es verwundert daher keinesfalls, dass vor allem der sinnliche Eindruck, das Zusammenspiel von haptischer und visueller Qualität, vermerkt und auch von Helmut Friedel im Katalog hervorgehoben werden, der zudem den Begriff «Schrift» einbringt, die Assoziation des «organischen Körpers», Schwellungen und Markierungen als kalligraphische Zeichen deutet.[5]

Leise tut sich immer etwas an der Außenhaut dieser Artefakte. Regung, Spannung, dezente Aktion, stets verhalten, verbünden sich mit sachlicher, klarer Silhouette. Handwerkliche Perfektion, biomorphe Anmutungen, poetischer Charakter geben den Ton an. Trotzdem: es macht sich an einigen Stellen Eruption bemerkbar, Widerstand gegen die Konventionen der Zunft[6], die Risse, Platzen, Brechen verbietet. Hilbert übt – an diesem Punkt bereits ablesbar – einen bewussten und disziplinierten «Aufstand» gegen klassische Positionen, oder – wenn wir so wollen – sie geht ihren Weg, ohne große Worte, aber durch Werke, die ihre Erfahrungen, ihre Empfindungen, ihre Evolution aufzeichnen.

Die genannte erste Solopräsentation, zusammen mit Otto Künzli, können wir, neben der Beteiligung an «Körper – Zeichen», 1979 in der Städtischen Galerie im Lenbachhaus in München, als Debüt einer beachtenswerten Karriere betrachten. Kurze Zeit später, 1982, sehen wir Hilbert zusammen mit Bernhard Schobinger und Otto Künzli, an der Seite von John M. Armleder, Mario Botta, Luciano Castelli, Martin Disler, Peter Fischli, David Weiss, Urs Lüthi und anderen, als «Celebrities» der Schweizer Avantgarde in Den Haag präsentiert.[7] 1985 identifiziert die Ausstellung «Bijou Frontal» eine Neigung zu «organischer Einheit» und «Körperzeichen» als aktuellste Tendenzen des zeitgenössischen Schmucks, verbunden mit «Inhaltsschwere»[8] und «Sinnbedürfnis»: «Jedes Schmuckstück ist ein kleines Welträtsel.»[9] Hilbert ist dabei und mittendrin. Rückblickend schildert Michael Koch 1996 die Arbeiten Hilberts als «Symbole von Wehrhaftigkeit und Verteidigungsbereitschaft», als «ästhetisch gebändigtes Widerspiel intro- und extrovertierter Ausdrucksformen», als Symptome einer «Spannung», die «auf kunstvolle Weise zur Balance gebracht ist.»[10]

4 A.a.O.

5 Ebda, S. 38–39.

6 Ursula Keltz, Schmuckgestaltung an der Akademie der bildenden Künste München: Die Klasse für Goldschmiedekunst 1946–1991. Weimar 1999, S. 179.

7 Ausst.-Kat. Zwitserse Avant-Garde, Galerie Nouvelles Images, Den Haag / NL 1982.

8 Bruno Haldner, Im Grenzbereich zwischen Spielerei und Existenzialität. In: Ausst.-Kat. Bijou Frontal. Neuen Tendenzen der Schmuckgestaltung in der Schweiz. Gewerbemuseum Basel, Museum für Gestaltung 1985, S. 5–10, S. 8.

9 Beat Wyss, Das symbolische Gerät. In: Ebda, S. 11–15, S. 14, S. 11.

10 Dr. Michael Koch, Referent Bayerisches Nationalmuseum München: Eröffnungsrede anlässlich der Ausstellung «Weiß und Schwarz». Emotionen, Gefäße, Vulkane. Schmuck von Therese Hilbert. Bayerischer Kunstgewerbeverein, München 1996 (Archiv Therese Hilbert).

Therese Hilbert. (EIN) SCHMUCK – LEBEN

Damit ist ein verbales Koordinatenfeld im Blick auf Hilberts Schmucktätigkeit abgesteckt, das dieser eine hintergründig sperrige Note sowie gleichsam physische Gegenwart zuschreibt. Dabei sind wir beim Debüt und die Goldschmiedin hatte noch gar nicht richtig zugepackt!

Allerdings liegen zu diesem Zeitpunkt, um 1980, längst entscheidende Etappen hinter ihr. Etwa die Ausbildung bei Max Fröhlich, die Zürcher Atmosphäre der sechziger Jahre, der Wechsel nach München an die Akademie der Bildenden Künste, das Studium bei Hermann Jünger, abgesehen von der persönlichen Situation als Künstlerin und Mutter.

Max Fröhlich (1908–1997), von 1948 bis 1970 Lehrer an der Kunstgewerbeschule Zürich (heute Schule für Gestaltung), vertrat exemplarisch die Schweizer Nachkriegszeit im Schmuck. Er favorisierte selbst das Silber als perfekten Werkstoff, eine gemäßigte geometrische Abstraktion und plastische Ausrichtung, wie seine Worte illustrieren[11]: «Als Silberschmied habe ich eine Vorliebe für Volumen. Gefäße – daher der Name – müssen etwas in sich zu ‹fassen› vermögen, buchstäblich voluminös sein.»[12] Später blitzen Anleihen von Minimalismus und Primitivismus bei ihm auf, etwa mit den Experimenten in farbigem Elektrodraht. Die Vor-Zeichnung bildete eher selten den Ausgangspunkt, «hingeworfene Ideen» vielleicht, vor allem jedoch das unmittelbare Modellieren, das direkte Eingreifen.[13] Fröhlich, das generelle Klima an der Kunstgewerbeschule und in Zürich lieferten eine Matrix für die frühe ästhetische Orientierung Hilberts. Als die Goldschmiedin 1965 bis 1969 bei Max Fröhlich und Fritz Loosli an der Kunstgewerbeschule studierte, sie war zu Beginn gerade einmal 17 Jahre alt, herrschten Leitlinien unter dem Vorzeichen von Bauhaus-Rezeption, Werkbund- und «Guter Form»-Ideologie, die «Gute Form» wie sie im gleichnamigen und 1952 publizierten Buch von Max Bill vorkommt. Die Kunstgewerbeschule galt als Hochburg eines moderaten Modernismus, den eine Mischung aus «tastwarmer» Form – vorwiegend Würfel, Quadrat, Kugel, Kreis – in Kombination mit eckiger und spitzwinkliger Bauart veranschaulicht.[14]

In Zürich regierten die Konkreten. Tachistische oder surreale Positionen waren verpönt – im Gegensatz etwa zur Berner Szene mit Bernhard Luginbühl, Franz Eggenschwiler und Jean Tinguely.[15] Max Bill, ebenfalls an der Kunstgewerbeschule als Silberschmied ausgebildet, stellte 1936 mit der Ausstellung «Zeitprobleme in der Schweizer Malerei und Plastik» im Kunsthaus Zürich und seinem Manifest zur «konkreten Gestaltung» die Weichen und gab die Richtung vor. 1949 organisierte er auf der Schweizerischen Mustermesse die Sonderschau «Die gute Form», bis 1968 ein jährlicher Event und «National Brand», der Maßstäbe setzte für «formal ‹richtiges› und ethisch vertretbares (Kunst-) Schaffen»[16] und als «schweizerischer

11 Annina Dosch, Max Fröhlich (1908–1997). Moderne Gestaltung von Schmuck und Gerät. Masterarbeit, Universität Bern 2015, S. 27ff, S. 45.

12 Ebda, S. 38.

13 Ebda, S. 39ff.

14 Ausst.-Kat. Gründung und Entwicklung. 1878–1978: 100 Jahre Kunstgewerbeschule der Stadt Zürich, Schule für Gestaltung. Auftrag: Bilden und Gestalten für Mensch und Umwelt. Hrsg. v. Hansjörg Budliger, Kunstgewerbemuseum der Stadt Zürich 1978, S. 149f.

15 Ausst.-Kat. Gründung und Entwicklung. 1878–1978: 100 Jahre Kunstgewerbeschule der Stadt Zürich, Schule für Gestaltung. Auftrag: Bilden und Gestalten für Mensch und Umwelt. Hrsg. v. Hansjörg Budliger, Kunstgewerbemuseum der Stadt Zürich 1978, S. 149f.

16 Kornelia Imesch, «Gute Form» und «Kalter Krieg». Die Schweizer Wochenschau – Billsche Ethik der Ästhetik «aus Funktion und als Funktion». In: Expansion der Moderne. Wirtschaftswunder – Kalter Krieg. Avantgarde – Populär – Kultur. Hrsg. v. Juerg Albrecht, Georg Kohler, Bruno Maurer. Schweizerisches Institut für Kunstwissenschaft, Zürich 2010, Bd. 5, S. 141–156, S. 145.

Exportstil» internationale Erfolge feierte.[17] Geometrische, rationale Ungegenständlichkeit und gesellschaftliche Verpflichtung verbanden sich in der Schweiz zu einem programmatischen «Kursbuch», das über die Kunst hinaus eine «Art des Denkens, Empfindens und Handelns» beinhaltete.[18] Die Kunstgewerbeschule – ein Hort des Funktionalismus – zelebrierte dementsprechend Zweckmäßigkeit und Sachlichkeit. Nur abseits existierte eine «Zürcher Schule der kleinen Wahnwelt» (Paul Nizon) der Fantasten und Surrealen.[19] Alles schien unter abstrakt-geometrischer Kontrolle. 1960 wird Bill mit einer bemerkenswerten Gesamtschau seines Werks im Helmhaus geehrt, 1968 mit dem Kunstpreis der Stadt. Dann kommt es zu Jugend- und Studentenunruhen, zu den legendären «Globuskrawallen»: «Zürich steht Kopf».[20] Erst um die Wende der siebziger Jahre brachen die legendären Ausstellungen «When Attitude becomes Form», kuratiert von Harald Szeemann 1969 in der Kunsthalle Bern, sowie «Visualisierte Denkprozesse» von Jean-Christoph Ammann in Luzern das Eis und verändern die Schweizer Kunstlandschaft.[21]

Vor diesem bewegten Hintergrund also erlebt Hilbert die Zürcher Kunstgewerbeschule. Die Ereignisse dürften ihr wohl kaum entgangen sein. Das Studium gab ihr auf jeden Fall eine praktische Anleitung, ein gestalterisches Fundament, eine innere Logik mit auf den Weg für ihre weitere Vorgehensweise im Schmuck. Zunächst führte dieser die junge Goldschmiedin zur Arbeit in diverse Werkstätten, unter anderem in Bern zu Othmar Zschaler.

1972 erfolgte der Umzug nach München und bis 1978 der Besuch der Schmuckklasse bei Hermann Jünger an der Akademie der Bildenden Künste. Nun sind wir dort, wo wir Hilbert am besten kennen.

Etappe I – Frühes Mittelfeld

Der Wechsel ist einschneidend. Jünger repräsentierte den Gegenpol zur «Zürcher Schule». Trotzdem gab es Berührungspunkte, zum Beispiel im Gebrauch elementarer Module wie Quadrat, Scheibe, Kugel in ihren «vielfältigen Variationsmöglichkeiten» oder im Fokus auf eine sensible Einbeziehung von Zeichen und Mustern. Wenn auch Jüngers eher malerische Haltung, seine Betonung der farblichen Komposition wohl nicht so ganz mit Hilberts Intentionen korrespondieren konnten, zog sie doch die Atmosphäre der Akademie, der Münchner Kunstszene in den Bann. Nicht zuletzt war ihr Jüngers Überzeugung von der Einheit im «Denken und Tun», vom Schmuck als «Lebensinhalt», als «Lebensbewältigung»[22], als Lebensaufgabe schlechthin nicht fern.

17 Vgl. Beat Wyss, 1945–1968. In: Das Kunstschaffen in der Schweiz 1848–2006. Hrsg. v. Schweizerischen Institut für Kunstwissenschaft. Im Auftrag der Jubiläumsstiftung der Credit Suisse. Bern / Zürich 2006, S. 71–85, S. 73.

18 Ebda, S. 156, Anm. 46. Zit. n. Willy Rotzler, Konstruktive Konzepte. Eine Geschichte der konstruktiven Kunst von Kubismus bis heute. Zürich 1995, S. 160.

19 Ebda, S. 363ff. und Anm. 1200.

20 Ausst.-Kat. 68 – Zürich steht Kopf. Rebellion, Verweigerung, Utopie. Hrsg. v. Fritz Billeter und Peter Killer, Seedamm Kulturzentrum Pfäffikon SZ, Stiftung Charles & Agnes Vögele, 2008.

21 Sibylle Omlin, 1968–2006. In: Das Kunstschaffen in der Schweiz 1848–2006, a.a.O., S. 85–97, S.87.

22 Keltz, S. 116ff.

Therese Hilbert. (EIN) SCHMUCK – LEBEN

In der Regel fertigt Hilbert Unikate, aber ein intensiver Impuls verlangt Zeit, Aufmerksamkeit und wiederholte Überlegung. Daher schlägt er sich zuweilen in nuancenreichen Werkgruppen nieder und wird dabei in Variationen jeweils neu durchdrungen, überprüft und verzweigt. Serien im engeren Sinne tauchen kaum auf, auch eigentlich nicht die Vor- oder Entwurfszeichnung. Hilbert sammelt ihre Ideen in Werkbüchern. Jedes Stück ist minutiös dokumentiert. Jede Arbeit spielt eine ganz dezidierte Rolle in der gesamten Abfolge.

So sehen wir auch die «Wimpel» und «Kissen» von 1980/82 nicht einfach als Abweichung und Ausnahme, sondern als logische Konsequenz der gerade angebahnten Formfindung bei Hilbert. Zwar bestehen sie aus Relikten billiger Plastiktüten und banaler Watte-, Pelz- oder Baumwolle-Füllung, alle gedacht als kostengünstige, serielle Produktion trendiger, «funkiger» Schmuckideen, doch verraten Umriss, Fütterung, Schlitze und Lochungen, austretende Borsten, weiche Schwellungen, ihre «biologische» Anbindung an die bisherigen Schöpfungen. Hilbert expandiert, im Material und parallel dazu räumlich, wie des Weiteren die «Spinnen», auch sie als Serie konzipiert, illustrieren. Simple Stahldrähte, durch silberne Knoten geschoben und vernietet, konstruieren Kreuze, minimalistische Konstellationen, die sich als Broschen «outen», deren Enden sich in den Trägerstoff bohren.

Zugegeben: Ähnliche Ambitionen – etwa die Einbeziehung von trivialem, farbigem Kunststoff, unauffällige pragmatische Gestalt – teilten andere Schmuckautor*innen, wie etwa Paul Derrez oder Johanna Hess-Dahm. Abstrakte Stab- und Rohrkonstruktionen wurden ebenso von Georg Dobler, Herman Hermsen, David Watkins produziert, um nur einige zu nennen. Man wollte den Schmuck vom Podest reißen und in ein zeitgemäßes und populäres Ornament überführen. Das lag in der Luft.[23]

Was vielleicht als Reflex auf jenes Bedürfnis nach veränderter Dimension, nach Neu-Verortung und -Verknüpfung von Körper und Planimetrie des Schmucks, jener Suche nach einer zeitgemäßen Systematik interpretiert werden könnte, ist im Werk von Hilbert natürlich schon allein durch ihre Zürcher Ursprünge etwas anders gelagert. Es geht einesteils um das Ausdehnen des Handlungsfeldes, andernteils um das Verschlanken, das Entkernen von Dichte und Kompaktheit, von historischer Last, die abgeworfen, deren inhärente Strukturen jedoch bloßgelegt und ästhetisch verwertet werden. Arbeiten wie eben die «Spinnen», bis hin zur «Dornenkrone» von 1983, reflektieren im übertragenen Sinn auf den eigenen Standort, auf Essenz, Zentrum und Umweg, auf Faktoren, welche Inspiration und Umsetzung kanalisieren, mit zeitgenössischen virulenten Bestrebungen, kurz mit dem Außenraum vernetzen. Wenn also Rainer Weiss 1983 zum rot lackierten Stab-Halsschmuck, dem sicherlich prominentesten Stück zu diesem Thema, lakonisch schreibt: «Ganz klar ist das 'ne Dornenkrone» und den scheinbar «archaischen» Charakter beschwört, wird das zeitgenössische konstruktive und konstruktivistische Statement dieser Arbeit übersehen. Diese «linearen» Kompositionen verkoppeln generell das Moment der Dynamik mit dem Aspekt der Statik. Den Höhepunkt an Komplexität markiert zweifellos jener rote Halsschmuck aus PVC und lackiertem Messing von 1983, die

23 Peter Dormer und Ralph Turner, The New Jewelery. Trend + Traditions. London/New York 1985, S. 70ff.

«Dornenkrone». Mindestens fünf Umwicklungen ergeben ein lebendiges Szenarium von mobilen Stäben. Damit wird der Trägerin, dem Träger die Anordnung überlassen, welche zwangsläufig in einer Polarisierung mündet: Kreis versus Linie.

Parallel entstehen schlichte Reifen mit reduzierten Stabzeichen, die als signifikante Akzente voluminös ihren Platz beanspruchen und dabei ein fiktives Feld ins Visier nehmen, knapp und prägnant. Hilbert schließt sich nicht einfach irgendwo an. Wenn man aber ihre Vorliebe für minimalistische Konzepte kennt, liegt eine Affinität nahe und die Halsreifen entpuppen sich als Installationen in Form von Schmuck, als eine ‹pfeilsichere› These.

Abgesehen von der stilistischen Affinität zu Minimalismus und den vorhergehenden Schmuckarbeiten, gewinnen überhaupt Spitzen, Sterne, ausufernde Ecken und Kanten als Symptomatik einer gewissen Ungeduld, einer Aversion gegen Potenzgebaren und tradierte Hierarchien innerhalb der männlich dominierten Disziplin des Schmucks an Bedeutung. Hilbert fährt, sozusagen im metaphorischen Sinne, die Stacheln aus, inspiriert von Waffenbüchern und -sammlungen. Ihre neuen Schmuckwerke strahlen Bewusstheit aus, subtilen Widerstand, der ohne Wildheit, ohne bombastische Wucht auskommt. Der Reigen spannt sich von hohlen Kugelanhängern, gerahmt von einem Kranz kometenartiger Zacken, den so genannten «Windrädern» über die «Himmelsleitern», die «Speer»-Broschen, die ‹Stab-Colliers›, die verzweigten «Ast»-Anhänger bis zum «Stern», eine besonders einprägsame Kugelbrosche aus Silber, opak, aber nicht poliert, aus der drei lang gezogene Kegel spektral entspringen, insgesamt in einer Ausdehnung von ca. 15 cm, also kein kleines schüchternes Objekt, sondern eines, das Stellung bezieht und sich bemerkbar macht. Die gesamte Werkgruppe zeugt von einer systematischen Ästhetisierung und Verbildlichung intensiver Emotionen, vom eleganten, aber kalten Chrom kontrastiert und verkleidet. Extreme treffen aufeinander, rationale Materialität und hitziger Inhalt, lineare Strenge und plastischer Organismus, Dynamik und spröde Kalkulation, Weichheit und Härte. Kurze Zeit später tauchen Zähne und Zacken erneut als vitale Glieder ihres Schmucks auf. Die vormaligen Kugeln wandeln sich nun zu ovalen, flachen Wölbungen, über die sich gebogene Zinken und Spangen beugen.

Man spürt den Nachhall anderer Künstlerinnen wie Louise Bourgeois, Rosemarie Trockel, Rebecca Horn. Hilbert beobachtet, sondert aus, greift auf, würdigt, wägt ab, lässt Anregung wirken – auch als eingefleischte Ausstellungsbesucherin. Und daher versteht sich der Schmuck von Hilbert keineswegs so harmlos, wie uns Hermann Jünger in einer Besprechung glauben lassen will: «Vertraut und doch ganz neu».[24]

Mit den «Stern»-Arbeiten, Mittelpunkt der Installation zur Verleihung des Förderpreises für Bildende und Angewandte Kunst der Landeshauptstadt München im Jahre 1986, steigert Hilbert Kompaktheit und Autonomie ihrer Konstruktionen. Schwebend, wie Himmelskörper, treten Anhänger und Broschen in Erscheinung. Kegel bedecken den zentralen Bauch ihrer Körper. Mal werden diese fast vom Kegelwald verschluckt, mal bekrönen sie ihn wie verstreute Gipfel, als sähe man Erde oder

24 Georg Wilhelm Friedrich Hegel, Ästhetik. Hrsg. v. Friedrich Bassenge. 2 Bde. Berlin/Weimar 1976, Bd. 1, S. 156; hier zit. n. Gottfried Boehm, Der hundertäugige Argus. Die Haut als Matrix der Sinne. In: Tina Zürn, Steffen Haug, Thomas Helbig (Hrsg.), Bild, Blick, Berührung. Optische und taktile Wahrnehmung in den Künsten. Paderborn 2019, S. 207–218, S. 214.

Mond von einem weit entlegenen Standort, als sei hier ein Geschoß unterwegs zu fernen kosmischen Galaxien, mysteriös, strahlend, verheißungsvoll. Prall spannt sich stets die Außenwand um einen unsichtbaren Raum, dessen gebündelte Energie verborgen bleibt, aber sich in Schwung und Charakter der Komposition vermittelt.

Hilbert entwickelt hiermit eine spezifisch skulpturale Bildsprache im Schmuck, nicht nur als persönliches gestalterisches Vokabular, sondern vor allem als Teil einer übergreifenden Ikonographie, die über die Beziehung von Innen und Außen, von Leib und Emotion, von Raum und Grenze, über fundamentale ästhetische Gesetzmäßigkeiten, über das Verhältnis des Selbst und Welt berichtet. Sie lässt sich dabei von ihrer «Stimme» tragen: «Diese Stimme trägt mich weiter, fast immer, ich vertraue ihr.»[25] Themen von außen, scheinbar außer Acht gelassen, schwingen in Atmosphäre, Schärfe und Wesen der Arbeiten mit.

Etappe II – Mittelfeld, nicht spät, nicht früh, dazwischen

Kugel, Konus und Scheibe – elementare Faktoren der Hilbertschen Semantik, auf denen letztlich das gesamte Œuvre basiert – interagieren nun verstärkt und erweitern so zunehmend das Formenspektrum in diesem Spagat zwischen organisch und abstrakt-geometrisch orientierter, bildnerischer Sprache.

Aus dem Rahmen fallen dabei: «Rose» und «Dornenkette», 1989. Der offensichtliche botanische Bezug kaschiert den konstruktiven Charakter, seine ambivalente Qualität zwischen Zierde und Bedrohung. Die schwarze Rose – kühl, scharfkantig, abweisend – spiegelt das Bild von Erstarrung, von Abschied, von Absterben. Geschichten zum Frausein und Frauenleben, verknüpft mit dem Verblühen, dem Vergehen, exemplarisch an der Rose ausgeführt, gibt es reichlich. Damit ist es nun zu Ende. Aber zu Ende ist auch eine Schmuckauffassung, die noch allein der Verschönerung, dem Putz huldigt. Hilbert fasst ihren Standpunkt in einem hintergründigen, verräterisch traditionellen, aber vor allem widersprüchlichen Imago zusammen. Jan Wardropper vom Art Institute of Chicago stellt dazu fest: «Hilbert's work also plays minimal form against tactile sensation but with hints of violence and intimations of cosmic forces. Her characteristic brooches are sharp, dangerous forms like propeller blades or handfuls of nails.»[26] Diese eigenwillige Verschwörung, eine Spezialität Hilberts, führen «Rose» und «Dornenkette» exemplarisch vor Augen.

Der Zyklus «Emotionen», Anfang der 1990er Jahre, einer der umfangreichsten, treibt besagte Formkontrastierung und -verschränkung erneut voran. Zusammen mit den «Gefäßen» und den ersten Vulkanen mit Namen «Nea Kameni» zieht Hilbert 1996 dazu in einer umfangreichen Werkschau der Galerie für angewandte Kunst im Bayerischer Kunstgewerbeverein (BKV), München, Bilanz. Das Vulkan-Sujet zirkulierte bereits in der vorhergehenden Dekade und man erahnt, dass es im Rumpf von Kugel und Kegel schlummerte. Die ersten persönlichen Besteigungen ereignen sich aber erst just in diesem Zeitraum. Damit ist eine schicksalhafte Wende besiegelt und ein Lebensthema begründet.

25 Therese Hilbert, unveröffentlichtes Manuskript, 2001.

26 Ian Wardropper, Einführung. In: Ausst.-Kat. 10 Goldsmiths. Reztac Gallery, Chicago 1988, S. 6.

Die «Emotionen» sondieren zunächst quasi spielerisch dieses Terrain. Nun sitzen Kegel, Dornen, Zacken, Zungen nicht mehr an der Oberfläche, sondern brechen abrupt aus den Schmuckkörpern hervor, besiedeln deren Innenraum oder belagern und akzentuieren ihn als Kranz, als Strahlenkrone, als Manschette an der Außenseite. Spannungsreich verhalten sich die Faktoren zueinander, der scheinbar sich gerade verschließenden, sich scheinbar entblätternden Gebilden, deren Sporne und Falzen sich nach außen klappen, strecken, beugen und bohren. Das kann an Blüten, Knospen, Kapseln erinnern, ist meiner Einschätzung nach aber außerdem universaler gedacht, als eine grundlegende Untersuchung zu Statik und Dynamik, zu den Bewegungsfreiheiten im Schmuck, zum Korpus überhaupt und seiner Metamorphose, zur Osmose zwischen Innen und Außen. Die «Geheimnisträger» – eine Reihe kleinformatiger Broschen – bestätigen diese Sicht, denn ihr Inhalt offenbart sich nur beim Tragen.

Die so genannten «Gefäße» dagegen vollziehen einen «rappel à l'ordre». Broschen und Anhänger, kugelig oder beutelförmig, flach oder reliefartig, mit Henkelchen oder ohne, gestreckt, gestaucht, in der Perspektive verzerrt oder gedrückt, mehr oder weniger bauchig, zitieren einen breiten Katalog an historischen Behältertypen. Die Gestalt kommt zur Ruhe. Man denkt an Krüge, Amphoren, Säckchen, Kannen, Kultgefäße, allerdings surreal manipuliert, wenn aus dem leicht gewölbten Opus seltsam befremdliche Schäfte oder Kragen steigen, wie Augen, Nasen, Münder.

Das «Gefäß» verschmilzt gar mit der Kugelbrosche und legt «Bullaugen» an, wie Taucherglocken mit multiplen Luken. Die Ratio der Kunst, der «Genius des Schmucks» richtet sich mit «Glubschern» auf uns, wie der hundertäugige Argus auf griechischen Vasen. Nach Hegel transformiert Kunst «jede Gestalt an allen Punkten der sichtbaren Oberfläche zum Auge» …, «damit die innere Seele und Geistigkeit an allen Punkten gesehen werde.»[27] Normalerweise ist der Schmuck abseits vom Kunstdiskurs angesiedelt, unberechtigterweise. Wir können jedoch den Anspruch erheben, dass solche Andeutungen, derartige intuitive Annäherungen auch im Schmuck geschehen können und von Hilbert hier eingeführt werden.

Diese Arbeiten vermitteln genuin eine doppelte Botschaft, da die innere Leere eben auch eine hypothetische Fülle suggeriert, wie Alex Selenitsch anlässlich einer Ausstellung Hilberts in Australien unterstreicht. Vakuum und Körper, Materie und Aussparung bedingen sich gegenseitig, dazwischen die Wand, die «Haut» im metaphorischen Sinne, welche die Dimensionen trennt und zugleich potenziert. Fast spüre man – nach Selenitsch – einen Druck, der sich vom Zentrum aus Geltung verschaffen wolle. «This brings the attention back to the wearer, who under these conditions is also a visible container with an invisible imaginary life.»[28] Der Schmuck beansprucht Präsenz als intimer, imaginativer Raum, aber ebenso als Metapher, als symbolisches Produkt, als Ort des «social settings», des gesellschaftlichen Ereignisses, der Begegnung von Innen und Außen.

27 Georg Wilhelm Friedrich Hegel, Ästhetik. Hrsg. v. Friedrich Bassenge. 2 Bde. Berlin/Weimar 1976, Bd. 1, S. 156; hier zit. n. Gottfried Boehm, Der hundertäugige Argus. Die Haut als Matrix der Sinne. In: Tina Zürn, Steffen Haugg, Thomas Helbig (Hrsg.), Bild, Blick, Berührung. Optische und taktile Wahrnehmung in den Künsten. Paderborn 2019, S. 207–218, S. 214.

28 Alex Selenitsch, Hollow but not empty. Jewellery by Therese Hilbert at Gallery Funaki. In: Objekt, Contemporary Craft + Design + 3D Art. Nr. 3, Sydney 2000, S. 32–33.

Etappe III – Exkurs: «das Unsagbare ausdrücken»

Therese Hilbert hat nie ein Geheimnis daraus gemacht, dass sie vom «Gelebten und Empfundenen» ausgeht, «eine lange anhaltende und fortwährende Auseinandersetzung» versinnbildlicht, sich «wohltuender Prozesse» bedient, um «die Hoch's und Tief's im Leben, im Gefühl wieder zu glätten und zu normalisieren. Gleichzeitig stimulieren sie mich und machen mich frei!»[29]

Es soll noch einmal betont sein, dass es sich nicht um tagebuchähnliche Aufzeichnungen in Form von Schmuck handelt, nicht um private Plaudereien. Hilberts Schaffen nimmt vielmehr Anteil an einem substanziellen Paradigmenwechsel in der Kunst seit den sechziger Jahren und begleitet diesen in Form von Schmuck. Dazu gehören etwa die Erforschung einer «individuellen Mythologie»[30], die Überlegungen zur Konditionierung als Frau und Künstlerin eingeschlossen, zu Körper und Körperlichkeit als Tatort, als Material, als Instrument, als eine Quelle künstlerischer Inspiration und Argumentation, zum Beispiel bei Rebecca Horn, Silvia Bächli, Hannah Villiger, Miriam Cahn (gerade in der Schweiz zunächst auch als Kontrapost zur konkreten Ästhetik gesehen), bei Rosemarie Trockel, Louise Bourgeois oder denken wir etwa an die Aussage Mona Hatoums jüngeren Datums: «Der Körper ist die Achse unserer Wahrnehmungen»[31]. Auf der Suche nach Zeichen, nach Parabeln für eine authentische Wirklichkeitserfahrung werden Befindlichkeiten als «imaginäres Gravitationszentrum» von zu usurpierenden, ästhetischen Räumen gewertet.[32]

Schmuck / Kunst signalisiert dabei die «zweite Haut», auf der sich Prozesse, Gedanken, Emotionen niederlassen oder einschreiben. Hilbert ist also nicht allein. Nach Gilles Deleuze und Félix Guattari gilt das generell: «Das Kunstwerk ist ein Empfindungssein ...»[33]. Es dreht sich nicht mehr um eine absolute Wahrheit, sondern um Bedingtheiten, ihre Reflexion und ästhetische Transformation, kurz um eine ästhetische Subjektivität, die jedoch in der künstlerischen Übertrag eine «Ich-Ferne»[34] erfährt und in einem «ästhetischen Raum»[35] angesiedelt wird. Und nicht zu übersehen: stets wird dabei die eigene Disziplin zur Diskussion gestellt, bis an Grenzen ausgelotet und herausgefordert.

Therese Hilbert bewegt sich im Schmuck-Areal. Ihre Arbeiten beziehen sich nicht auf konkrete Leiblichkeit, aber sie beinhalten oft einen Wink, ein Indiz für körperlich anmutende Momente, die von eher leisen, sich an den Oberflächen abzeichnenden

29 Therese Hilbert, unveröffentlichtes Manuskript, Ende der 1980er-Jahre.

30 1972 kuratierte Harald Szeemann die Abteilung «Individuelle Mythologie» auf der documenta 5 in Kassel.

31 Deutschlandfunk, 29.07.2002, Besprechung zu Marina Schneede, Mit Haut und Haaren. Martina Wehlte-Höschele im Gespräch mit Marina Schneede.

32 Susanne von Falkenhausen, Gert Mattenklott, Angela Lammert: Raum und Körper in den Künsten der Nachkriegszeit. A.a.O., S.9–10, S. 9.

33 Gilles Deleuze und Félix Guattari, Was ist Philosophie (1991). Frankfurt / Main 2000, S. 191–237, S. 191; hier zit. n. Kerstin Thomas, Du lebst und tust mir was. Die Bilder von Miriam Cahn. In: Ausst.-Kat. Miriam Cahn. Das Genaue Hinschauen. Kunsthaus Bregenz 2019, S. 37–43, S. 42.

34 Paul Celan zit. n. Georges Bloess, «Mein Körper wird zum Material ...». Skulptur, Selbstgestaltung und Innenraum im Werk von Louise Bourgois. In: Raum und Körper in den Künsten der Nachkriegszeit. Hrsg. v. d. Akademie der Künste, zusammengestellt v. Angela Lammert. Symposium 1997 anlässlich d. Ausst. Germaine Richier. Akademie der Künste, Berlin 1997, Amsterdam/Dresden 1998, S. 218–227, S. 226.

35 Kerstin Thomas, Du lebst und tust mir was. Die Bilder von Miriam Cahn. In: Ausst.-Kat. Miriam Cahn. Das Genaue Hinschauen. Kunsthaus Bregenz 2019, S. 37–43; S. 40.

Spuren, die damit das «Visuelle einer taktilen Energie» einbringen, bis zu offensichtlich räumlich gedachten Gebilden als Bildern einer internen Mobilität reichen[36]. Hilbert baut Kammergehäuse. Das führt uns zu den geheimnisvollen Anhängern mit den vielsagenden Titeln «in sich», «für sich» sowie «Ein Trichter und eine Seele» von 2003. Eine Kugel versenkt sich in die andere Halbkugel, ein Krater steigt aus tiefer Schale, der Schlund des Trichters mündet in schmalem Rohr. Lichtwirkung und Beweglichkeit der Bestandteile, beim Trichter quasi monumental mit seinen ca. 17cm Länge, vervollständigen den Eindruck von einer äußerst bewusst kalkulierten, sublimen Gestaltung.

Vergleichen wir Hilberts Vorgehen mit oben angesprochenen Tendenzen in den so genannten «freien» Künsten, dann stoßen wir auf Berührungspunkte. Gerade Konzepte, die auf eine Visualisierung sinnlicher Erfahrung fokussieren, vollziehen sich an «Bruchstellen», um «das Unsagbare ästhetisch auszudrücken ...»[37] Taktile und optische Konzepte galten lange Zeit als unvereinbarer Gegensatz. Allein Auge und Blick genossen eine Sonderstellung. Davon nahmen künstlerische Theorie und Praxis spätestens seit den sechziger Jahren des 20. Jahrhunderts, vor allem im Zusammenhang mit feministischen Strategien, Abschied: es wird eine «Rückbindung des Sehsinns an den Körper eingeklagt.»[38] Damit haben sich grundsätzliche Parameter verschoben. Der Tastsinn, angeblich ohne «intellektuelle Distanz», «ohne Abstraktionsvermögen»[39] ehemals diskriminiert, erfährt eine völlig neue Würdigung als Erkenntnisorgan und -instrument.

Der Körper als Referent gesellschaftlicher Wirklichkeit schiebt sich ins Zentrum der Aufmerksamkeit, ob nun lebendig oder imaginär. Er füllt die bisherige Leere, er garantiert in der ästhetischen Auseinandersetzung eine Vervollständigung der Perspektiven, als «Zeichen für eine leibphilosophische Wende des Denkens»[40]. Zahlreiche Positionen in der Kunst kreisen um diese Argumente, um Definitionen von Bild, Ort und Identität zu revidieren: «An imaginary body is not simply a product of subjective imagination, fantasy or floklore. The term imaginary will be used in a loose but nevertheless technical sense to refer to those images, symbols, metaphors and representations which help to construct various forms of subjectivity.»[41]

Unterschiedliche Ansätze bei Carolee Schneemann, Miriam Cahn oder Rebecca Horn verraten ein Handlungsmodell, das innovative «Identifikationsstrukturen» vorschlägt. Sie lassen uns teilhaben an einem «Nachdenken über sich selbst».[42]

Cahn etwa studierte an der Basler Kunstgewerbeschule unter Bauhaus-Vorzeichen und vollzieht in ihrer späteren Tätigkeit einen radikalen Sprung. Ein solches

36 Hartmut Böhme, Der Tastsinn im Gefüge der Sinne. In: Anthropologie. Hrsg. v. Gunter Gebauer. Leipzig/Stuttgart 1998, S. 214-225, online aufgerufen am 27.03., o.S.

37 Barbara Lange, Einleitung. Körper-Konzepte. Strategien von Visualisierung sinnlicher Erfahrungen. In: Barbara Lange (Hrsg.), Visualisierte Körperkonzepte. Strategien in der Kunst der Moderne. Berlin 2007, S. 9-13, S. 10..

38 Mechthild Fend, Sehen und Tasten. Zur Raumwahrnehmung bei Alois Riegl und in der Sinnesphysiologie des 19. Jahrhunderts. In: Ebda, S. 15–38; S. 16.

39 Tina Zürn, Steffen Haug, Thomas Helbig (Hrsg.), Bild, Blick, Berührung. Optische und taktile Wahrnehmung in den Künsten. Paderborn 2019, S. 2 (Einleitung).

40 Vgl. Claudia Benthien, Haut. Literaturgeschichte – Körperbilder – Grenzdiskurse. Hamburg 1999, S. 14.

41 Moira Gatens, Imaganinary Bodies, Ethics, Power and Corporeality. London 1996, S. 8; hier zit. n. Sabine Gebhardt Fink, Transformation der Aktion. Miriam Cahns performative Arbeiten und Rebecca Horns Personal Art. Wien 2003, S. 159.

42 Ebda, S. 189.

Therese Hilbert. (EIN) SCHMUCK – LEBEN

Vorgehen, ein solch aggressiver und gewollter Kontrollverlust kann nicht die Sache einer Therese Hilbert sein. Obwohl: Der Entwurf geheimer Räume für intime Befindlichkeit, ihre Intensität und geballte Ladung spielen auch bei Cahn eine Rolle.[43]

Da steht ihr jedoch sicher Rosemarie Trockel näher, deren «Widerständigkeit gegen Normen und festgelegte Bilder» in einem «Zitieren, Überschreiben und Umkodieren» historischer Muster mündet[44] und dabei leisere, ironische Töne anschlägt.

Im Bereich des Schmucks bietet sich die Brücke zum Körper naturgemäß an und die Interpretation von Schmuck als symbolische Projektionsfläche, als «Gleichnis für das Selbst-Welt-Verhältnis»[45], als kulturelles Zeichen, als Ausdruck von Identität, von Tiefe, Seele, Innerlichkeit, als deren Gehäuse. Eine lange «ikonographische und metaphorische Tradition»[46] von Analogien und Idiomen kann also von Hilbert beansprucht werden.

Etappe IV – «Ich bin ein Vulkan»

Für den Augenblick existiere ich.
In mir schlummern Leidenschaften, die explodieren,
doch auch in Schach gehalten werden können …
Ich bin voller Energien, Feuer und Lava. Ich bin ein Vulkan.
(Eugène Ionesco)[47]

Immer wieder zieht es Hilbert in den griechischen Archipel, auf die scheinbar harmlosen, verschlafenen Krater, gerne spürt sie dem kaum wahrnehmbaren Zittern der Erde unter sich, den verborgenen Kräften nach. Das bereits in den achtziger Jahren virulente Motiv des Vulkan gewinnt mehr und mehr an Auftrieb, entwickelt sich nachgerade zu einem zentralen, fundamentalen Motor des weiteren Schaffens.

Die erwähnte erste Werkgruppe zum Thema «Nea Kameni», bleibt dem realen Vorbild verpflichtet: vorwiegend kegelförmige Broschen, geschwärzt, vereinzelt gerundet, geben faszinierende Zungen, Einsätze, Flügel und Flanken preis. Rote, weiße, blaue Korallen quellen aus soliden Sockeln hervor, bedrohlich, überraschend, befremdlich, steigen aus Einschnitten, Senken, Kesseln. Andere Beispiele ohne «Zuwachs» zeichnen sich durch ihren perforierten Mantel aus, der den Blick auf den stabilen Unterbau lenkt. Eine weitere Variante vertreten gelochte Kuppeln, die sich in kreisrunden Schalen einnisten. Was da noch alles sich verbirgt, wird nicht verraten. Allerdings indiziert der «doppelte Boden» eine versteckte Ebene, ein «Doppelleben», dessen Existenz das Schmuckstück metaphorisch bekundet.

Ein ungewohntes Farbenspektrum auf meist anthrazit grauem Grund wird entfacht, das zum Motiv korrespondiert und bis zum gegenwärtigen Zeitpunkt dominiert.

43 Vgl. Ausst.-Kat. Miriam Cahn. Ich als Mensch. München 2019, Warschau 2019/2020.

44 Vgl. Beate Söntgen, Mit Liebe betrachten. Rosemarie Trockels Kunst der Anerkennung. In: Ausst.-Kat. Rosemarie Trockel. Märzôschnee ünd Wiebôrweh sand am Môargô niana më. Kunsthaus Bregenz 2015, S. 155–169.

45 Inspiriert von Claudia Benthien, Haut. Literaturgeschichte – Körperbilder – Grenzdiskurse. Hamburg 1999, S. 7.

46 Ebda, S. 13ff.

47 Eugène Ionesco: Vorwort. Maurice & Katia Krafft, Volcano. Paris / New York 1975, S. 8.

Gleich im Anschluss widmet sich Hilbert der Glut. Knallrot lackierte Flächen versiegeln geschwärzte Dosenbroschen, wie Zungen oder unregelmäßige Lappen, dynamisch, poppig, manchmal kompakt und nahezu hermetisch geschlossen, dann wieder nur als Reif, zwischen dem sich schwarze Buckel aus flachen Zylindern nach oben drängen. Blau oder grün lackierte «Intarsien» vor dunklem oder silbernem Fond verweisen auf die milchig-giftigen Kraterseen. Weitere Exempel dieser Vulkanvarianten bestehen aus mehr oder weniger gedrungenen Konussen, zuweilen zur Seite gekippt, mit flammenden oder schweflig gelben, sie durchbohrenden, in sie versenkten oder bekrönenden Applikationen. Es entfaltet sich eine unglaubliche Bandbreite an Facetten. Hilbert schöpft aus der Macht der Natur, allen voran natürlich dem Feuer als Symbolfeld jener Gewalten, die den Menschen am meisten bewegen,[48] abgesehen von der elementaren schicksalhaften Verkettung ihrer Zunft mit Hephaistos und seinem römischen Pendant, Vulcanus, Gott des Feuers und der Schmiedekunst. Schwarz und Rot agieren, zusammen mit dem Weiß – im Silber gegenwärtig – in wechselvollen Konstellationen.

Wie Maribel Königer bemerkt, der Vulkan wird zwar zu Hilberts Ikone, zu ihrem Markenzeichen, allerdings nicht ausschließlich auf den konkreten Ursprung bezogen, sondern in adäquater Analogie zum dem «Aus-sich-selber-Schöpfen», dem Schürfen, Hervorbringen und Versinnbildlichen verschlüsselter Inhalte.[49] Es sei damit eine kreative Leidenschaft gemeint, die sich immer wieder auf die Vulkanlandschaft stürzt, als adäquate Allegorie für Identität und kreatives Potenzial in ihren unterschiedlichsten «Personifikationen» oder Formationen. Das Spektrum erstreckt sich von der komplexen, eleganten Kegelhäufung bis zum raffinierten Einsatz des Lavagesteins auf Broschenrücken und der Streuung von Obsidiankügelchen auf Anhängern oder großflächigen, oft mehrschichtigen Anhängern in nuanciertem Zinnoberrot, die eine Vorstellung von glühenden Lavamassen evozieren. Eine andere Variante dokumentiert schlichte Scheiben, über die sich im Halbrund unregelmäßig durchbrochene Dächer spannen, auf deren Grund man dann das Kolorit erspähen kann. Selbst gefundener Obsidian und Lavagestein erweisen sich als sinnvoller Partner, als zusätzlicher Referent vulkanischer Materie. Wie wahrhaftige Gesteinsproben belagert er die Gebilde, lugt aus Miniaturkaminen hervor oder ruht in quaderförmigen Kästchen. Hilbert ordnet hier nicht nur eigene Fundstücke, sondern Spuren von Materie und Prozess. Diesen plastischen Arbeiten stehen rechteckige Broschen gegenüber, auf deren schwarz lackierten Feldern sich weiche Erhebungen abzeichnen, wie Blasen. Andere wiederum dokumentieren in gesprenkelter Oberfläche seismographisch eine mysteriöse Regung unter ihrer Schale. Flirrende Hitze, unruhiger Fluss von Magma, geheimnisvolles Dunkel, unergründliche Tiefe – dramatische und gewaltige Mechanismen gelangen allerdings in den Schmuckbildern von Hilbert zur Ruhe und manifestieren sich in dichten, konzentrierten, symbolischen Tableaus. Monochrome Tafeln, die sich vor konvex gebogenen Schalen abheben, oder Medaillons mit gelb gestrichenem Rand, greifen ein klassisches Motiv der Schmuckgeschichte auf. Hilbert gelingt eine Verquickung von versteckter

48 Vgl. Gernot Böhme, Hartmut Böhme, Feuer, Wasser, Erde, Luft. Eine Kulturgeschichte der Elemente. München 1996.

49 Maribel Königer, Kraterwanderung. In: Ausst.-Kat. «Weiss und Schwarz». Therese Hilbert. Schmuck. München 1996, S. 7–11, S. 11.

Selbstreflexion und Einladung an Träger und Trägerin zur Beteiligung an diesem raffinierten Oszillieren zwischen Fremd- und Eigenbespiegelung. Dem Schmuck kommt damit die Funktion einer Schwelle zu,[50] welche dieses soziale Geschehen ebenso wie das innerste Gemütsleben symbolisch reguliert und kaschiert.

Spannung, Gegensätze, Interaktion, Einklang zwischen Fläche und Volumen, zwischen den multiplen Charakteren ihrer Artefakte, zwischen Raum und Struktur, zwischen Expansion und Introversion prägen die ästhetischen Entscheidungen bei Hilbert. Der Vulkan dient als ein Bild für diese komplexen Vorgänge. In ihm kondensiert sich überhaupt die Vision vom Leben, vom schöpferischen Akt, vom Prozess, der sich schließlich in einer finalen Form niederlässt.

Das verborgene Innere, der vorhandene, aber oft nicht sichtbare Raum ist ein wesentlicher Aspekt dabei. Der Schmuck definiert ihn, artikuliert ihn, beschwört ihn. Das Sujet des Raumes erfüllt nach Bachelard in Literatur und Kunst als Teil einer Phänomenologie der Seele eine «Tatsache von großer ontologischer Bedeutung».[51] Haus, Raum, Körper können an einem Faden aufgefädelt werden. Sie stehen in unmittelbarer Korrelation. Die Vision des Körpers als Gefäß, des Ich als Behälter, geht zudem mit der Anthropomorphisierung architektonischer Terminologie einher: «… das Haus lässt sich im Sinne Hans Blumenbergs als ‹absolute Metapher› des Leibes bezeichnen …».[52] Bachelard ordnet es zudem einer «Topographie unseres intimen Seins» zu, unseres ganz eigenen «Winkels der Welt», des «Kosmos».[53] Erinnerungen, Gedanken, Träume, Empfindungen werden in solchen Bildern gespeichert, finden Zuflucht und Versteck, werden im Kunstwerk transzendiert, abstrahiert und kollektiviert.

Hilbert verknüpft stilistisch diverse Leitfiguren, die ikonographisch verflochten sind: die des Vulkans, des Gehäuses (organisch oder tektonisch), des Korpus, des Raumes. Der Vulkan mag zunächst keinen Körper darstellen, kein Haus, aber er repräsentiert Raum, er steht in engem Zusammenhang mit den Körper- und Gehäuse-Metaphern. Er ist ein weiteres Imago in dieser kulturellen Verkettung.

Die Fäden dieser Verstrickungen laufen hier zusammen, insbesondere dort, wo sich ein Konglomerat von zylindrischem Gefäß, Trichter, Halbkugel, Pyramide und Spirale entwickelt, alles Elemente, die sich ineinander verschrauben und verschachteln, aufeinanderstapeln und dabei virtuose Konstrukte zaubern – die vorläufig letzte Phase und bislang expressivste Modulation des Sujets. Hier explodiert Hilberts Bandbreite und Könnerschaft, vormals angebahnte Tendenzen in einer Synthese zelebrierend.

50 Vgl. Ina Fuchs, Die Hüllen der Menschen. Natürliche und kreatürliche Kleidung in der zeitgenössischen Kunst. In: Ausst.-Kat. Die zweite Haut. Bad Homburg 2016/2017, S. 9–30.

51 Gaston Bachelard, Poetik des Raumes. Frankfurt / Main 1987, S. 8.

52 Zit. n. Benthien, a.a.O., S. 34.

53 Bachelard, a.a.O., S. 26 und 31.

Epilog

Es dreht sich immer und weiterhin um eine singuläre ästhetische Semantik, die dem Werk, dem Leben und der Identität als Frau und Künstlerin entspricht, deren Parallelität, Konditionen und Situationen reflektiert, in einer spezifischen Schmucksprache transformiert. Maribel Königer nennt es «Sensibilität für jene Art von Weiblichkeit ..., in der Wehrhaftigkeit und Verteidigungsbereitschaft nicht im Widerspruch stehen zu Schönheit, Eleganz und Anmut.»[54]

Hilbert pflegt die Kunst der metaphorischen Verwicklung und Chiffrierung ihrer Impulse, die – vielleicht, aber nicht unbedingt zwangsläufig – intimen Charakter besitzen. Dabei bedient sie sich einfachster geometrischer Module und Typologien, die dann im Werk dynamisch aufgeladen werden und vielfältige Mutationen erfahren. So entsteht eine persönliche und zugleich sachliche Methode. Überall lauert die Ahnung von Haut und Haus, von Gefäß und Körper, vom Behälter, darin verborgen in kleinem Maßstab – mit den Worten Bachelards – die «innere Unermeßlichkeit».[55]

Louise Bourgeois fand am Anfang Gehör und soll auch am Ende dieses Textes wieder dabei sein. Sie ist weit entfernt vom Schmuck und doch zeigen «Motivkonfigurationen» und Haltung – vorsichtig gesagt – eine gewisse Verwandtschaft. Ihre Erfahrungen entfachen ebenso wie bei Hilbert den zündenden Funken, um ihre Arbeiten zu schaffen. Sie sind aber nicht der eigentliche Inhalt. Doch vor allem vereint Bourgeois und Hilbert die künstlerische Ausbeutung von ästhetischen Topoi in sehr unterschiedlichen finalen Werken. Hilbert gehört nicht zur Body-Art, es fehlt ihr die Dramatik der Bourgeois, die radikale Geste der Cahn. Der Schmuck allerdings erlangt bei Hilbert eine ähnliche Bedeutung, denn er vermag zu fassen, was nur in einer metaphorischen Übertragung ausgedrückt werden kann. An ihm offenbaren sich – immer im Rahmen seiner Möglichkeiten – wie an einer «dritten Haut»[56] sensible Vorgänge. Während Bourgeois jedoch Brüchigkeit, Schutzlosigkeit und Verlust berücksichtigt, etabliert Hilbert in ihrer Arbeit eine authentische Beheimatung. Ihr Schmuck – das ist sie selbst: gehalten, konsequent, auch wehrhaft und kämpferisch, aber im Prinzip stabil.

54 Ausst.-Kat. München 1996, a.a.O., S. 8.
55 Bachelard, a.a.O., S. 186.
56 Anna-Lena Krämer, Femme Maison von Louise Bourgeois. Architekturen der Weiblichkeit. Diss. phil. Regensburg 2015, S. 54, S. 59.

Therese Hilbert
(A) LIFE OF JEWELRY

«Art is not about art.
Art is about life,
And that sums it up»
(Louise Bourgeois)[1]

«I try to express myself,
to articulate through my jewelry.
They are reactions and reflections
on my life … My ‹words› are
my brooches, pendants, rings.»
(Therese Hilbert)[2]

Louise Bourgeois' statement reveals an artistic perspective that can also be observed in the work of Therese Hilbert, latent and transcribed in the expressive shapes of her jewelry. However, it is never about specific autobiographic experiences or narrative content, but about a general temperament, a stance, an inner conviction that fundamentally informs her work as a goldsmith.

Prelude and Approach

Early commentary on the work gives us parameters for an initial approach to her oeuvre. Wolfgang Wunderlich for example, who in 1979 – one year after Hilbert graduated under Hermann Jünger at the Academy of Fine Arts in Munich – declared the objects she exhibited for the first time back then in the Pforzheim Jewelry Museum to attest to «an ambivalent relationship between inside and outside, between the hidden and the visible». He saw the pieces of jewelry, made predominantly from silver, as being documents of an independent design idiom that «bore witness

[1] Donald Kuspit, «An interview with Louise Bourgois», (New York, 1988); quoted from Henry Meyric Hughes, «La casa», in: exh. cat. La casa, il corpo, il cuore. Konstruktionen der Identitäten, Lóránd Hegyi (ed.) Museum moderner Kunst Stiftung Ludwig. 20er Haus, (Vienna, 1999). pp. 55–63, here p. 55.

[2] Therese Hilbert, unpublished manuscript, 2001.

to a principle of rupture, of permeation …» of «destruction», «injury», of a quasi-aggressive, libidinous, vegetative-seeming organic chemistry.[3] He was of course writing about brooches, rings, and pendants carried out in a geometric style – predominately based around a set of figures: the square, cylinder and circle. They all possess a smooth or delicately punched, slightly wavy surface structure and were characterized by wart-like elevations driven almost excessively into the material. Tiny silver beads and the odd gold one sit on these burls, almost unnoticeable golden bands and delicate inlays accentuate «soft, satin materiality»[4]. Pod-like, perforated pendants represent vessels on a miniature scale. They are reminiscent of the delicate pomanders and perfume vials of the Victorian era. Other brooches bear bulges or lip-like attachments and insertions that emerge from otherwise smooth, disc-shaped plateaus or nestle into them. It is thus in no way surprising that it was the sensual impression first and foremost, the interplay of haptic and visual quality, that was noted and emphasized by Helmut Friedel in the catalogue. He also introduced the term «writing», the association of an «organic body», and interpreted swellings and markings as calligraphic characters.[5]

There is always something subtle going on when it comes to the outer skin of these artefacts. Restrained dynamism and tension as well as discreet activity are combined here with an objective, clear silhouette. Perfect craftsmanship, biomorphic impressions and poetic character set the tone. Yet in some places, eruptions become noticeable, a resistance to the conventions of the crafts tradition[6] which prohibits tears, cracks or breaks. It already became clear at this point that Hilbert was practicing a conscious and disciplined «insurrection» against classical positions, or – if you like – that she was going her own way, albeit without making much of a fuss about it. Instead, she was creating works that registered her experiences, her sentiments, her evolution.

The abovementioned first solo show together with Otto Künzli can be regarded, along with Hilbert's participation in the 1979 «Körper – Zeichen» exhibition at Städtische Galerie im Lenbachhaus in Munich, as the debut of a remarkable career. A short time later, in 1982, we saw Hilbert presented together with Bernhard Schobinger and Otto Künzli as «celebrities» of the Swiss avant-garde in The Hague alongside John M. Armleder, Mario Botta, Luciano Castelli, Martin Disler, Peter Fischli, David Weiss, Urs Lüthi and others.[7] In 1985, the exhibition «Bijou Frontal» identified a trend toward «organic unity» and «body signs» as the most topical tendencies in contemporary jewelry, which were here linked to «profundity»[8] and «a desire for

3 Wolfgang Wunderlich in: exh. cat. Therese Hilbert, Schmuckmuseum Pforzheim 1979, Deutsches Goldschmiedehaus Hanau, Galerie Alberstraße Graz & Loft Vienna (1980), p. 2 (solo exhibition with Otto Künzli).

4 Op. cit.

5 Ibid., pp. 38–9.

6 Ursula Keltz, Schmuckgestaltung an der Akademie der bildenden Künste München: Die Klasse für Goldschmiedekunst 1946–1991, (Weimar, 1999), p. 179.

7 Exh. cat. Zwitserse Avant-Garde, Galerie Nouvelles Images, (The Hague, 1982).

8 Bruno Haldner, «Im Grenzbereich zwischen Spielerei und Existenzialität», in: exh. cat. Bijou Frontal. Neuen Tendenzen der Schmuckgestaltung in der Schweiz, Gewerbemuseum Basel, Museum für Gestaltung, (Basel, 1985), pp. 5–10, p. 8.

Therese Hilbert. (A) LIFE OF JEWELRY

meaning»: «Every piece of jewelry is a small world riddle.»[9] Hilbert is present and at the heart of the action. Looking back, in 1996 Michael Koch described Hilbert's works as «symbols of defensive capability and the readiness to put up a fight», as «the aesthetically restrained confrontation of introverted and extroverted forms of expression», as symptoms of a «tension» that was «brought into balance with great artistry».[10]

Thus, a verbal field of coordinates has been established with a view to Hilbert's jewelry that ascribes a somewhat awkward quality to it as well as a very present physicality, so to speak. Yet we are still just at the very beginning of her career and have hardly covered what happened once she really knuckled down to it!

Nevertheless, at this point – around 1980 – she could already look back on some decisive stages in her journey. For example, her training under Max Fröhlich, the atmosphere in Zurich in the 1960s, the transfer to the Academy of Fine Arts in Munich, her studies under Hermann Jünger, to say nothing of her personal situation as an artist and mother.

Max Fröhlich (1908–1997), who taught at Kunstgewerbeschule Zürich from 1948 through to 1970 (now Schule für Gestaltung) epitomized Swiss post-War jewelry. He favored silver as the perfect working material, along with a moderate geometrical form of abstraction and a sculptural slant, as his words illustrate[11]: «As a silversmith, I have a penchant for volume. Receptacles – that is why they have that name – need to be able to ‹receive›, or hold something, they need to quite literally contain volume.»[12] Later his works subtly borrowed from Minimalism and Primitivism, as can be seen for example in his experiments with colorful electric wire. He rarely based his pieces on preliminary drawings, sometimes maybe on «ideas that had been jotted down», but above all else his method was informed by hands-on modelling and direct intervention.[13] Fröhlich, along with the general mood at the design school and in Zurich at the time, provided a matrix for Hilbert's early aesthetic orientation. The artist began her studies with Max Fröhlich and Fritz Loosli at the Kunstgewerbeschule aged just 17 and would stay at the college from 1965 until 1969. In that era, the guiding principles to be followed were based on the reception of the Bauhaus and the ideology of the Werkbund and of «Gute Form» – good form, as put forward in the eponymous 1952 book by Max Bill. The Kunstgewerbeschule was regarded as a bastion of moderate Modernism exemplified by a juxtaposition of shapes that were «warm to the touch» – primarily cubes, squares, orbs, circles – in combination with an angular and acute-angled construction style.[14]

9 Beat Wyss, «Das symbolische Gerät», in: ibid., pp. 11–15, p. 14, p. 11.

10 Dr. Michael Koch, giving the opening speech at Bayerisches Nationalmuseum Munich on the occasion of the exhibition «Weiß und Schwarz. Emotionen, Gefäße, Vulkane. Schmuck von Therese Hilbert», Bayerischer Kunstgewerbeverein, (Munich, 1996), (archive of Therese Hilbert).

11 Annina Dosch, Max Fröhlich (1908–1997). Moderne Gestaltung von Schmuck und Gerät, Master thesis, University of Bern (2015), pp. 27ff., p. 45.

12 Ibid., p. 38.

13 Ibid., pp. 39ff.

14 Exh. cat. Gründung und Entwicklung. 1878–1978: 100 Jahre Kunstgewerbeschule der Stadt Zürich, Schule für Gestaltung, commissioned by: Bilden und Gestalten für Mensch und Umwelt, Hansjörg Budliger (ed.), Kunstgewerbemuseum der Stadt Zürich, (Zurich, 1978), pp. 149f.

Zurich was ruled by disciples of the Concrete Art movement. Approaches derived from Tachism or Surrealism were frowned upon – in contrast for example to the Bern art scene with Bernhard Luginbühl, Franz Eggenschwiler and Jean Tinguely.[15] Max Bill, who had also trained as a silversmith at the Kunstgewerbeschule, set the approach and the agenda with his 1936 exhibition «Zeitprobleme in der Schweizer Malerei und Plastik» held at Kunsthaus Zürich and his manifesto on «Concrete design». In 1949, he organized the first «Die gute Form» special exhibition at the Swiss Mustermesse trade fair, which was to be held annually until 1968 and as a «national brand» set standards for «formally ‹correct› and ethically acceptable (art) production»[16] and which enjoyed international success as the «Swiss export style».[17] In Switzerland, geometrical, rational abstraction and social commitment were fused in a programmatic «textbook» approach, which involved a «way of thinking, feeling and acting» that went beyond art.[18] The Kunstgewerbeschule as a stronghold of Functionalism correspondingly celebrated functionality and objectivity. What Paul Nizon termed a «Zurich school of the small world of madness» of fantasists and Surrealists only existed well outside the limelight.[19] Everything seemed to be in the grip of abstract-geometrical control. In 1960, Bill was honored with a remarkable retrospective of his work at the Helmhaus, in 1968 he was awarded the city's art prize. Shortly after this, the youth and student skirmishes, the legendary «Globuskrawalle» broke out: «Zurich turned upside down».[20] It was only at the turn of the decade that the legendary exhibitions «When Attitude becomes Form» curated by Harald Szeemann in 1969 at Kunsthalle Bern and «Visualisierte Denkprozesse» by Jean-Christoph Ammann in Lucerne broke the spell and transformed the Swiss art scene.[21]

Hilbert experience of Zurich's Kunstgewerbeschule thus occurred against this checkered backdrop. The events will surely have left an impression on her. In any case, her studies equipped her with the practical foundations, a solid base of design knowledge and an internal logic for her further approach to jewelry. To begin with, this led the young goldsmith to work in a range of workshops, among others the one led in Bern by Othmar Zschaler.
Then in 1972 Hilbert relocated to Munich were until 1978 she attended the jewelry class of Hermann Jünger at the Akademie der Bildenden Künste. Which leaves us at the point at which Hilbert entered the public eye to a much greater degree.

15 Kathrin Frauenfelder, In die Breite: Kunst für das Auge der Öffentlichkeit. Zur Geschichte der Kunstsammlung des Kantons Zürich – vom Nationalstaat bis zur Globalisierung, Ph.D., (Zurich, 2018), University of Zurich ZORA, pp. 332ff., www.zora.uzh.ch/id/eprint/156846/, last retrieved December 14, 2021.

16 Kornelia Imesch, «‹Gute Form› und ‹Kalter Krieg›. Die Schweizer Wochenschau – Billsche Ethik der Ästhetik ‹aus Funktion und als Funktion›,» in: Expansion der Moderne. Wirtschaftswunder – Kalter Krieg. Avantgarde – Populär – Kultur, Juerg Albrecht, Georg Kohler & Bruno Maurer (eds.), Schweizerisches Institut für Kunstwissenschaft, (Zurich, 2010), vol. 5, pp. 141–56, p. 145.

17 Cf. Beat Wyss, «1945–1968», in: Das Kunstschaffen in der Schweiz 1848–2006, Schweizerisches Institut für Kunstwissenschaft (ed.) commissioned by the Jubiläumsstiftung of Credit Suisse, (Bern/ Zurich, 2006), pp. 71–85, p. 73.

18 Ibid., p. 156, note 46, cited after Willy Rotzler, Konstruktive Konzepte. Eine Geschichte der konstruktiven Kunst von Kubismus bis heute, (Zurich, 1995), p. 160.

19 Ibid., p. 363ff and note 1200.

20 Exh. cat. 68 – Zürich steht Kopf. Rebellion, Verweigerung, Utopie, Fritz Billeter & Peter Killer (eds.), Seedamm Kulturzentrum Pfäffikon SZ, Stiftung Charles & Agnes Vögele, (2008).

21 Sibylle Omlin, «1968–2006», in: Das Kunstschaffen in der Schweiz 1848–2006, loc. cit., pp. 85–97, p.87.

Therese Hilbert. (A) LIFE OF JEWELRY

Stage I – Early Midway

The shift was incisive. Jünger presented the antithesis to the «Zurich school». Yet there were points of contact, for example in the use of basic modules such as squares, discs or balls in their «diverse possibilities for variation» or in the focus on a precise inclusion of characters and patterns. While Jünger's somewhat more painterly approach and his emphasis on color composition did not entirely correspond with Hilbert's intentions, the atmosphere at the academy and the Munich art scene nevertheless captured her imagination. If nothing else, Jünger's belief in a unity of «thinking and action», of jewelry as «raison d'être» as «the method for coping with life»[22] and thus as mission in life per se was close to her own thinking.

In general, Hilbert created one-offs, but an intense impulse also requires time, attention and repeated consideration. At times, this meant such impulses would on occasion be reflected in nuanced work groups, be gone into in depth, deliberated anew, reviewed and varied in new versions. Series in the strictest sense do not really appear in her oeuvre, and neither do preliminary or design sketches. Hilbert collected her ideas in workbooks. Every piece was documented meticulously. And every piece played a distinct role in the overall sequence of works.

As a result, the «Wimpel» (pennants) and «Kissen» (cushions) of 1980-82 do not appear simply as divergence and exception, but as a logical consequence of Hilbert's ongoing form finding process. While employing remnants of cheap plastic bags and banal cotton wool, fur or cotton padding as materials, selected for the cost-effective, serial production of trendy, «funky» jewelry ideas, the contours, lining, slits and perforations, jutting out bristles and soft bulges of these pieces manifest their «biological» connection to her former creations. Hilbert was allowing her work to expand, both in terms of the material used as well as physically into space, as is also illustrated by the «Spinnen» (spiders) which she conceived as a series. She used simple steel wires, pushed through silver knots and riveted, to construct crosses, minimalistic constellations that reveal themselves to be brooches, their ends boring into the carrier material.

Admittedly: Other designers of studio jewelry such as Paul Derrez or Johanna Hess-Dahm shared similar ambitions – such as the inclusion of trivial colored plastic, or the use of inconspicuous, pragmatic shapes. Moreover, Georg Dobler, Herman Hermsen and David Watkins, to name but a few, also produced abstract constructions of rods and tubes. The aim of that generation of designers was to knock jewelry off its pedestal and turn into an up-to-date and popular ornament. It was in the wind.[23]
However, what could possibly be interpreted as a reflex response to the desire for a changed dimension, for a repositioning and reconnection of the body and the planimetry of jewelry, for that search for a contemporary system, is of course somewhat different in nature when it comes to Hilbert's oeuvre, simply because of her Zurich origins. What was at stake was on the one hand an expansion of the sphere of activity, but on the other hand a slimming down, a gutting of density

22 Keltz, pp. 116ff.

23 Peter Dormer & Ralph Turner, The New Jewelery. Trend + Traditions, (London & New York, 1985), pp. 70ff.

and compactness; the historical charge needed to be shed, yet at the same time its inherent structures exposed and aesthetically exploited. Works such as the «Spinnen» (spiders) and right up to the «Dornenkrone» (crown of thorns) of 1983 are metaphorical reflections on the artist's own perspective, on essence, center and detour, factors that channel inspiration and implementation and link it with contemporary virulent aspirations, or in short with the outside world. So when Rainer Weiss in 1983 wrote laconically about the red varnish rod-necklace, probably the most prominent piece on this topic, that «of course this is a crown of thorns» and invoked the ostentatiously «archaic» character, he was overlooking the contemporary, constructive and Constructivist statement of the work. These «linear» compositions generally couple the element of dynamism with a static aspect. The pinnacle of complexity is without doubt reached in the 1983 red necklace made of PVC and varnished brass, the «crown of thorns». By wrapping the piece of jewelry around one's neck at least five times, a lively scenario of mobile rods is created. This leaves the arrangement in the wearer's hands, while nevertheless inevitably leading to a polarization: circle versus line.

Alongside this piece, Hilbert also created some very concise and incisive works in the shape of simple circles with fewer rod symbols. Here, the simple circle with rods dominate as signs in their respective position and concisely amd incisively engender a fictiti territory.ous. Hilbert did not simply follow a trend. Yet as we know, she had a penchant for Minimalist concepts – and so an affinity immediately suggests itself: we may also look at the necklaces as an art installations in the guise of jewelry in order to hit the nail on the head.

The stylistic affinity to Minimalism and preceding jewelry aside, at this point in time spikes, stars, exaggerated corners and edges began to gain importance as symptoms of a certain impatience, an aversion against the shows of virility and traditional hierarchies within the male dominated field of jewelry. In a metaphorical sense, Hilbert was baring her teeth, inspired by books and collections on weapons. Her new works of jewelry exude self-consciousness, a subtle resistance that eschews wildness or bombastic vehemence. These works range from hollow spherical pendants, framed by a corona of comet-like prongs, to the so-called «Windräder» (windmills) to the «Himmelsleitern» (Jacob's ladders), the «Speer» (spear) brooches, the ‹rod colliers›, the ramified «Ast» (branch) pendants and finally the «Stern» (star), an especially memorable spherical silver brooch, opaque, but not polished, from which three elongated cones arise. The latter measures about 15 cm in total, it is very much not a small, demure object, but an impactful one that makes a statement. The entire group of works bears witness to the systematic aestheticization and visualization of intense emotions, contrasted and clothed in elegant yet cold chrome. Extremes clash here: rational materiality with heated content, linear rigor with sculptural organic shapes, dynamism with dispassionate calculation, softness with severity. A short while later, teeth and prongs appeared as vital limbs of her jewelry once more. The former orbs were now replaced by shallow oval bulges with curved spikes and forks bending over them.

Therese Hilbert. (A) LIFE OF JEWELRY

The influence of other female artists, such as Louise Bourgeois, Rosemarie Trockel, Rebecca Horn can be felt here. Hilbert observed, singled out, honored, weighed up, and allowed herself to be inspired – even and especially as a die-hard art groupie. Which is why Hilbert's jewelry is not remotely as harmless as Hermann Jünger wanted to make us believe in a review: «familiar yet brand new».[24]

With the «Stern» (star) pieces, which formed the central element of her installation for the award ceremony of the City of Munich's Förderpreis für Bildende und Angewandte Kunst (Advancement Award for Fine and Applied Art) in the year 1986, Hilbert's output now boasted compactness and autonomy. Pendants and brooches were displayed floating like celestial bodies. Cones cover the central swell of these objects. In some pieces, these ‹bellies› are almost entirely covered in forests of cones, in others the cones crown them like scattered peaks, the effect mimicking that of a far-away perspective onto the earth or moon, or of a missile on its way to distant galaxies, mysterious, glowing, auspicious. The outer skin always wraps itself tightly around an invisible space, the focused energy of which remains hidden, yet is conveyed in the panache and character of the composition. Hilbert was developing a specific, sculptural idiom in jewelry, not just as a personal design vocabulary, but primarily as part of a comprehensive iconography that chronicles the relationship between inside and outside, body and emotion, space and boundary, and gives account of fundamental aesthetic regularities, of the rapport between self and world. In doing so, she has always allowed her «voice» to carry her: «This voice carries me further, almost always, I trust it.»[25] We find themes from without, ostentatiously seemingly neglected, resonating with the atmosphere, poignancy and character of her works.

Stage II – Midway, not late, not early, in between

Sphere, cone and disc – elementary factors of Hilbert's semantics, on which her entire oeuvre is ultimately based – now began to interact more strongly so increasingly expanded the spectrum of shapes in the balancing act between organic and abstract-geometrically oriented visual language. Two works deviate from this. «Rose» and «Dornenkette» (chain of thorns) of 1989. The overt botanical reference masks the Constructivist character of these works, the ambivalent quality between decoration and threat. The black rose – cool, sharp-edged, forbidding – mirrors the image of ossification, of farewell, dying-off. Stories about being a woman and a woman's life in relation to withering and decay told through the gimmick of the rose as a symbol are two a penny. We no longer have any need for them. But the understanding of jewelry as something used solely for adornment and beautification is also over. Hilbert subsumes her point of view in an enigmatic, suspiciously traditional, but most notably contradictory imago. Jan Wardropper of the Art Institute of Chicago observed that «Hilbert's work also plays minimal form against tactile sensation but with hints of violence and intimations of cosmic forces. Her characteristic

24 Hermann Jünger, «Vertraut und doch ganz neu», in: Art Aurea, vol. 3, (1989), pp. 76-8.
25 Therese Hilbert, unpublished manuscript, Jahr 2001.

brooches are sharp, dangerous forms like propeller blades or handfuls of nails.»[26] Such idiosyncratic conspiracy, a specialty of Hilbert's, can be seen in an exemplary way in «Rose» and «Dornenkette».

The cycle «Emotionen» (emotions), created in the early 1990s, is one of Hilbert's most comprehensive, and it pushes said juxtaposition and interweaving of contrasting forms even further. Hilbert took stock of her oeuvre thus far when she presented this cycle together with her «Gefäße» (vessels) works and the first volcano pieces under the title «Nea Kameni» in a comprehensive exhibition held at Galerie für angewandte Kunst im Bayerischen Kunstgewerbeverein (BKV) in Munich in 1996. The volcano theme had already been circulating in the previous decade and one may intuit that it had lain dormant in the figure of ball and cone. Her very own first ascents however only occurred around this particular time. And thus a fateful turn was taken and a topic of a life time addressed.

The «Emotionen» effectively started off by the artist playfully sounding out this terrain. Now the cones, thorns, prongs, tongues no longer sat on the surface but abruptly broke through the jewelry's corpuses, colonized their insides or laid siege to and accentuated them as garland, aureole, cuff on the outside. The factors entered into a striking, expressive relationship with each other: The structures now appeared to be defoliating, their spurs and seams folding, stretching, bending and boring outward. While this may be seen as reminiscent of flowers, buds, pods, I believe that the artist was thinking more universally, was carrying out a much more fundamental examination of statics and dynamism, on the freedoms of movement in jewelry, on the body in general and its metamorphosis, on osmosis between inside and outside. The «Geheimnisträger» (carriers of secrets) – a group of small format brooches – confirm this assumption, as their content is only revealed when they are worn.

By contrast, the «Gefäße» (vessels) function as a call to order. Brooches and pendants, spherical or pouch-shaped, flat or relief-like, with little handles or without, elongated, clinched, distorted in perspective or squashed, more or less bulbous, cite a broad range of historical shapes for receptacles. Here, form gains a new sense of calm. We are reminded of jugs, amphoras, little bags, pitchers, cultish vessels, yet where they are manipulated they do a surreal aspect when oddly disconcerting shafts or collars arise from the gently curved body like eyes, noses, mouths. The so-called vessels even at times merge with the spherical brooches and don «portholes», making them look like diving bells with multiple portholes. The artistic intellect, the «genius of jewelry» turns its peepers in our direction, much like the many-eyed giant Argus Panoptes on Greek vases. According to Hegel, art transforms «every shape in all points of its visible surface into an eye» … such that «the inner soul and spirit is seen at every point.»[27] Jewelry unjustifiably tends to be considered outside of artistic discourse. However, we may contrarily assert the claim that such intimations, such intuitive approaches may also occur in jewelry and were here introduced by Hilbert.

26 Ian Wardropper, «Introduction», in: exh. cat. 10 Goldsmiths. Rezac Gallery, (Chicago, 1988), p. 6.

27 Georg Wilhelm Friedrich Hegel, Ästhetik, Friedrich Bassenge (ed.), 2 vols. (Berlin & Weimar, 1976), vol. 1, p. 156; here quoted from Gottfried Boehm, «Der hundertäugige Argus. Die Haut als Matrix der Sinne», in: Tina Zürn, Steffen Haug & Thomas Helbig (eds.), Bild, Blick, Berührung. Optische und taktile Wahrnehmung in den Künsten, (Paderborn, 2019), pp. 207-18, p. 214.

These works genuinely convey a double meaning, with the inner emptiness simultaneously also suggesting a hypothetical fullness, as Alex Selenitsch emphasizes on the occasion of Hilbert's exhibition in Australia. Vacuum and body, material and cavity mutually define each other and between them lies the wall, the «skin» in the metaphorical sense, dividing the dimensions and at the same time potentiating them. In Selenitsch's words, it is almost as though we could feel a pressure asserting itself from the center of the works. «This brings the attention back to the wearer, who under these conditions is also a visible container with an invisible imaginary life.» [28]

Jewelry demands presence as an intimate, imaginative space, but also at the same time as metaphor, as symbolic product, as a space of «social setting» related to the event in society, the encounter of inside and outside.

Stage III – Excursion: «Expressing the ineffable»

Therese Hilbert has never made a secret of the fact that she draws inspiration from «lived and felt» experience, that she allegorizes «a long-running and perpetual examination» in her work and draws on «soothing processes» in order to «smooth and normalize the ups and downs in life and emotion. Yet at the same time they stimulate me and liberate me!»[29]

It should be emphasized at this point that we are not looking at diary-esque chronicles in the shape of jewelry, or at private gossip. Rather, Hilbert's work is informed by a substantial paradigm shift in art since the 1960s and accompanies this shift through jewelry. This involves among other things the exploration of an «individual mythology»[30], including deliberation on one's conditioning as woman and artist, on body and physicality as a site of investigation, material, instrument and source of artistic inspiration and argumentation – for example, in the work of Rebecca Horn, Silvia Bächli, Hannah Villiger, Miriam Cahn (viewed especially in Switzerland as opposition to Concrete aesthetic), of Rosemarie Trockel, Louise Bourgeois, or even Mona Hatoum's more recent statements come to mind: «The body is the axis of our perceptions»[31]. In search of signs, of parables for an authentic experience of reality, mental states are classified as an «imaginary gravitational center of aesthetic spaces to be usurped».[32]

In all of this, jewelry/art signals the «second skin» on which processes, thoughts, emotions, settle and inscribe themselves. Hilbert is thus not alone. According to Gilles Deleuze and Félix Guattari it is a general rule that «The work of art is a being of sensation…»[33] It is no longer about absolute truth, but about conditionalities,

28 Alex Selenitsch, «Hollow but not empty. Jewellery by Therese Hilbert at Gallery Funaki», in: Objekt, Contemporary Craft + Design + 3D Art. Nr. 3, (Sydney, 2000), pp. 32–3.

29 Therese Hilbert, unpublished manuscript, late 1980s.

30 In 1972 Harald Szeemann curated the «individual mythology» section of documenta 5 in Kassel.

31 Deutschlandfunk, July 29, 2002, review of Marina Schneede, Mit Haut und Haaren. Martina Wehlte-Höschele in conversation with Marina Schneede.

32 Susanne von Falkenhausen & Gert Mattenklott & Angela Lammert, «Raum und Körper in den Künsten der Nachkriegszeit», loc. cit., pp.9–10, p. 9.

33 Gilles Deleuze & Félix Guattari, Was ist Philosophie, (Frankfurt a. M., 1st edition 1991, quoted here from the 2000 edition), pp. 191–237, p. 191 and cited from Kerstin Thomas, «Du lebst und tust mir was. Die Bilder von Miriam Cahn», in: exh. cat. Miriam Cahn. Das Genaue Hinschauen, Kunsthaus Bregenz (Bregenz, 2019), pp. 37–43, p. 42.

their reflection and aesthetic transformation, in short about an aesthetic subjectivity that nevertheless in the translation into art experiences a «distancing from the self»[34] and is established in an «aesthetic space»[35]. And, not to be overlooked: in doing so, the discipline in which the work is created is also always put up for discussion, its limitations sounded out and challenged.

Therese Hilbert operates in the field of jewelry. Her works do not reference a specific physicality in concrete terms, yet they often contain a cue, a suggestion of aspects that appear bodily. These range from subtle traces left on surfaces that introduce the «visual aspect of a tactile energy» to manifestly spatially conceived structures that function as images of an internal mobility[36]. Hilbert builds sets of chambers. Thus, in 2003 she created the mysterious pendants with evocative titles such as «in sich» (in itself), «für sich» (for itself) and «Ein Trichter und eine Seele» (a funnel and a soul). In them, an orb is sunk into another semi-sphere, a crater rises up from a deep bowl, the mouth of a funnel leads into a narrow pipe. Light effect and mobility of the component parts – and in this case, with the funnel measuring 17 cm these are downright monumental – complete the impression of a very deliberately calculated, sublime composition.

If we now compare Hilbert's approach with the above-discussed tendencies in the so-called liberal or fine arts, we encounter points of contact. It is in particular concepts that focus on the visualization of sensory experience that come into play along the «fault lines» in order to «aesthetically express the ineffable…»[37]. For a long time, tactile and visual concepts were seen as an irreconcilable contradiction. Eye and gaze alone enjoyed a special status. Artistic theory and practice backed away from this imperative in the 1960s at the very latest, especially in the context of feminist strategies: A «reconnection of the visual sense to the body»[38] was called for. This in turn meant a shift in fundamental parameters. The sense of touch, formerly decried as supposedly «deficient in intellectual distance» and «lacking the faculty of abstraction»[39], now received an entirely new appreciation as cognitive organ and instrument.

The body (whether alive or imaginary) as a referent of social reality started to take center stage. It filled the former void and in aesthetic analysis guaranteed a completion of perspectives as a «signifier for a body philosophical turn in thinking»[40].

34 Paul Celan quoted after Georges Bloess, «‹Mein Körper wird zum Material …› Skulptur, Selbstgestaltung und Innenraum im Werk von Louise Bourgeois», in: Raum und Körper in den Künsten der Nachkriegszeit. Akademie der Künste (ed.), compiled by Angela Lammert. Symposium held in 1997 on the occasion of the exhibition Germaine Richier, Akademie der Künste, (Berlin, 1997; Amsterdam & Dresden 1998), pp. 218–27, p. 226.

35 Kerstin Thomas, «Du lebst und tust mir was. Die Bilder von Miriam Cahn,» in: exh. cat. Miriam Cahn. Das Genaue Hinschauen. Kunsthaus Bregenz, (Bregenz, 2019), pp. 37–43; p. 40.

36 Hartmut Böhme, «Der Tastsinn im Gefüge der Sinne», in: Anthropologie, Gunter Gebauer (ed.) (Leipzig & Stuttgart, 1998), pp. 214–225, last retrieved March 27, 2020, unpaginated.

37 Barbara Lange, «Einleitung. Körper-Konzepte. Strategien von Visualisierung sinnlicher Erfahrungen», in: Barbara Lange (ed.), Visualisierte Körperkonzepte. Strategien in der Kunst der Moderne, (Berlin, 2007), pp. 9–13, p. 10.

38 Mechthild Fend, «Sehen und Tasten. Zur Raumwahrnehmung bei Alois Riegl und in der Sinnesphysiologie des 19. Jahrhunderts», in: ibid., pp. 15–38; p. 16.

39 Tina Zürn, Steffen Haug & Thomas Helbig (eds.), Bild, Blick, Berührung. Optische und taktile Wahrnehmung in den Künsten, (Paderborn, 2019), p. 2 (introduction).

40 Cf. Claudia Benthien, Haut. Literaturgeschichte – Körperbilder – Grenzdiskurse, (Hamburg, 1999), p. 14.

Therese Hilbert. (A) LIFE OF JEWELRY

Numerous artistic positions revolve around these arguments and seek to revise the definitions of image, space and identity: «An imaginary body is not simply a product of subjective imagination, fantasy or folklore. The term imaginary will be used in a loose but nevertheless technical sense to refer to those images, symbols, metaphors and representations which help to construct various forms of subjectivity.»[41]

Various approaches by Carolee Schneemann, Miriam Cahn or Rebecca Horn reveal an operative model that suggests innovative «structures of identification». These allow us to participate in a «contemplation of ourselves»[42].

Cahn for example studied at the Kunstgewerbeschule in Basel when it was still very much informed by Bauhaus concepts and only performed a radical leap in her later practice. Such a course of action, such an aggressive and deliberate loss of control could never be Therese Hilbert's thing. And yet: The layouts of secret rooms for intimate affectivity, the intensity of these states and their concentrated charge also play a role in Cahn's work.[43] Yet it is almost certainly Rosemarie Trockel with whom Hilbert has a greater affinity and whose «resistance to norms and prescriptive images» results in a «citing, re-writing and re-coding» of historical patterns[44] while striking softer and more ironic notes.

In the field of jewelry, the bridge to the body naturally offers itself, as does the interpretation of jewelry as a field for symbolic projection, as an «allegory for the relationship between self and world»,[45] as cultural sign, as expression of identity, depth, soul, subjectivity, as its shell. A long «iconographic and metaphorical tradition»[46] of analogies and idioms can thus be claimed by Hilbert.

Stage IV – «I am a volcano»

For now I exist.
There are passions that exist inside me
that may explode or be kept at bay …
I am full of energies, fire and lava. I am a volcano.
(Eugène Ionesco)[47]

Hilbert has been drawn time and again to the Greek archipelago, to the seemingly harmless, sleepy craters, she loves to feel the barely noticeable shivers of the earth, its hidden powers under her feet. The theme of the volcano, which had begun to fascinate her in the 1980s and has become ever more important since, has gradually established itself as a central, fundamental motor to her further work. The

41 Moira Gatens, Imaginary Bodies, Ethics, Power and Corporeality, (London, 1996), p. 8; quoted here from Sabine Gebhardt Fink, Transformation der Aktion. Miriam Cahns performative Arbeiten und Rebecca Horns Personal Art, (Vienna, 2003), p. 159.

42 Ibid., p. 189.

43 Cf. exh. cat. Miriam Cahn. Ich als Mensch, (Munich, 2019; Warsaw 2019–2020).

44 Cf. Beate Söntgen, «Mit Liebe betrachten. Rosemarie Trockels Kunst der Anerkennung», in: exh. cat. Rosemarie Trockel. Märzôschnee ûnd Wiebôrweh sand am Môargô niana më, Kunsthaus Bregenz, (Bregenz, 2015), pp. 155–69.

45 Inspired by Claudia Benthien, Haut. Literaturgeschichte – Körperbilder – Grenzdiskurse, (Hamburg, 1999), p. 7.

46 Ibid., p. 13ff.

47 Eugène Ionesco, Introduction to Maurice & Katia Krafft, Volcano, (Paris & New York, 1975), p. 8.

aforementioned first work group on the theme, titled «Nea Kameni», remains indebted to the real-life model: predominantly conical brooches, blackened, some of them rounded, offer fascinating views of tongues, inserts, wings and flanks. Red, white or blue corals well up from solid bases, threatening, surprising, disconcerting, rise out of incisions, depressions, sinkholes. Other examples without added «growths» are characterized by their perforated outer shell, allowing us to gaze into the sturdy substructure. A further variant are the punched domes that nestle into circular basins. They do not reveal what else may be hiding inside them. Yet nevertheless the «double bottom» implies a hidden level, the existence of a «double life», to which the piece of jewelry alludes metaphorically.

Hilbert here introduces an unusual color spectrum, set for the most part against an anthracite-colored ground, that corresponds with the theme and has dominated the work to date.

Immediately after this, Hilbert devoted her work to embers. Bright red surfaces now covered blackened box brooches, like tongues or ragged pieces of cloth, dynamic, jazzy, at times compact and downright hermetically sealed, then again just as a circlet through which black bulges pushed upwards out of low cylinders. Blue or green varnished «inlay work» set against a dark or silver ground reference milky-poisonous crater lakes. Further examples of these volcano variants consist of more or less squat cones, at times tilted to the side, with flaming or sulfur-yellow applications that burst through, plunge into or crown them. Hilbert has developed an incredible range of facets in this work group. She has done so drawing from the power of nature – and course primarily from fire as a symbol of those powers, and the one that has the greatest emotive force in human imagination nonetheless,[48] as well as being tied in an elementary and fateful way to her craft with Hephaestus and his Roman counterpart Vulcan, god of fire and the art of smithery. Black and red come together with white – present in silver – in varied constellations here.

Maribel Königer remarked that while the volcano did become iconic for Hilbert and somewhat of a trademark, its symbolism in her oeuvre was not solely based on the concrete natural origins, but could instead be regarded as an adequate analogy on a «drawing from within oneself», on a digging up, bringing forth and allegorizing of coded subject matter.[49] This relates to a creative passion that time and again dives into volcanic landscape as an adequate allegory for identity and creative potential in its most diverse of «personifications» or formations. The spectrum straddles complex, elegant groupings of cones, the artful use of lava rock on brooches and scattered beads of obsidian on pendants as well as large, often multi-layered pendants in nuanced vermillion red that evoke the image of glowing masses of lava. Another variant consists of simple discs across which semicircular, perforated rooves have been stretched, with the holes in the upper layers allowing a view of the colors beneath. Even found obsidian and lava rock turned out to be useful partners as additional references to volcanic matter. Hilbert scattered these rock samples across her structures, allowed them to peek out of miniature chimneys or rest in cuboid box shapes. She not only organized and arranged her own found objects here, but

48 Cf. Gernot Böhme & Hartmut Böhme, Feuer, Wasser, Erde, Luft. Eine Kulturgeschichte der Elemente, (Munich, 1996).

49 Maribel Königer, «Kraterwanderung» in: exh. cat. Weiss und Schwarz. Therese Hilbert. Schmuck, (Munich, 1996), pp. 7–11, p. 11.

also traces of material and process. These sculptural works were juxtaposed by square brooches with varnished black planes on which soft shapes rise like bubbles. Others in turn seismographically document mysterious movements under their skin by way of a dappled coloring. Shimmering heat, turbulent rivers of magma, mysterious darkness, unfathomable depths – dramatic and epic mechanisms come to rest in the imagery of Hilbert's jewelry and manifest in dense, concentrated, symbolic tableaus. Monochrome panels that stand out against convex basins or medallions with edges painted in yellow draw on a classical theme of jewelry history. Hilbert achieves a fusion of oblique self-reflection and an invitation extended to the wearer of her jewelry to participate in this subtle oscillation between reflecting her/his self and reflecting the other. In this sense, the jewelry has the function of a threshold[50] that symbolically regulates and masks this social event as well as the innermost emotional life of the individual.

Tension, contradictions, interactions, harmony between surface and volume, between the multiple characters of her artefacts, between space and structure, expansion and introversion shape Hilbert's aesthetic decisions. The volcano serves as an image for these complex processes. Condensed in it is the vision of life per se, of the creative act, of process that settles in a final form.

The hidden interior, the existent but often invisible space is a crucial aspect in all of this. Jewelry defines this space, articulates it, evokes it. According to Bachelard, the theme of the image constitutes a «fact of great ontological significance» in literature and art as part of a phenomenology of the soul.[51] House, room, body belong to the same thread. There is a direct correlation between them. The vision of the body as a vessel, the ego as container, also goes hand in hand with the anthropomorphization of architectural terminology: «… In line with Hans Blumenberg's thought, the house may be characterized as an ‹absolute metaphor› for the body …»[52] Bachelard further correlates it with the «topography of our intimate being», our very own «corner of the world» and of the «cosmos».[53] Memories, thoughts, dreams, sentiments are saved in such images, find shelter and a hiding place, are transcended, abstracted and collectivized in the work of art.

Hilbert stylistically connects diverse guiding principles that are iconographically linked: That of the volcano, the shell (organic or tectonic), the body, the space or room. While the volcano may not directly depict a body or a house, it nevertheless represents an enclosed space and stands in close relation to the body and shell metaphors. It is a further imago in this cultural nexus.

It is here that the threads of this entanglement converge, especially in those instances in which a conglomerate of cylindrical vessel, funnel, semi-sphere, pyramid and spiral develops, with all of these elements interlocking and interleaving, piling

50 Cf. Ina Fuchs, «Die Hüllen der Menschen. Natürliche und kreatürliche Kleidung in der zeitgenössischen Kunst» In: exh. cat. Die zweite Haut, (Bad Homburg, 2016–2017, pp. 9–30).

51 Gaston Bachelard, Poetics of Space, tr. M. Jolas (Beacon: Boston, 1969), p. xiii

52 Quoted after Benthien, op. cit., p. 34.

53 Bachelard, op. cit., p. xxxii, p. 4.

on top of each other and in so doing creating masterful constructs – for the time being the last and thus far most expressive modulation of the theme. It is here that Hilbert's range and ability really takes off, while celebrating previously initiated tendencies in synthesis.

Epilogue

What has always been and continues to be at stake is a singular aesthetic semantics that corresponds to Hilbert's work, life and identity as woman and artist, the concurrency of which reflects conditions and situations, transforms these in a specific language of jewelry. Maribel Königer calls this a «sensitivity for the kind of femininity… in which fortitude and readiness to defend do not form a contradiction to beauty, elegance and grace.»[54]

Hilbert's art is one of metaphorical entanglement and of the codification of her impulses, which may be, but are not inevitably, of intimate nature. She draws on the most basic of geometric modules and typologies, gives these a dynamic charge in her work and allows them to undergo a multitude of mutations. This gives rise to a method that is at the same time personal and objective. The allusion to skin and house, to vessel and body, to something that contains pervades her oeuvre, and inside this we find, on a small scale – to use Bachelard's words – «an intimate immensity».[55]

Louise Bourgeois was cited at the beginning of this text and so it shall be at the end, too. Cautiously speaking, while she is far removed from jewelry, her «thematic configurations» and stance nevertheless exhibit a certain kinship to Hilbert's. Bourgeois' experiences are what provides the creative spark for her work, and the same holds true for Hilbert. Yet in neither case are their personal experiences the actual content of the work. The most striking similarity in the two women's oeuvres, however, is the artistic exploitation of aesthetic themes in very different, definitive works. Hilbert does not belong to the genre of Body Art, her work is not as dramatic as that of Bourgeois, lacks Cahn's radical gesture. But still jewelry gains a similar meaning with Hilbert, as it is able to grasp what may only be expressed in metaphorical transference. It is in her jewelry that sensitive processes reveal themselves like a «third skin».[56] Yet while Bourgeois considers fragility, vulnerability and loss, Hilbert establishes an authentic provision of home in her work. Her jewelry is exactly what she is: composed, consistent, also resistive and combative, but fundamentally stable.

54 Exh. cat., (Munich, 1996), op. cit., p. 8.

55 Bachelard, op. cit., p. 183.

56 Krämer. Anna-Lena, Femme Maison von Louise Bourgeois. Architekturen der Weiblichkeit. Diss. phil. Reegensburg 2015, pp. 54, 59.

Zürich und Bern
Zurich and Bern
1966–1972

▲ Kunstgewerbeschule (School for Arts and Crafts) and Museum
Zurich, Switzerland, 1933. Architects Adolf Steger and Karl Egender.
▶ Bracelet, 1966, silver, 8.0 x 7.7 x 3.6 cm.
Die Neue Sammlung – The Design Museum, Munich, Germany.
Ring, 1967, silver, 2.9 x 2.8 x 1.4 cm.

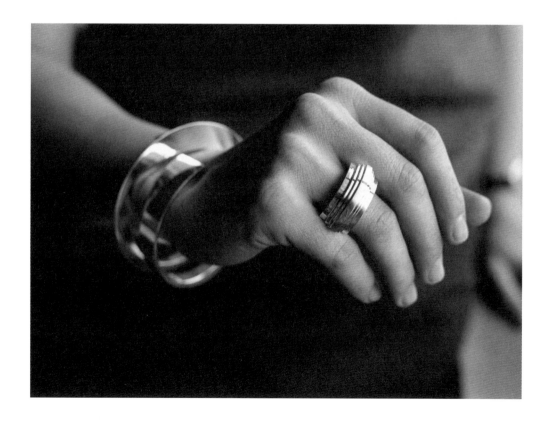

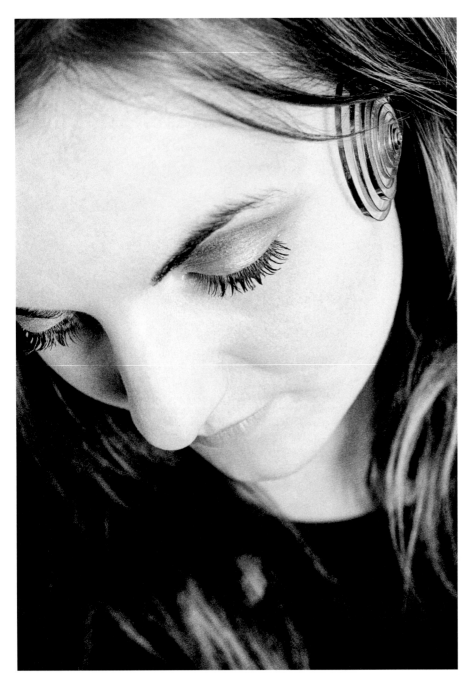

▲ Single ear jewelry, 1969, gold, 5.0 x 7.6 cm, part of the final year project at the Kunstgewerbeschule, Zurich, Switzerland.

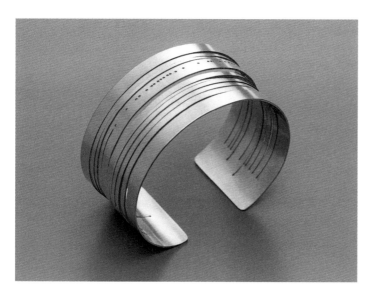

◄ Bracelet, 1972, gold, 5.0 x 5.7 x 2.9 cm.

◄ Brooch, 1971, silver, ruby, 3.7 x 4.5 cm. Die Neue Sammlung – The Design Museum, Munich, Germany.

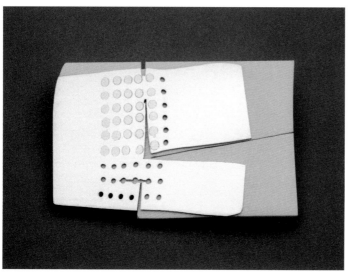

◄ Brooch, 1972, silver, gold, acrylic, 3.7 x 5.8 cm. Die Neue Sammlung – The Design Museum, Munich, Germany.

Aufbruch in München
New Start in Munich
1972–1979

▲ Hermann Jünger with students in front of Akademie der
Bildenden Künste Munich, Germany 1979.

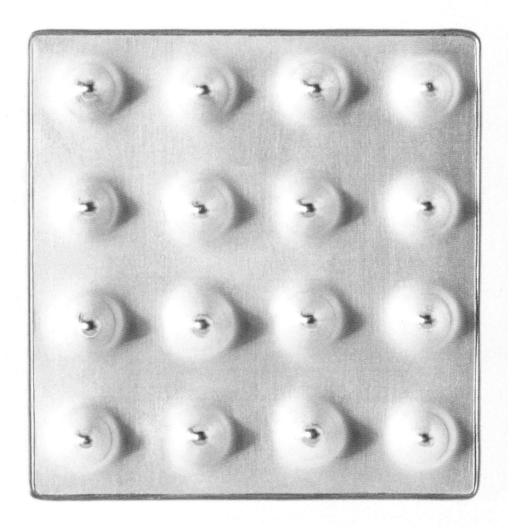

▲ Brooch, 1975, silver, gold, 4.2 x 4.2 cm. Die Neue Sammlung – The Design Museum. Permanent loan from the Danner Foundation, Munich, Germany.

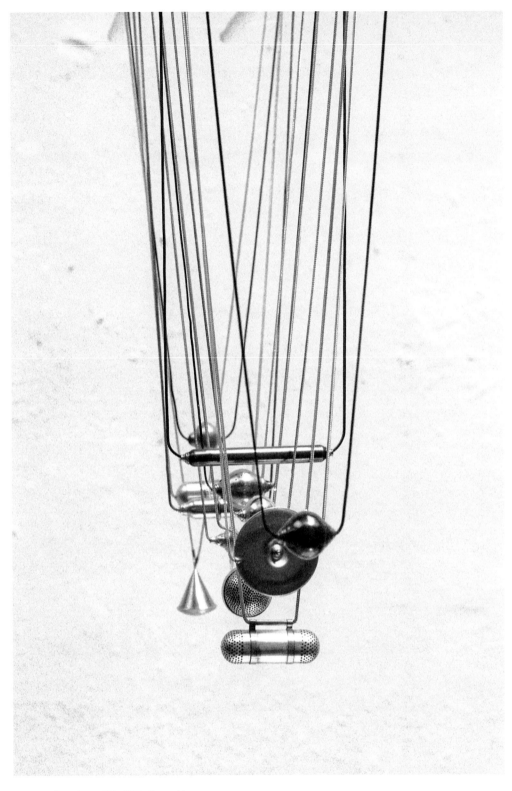

▲ Group of pendants, 1973–1976, silver, gold, different dimensions.

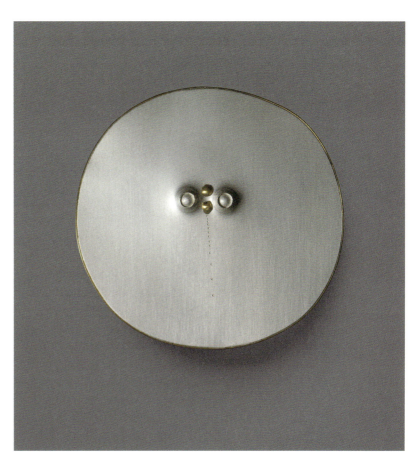

▲ Brooch, 1974, silver, gold, 5.1 x 5.5 cm.

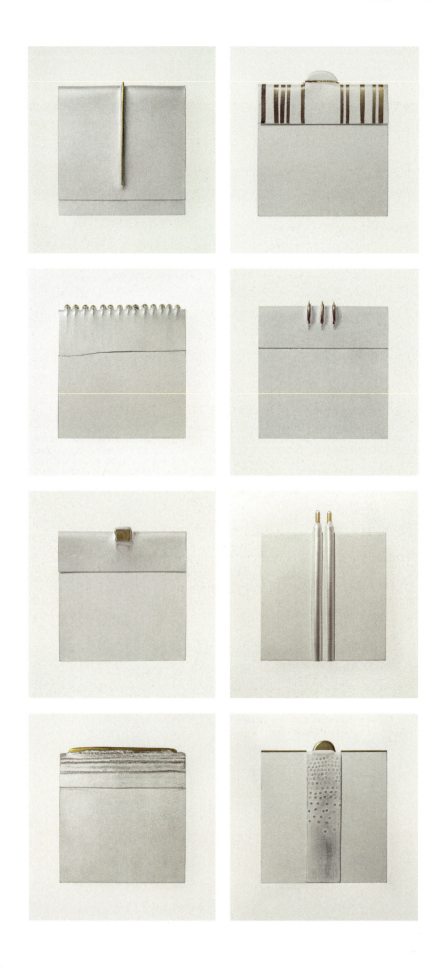

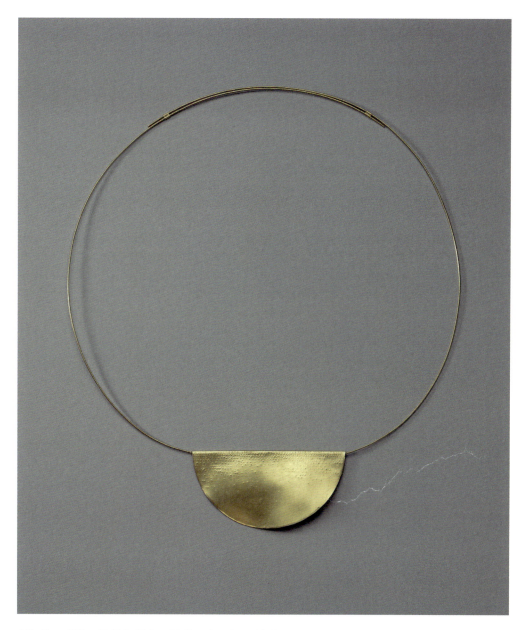

▲ Necklace, 1978, gold, 23.9 x 21.5 cm. Die Neue Sammlung – The Design Museum. Permanent loan from the Danner Foundation, Munich, Germany.
◄ Brooches, 1977, silver, gold, each 4.0 x 4.0 cm.

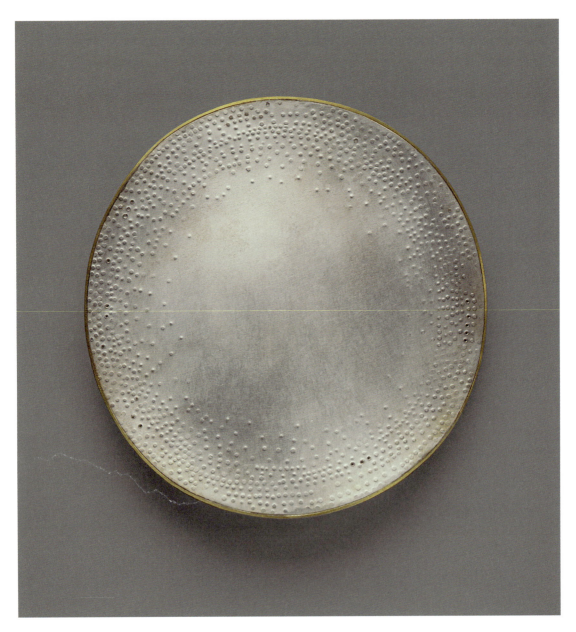

▲ Brooch, 1978, silver, gold, 8.7 x 8.8 cm. Die Neue Sammlung –
The Design Museum. Permanent loan from the Danner Foundation,
Munich, Germany.

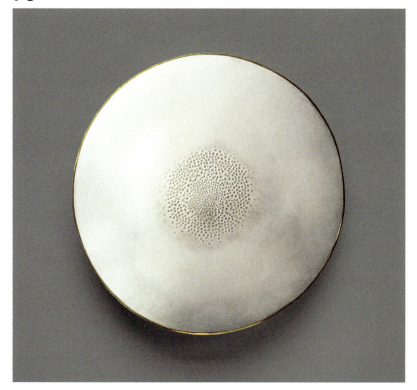

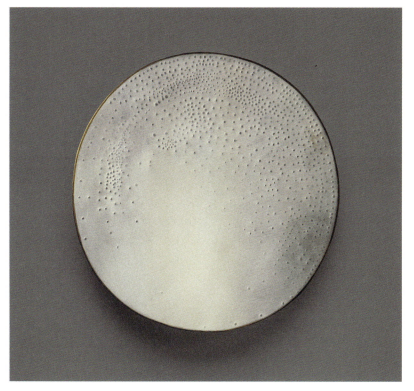

▲ Brooch, 1978, silver, gold, 8.7 x 8.5 cm.
Private collection, Munich, Germany.
▲ Brooch, 1978, silver, gold, 8.6 x 8.5 cm.

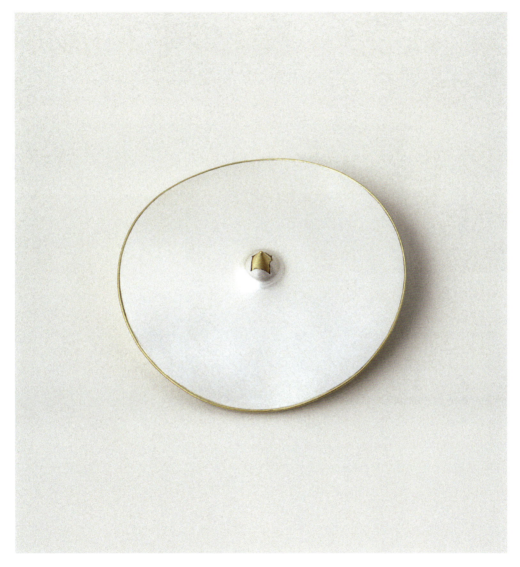

▲ Brooch, 1979, silver, gold, ø 7.5 cm. The Museum of Fine Arts, Houston (MFAH), The Helen W. Drutt Collection, Houston, USA.
◀ Schmuckmuseum Pforzheim, exhibition poster, 1979. Graphic design by Dieter Vollendorf. Offset print. Germany.

▲ Five Discus-Pendants, 1979, silver, gold, each, ø 7.0 cm. Two parts build a hollow pendant which can be used as a container.
◄ Discus-Pendant, 1979, silver, gold, ø 7.0 cm. Privat collection, Munich.

Kirschen

Intermezzo
1973

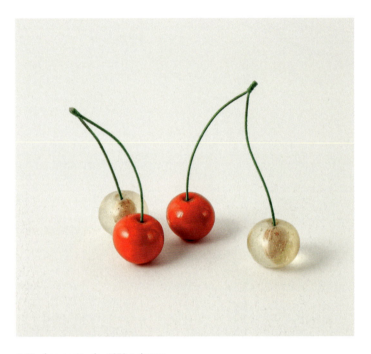

▲ Kirschen, ear jewelry, 1973, polyester,
cherry-stone, cotton, 8.5 x 2.4 cm.
▶ Mila T., 2020.

Cherries

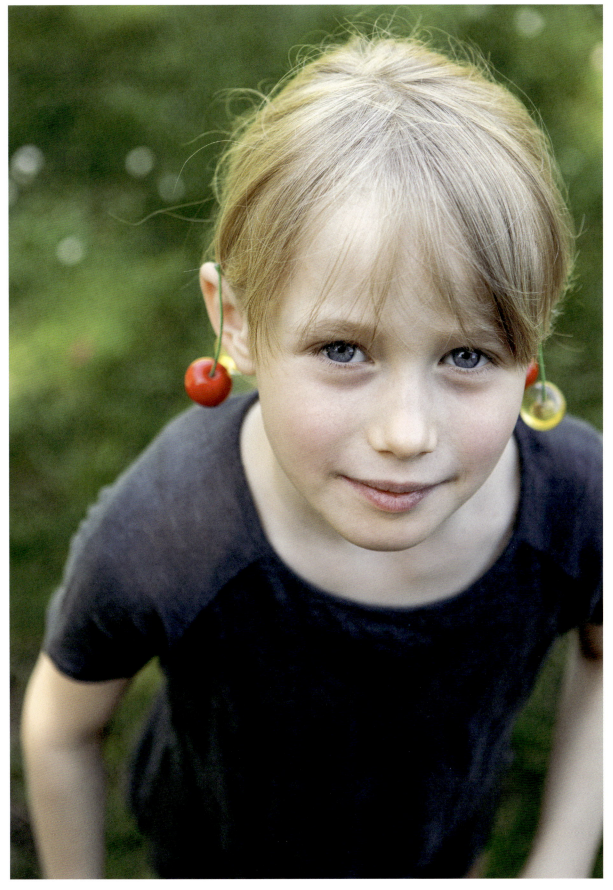

Apfel

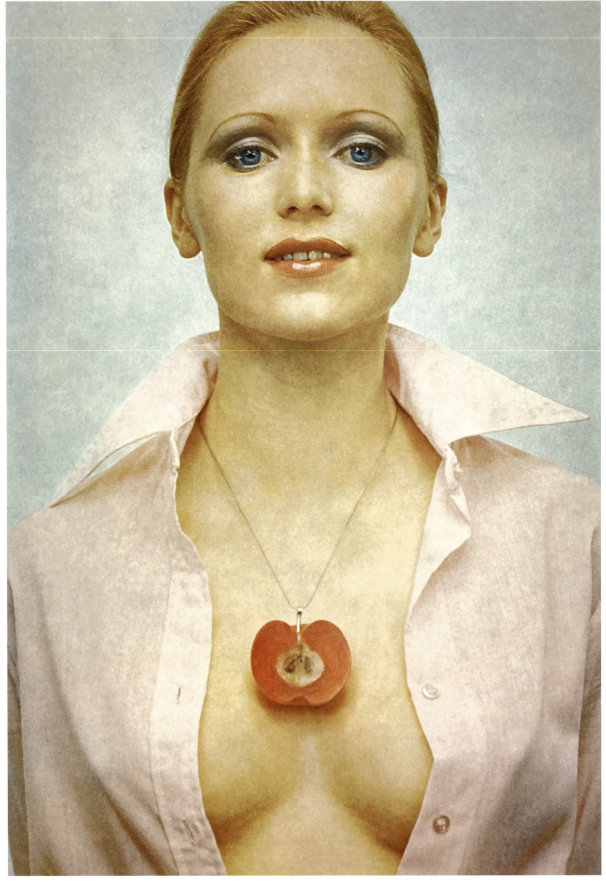

Apple

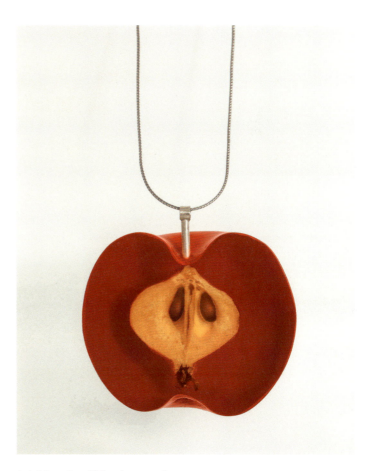

▲ Apfel, pendant, 1973, polyester, apple core, silver, 4.8 x 5.8 x 3.1 cm. Die Neue Sammlung – The Design Museum, Munich, Germany.
◄ Portrait by Regina Relang, 1973. Cover of the publication «Modeschmuck 1973», Neugablonz, Germany.

Getragene Düfte

In der Zeit
Those Days
1980–1984

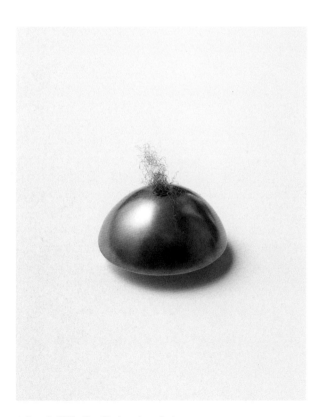

▲ Brooch, 1981, silver blackened, synthetic cotton wool, ø 4.0 cm, d 1.6 cm.
▶ Gabi S., 1981.

Getragene Düfte

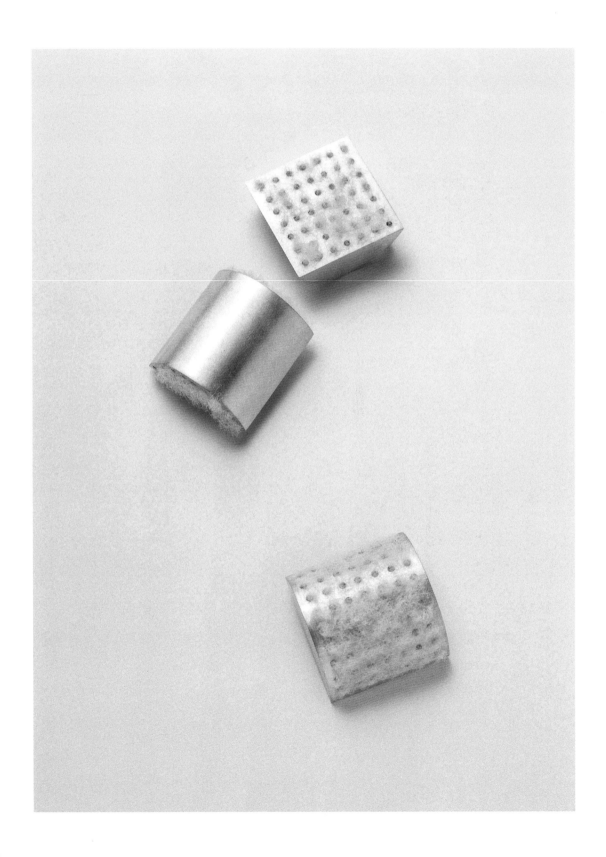

Fragrance Borne

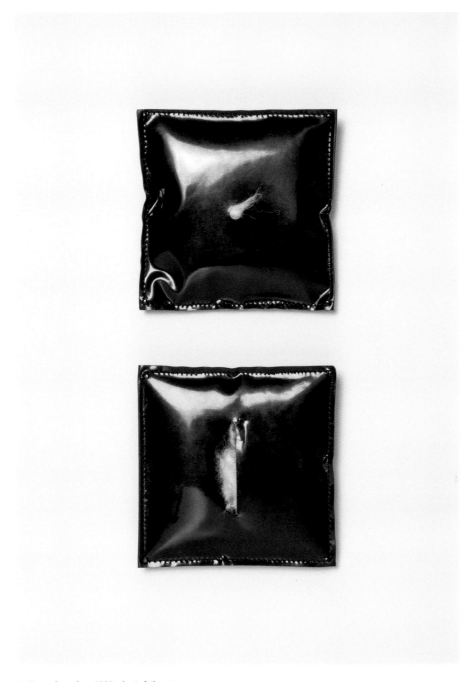

▲ Kissen, brooches, 1980, plastic foil, cotton wool, silver, each, 8.0 x 8.0 cm.
◄ Brooches, 1980, silver, synthetic cotton wool, each, 3.8 x 3.8 x 1.3 cm.

Getragene Düfte

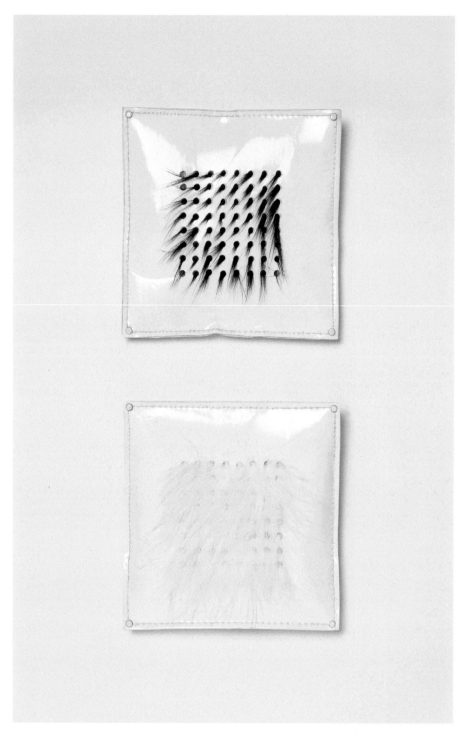

▲ Kissen, brooches, 1980, plastic foil, fur, silver, each, 8.0 x 8.0 cm.
▶ Kissen, brooches, 1980, PVC foil, cotton thread, cotton wool, silver, each, 8.0 x 8.0 cm.

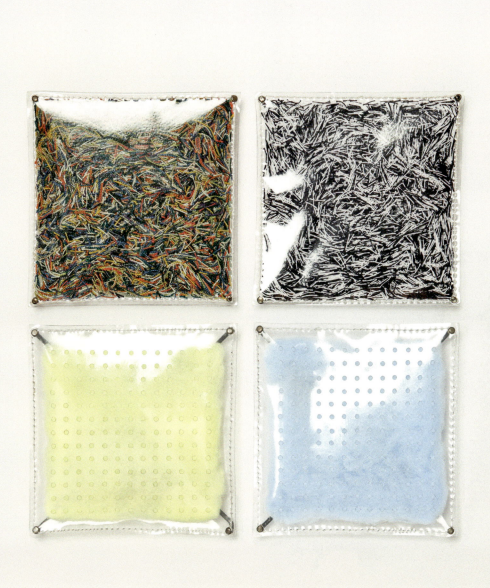

Getragene Düfte

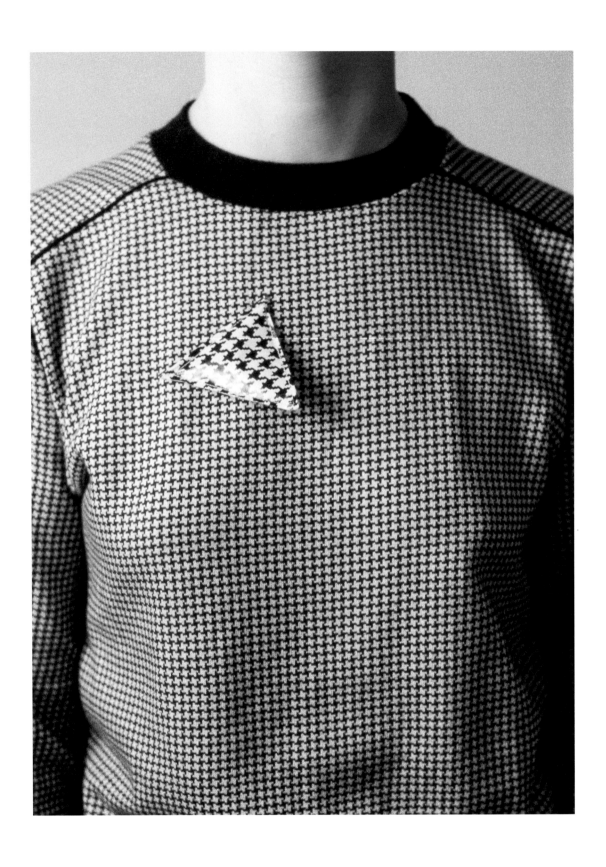

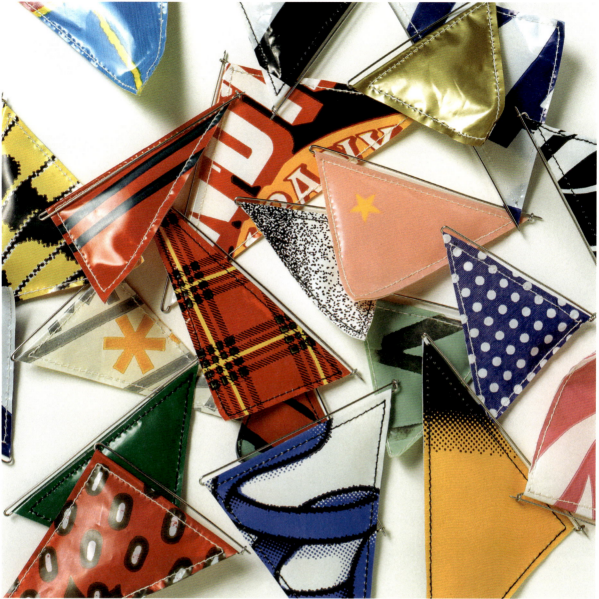

▲ Wimpel, brooches, 1981, plastic bag foil, steel, approx. 3.5–11.0 cm.
◀ Wimpel, brooch, 1981, plastic bag foil, steel, 7.0 x 5.5 cm.

Getragene Düfte

Getragene Düfte

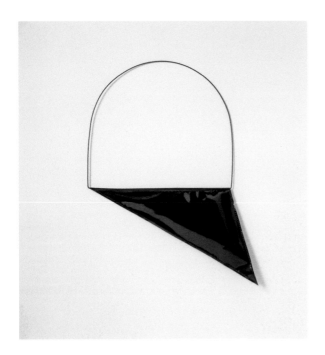

▲ Necklace, 1981, PVC foil, cotton, aluminum, 35.0 x 23.0 cm.
◄ Wimpel, brooches, 1981, PVC foil, synthetic cotton, steel, approx. 4.0 x 10.0 cm. (copying technology, pp. 92–93).
► Gabi S., 1981.

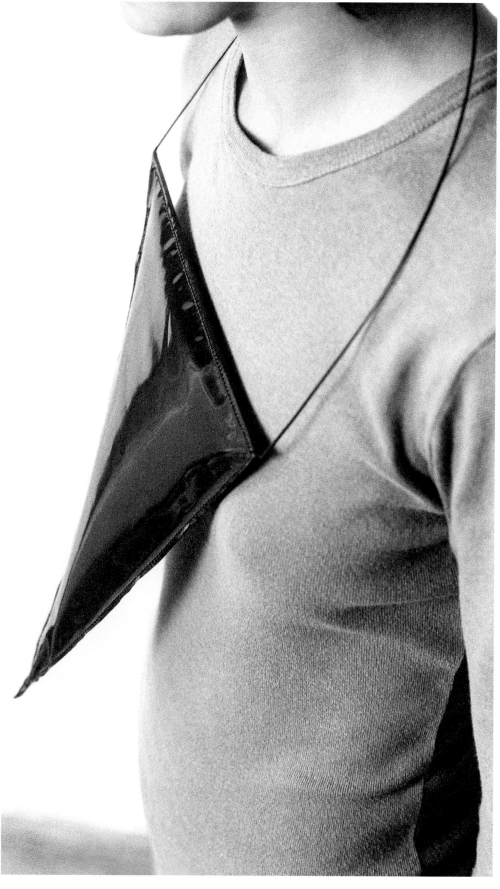

Getragene Düfte

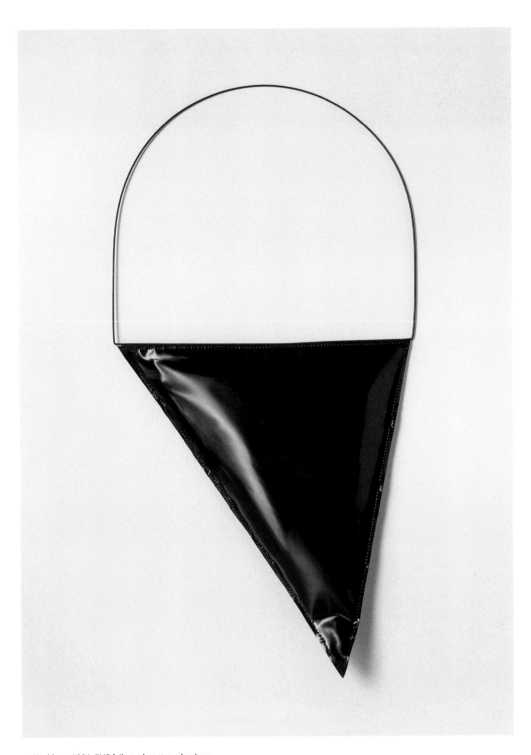

▲ Necklace, 1981, PVC foil, steel, cotton, aluminum, 43.5 x 23.0 cm.

Fragrance Borne

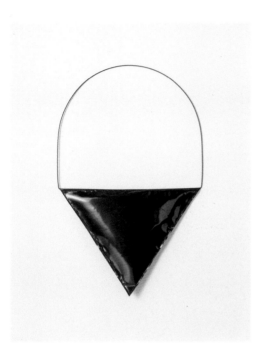

▲ Necklace, 1981, PVC foil, steel, cotton, aluminum, 40.5 x 23.0 cm.
▶ Necklace, 1981, PVC foil, steel, cotton, aluminum, 30.0 x 23.0 cm.
▶ Necklace, 1981, PVC foil, steel, cotton, aluminum, 27.5 x 23.0 cm.
▶ Necklace, 1981, PVC foil, cotton, aluminum, 32.0 x 23.0 cm.

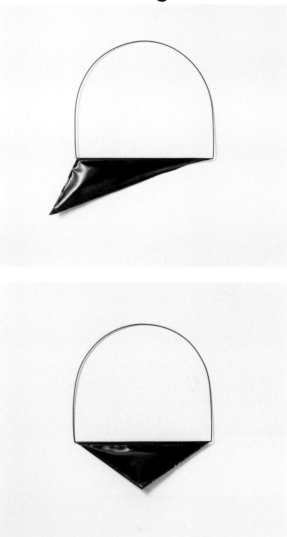

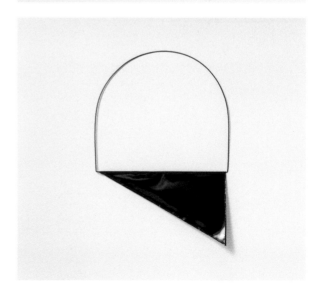

Spinnen

◀▲ Pins, 1981, steel, silver, each approx. 19.0 x 20.0 cm.

Spinnen

◀▲ Pins, 1981, steel, silver, each approx. 19.0 x 20.0 cm.

Leitern

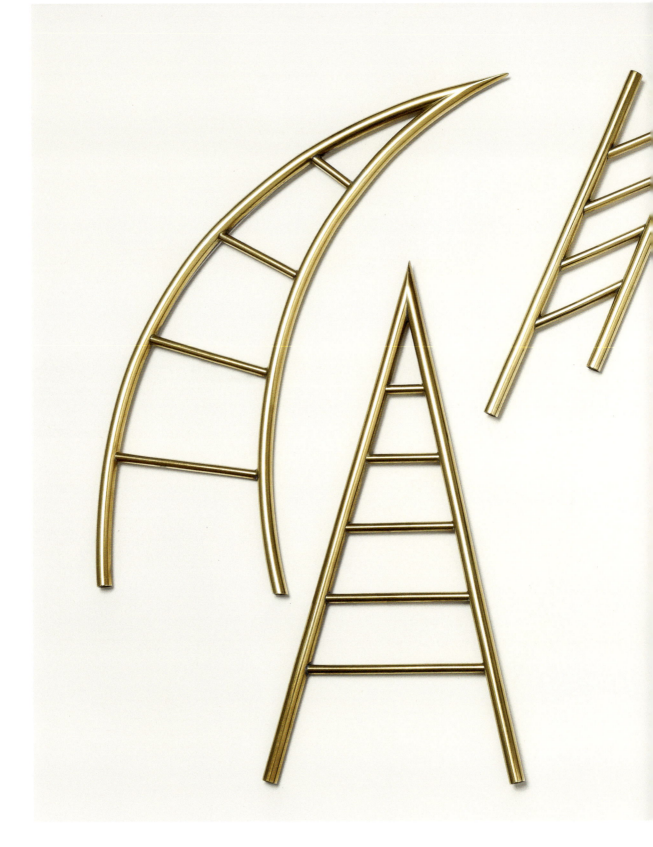

Ladders

▲ Brooches, 1985, brass, steel, 21.5 x 6.5 x 0.5 cm (largest).

Stäbe Sticks 104

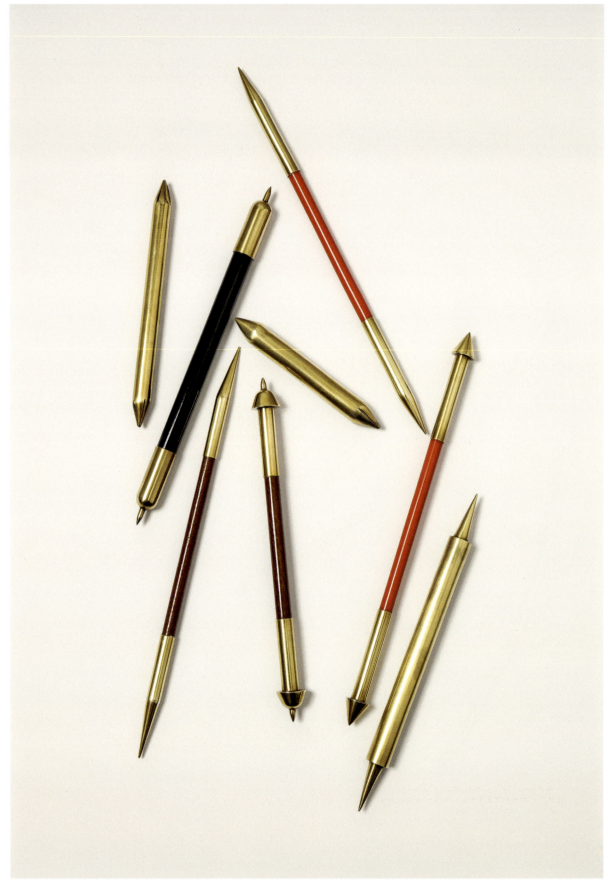

105 Äste Branches

▲ Necklace, 1983, brass, steel, 41.0 x 27.0 x 0.7 cm.
◀ Brooches, 1985, brass, steel, acrylic, bakelite,
ø 0.7–1.1 cm, l 12.0–19.6 cm.

Äste

▲ Necklace, 1983, brass, steel, 42.0 x 27.0 x 0.7 cm.
▶ Necklace, 1983, brass, steel, 38.0 x 27.0 x 0.7 cm.

Um den Kopf

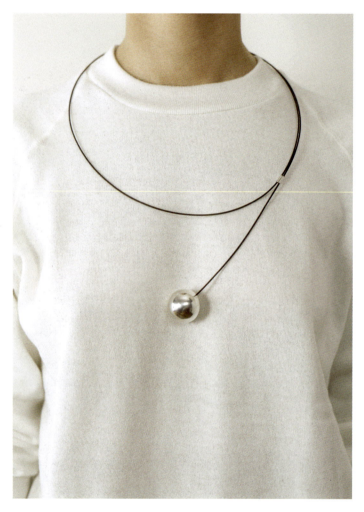

▲ Necklace, 1982, silver, PVC, steel, 27.0 x 22.0 x 2.8 cm.

Around the Head

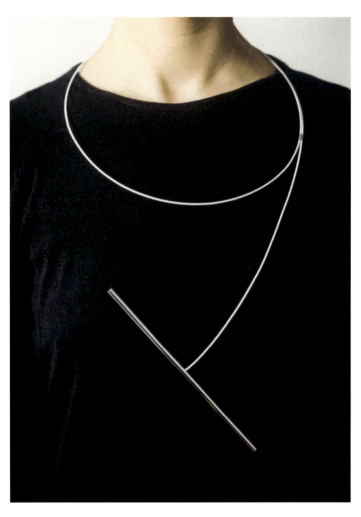

▲ Necklace, 1982, silver, PVC, steel, 33.0 x 22.0 x 0.6 cm.

Um den Kopf

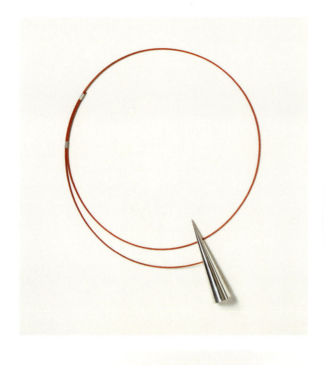

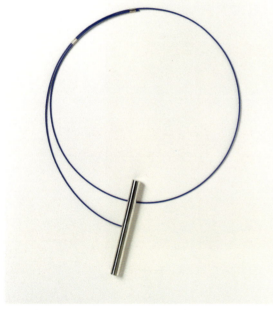

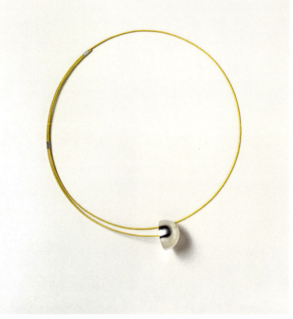

▲ Necklace, 1982, silver, steel, PVC, ø 3.2 cm (hemisphere).
◄ Necklace, 1982, silver, steel, PVC, l 9.4 cm, ø 2.2 cm (cone).
◄ Necklace, 1982, silver, steel, PVC, ø 1.0 cm, l 10.5 cm (stick). Private collection, The Hague, The Netherlands.

Around the Head

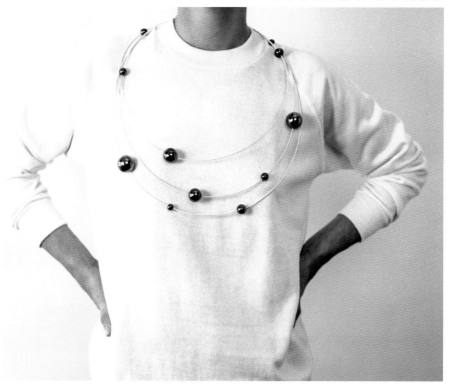

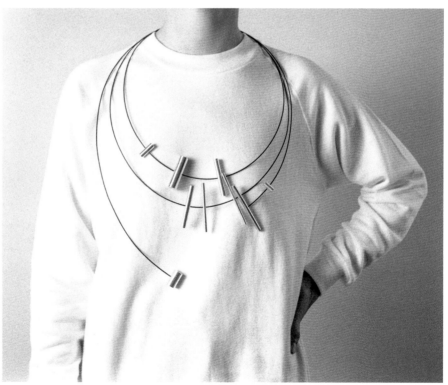

▲ Necklace, 1983, silver blackened, PVC, steel, ø 37.0 cm.
▲ Necklace, 1983, silver, PVC, steel, ø approx. 40.0 cm.
The Dallas Museum of Arts, The Edward W. and
Deedie Potter Rose Collection, Dallas, USA
(former Inge Asenbaum collection, Vienna, Austria).

Um den Kopf

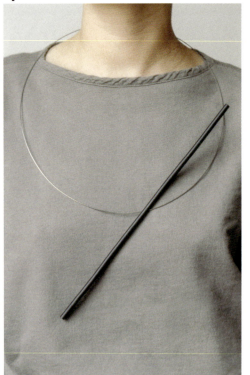 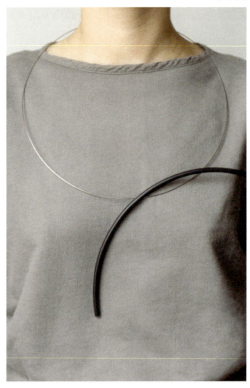

◄▲► Necklaces, 1983, brass lacquered, steel, approx. 39.5 x 27.0 x 0.6 cm. The Power House Museum – Museum of Applied Arts and Sciences, Sydney, Australia.
► Necklace, 1983, brass lacquered, steel, 40.0 x 27.0 x 0.6 cm.

Around the Head

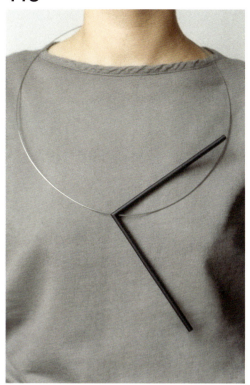

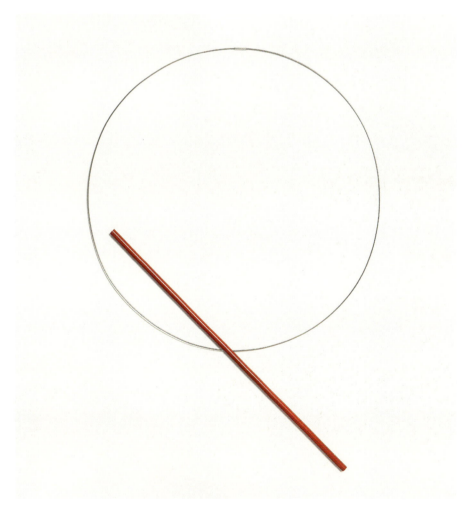

Um den Kopf

Around the Head

◄ Necklace, 1983, brass lacquered,
PVC, steel, ø approx. 44.0 cm.
► Necklace, 1983, brass lacquered,
PVC, steel, approx. 45.0 x 43.0 cm (p. 117).
The Power House Museum – Museum of
Applied Arts and Sciences, Sydney, Australia.

Dornenkrone

Ganz klar ist das 'ne Dornenkrone. Und das Rosa ist nicht rosa, sondern rot. Oder eben doch rosa wie das mit viel Schweiß gemischte Blut. Das Blut, das in einem schlichten Krug gefangen wird. Die Dornenkrone schwebt. Ein Meteor ohne Schweif. Schwebt in Augenhöhe, vielleicht etwas darüber, und summt vor sich hin. Enthoben, entrückt, kopflos. Alleine. Summt ein altes Lied, das keiner mehr kennt. Erinnert in seiner archaischen Form und mit dem Lied an die Zeit, in der die Flüsse reißend waren und die Oasen bevölkert. In der die Suchenden suchten und sich Gesetze gaben aus der Not des Augenblicks. Täglich. Ordnende Gesetzte, Regeln, die mit Freude befolgt wurden. Sie mahnt, die Dornenkrone, aber ohne Druck. Eher heiter, wenn man genau hinsieht. Ganz rein ist sie, hat sich geputzt und blinkt. Um einen Hals mag sie sich legen, will Schutz sein. Stachelig, falls nötig, wärmend, so gewünscht. Und schwebt dahin, noch unentdeckt. Und summt und mahnt und blinkt. Doch da, jetzt, jetzt in diesem Moment, steht ein kleines Mädchen vor ihr und staunt. Lächelt und fragt dann leise: «Sag mal, bist du 'ne Dornenkrone?» Da stutzt die Krone und lächelt auch. «Klar, na klar bin ich 'ne Dornenkrone. Willst du mich haben?»

Of course it's a Crown of Thorns. And the pink isn't pink, but red. Or as pink as blood when mixed with a lot of sweat. The blood, that is caught up in a simple jug. The Crown of Thorns hovers. A comet with no tail. Hovers at eye level, perhaps a little above, and hums away to itself. Aloof, apart, unawares. Alone. Hums an old song that is long forgotten. Recalling in its archaic state and through the song, the times when rivers still raged, and the oases were still inhabited. In which the searchers searched and drew up laws for themselves from the wants of the moment. Daily. Ordered laws, rules which were followed with pleasure. It admonishes, – the Crown of Thorns – , but without pressure. Rather with serenity when one looks more closely. It is very clean – it has washed and polished itself and shines. It likes to lie around a neck, wants to protect. Prickly, if need be, warming if desired. And just hovers, still undiscovered. And hums and admonishes and shines, though now, just, just at this moment a little girl stands in front of it, and stares. Smiles, then asks softly: «Hey, are you a Crown of Thorns?» The Crown hesitates, and then smiles back. «Sure, of course I'm a Crown of Thorns. Do you want me?»

Rainer Weiss 1983

Crown of Thorns

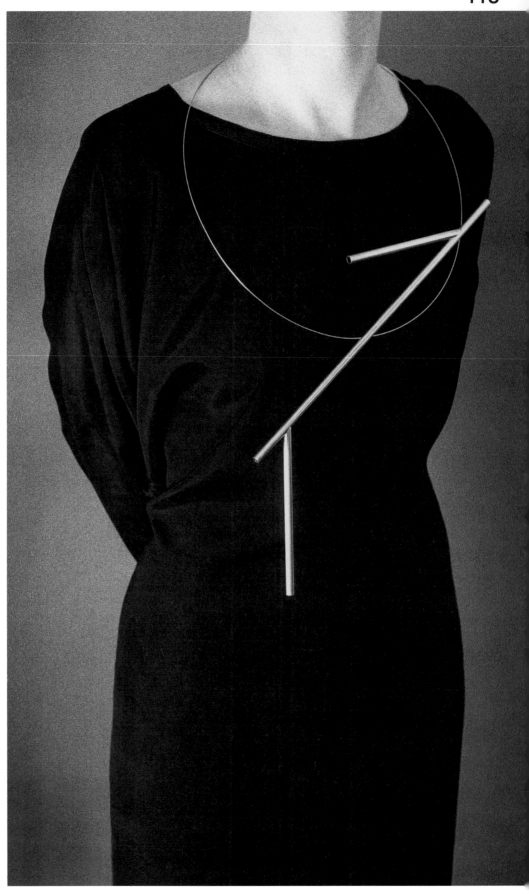

Insert 1985

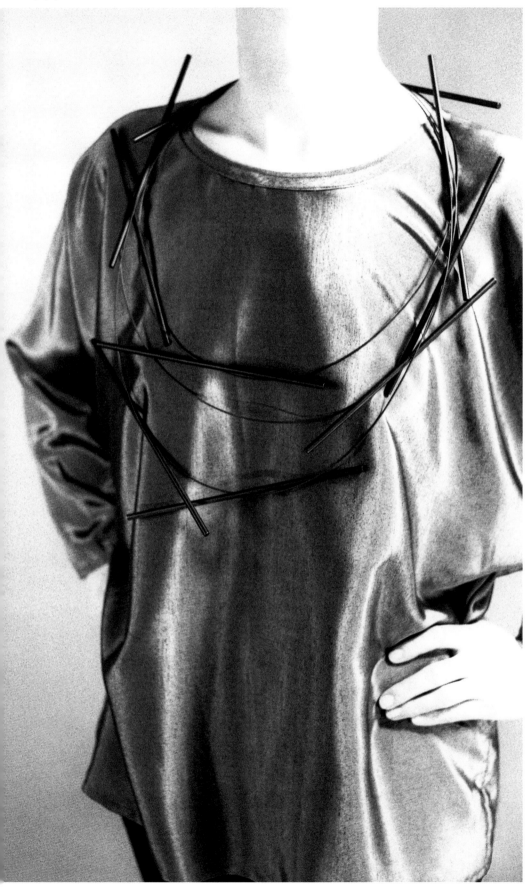

▲ Ast, necklace, 1983, brass, steel, ø 0.7 cm, l 48.0 cm.
▲ Neckpiece, 1983, brass lacquered, PVC, steel, ø approx. 45.0 cm.

◀ Leiter, brooch, 1985, brass, steel, 15.0 × 8.8 × 0.5 cm.
◀ Leiter, brooch, 1985, brass, steel, 17.7 × 3.8 × 0.5 cm.

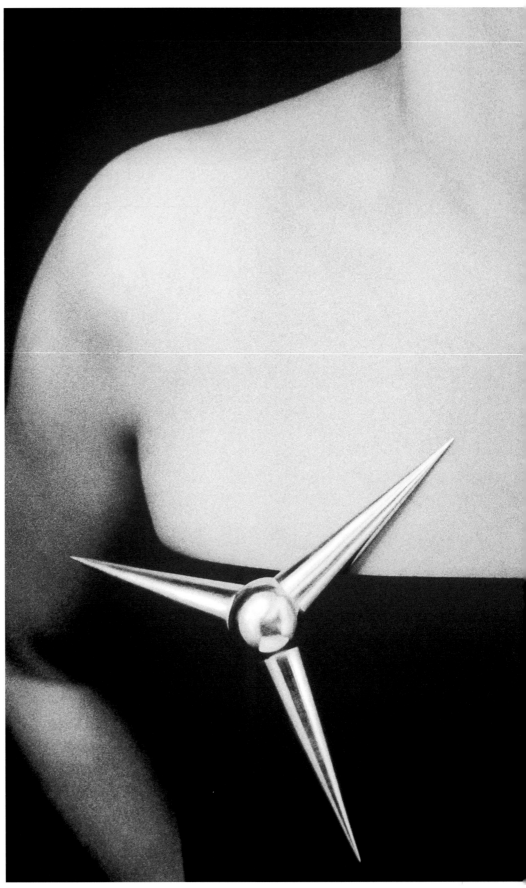

▲ Stern, brooch, 1985, silver, 15.0 x 12.5 x 3.2 cm. The Museum of Fine Arts, Houston (MFAH), The Helen W. Drutt Collection, Houston, USA.

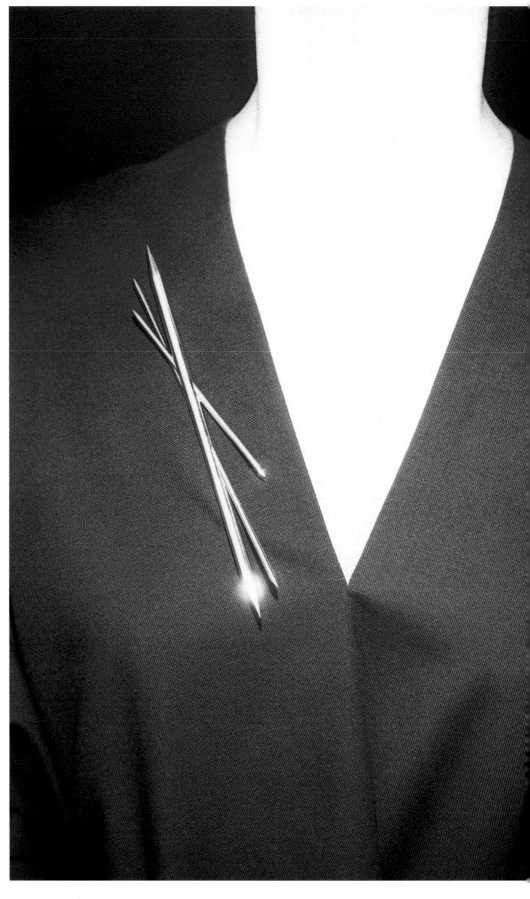

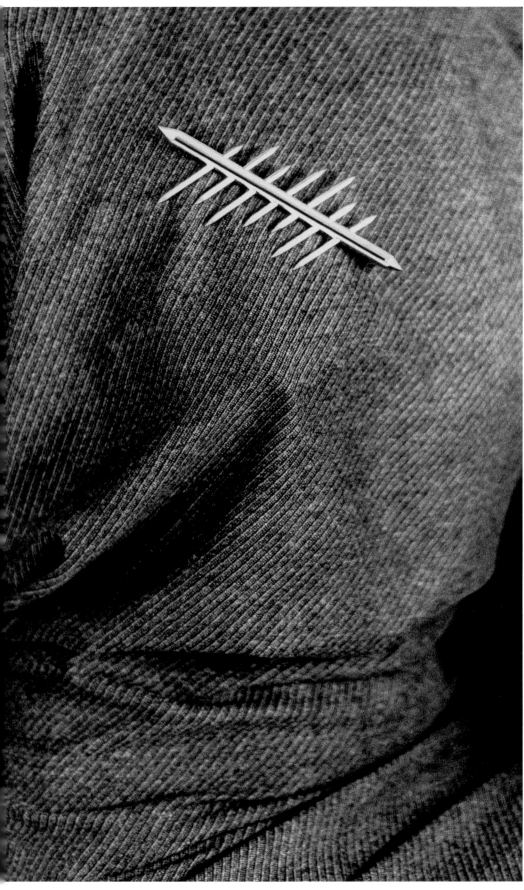

◀ Brooch, 1985, chromed brass, steel, 18.5 x 4.2 x 0.6 cm.
◀ Brooch, 1985, chromed brass, steel, 13.6 x 6.0 x 0.8 cm.
Private collection, New York, USA.

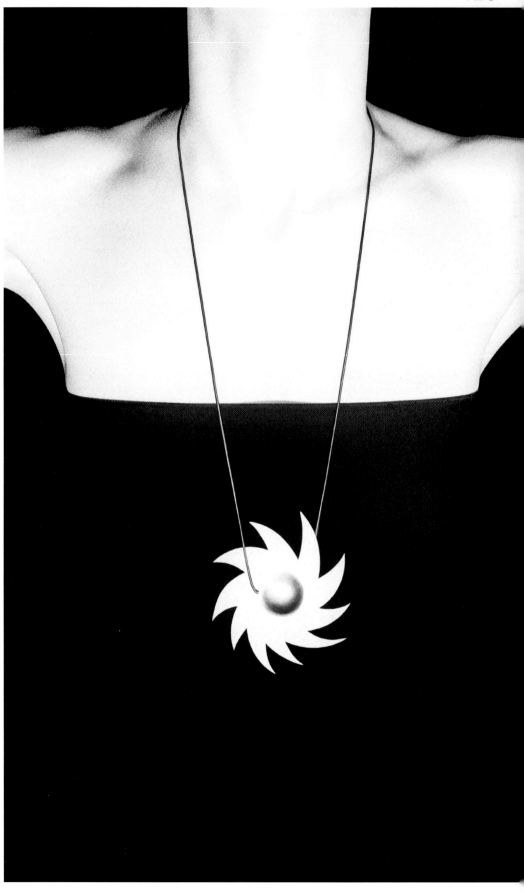

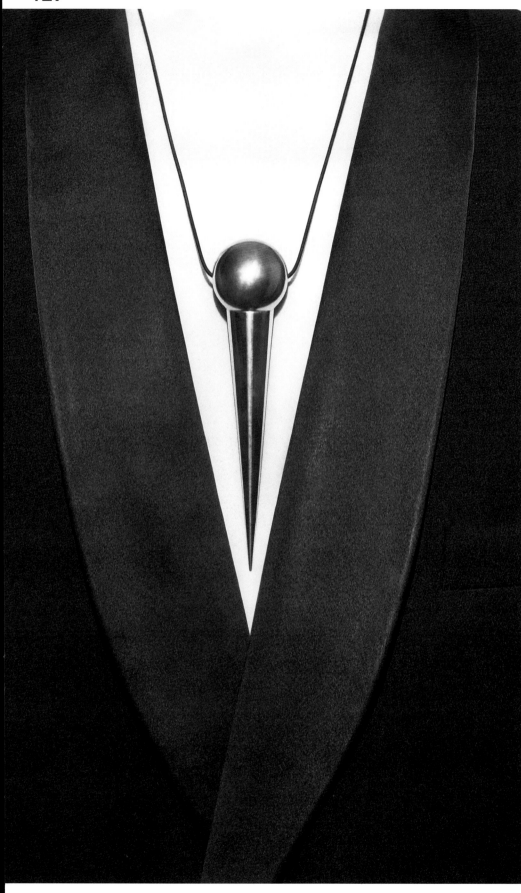

▲ Pendant, 1985, silver, 10.0 x 3.0 cm. The Museum of Fine Arts, Houston (MFAH), The Helen W. Drutt Collection, Houston, USA.
▲ Nase, pendant, 1985, silver, 13.5 x 3.0 cm. Die Neue Sammlung – The Design Museum. Permanent loan from the Danner Foundation, Munich, Germany.

Dornen

Unmut und Widerstand
Anger and Resistance
1985–1989

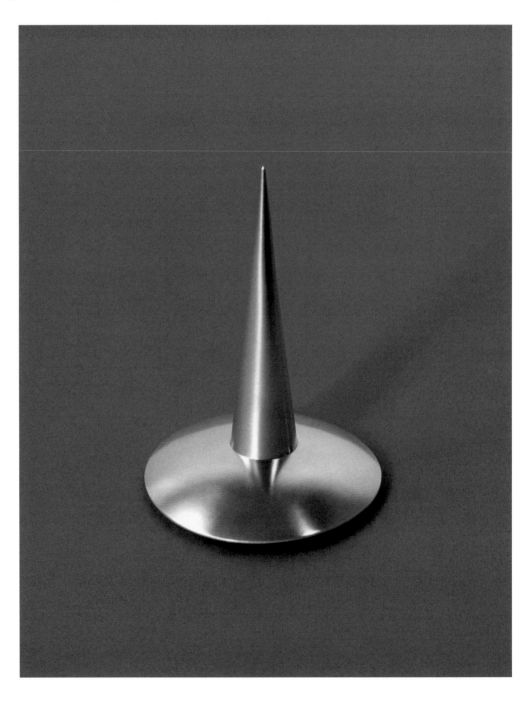

Thorns

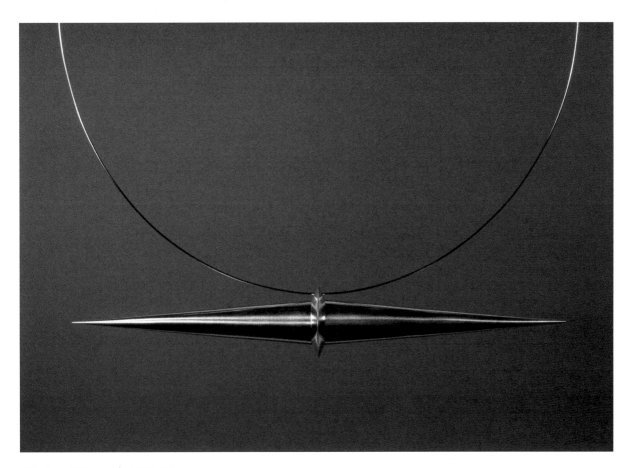

▲ Necklace, 1986, silver, steel, 23.0 x 3.3 cm.
Schmuckmuseum Pforzheim, Germany.
◄ Dorn, brooch (shoulder piece), 1986, silver,
8.3 x 7.0 cm.

Dornen

Thorns

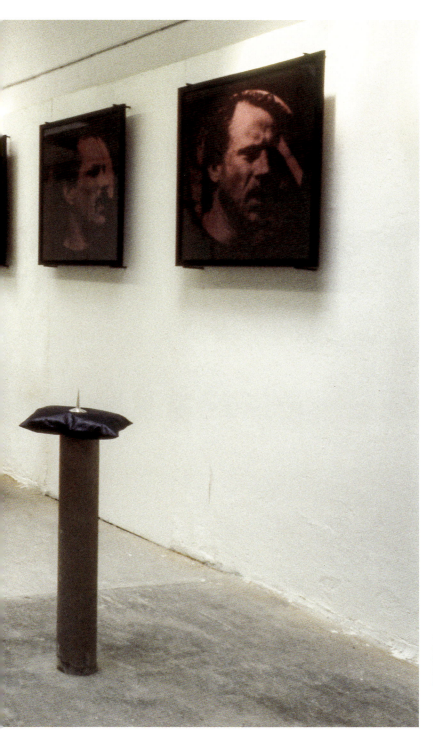

◀ View into the exhibition «Stern – Marathon», Lothringer 13, art center Munich 1985/86. Jewelry by Therese Hilbert, photography by Angelika Bader and Dietmar Tanterl, exhibition concept by Bruno Menzebach-Haslinger.

Dornen

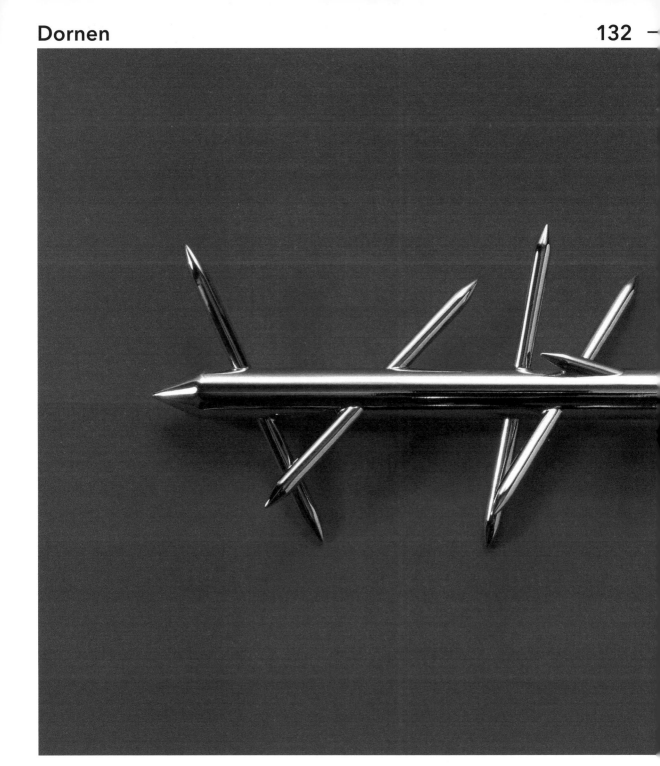

Thorns

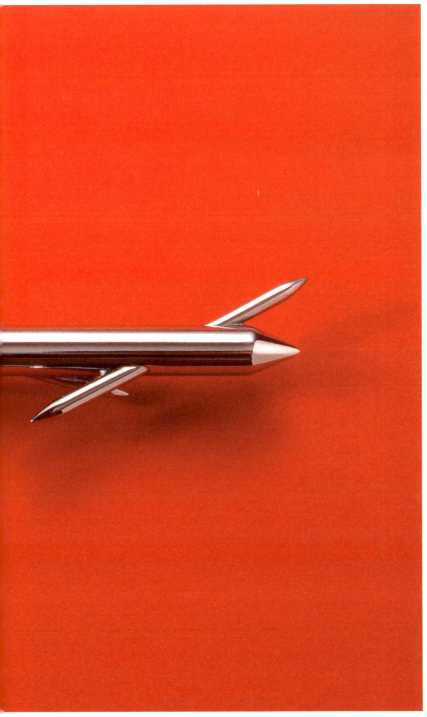

▲ Brooch, 1984, chromed brass, steel, 13 x 5.0 x 0.8 cm.
The Power House Museum – Museum of Applied Arts
and Sciences, Sydney, Australia.

Dornen

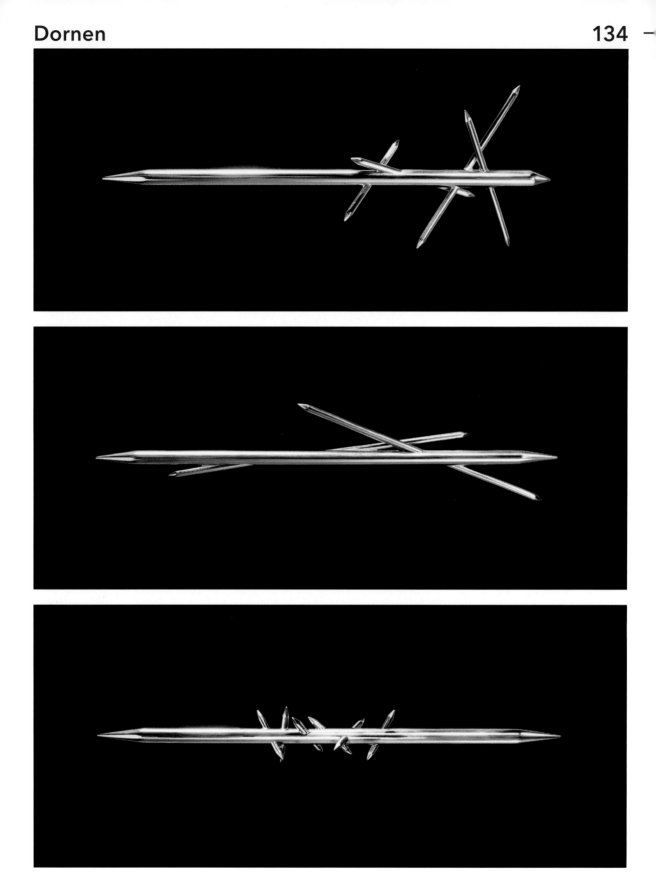

Thorns

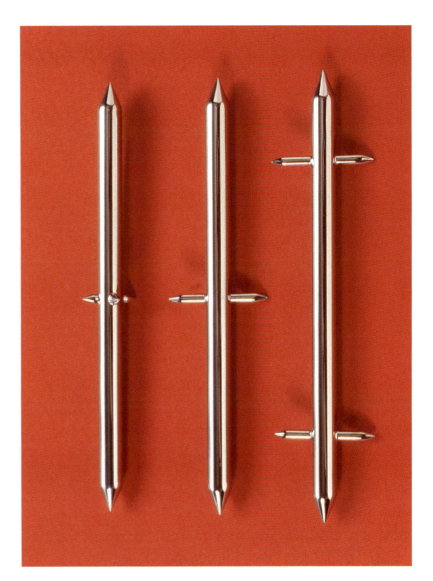

▲ Brooches, 1984, chromed brass, steel, each ø 0.8 cm, l 13.5 cm.
◄ Brooch, 1984, chromed brass, steel, 18.0 x 6.2 x 0.7 cm.
The Museum of Fine Arts Houston (MFAH), The Helen W. Drutt Collection, Houston, USA.
◄ Brooch, 1984, chromed brass, steel, 18.0 x 3.8 x 0.7 cm.
◄ Brooch, 1984, chromed brass, steel, 18.0 x 2.3 x 0.7 cm.

Dornen

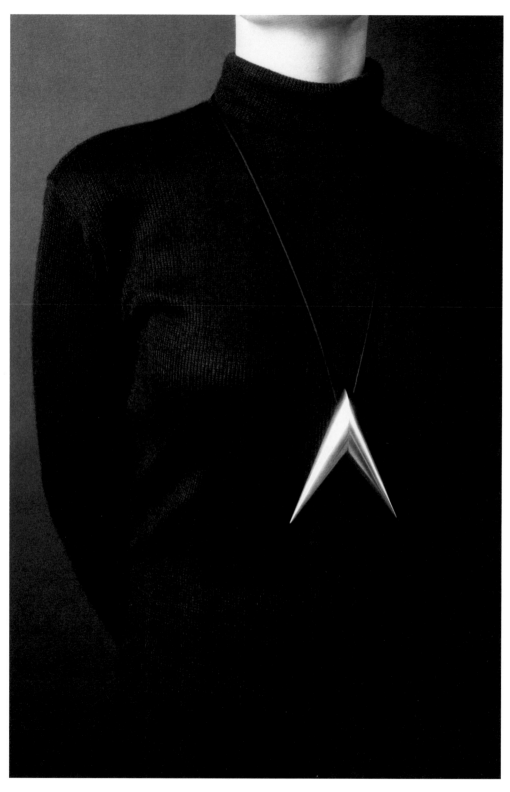

▲ Pendant, 1987, silver, 11.5 x 9.0 x 2.6 cm.

▲ Palazzuolo / Monte S. Savino, Italy, 1986.

Sterne

▲ Saturn, pendant, 1989, silver, ø 6.5 x 4.2 cm.
Private collection, Munich, Germany.
▶ Stern, pendant, 1986, silver, ø 5.4 cm (p.140).
▶ Stern, pendant, 1986, silver, ø 7.4 cm (p.140).
Schmuckmuseum Pforzheim, Germany.
▶ Stern, pendant, 1986, silver, ø 3.2 cm (p.141).
Private collection, Munich, Germany.
▶ Stern, brooch, 1986, silver,
15.0 x 12.5 x 3.2 cm (p.142). The Museum
of Fine Arts, Houston (MFAH), The Helen W. Drutt
Collection, Houston, USA.
▶ Stern, brooch, 1986, silver, 5.7 x 3.2 cm (p.143).

Stars

Sterne

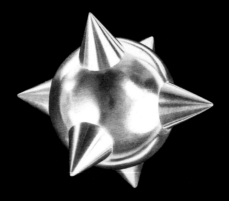

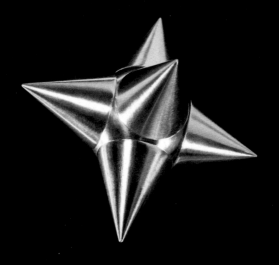

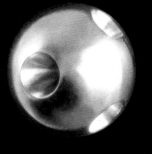

Sterne

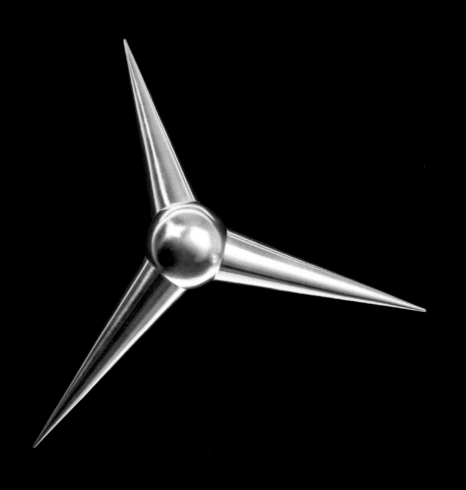

Waffen 144

Weapons

▲ Pendant, 1987, silver, l 8.5 cm (total), ø 2.8 cm (sphere).
▶ Pendant, 1987, silver, ø 8.0 cm (total), ø 2.8 cm (sphere).
◀ Palazzuolo / Monte S. Savino, Italy, 1986.

Waffen

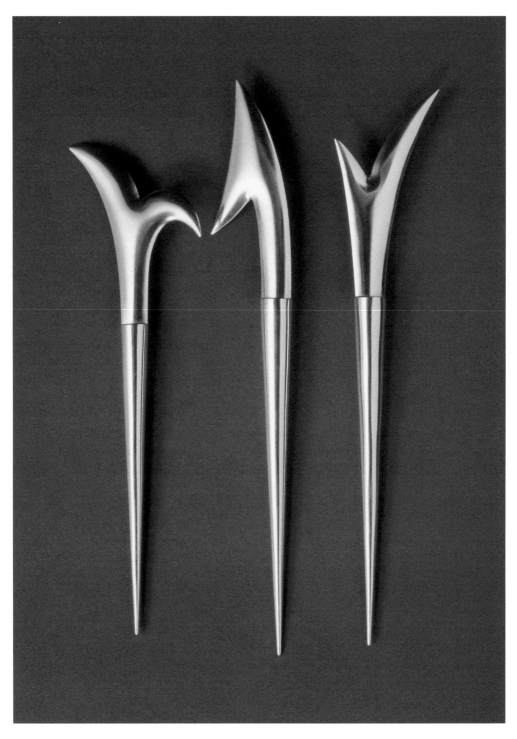

▲ Brooches, 1989, silver, steel, l 19.0–21.0 cm, ø 1.2 cm.

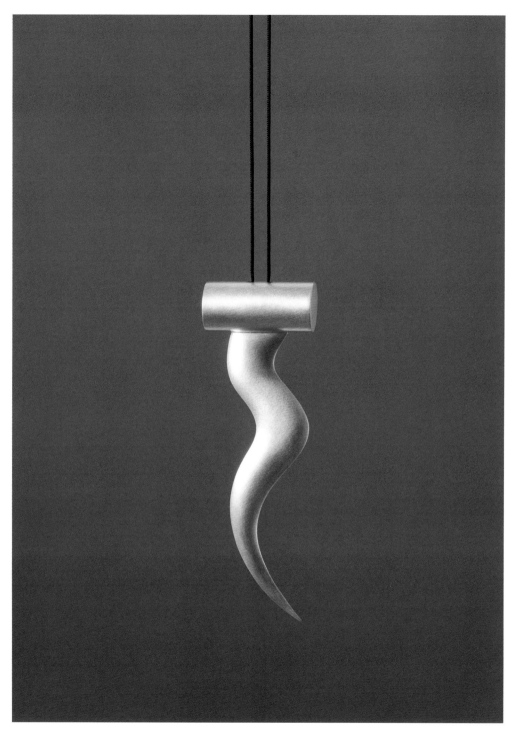

▲ Pendant, 1989, silver, 14.8 x 4.9 x 2.1 cm.

Waffen

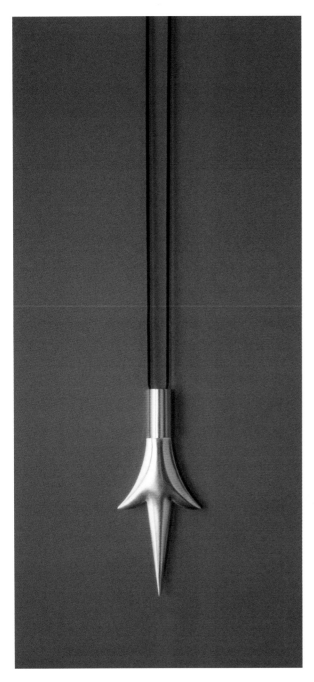

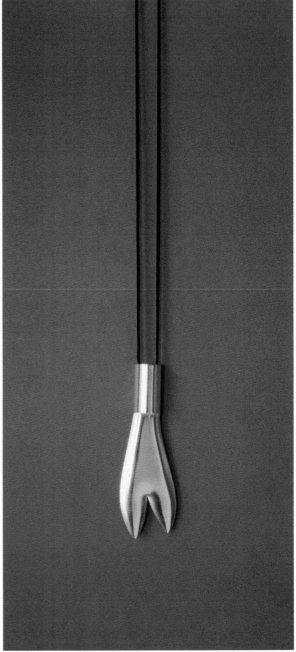

▲ Pendant, 1988, silver, 11.0 x 5.5 cm.
◄ «Therese Hilbert», invitation card. Galerie für modernen Schmuck, Frankfurt a. M., Germany, 1991. Here: brooch, 1989, silver, ø 6.2 cm, d 1.1 cm.

▲ Pendant, 1988, silver, 10.7 x 3.7 cm.
► Brooch, 1989, silver, 11.5 x 3.7 x 1.6 cm. mudac, Musée de design et d'arts appliqués contemporains, Lausanne, Switzerland.

— 151　　　　　　　　　　　　　　　　　　　　　　　Weapons

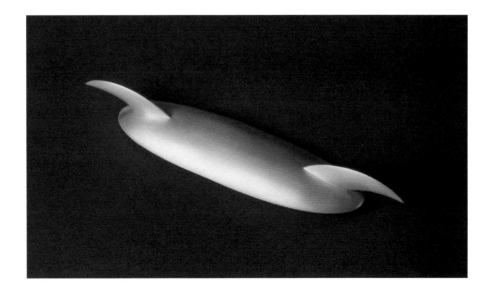

Waffen

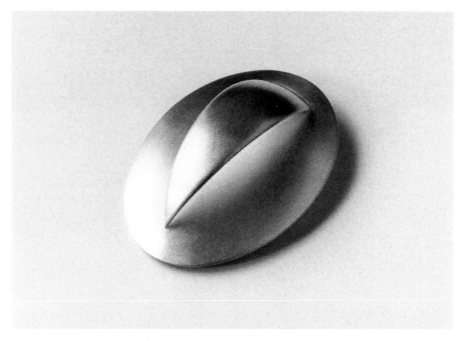

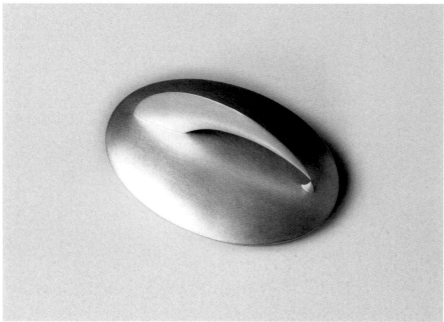

▲ Brooch, 1989, silver, 8.2 x 5.8 x 1.8 cm.
▲▶ Brooch, 1989, silver, 8.0 x 5.8 x 2.8 cm.

Weapons

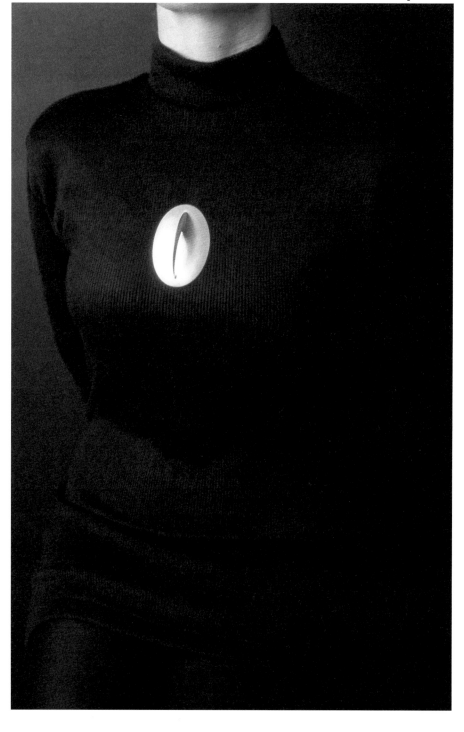

Rose

Dolor
1989

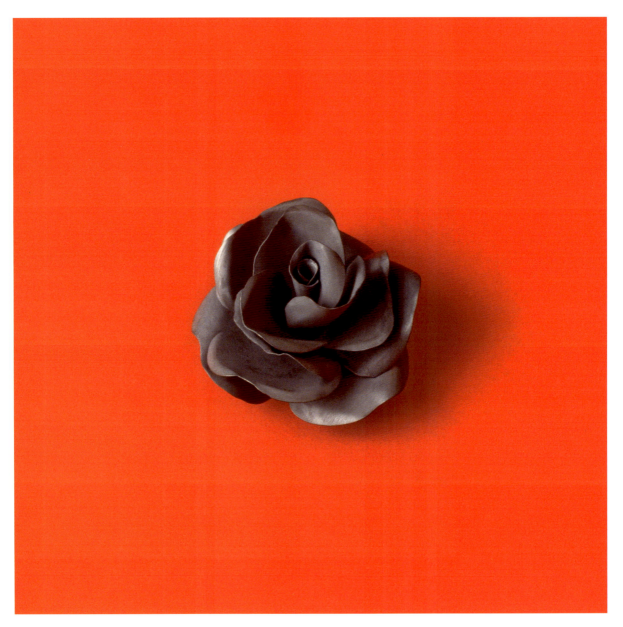

▲ Rose, brooch, 1989, silver blackened, ø 6.5 cm. Die Neue Sammlung –
The Design Museum. Permanent loan from the Danner Foundation, Munich, Germany.
▶ Dornenkette, chain, 1989, silver, l 135.0 cm. Die Neue Sammlung –
The Design Museum. Permanent loan from the Danner Foundation, Munich, Germany.

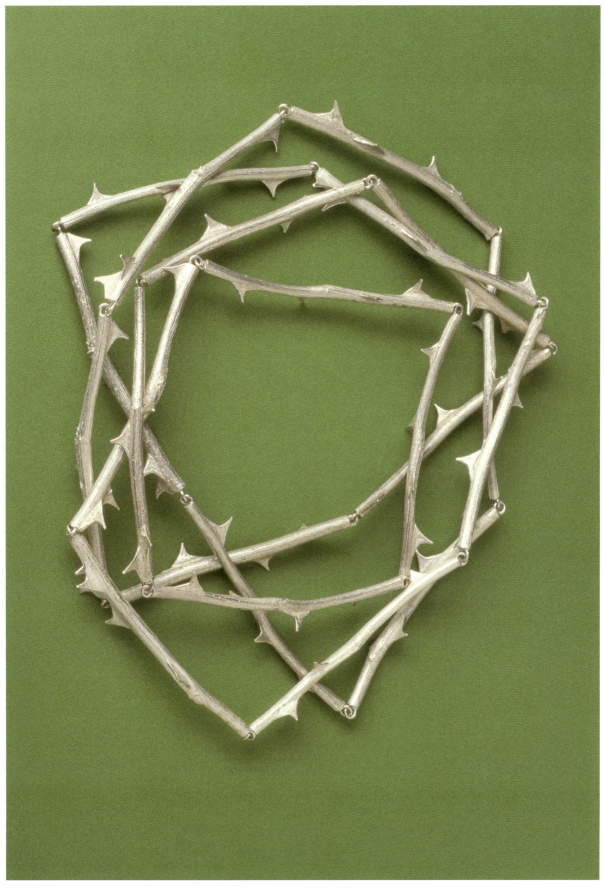

Bambus

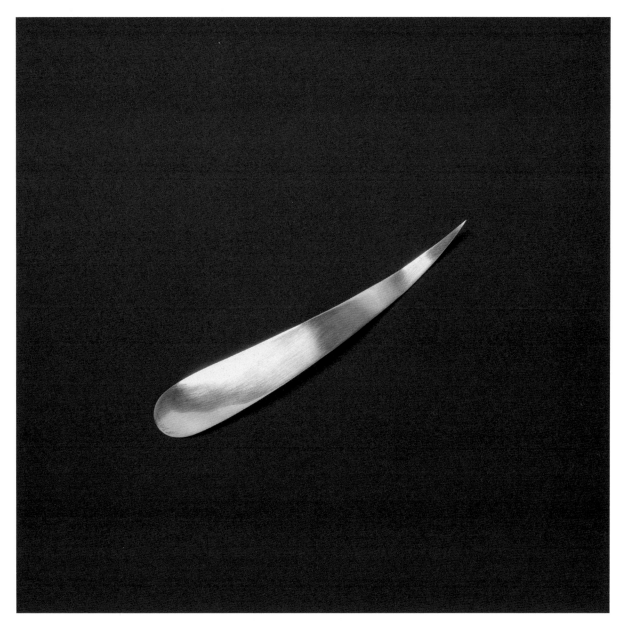

▲ Blatt, brooch, 1989, silver, 20.5 x 2.3 cm. Die Neue Sammlung – The Design Museum. Permanent loan from the Danner Foundation, Munich, Germany.
◄ Bambuskette, chain, 1989, bronze, l 82.0 cm. Die Neue Sammlung – The Design Museum. Permanent loan from the Danner Foundation, Munich, Germany.

Kern
Core
1989

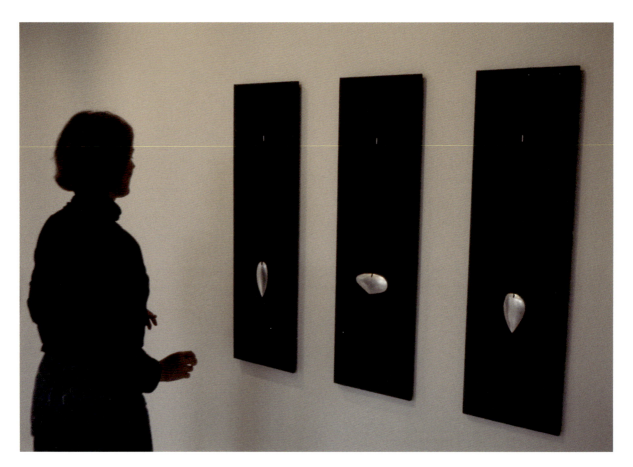

▲ Rezac Gallery, Chicago, view into the exhibition «Therese Hilbert», 1990.
▶ Pendant, 1989, silver, 10.5 x 6.6 x 1.0 cm. Private collection, Bern, Switzerland.
▶ Pendant, 1989, silver, 12.0 x 4.5 x 1.0 cm (p. 160).
▶ Pendant, 1989, silver, 6.4 x 11.8 x 1.0 cm (p. 161). mudac, Musée de design et d'arts appliqués contemporains, Lausanne, Switzerland.

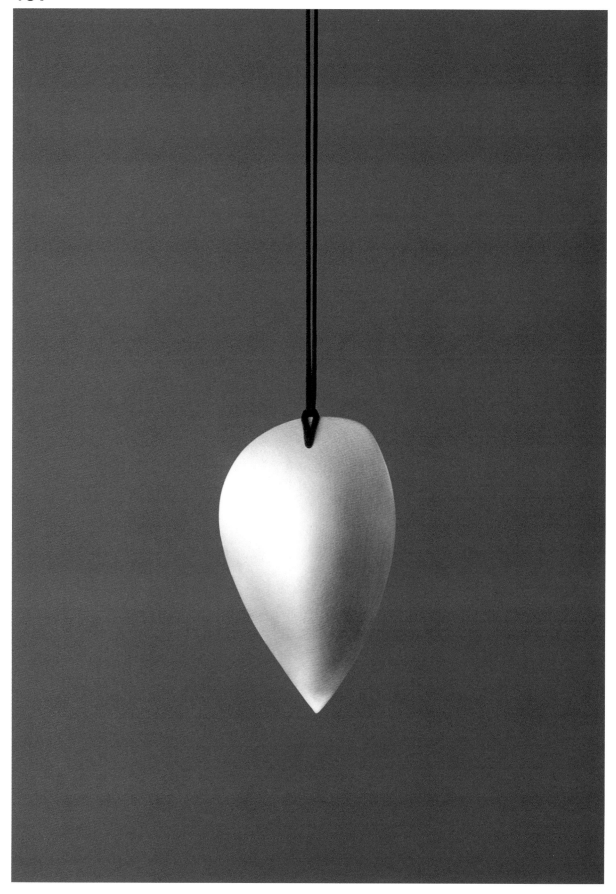

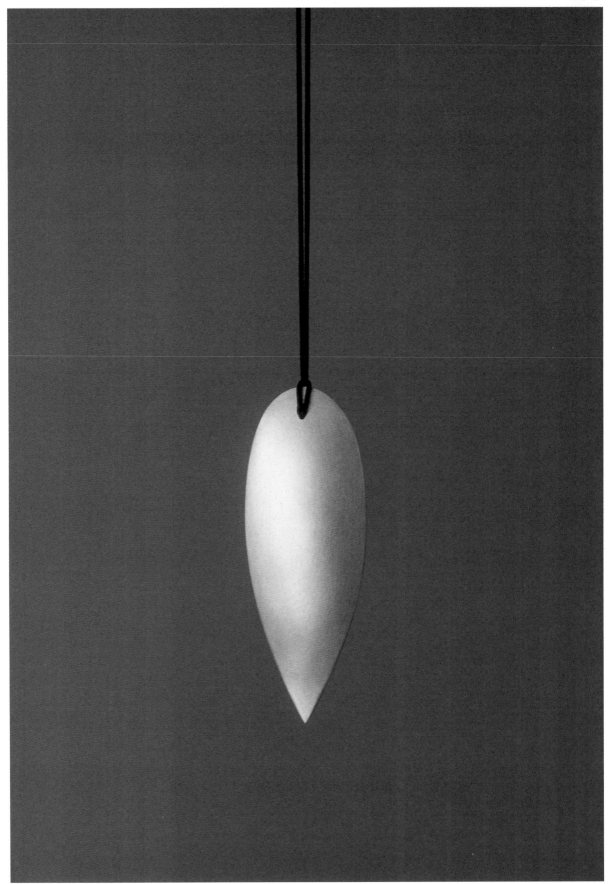

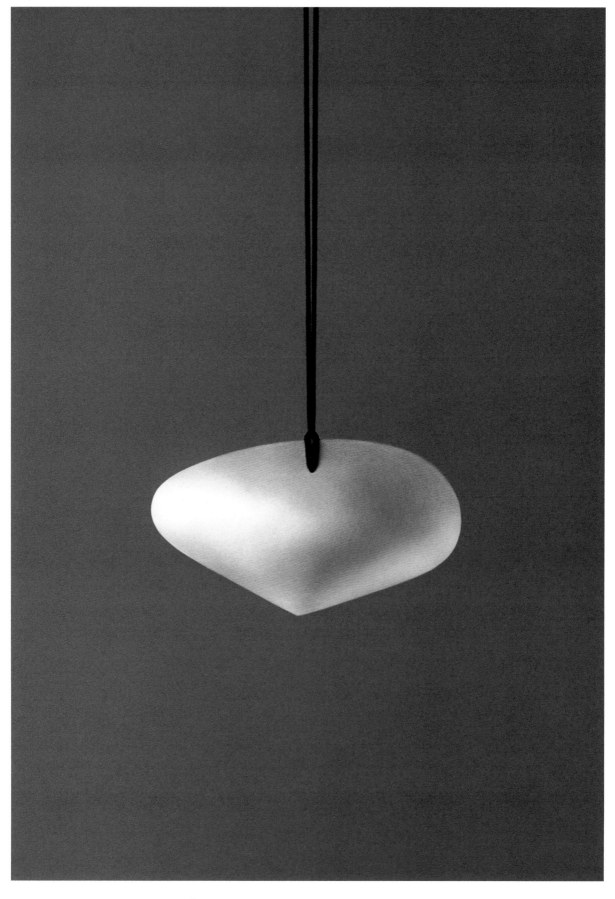

Emotionen
Emotions
1990–1994

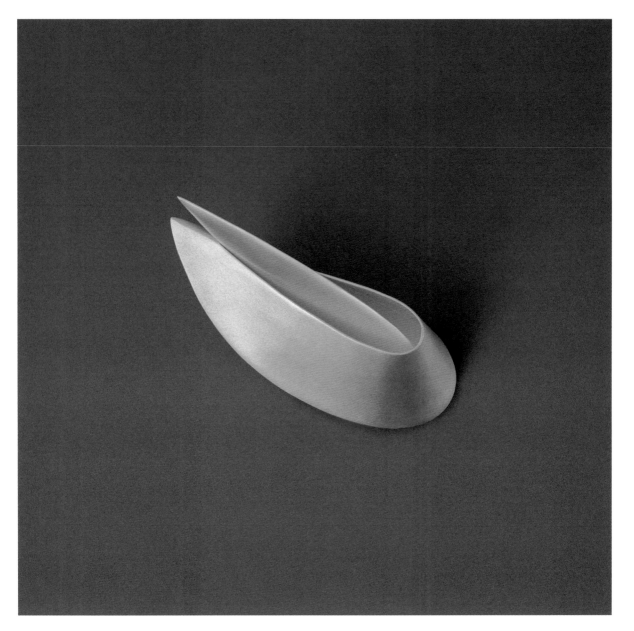

▲ Brooch, 1991, silver, 8.2 x 4.1 x 4.3 cm. Private collection, Vienna, Austria.

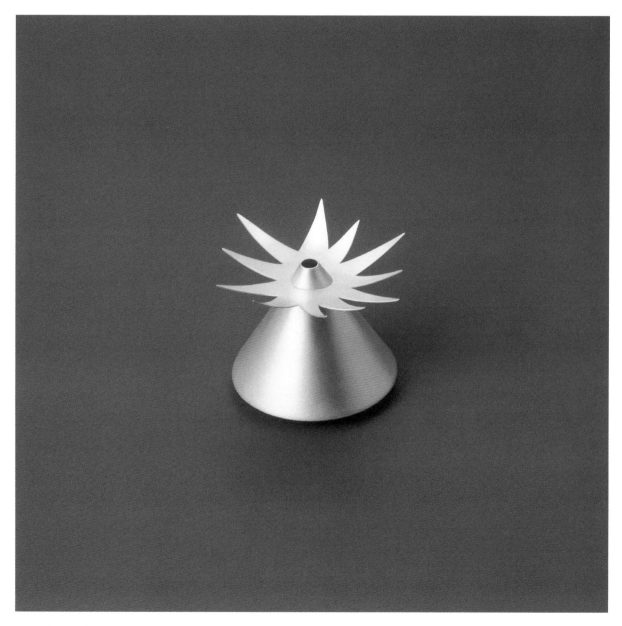

▲ Brooch, 1993, silver, 4.4 x 3.6 cm. Die Neue Sammlung – The Design Museum. Permanent loan from the Danner Foundation, Munich, Germany.

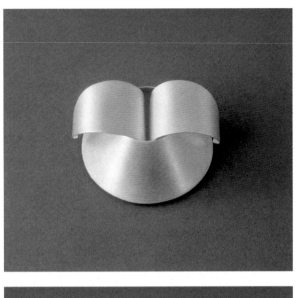
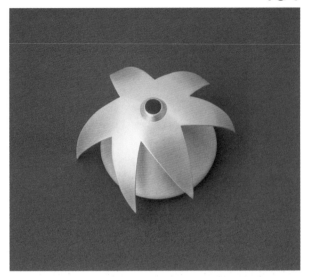
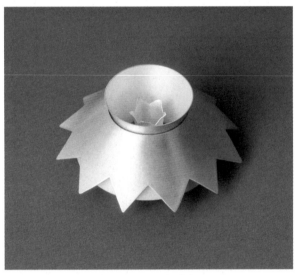
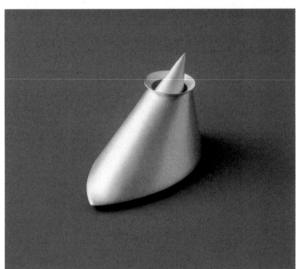
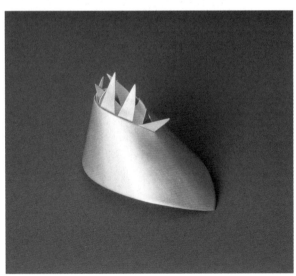
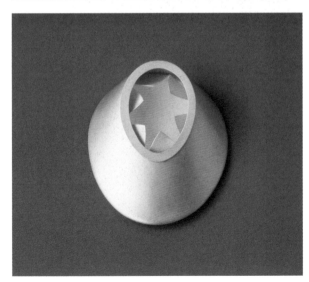

▲ Brooch, 1991, silver, 5.5 x 2.8 cm.
▲ Brooch, 1992, silver, 7.5 x 2.8 cm.
▲ Brooch, 1993, silver, 7.5 x 4.8 x 4.5 cm.

▲ Brooch, 1991, silver, 4.4 x 3.0 cm.
▲ Brooch, 1994, silver, 7.3 x 4.2 x 3.7 cm.
Private collection, Washington, D.C., USA.
▲ Brooch, 1992, silver, 7.5 x 6.2 x 2.4 cm.

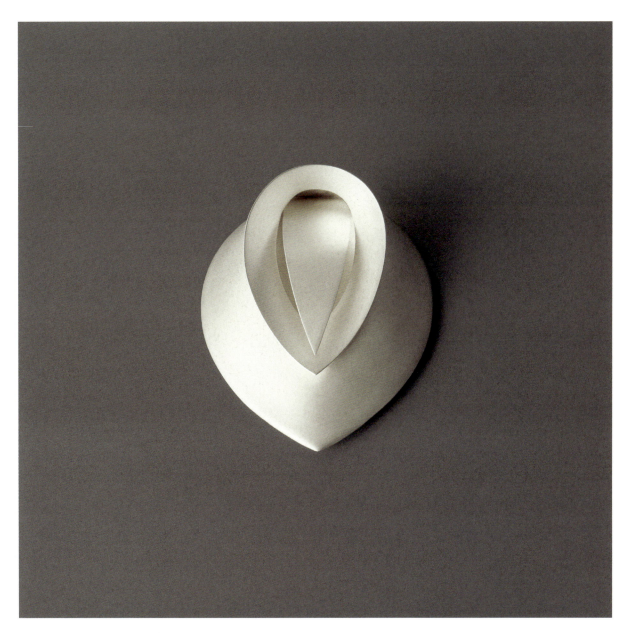

▲ Brooch, 1991, silver, 8.5 x 6.4 x 2.5 cm.

▲ Paper models from the 1990s.

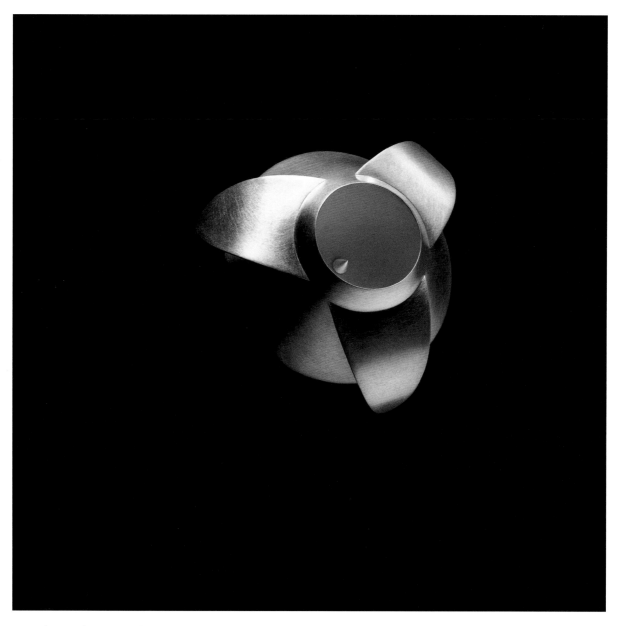
▲ Brooch, 1990, silver, ø 6.0 cm, d 2.7 cm.

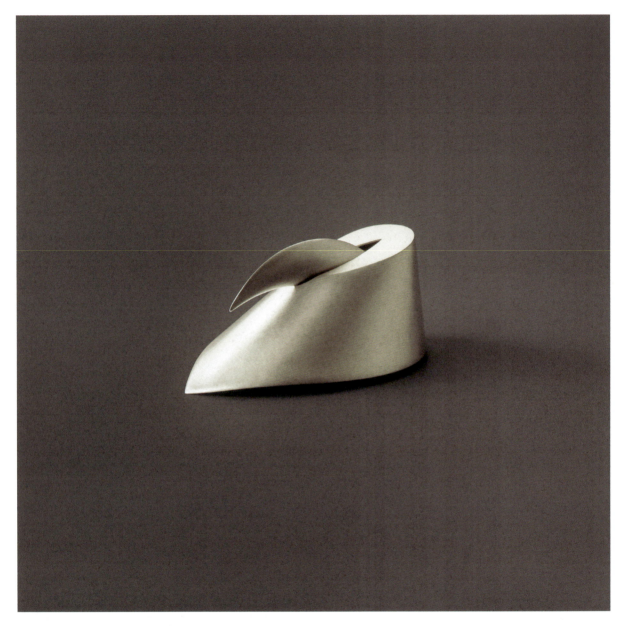

▲ Brooch, 1994, silver, 7.5 x 4.5 x 3.3 cm. Die Neue Sammlung – The Design Museum. Permanent loan from the Danner Foundation, Munich, Germany.
▶ Chain, 1992, silver, l 120.0 cm. Private collection, Graz, Austria.

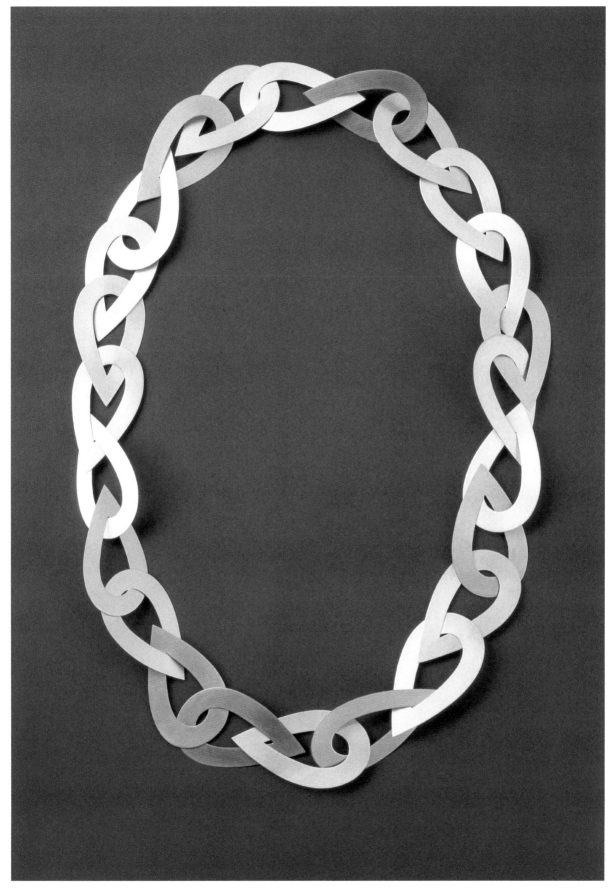

Gefäße

Geheime Orte
Secret Places
1995–2003

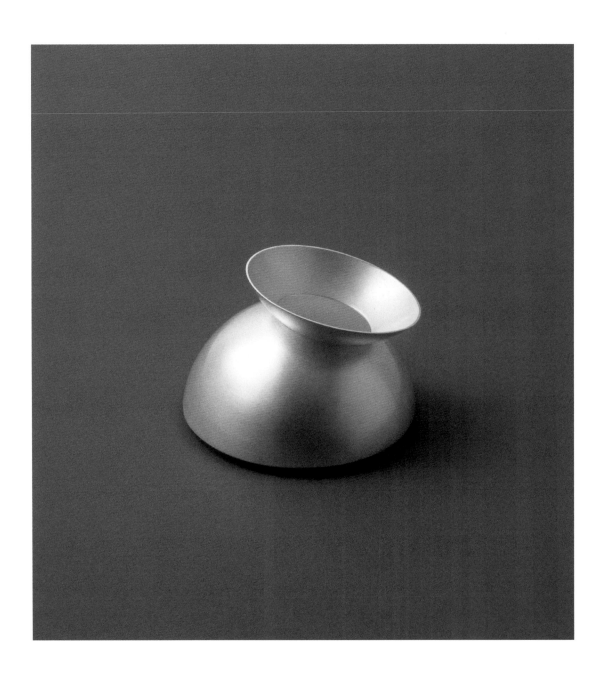

Vessels

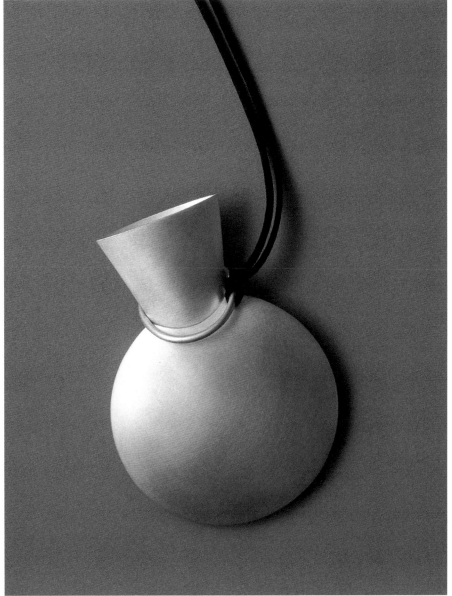

▲ Pendant, 1995, silver, 9.2 x 6.6 x 1.5 cm.
Die Neue Sammlung – The Design Museum. Permanent loan from the Danner Foundation, Munich, Germany.
◄ Brooch, 2001, silver, ø 5.4 cm, d 3.4 cm.
Museum Angewandte Kunst, Frankfurt a. M., Germany.

Gefäße

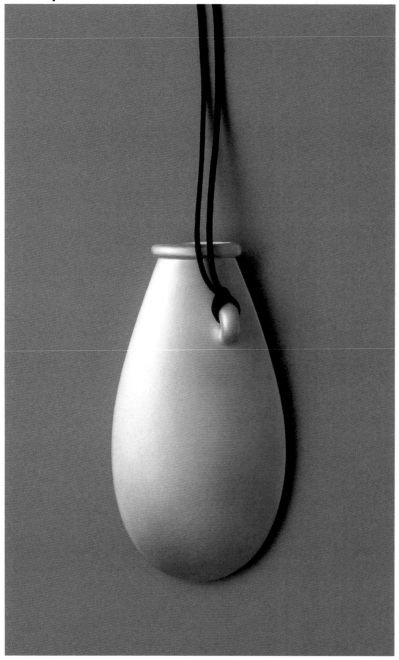

▲ Pendant, 1995, silver, 10.7 x 5.7 x 1.5 cm.
Private collection, Munich, Germany.

Vessels

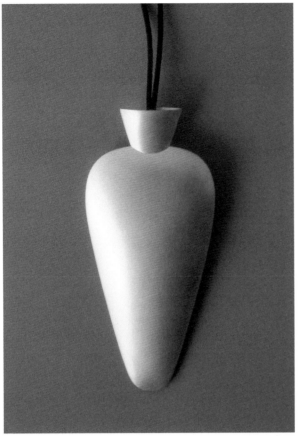

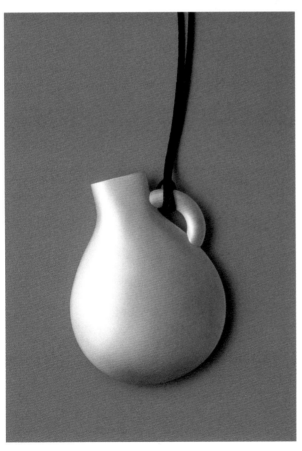

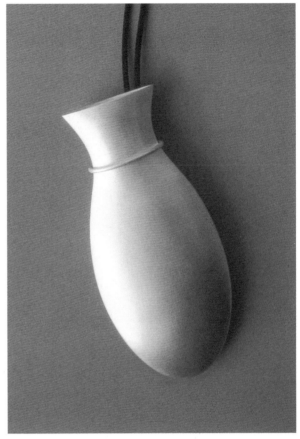

▲ Pendant, 1995, silver, 11.8 x 5.5 x 1.5 cm.
National Gallery of Victoria (NGV),
Melbourne, Australia.
◄ Pendant, 1995, silver, 12.2 x 5.5 x 1.4 cm.
Kunstgewerbemuseum, Staatliche Museen zu
Berlin. Preußischer Kulturbesitz, Berlin, Germany.
◄ Pendant, 1995, silver, 8.4 x 6.5 x 1.5 cm.
► Pendant, 2000, silver, 10.6 x 6.1 x 1.7 cm.

Gefäße

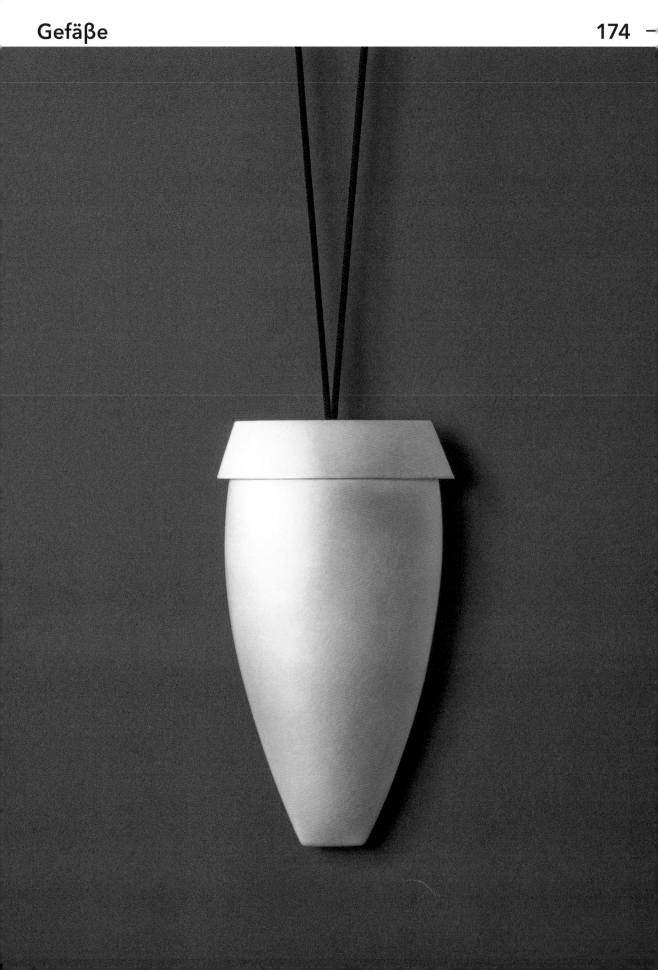

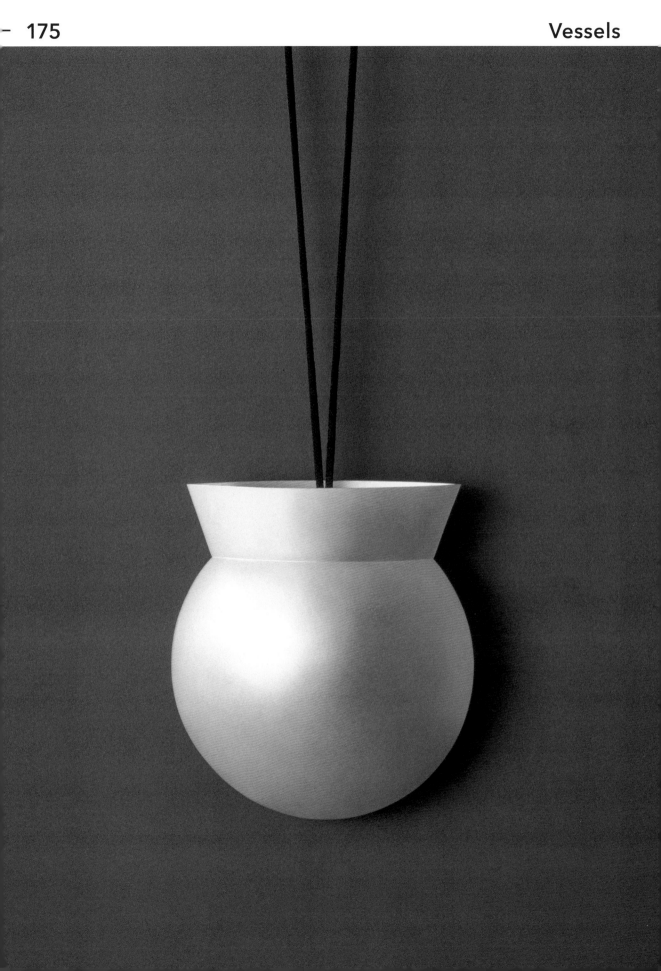

Gefäße

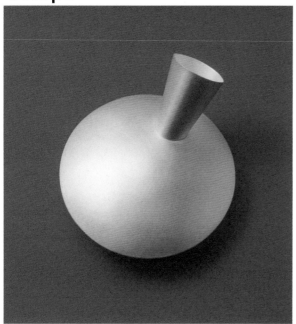

▲ Brooch, 1999, silver, ø 6.7 cm, d 4.0 cm.
Private collection, New York, USA.
▶ Brooch, 1999, silver, ø 6.7 cm, d 1.9 cm.
◀ Pendant, 2001, silver, 8.3 x 7.6 x 3.0 cm.

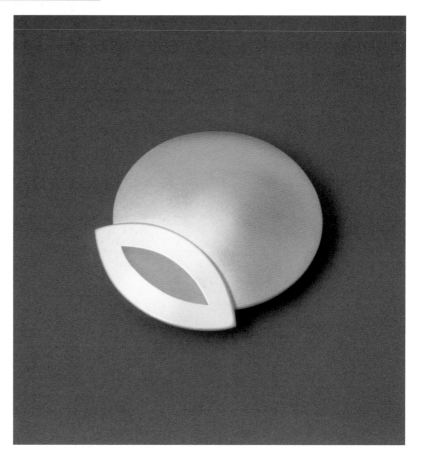

Vessels

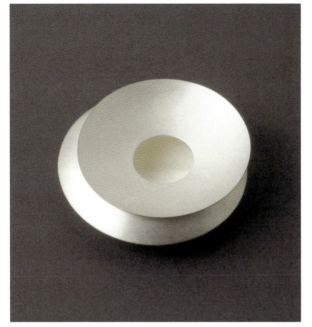

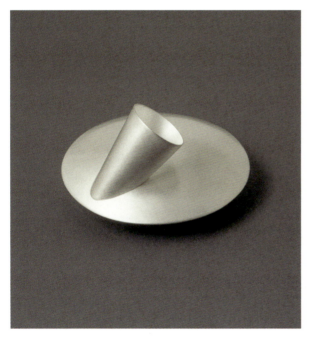

▲ Brooch, 1999, silver, ø 6.7 cm, d 2.4 cm.
▲ Brooch, 1999, silver, ø 6.7 cm, d 4.2 cm.

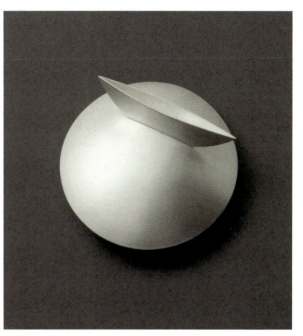

▲ Brooch, 1999, silver, ø 6.7 cm, d 2.9 cm.
Private collection, New York, USA.

Gefäße

178

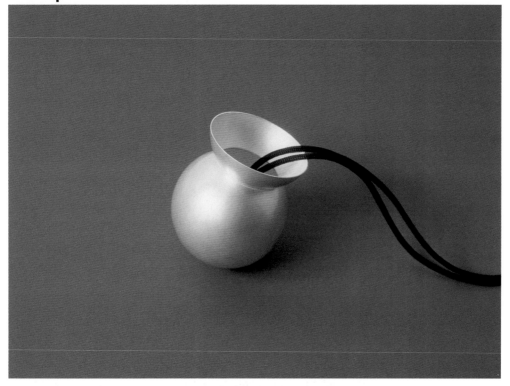

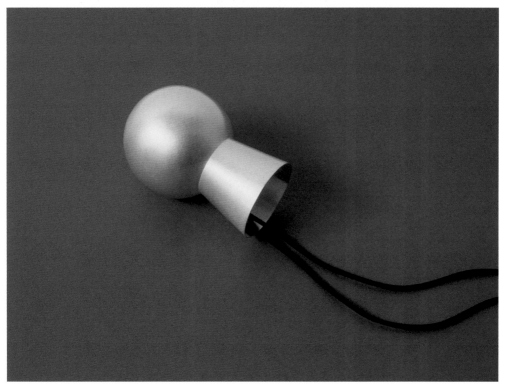

▲ Pendant, 1997, silver, ø 4.5 cm, h 5.6 cm.
▲ Pendant, 1997, silver, ø 4.5 cm (sphere), h 7.3 cm.

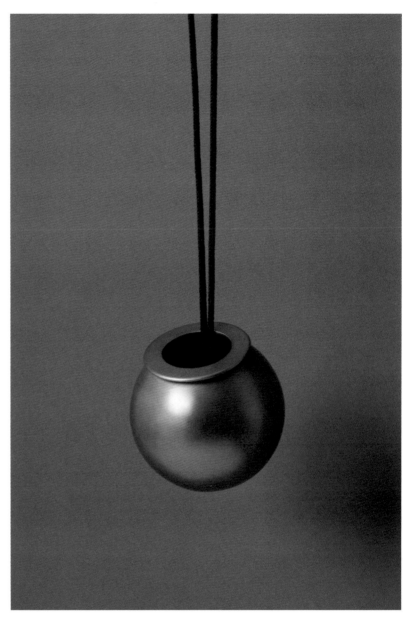

▲ Pendant, 1997, silver blackened, ø 4.7 cm.
Private collection, Melbourne, Australia.

Gefäße

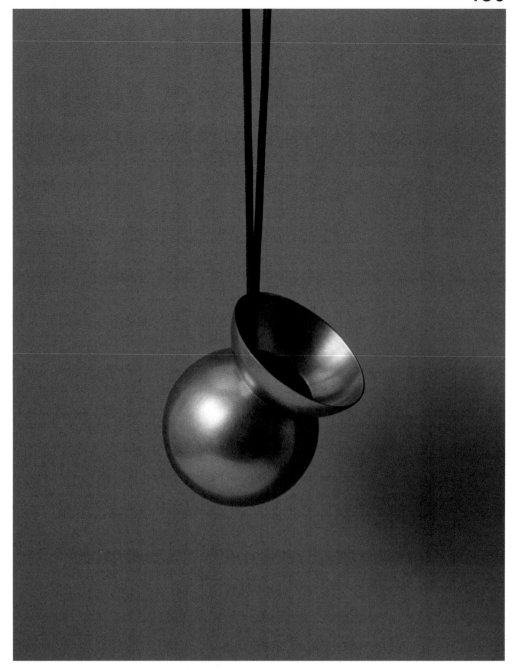

▲ Pendant, 1997, silver blackened, ø 4.7 cm, h 6 cm.
▶ Group of pendants, 1997, silver blackened, different dimensions.

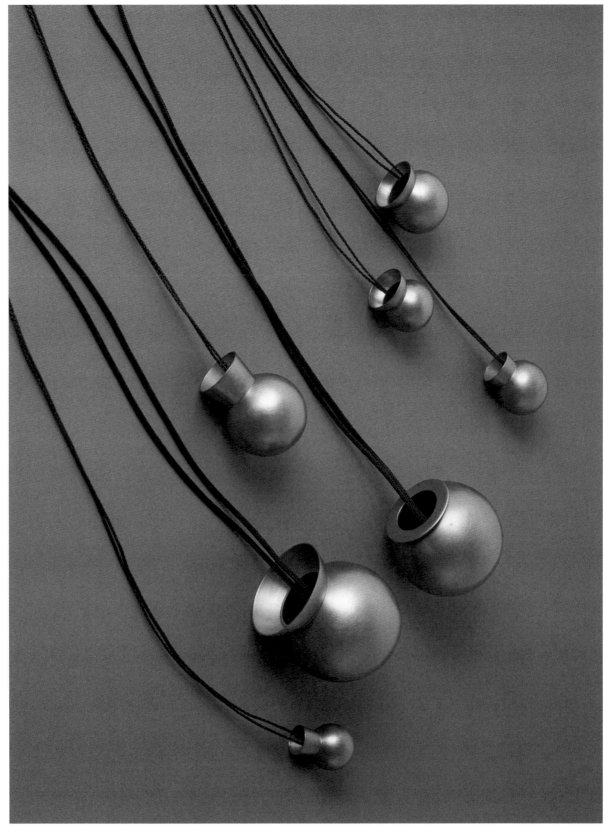

Bearers of Secrets

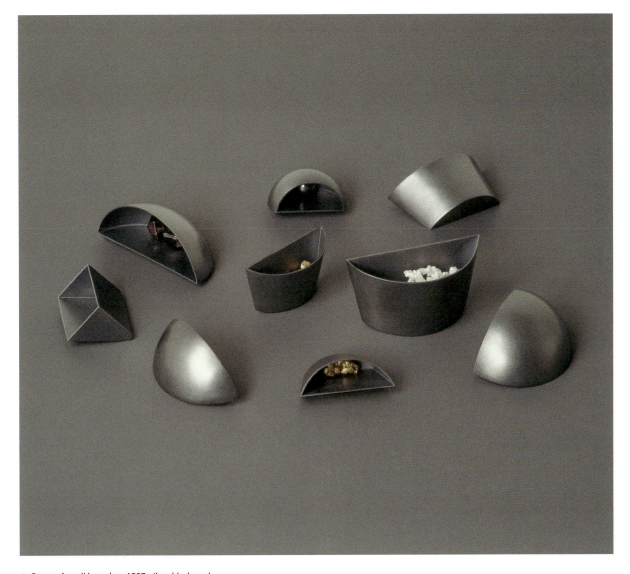

▲ Group of small brooches, 1997, silver blackened and secrets inside, different dimensions.
◄ Lionel L., 2020.

Hohl aber nicht leer

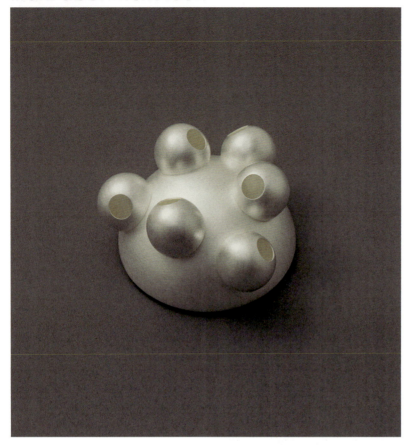

▲ Brooch, 1999, silver, ø 5.5 cm, d 3.3 cm.
▶ Brooch, 1999, silver, ø 5.5 cm, d 3.4 cm.

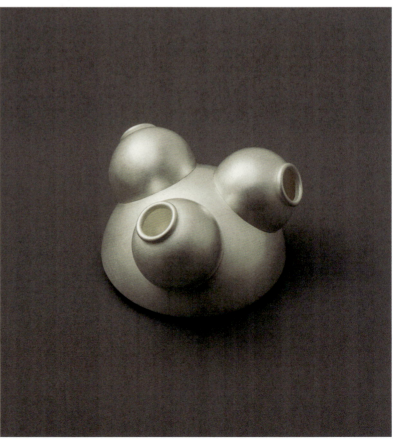

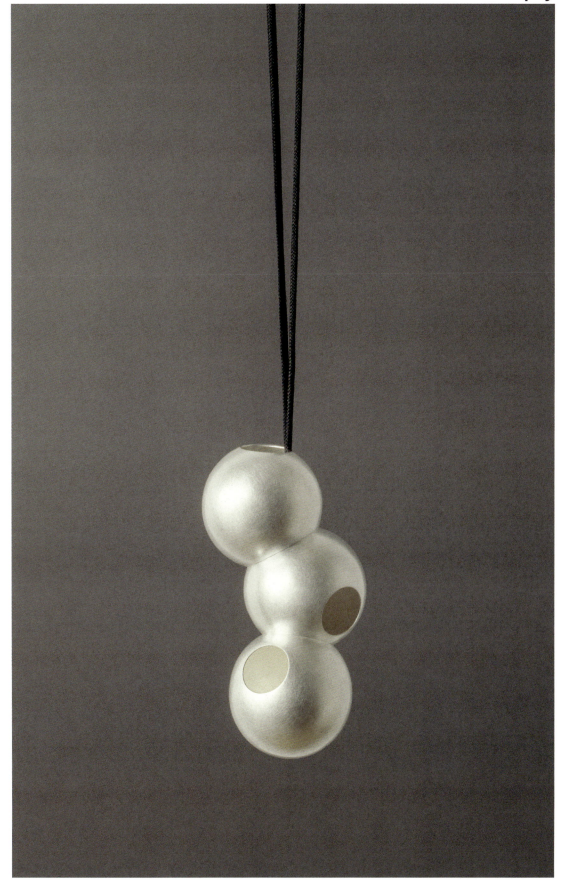

Hohl aber nicht leer

186

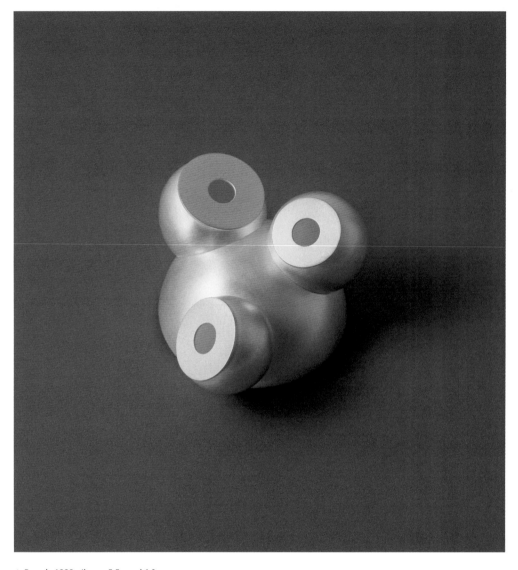

▲ Brooch, 1999, silver, ø 5.5 cm, d 4.0 cm.
◄ Pendant, 2003, silver, 8.1 x 4.5 x 3.2 cm.
Private collection, Padua, Italy.

Hollow but not empty

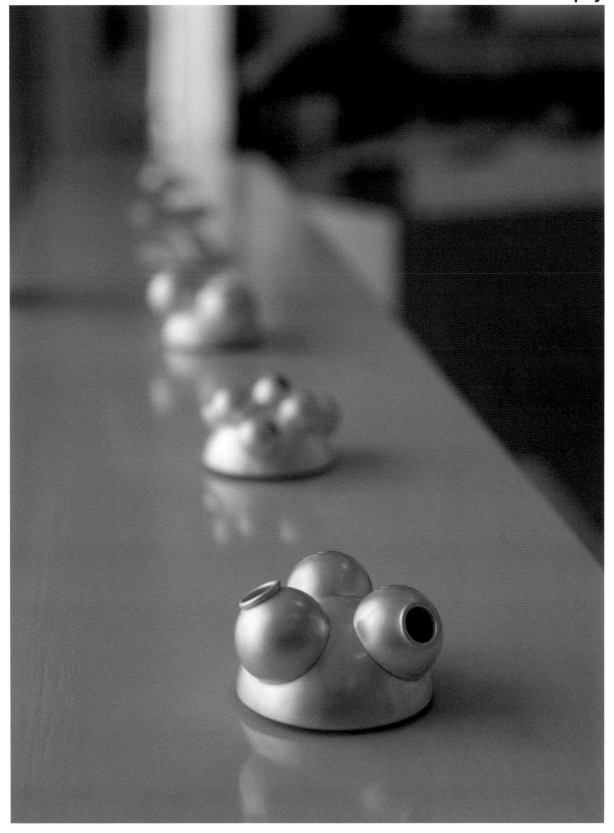

▲ Gewerbemuseum Winterthur, view into the exhibition «&: Hilbert & Künzli», 2016.

Wölkchen
Cloudlet
1999

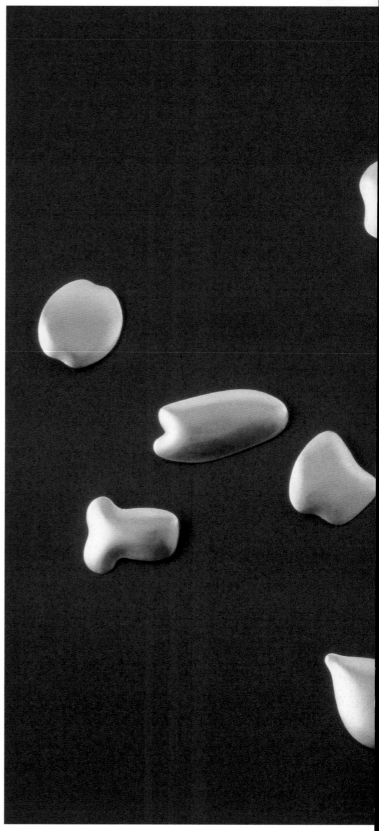

▲ Brooches, 2001, silver, max. 4.4 x 2.9 cm, min. 2.3 x 2.1 cm.

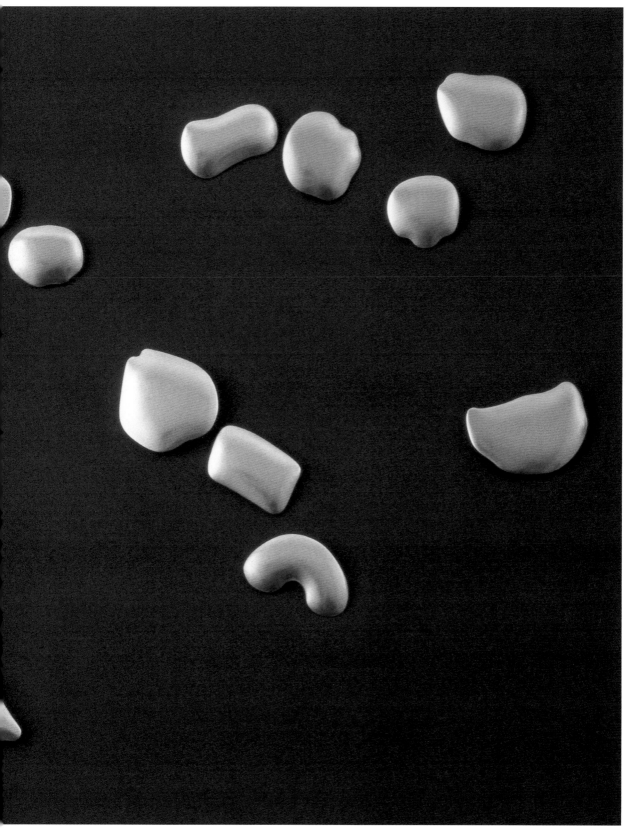

Das Vertraute
Familiar
2001–2005

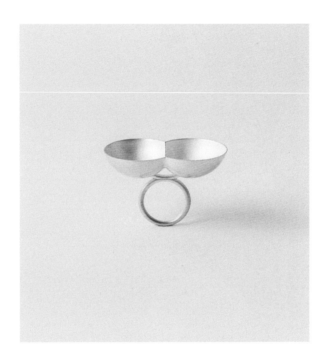

191　Gedächtnisinseln　　　　Islands of Memory

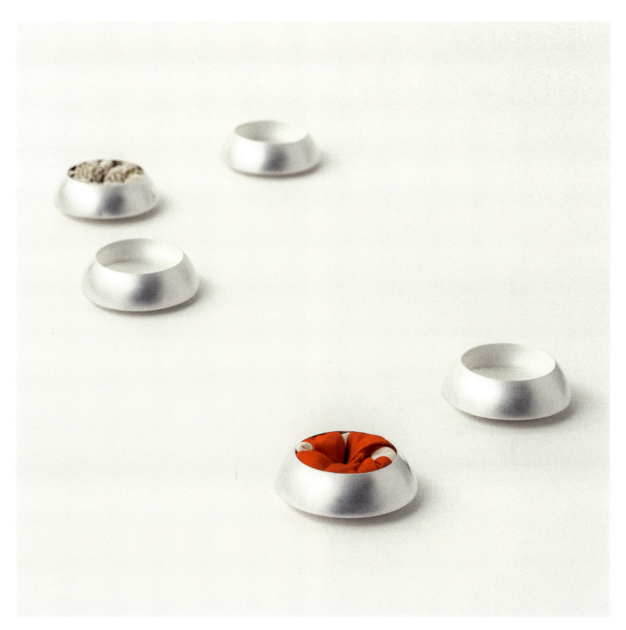

▲ Brooches, 2003, silver, cotton, ø 6.4 cm, d 1.9 cm.
◄ Ring, 2003, silver, 3.5 x 3.6 x 5.4 cm.

In sich In itself 192

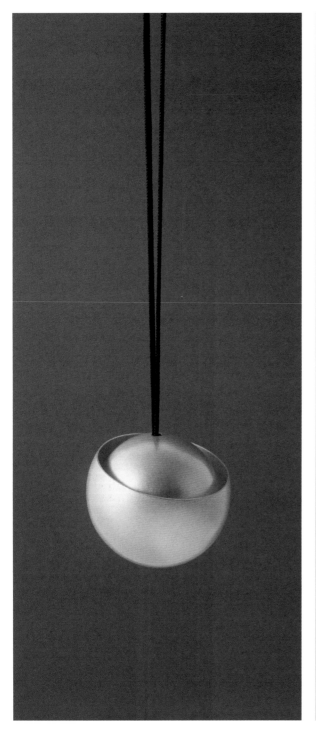 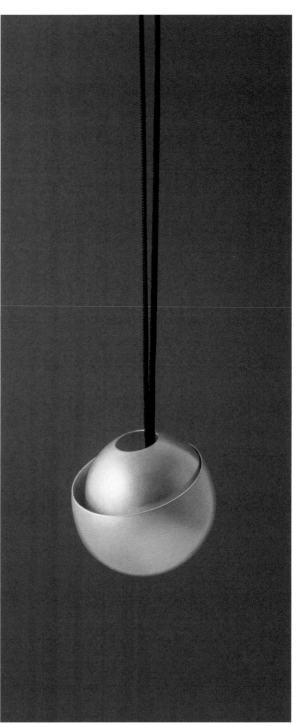

◀▲ Pendant, 2003, variable, silver, ø 4.8 cm, h 4.4 cm.

193 Für sich — For itself

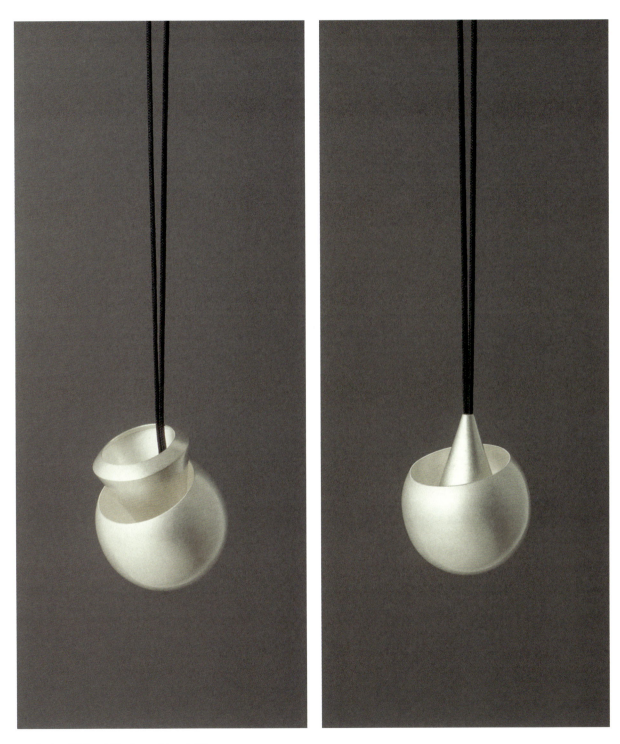

▲▶ Pendant, 2003, variable, silver, ø 4.6 cm, h 5.9 cm.

Hülle

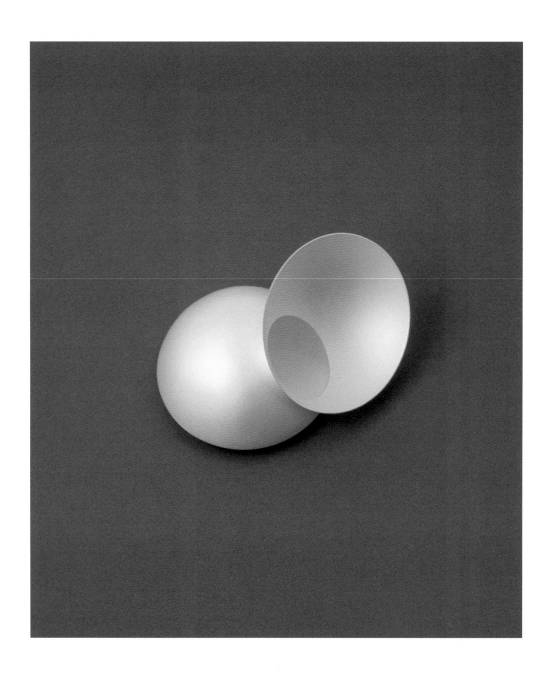

Shell

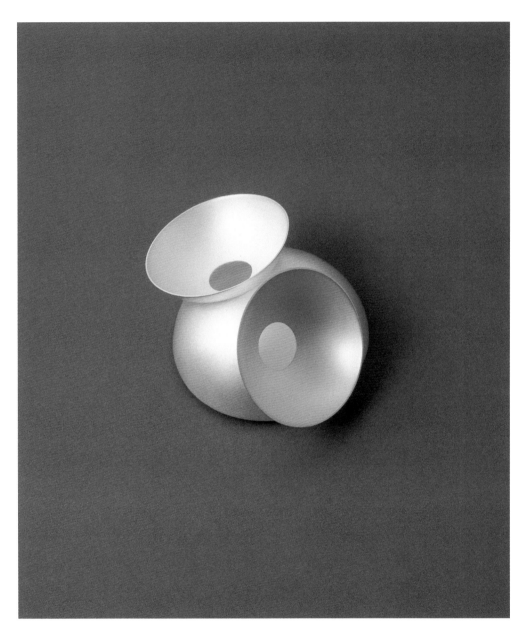

▲ Brooch, 2003, silver, ø 5.4 cm, d 4.0 cm.
◄ Brooch, 2003, silver, ø 5.4 cm, d 2.7 cm.

Hülle

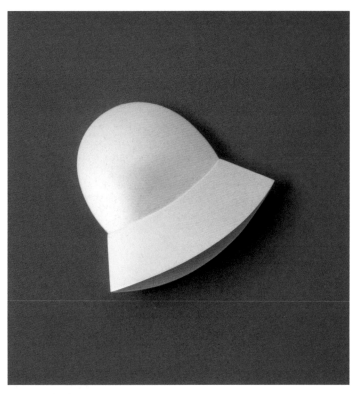

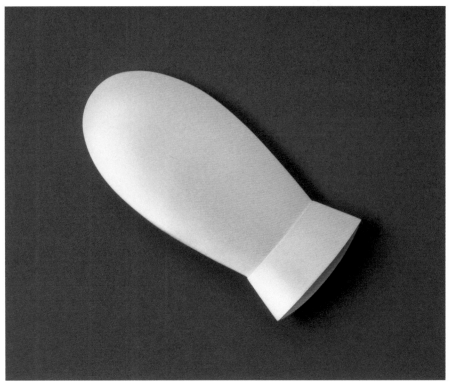

Shell

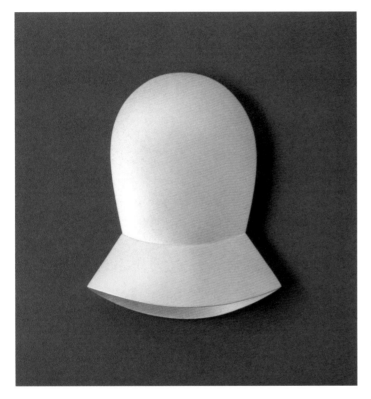

▲ Brooch, 2002, silver, 10.0 x 7.4 x 1.6 cm.
◀ Brooch, 2002, silver, 8.5 x 7.1 x 1.5 cm.
◀ Brooch, 2002, silver, 11.0 x 5.1 x 1.4 cm.

SCHMUCK TRÄGT MICH

— 199 Ein Trichter & eine Seele A Funnel & a Soul

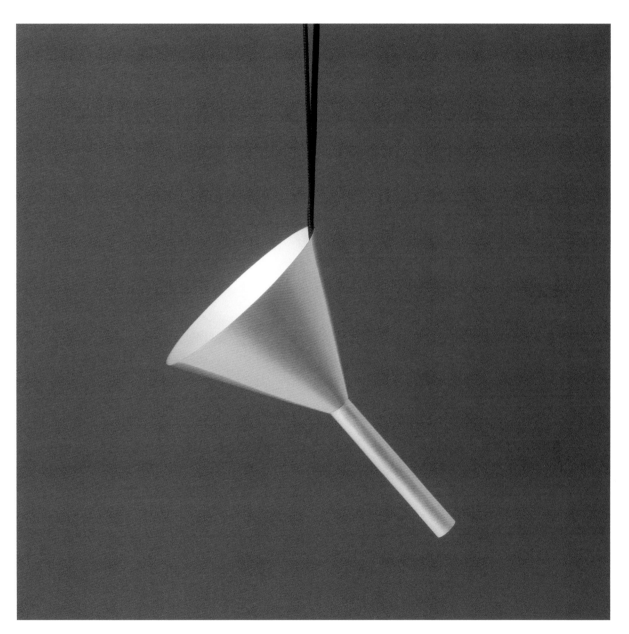

▲ Pendant, 2003, silver, ø 6.5 cm, h 10.3 cm.

Die wohldosierte Ferne — Pravu Mazumdar

Die wohldosierte Ferne – Schmuck und Vulkanismus bei Therese Hilbert

«Die Zivilisation beruht auf einer geologischen Zustimmung, die ohne Vorwarnung zurückgenommen werden kann.» – Will Durant[1]

Auf der einen Seite gibt es die *Kräfte*, wie wenn eine Supernova aufblitzt, ein Wirbelsturm heraufzieht, ein Staat oder ein biologischer Organismus zusammenbricht. Auf der anderen Seite gibt es die *Formen*. Das sind die Umlaufbahnen der Himmelskörper; die Geometrie kristalliner Strukturen; die immer wiederkehrenden Schleifen der Gewohnheiten; oder auch nur der ferne, helle Strich eines Wasserfalls, der sich aus der Nähe als schäumendes Inferno erweist. Jede Form zeigt sich aus der Nähe als Kraft. Jede Kraft beruhigt sich in der Ferne zur Form. 〔1〕

Ein solches Spiel aus Nähe und Ferne ist prägend für die Begegnung mit dem Vulkan, der aus der Ferne das Bild eines glühenden Feuerbergs bietet, in der Nähe hingegen zum explodierenden Innenleben der Erde wird, das sich meist im Verborgenen abspielt und in schwer absehbaren Augenblicken ausbricht, um den tektonischen Frieden am Fundament alles Menschlichen in Schutt und Asche zu legen. Deshalb erscheinen die Vulkane historisch als eine Serie kollektiver Traumata. Ob es um Santorin, Vesuv, Krakatau oder Pinatubo geht: Jedes Mal haben sie etwas von der Endgültigkeit eines Punktes, mit dem die Syntax der menschlichen Geschichte abzubrechen scheint. Im Diskurs der Moderne setzen die Vulkane der technologischen Souveränität des Menschen eine schroffe Grenze entgegen und erscheinen in der Schreckensgestalt des *Erhabenen*, das erst durch einen Filter aus Ferne und Abstraktion leb- und erfahrbar wird. 〔2〕

Seit Längerem setzt sich Therese Hilbert mit der Welt der Vulkane auseinander, die in ihrer Arbeit als das Erhabene zum Ausdruck kommt: nicht nur als eine unverfügbare, äußere Naturgewalt, sondern auch als die ferne, innere Natur des Menschen. Das plötzliche Schwanken des Bodens, der Rauch und die Schwefeldämpfe aus den Erdspalten, die aus dem Erdinnern ausbrechenden Flammen, das Glutrot überströmender Gesteinsschmelzen, der Blick ins Bodenlose … all das trifft die Menschen tief und erschüttert ihr Vertrauen in den Boden ihres täglichen Tuns. Erst mit Flucht und Ferne werden die Explosionen der Nähe zum Bild des fernen Feuerkegels, der in der Arbeit Hilberts zunächst zum Symbol der menschlichen Hinfälligkeit wird. 〔3〕

Am besten formuliert es der junge Nietzsche[2]: Die Ferne geht aus einem Akt der Distanzierung hervor, der das kochende Herz der Dinge bezähmt und in ein 〔4〕

1 Durant, Will «What is Civilization?» in: Ladies' Home Journal, LXIII, January 1946.
2 Nietzsche, Friedrich, «Die Geburt der Tragödie aus dem Geiste der Musik» in ders., Kritische Studienausgabe in 15 Bänden, hg. v. Giorgio Colli und Mazzino Montinari, München 1980, Bd. 1, 9–156.

◀ Poster, Graphic Design: FREDERIK LINKE, July 2015

Die wohldosierte Ferne

apollinisches Traumbild verwandelt. Entscheidend dabei ist das *Maß* der Distanzierung. Entfernt man sich zu sehr, so bleibt nur noch die kalte Abstraktion der Erkenntnis übrig. Man friert ein. Entfernt man sich zu wenig, so gibt es weder Erkenntnis noch Leben. Man verbrennt vollends. Das Maß einer *wohldosierten Ferne* ist Mitte und Kompromiss in einem. Man nimmt das ferne Bild wahr, spürt aber doch noch etwas von der Kraft, die, durch die Ferne abgemildert, nicht mehr tötet, sondern eher nur verwandelt.

Das geschieht beispielsweise in der antiken Tragödie, wo die Bilder der fernen Bühne mobilisiert werden, damit die Kräfte des tragischen Dramas die Zuschauer erreichen und bis ins Innerste ergreifen können. Oder in der Wärmelehre, wo das thermische Chaos der Moleküle zur statistisch gestreuten Ordnung wird, wenn es aus der Ferne ausreichend großer Populationen betrachtet wird. Oder in der Schmuckkunst, wo der schmucktragende Körper zur Bühne der Auseinandersetzungen zwischen Nähe und Ferne wird: zwischen der Erotik der Nähe, wenn man dem Sirenengesang des Schmucks folgt und in den Bann des geschmückten Körpers gelangt; und einer Ästhetik der Ferne, die den geschmückten Menschen zum fernen, sichtbaren Kunstwerk modelliert.

Dabei besagt «Ferne» nicht bloß den räumlichen Abstand zwischen Bild und Betrachter*in, sondern auch den zeitlichen zwischen der Vergangenheit des Formens und der Gegenwart der Form. Als die Spur ihres eigenen Entstehens ist die ferne Form Ergebnis und Archiv der krafthaften Ereignisse der Nähe – wie Pinselstriche, Hammerschläge, stürzende Wassermassen. Das sind Kräfte, die formend wirken und Form hervorbringen.

5 In diesem Sinne entfaltet Hilbert ihre Schmuckkunst im Ausgang von ihren Auseinandersetzungen mit dem Vulkanismus: als eine Reihe wiederholter Versuche zur Modellierung der wohldosierten Ferne. Der Prozess einer solchen Modellierung besteht aus drei Teilschritten: einer rudimentären *Analyse*, die Form und Farbe als zwei distinkte Kategorien auseinanderlegt; einem Vorgang der *Reduktion*, die den Vulkanismus auf eine Handvoll elementarer Formen und Farben zurückführt; und einer *Synthese*, die die Formen und Farben zu Schmuck verbindet.

6 Der konkrete Einsatz dieses Verfahrens besteht darin, dass aus dem Inferno, das die Nähe offenbart, das Wunder der Hohlform herausgelöst wird. Diese aber umschließt keine leblose Leere, sondern einen krafterfüllten Raum, in dem verborgene, unberechenbare und jederzeit ausbruchsbereite Energien wuchern. Die wohldosierte Ferne offenbart sich im Bild des Hohlraums: als Verbindung aus *Form* im Sinne der äußeren Hohlform und *Kraft* im Sinne der von der Form umschlossenen Energien.

Zur symbolischen Verdichtung und Darstellung des Infernos aus der Nahperspektive soll *erstens* die äußere Erscheinung des Hohlraums auf klare und einfache Formen reduziert werden. Konkret bedeutet das, dass die komplexen Räume, die wir mit dem Vulkan verbinden – wie Berge, Löcher, Blasen, Krater, Calderas –, zu

elementaren geometrischen Figuren wie Kreis, Ellipse, Kegel geglättet werden: als die Buchstaben eines Alphabets gleichsam, das die Grundzüge der menschlichen Vulkanerfahrung artikuliert. Im Ausgang von solchen Elementarfiguren entfaltet Hilbert eine detailgetreue Phänomenologie der Öffnungen, durch die hindurch das innere Feuer der Erde nach außen gelangt. Unter der Hand wird der Vulkan zur Metapher des *Ausdrucks*.

Zweitens aber geht es bei der Darstellung des Kraftraums auch darum, dass die Sichtbarkeit der vulkanischen Kräfte – das ausbrechende Erdfeuer, der farbige Nebel der Fumarolen, die Glut flüssiger Gesteinsmassen – auf Grundfarben wie Rot, Gelb, Schwarz reduziert wird.

Das Verfahren ergibt also zum einen die *geometrisierten Formen* als Repräsentationen der Orte des Ausbruchs. Zum anderen ergibt es die Grundfarben als Repräsentationen der ausbrechenden Energien.

Diese Kombination aus Analyse, Reduktion und Synthese kann man am besten an den Broschen der Gruppe Nea Kameni (1996) ablesen. Der Titel der Gruppe – wörtlich die «Neue Verbrannte» – bezieht sich auf die jüngste der Kamenes-Inseln des Santorin-Archipels. Diese Inseln haben ihren geologischen Ursprung in den Eruptionskegeln, die durch die häufigen Vulkanausbrüche in diesem Teil des Ägäischen Meeres entstehen. So begegnet man auch in den Arbeiten dieser Gruppe, die alle aus geschwärztem und gebogenem Silberblech bestehen, der Grundgestalt des Konus in vielfältigen Bearbeitungen. Mal endet die Kegelform in einer Spitze, mal ist die Spitze entlang einer Kegelschnittlinie abgeschnitten, um einen Krater zu offenbaren, aus dem zuweilen die Form einer silbernen Zündschnur oder ein Büschel silberner Pfeilspitzen herausbricht.

7

Bei einem dieser Objekte hat der Krater die Form einer klaffenden Schnittwunde, die sich quer über die Spitze zieht und die überquellende Masse einer roten Koralle zum Vorschein bringt. Ein anderes Objekt evoziert den züngelnden Ausbruch des unterirdischen Feuers anhand der flachen, gekräuselten Masse einer blauen Koralle, die aus einem Schlitz am Kegelmantel heraustritt. Bei einer weiteren Arbeit ist der Kegelmantel ein Netz aus Löchern mit der Form unterschiedlich gestauchter Kreise, die sich vom Krater bis zur Basis verteilen und sich dabei nach unten vergrößern. Bei einer anderen Arbeit findet sich, dicht unter dem Kraterrand, die Form eines breiten, spitz zulaufenden Streifens quer in den Kegelmantel hinein geschnitten und zu einer Spirale gebogen, die sich in die Höhe windet, um das überbordende Rot einer Koralle zu umfangen. Als eine der Farben, die konstitutiv zum Phänomen des Vulkanismus gehören, zeigt das Rot die Energien des vulkanischen Ausbruchs an.

Damit gibt es in diesen Arbeiten *erstens* die Seite der *Form* und die Seite der *Kraft*. Es gibt einmal die Hohlform als Verbindung einer geometrisierten Schalenform mit der reduzierten Farbe geschwärzten Silbers. Und es gibt einmal die Dynamik der vulkanischen Kräfte, die von einer Verbindung aus leuchtenden Farben und

Die wohldosierte Ferne

amorphen Massen passender Materialien wie Koralle oder Vulkanit dargestellt wird. Die Opposition zwischen der Hohlform und den farbigen Materialmassen verweist auf eine vorgängige *analytische Scheidung zwischen Form und Farbe*. *Zweitens* entspringen Elemente wie die geometrisierten Formen oder Grundfarben wie Rot, Blau, Gelb einer *vorgängigen Reduktion* vulkanischer Wirklichkeiten. Solche Elemente funktionieren als die Buchstaben eines im Entstehen begriffenen Alphabets des Vulkanismus. «*Drittens*» ergibt sich das Schmuckobjekt selbst als die Rekombination oder *Synthese* der «Buchstaben» dieser zwei Gruppen aus zuvor unterschiedenen und reduzierten Elementen. Ein solches Schmuckobjekt kann in der Folge auch als Metapher für die vulkanischen Abgründe desjenigen Menschen verstanden werden, der sich damit schmücken wird.

8 Dabei ist das konkrete Verhältnis zwischen *Farbe* und *Form* in diesen frühen Arbeiten noch recht einfach. Aus dem Hohlraum der grauen Kegelform schießt die Farbe als Sinnbild des unterirdischen Feuers.

In den späteren Arbeiten Hilberts wird dieses Verhältnis einer komplexen Variation unterzogen. Ein Beispiel dafür bieten einige Arbeiten aus der Serie Glut (2004). In diesen Stücken ist der Farbträger nicht mehr ein amorphes Material, sondern lackiertes, zweidimensionales, zu klaren Formen herausgeschnittenes Silberblech. Es handelt sich in dieser Art der Formforschung grundsätzlich um die Frage, ob dem Feuer, der *Kraft*, der Farbe eine eigene und eigentümliche *Form* zukommt: eine *Form der Farbe*, dargestellt etwa von einer flackernd roten, von Löchern und Schlitzen durchbrochenen Scheibe auf dem breiten Rand oder Boden eines silbernen Behältnisses; oder einer kreisförmigen, ockerfarbenen Scheibe mit einem Loch in der Mitte, die um die Krateröffnung herum eine Art von Kranz bildet; oder einem schmalen, gelben Rechteck, das aus einem quer gezogenen Schlitz am Kegelmantel herausragt; oder der geraden Linie eines rot lackierten Silberstreifens am Kegelmantel, der von unterhalb der Spitze fast bis zur Basis sich zieht.

Ein weiteres Verhältnis zwischen Form und Farbe ist den späteren «Glutbroschen», etwa aus der Gruppe Yali (2009), zu entnehmen, die alle die Form von Halbkugeln aus Silber besitzen. In jedem dieser Objekte ist die Oberfläche der Halbkugel zu einem Netz aus länglichen Löchern bearbeitet, während die Innenseite des Bodens mit Vulkanfarben lackiert ist, die somit durch das Netz hindurch wie ein unterirdisches Glimmen wirken. Somit scheinen die vulkanischen Energien durch eine *zweite Ferne* hindurch und leuchten uns als apollinisches Glutbild entgegen. Diese zweite, *vertikale Ferne* der Tiefe kreuzt sich mit der ersten, *lateralen Ferne* des Blicks auf die fernen Feuerberge. Aus dieser Kreuzung geht die Form des Hohlkörpers mit der netzartigen Oberfläche und der Glutkraft im Innern hervor. Das Kreuz beider Fernen funktioniert gewissermaßen wie eine apollinische Maschine, die die Materialität der Brosche gliedert und zu einem tragbaren Bild des ursprünglichen, vulkanischen Infernos umarbeitet.

9 Eine weitere Tendenz dieser Arbeiten besteht in der Radikalisierung der analytischen Unterscheidung von Form und Farbe bis zur materiellen Differenz unterschiedlicher

Objekte. Das liegt daran, dass eine künstlerische Forschung dieser Art, die das Maß der wohldosierten Ferne auslotet und Form und Farbe analytisch scheidet, um sie erneut zu verbinden und neuartige Objekte zu komponieren, die vorbereitende Analyse stets innerhalb der Materialität der verwendeten Materialien vollzieht. Daher rührt die Möglichkeit, dass die analytische Unterscheidung bis zur Schwelle der materiellen Verselbständigung der unterschiedenen Momente gesteigert wird. Eine solche Schwelle, an der die farbigen Glutkräfte und die Kegelform der Ausbruchsstätten nicht mehr aufeinander bezogen sind, kommt in den späteren Arbeiten Hilberts mehrfach zum Vorschein.

Ein Beispiel ist ein zweiteiliger Anhänger aus dem Jahr 2007. Beide Teile, die dicht aneinander liegen und parallel hängen können, bestehen jeweils aus einer runden, rot lackierten, von Löchern durchbrochenen Silberscheibe mit flackernd unregelmäßigem Rand. Dass die Teile aneinander liegen, führt nicht nur dazu, dass das Netz der Löcher komplexer wird. Zudem entfalten die flackernden Farbscheiben eine neuartige Tiefe: die gestufte Tiefe einer feurigen, netzartigen Oberfläche, genauer, *einer Form gewordenen Farbe*, die die vulkanischen Energien vergegenwärtigt, ohne auf den Ort und das Ereignis ihres Ausbruchs zu verweisen. Gewissermaßen als Negativ dieser Arbeit erscheinen zwei frühere Arbeiten aus dem Jahr 2006 aus geschwärztem Silber. Auch hier handelt es sich um Anhänger, allerdings um einteilige, die jeweils aus einer flammenförmigen, von Löchern durchbrochenen Scheibe bestehen. Nur: diesen Objekten scheint jegliche Farbe entwichen zu sein, so dass sie das verkohlte, zur reinen Form geronnene Herz des feurigen Elements darzustellen scheinen. Der unerbittliche Gang der Abstraktion scheidet hier selbst die Farbe aus und behält nur noch die flackernde Flammenform der Energie bei.

Doch nicht nur die Farbe, sondern auch die Form wird von der Macht der Abstraktion erfasst, wie man es an den Broschen der Gruppe Schwarze Berge (2015/16) aus MDF erkennt. Die Objekte dieser Gruppe sind kleine schwarze Skulpturen, die sich von der reinen Geometrie der Kegelform lösen und erneut unregelmäßig werden wie die vulkanischen Naturformen, indem sie die Gestalten von Kuppeln, Türmen, Hütten, konischen Hügeln annehmen, zuweilen mit heraus geschnitzten Aderungen an ihren Fassaden. Dennoch bleibt die Kegelform, die sich von jeglicher Verbindung mit den farbigen Materialien der früheren Arbeiten gelöst hat, die formale Grundlage dieser kleinen Schmucksulpturen, die mit ihren unregelmäßigen Konturen als Variationen einer einzigen Grundform erscheinen. Dabei entfallen nicht nur die Farbe und der scharfe Kontrast der farbigen Materialien zum Silberblech der Kegelform. Hinzu kommt das vollständige Fehlen von Löchern, Blasen und Krateröffnungen, so dass diese Stücke mit ihrer fensterlosen Solidität und ihrem unerbittlichen Schwarz das Geheimnis des krafterfüllten Hohlraums und der Unberechenbarkeit des Ausbruchs in sich aufgesogen zu haben scheinen. Was bleibt, ist das verkohlte Herz der vulkanischen Form: der quasi konische Berg, der sich von der Kraft des Ausbruchs gelöst hat.

Somit zeichnen sich im Zuge der künstlerischen Auseinandersetzungen Hilberts zwei Wege der Abstraktion ab: das *Absehen von der Farbe* und das *Absehen von*

10

der Hohlform. Bereits an den frühen Objekten der Nea Kameni-Gruppe mit ihrem Dualismus von Farbe und Form kann man eine Präfiguration dieser zwei Optionen erkennen. Der Ausbruch der Farbe und des farbigen Materials erfordert den Schnitt, die Öffnung, die Unterbrechung am geschwärzten Silber der Kegelform und offenbart das Verhältnis zwischen Form und Farbe als scharfen Gegensatz. Darin ist der Prozess der Abstraktion und Verselbständigung der zwei Elemente vorgezeichnet. Die materialisierte Farbe ergibt sich aus der Absehung von der Form. Die materialisierte Form ergibt sich aus der Absehung von der Farbe.

In diesen frühen Arbeiten erkennt man aber auch den Ansatz einer weiteren Tendenz, die bei den späteren Arbeiten deutlich zum Vorschein kommt. Das Material, das bei den Nea Kameni-Objekten die Feuerfarben trägt, ist Koralle oder Vulkanit. Korallen haben geologisch keinerlei Verbindung mit der Welt des Vulkans. Sie sind weder Gestein, noch entstammen sie einer Eruption. Sie «kooperieren» nur zuweilen mit Vulkanen zur Hervorbringung von Riffen, indem sie – laut Darwin – auf den Gipfeln im Meer untergehender Vulkane wachsen. Demgegenüber ist Vulkanit ein Material, das dem vulkanischen Geschehen selbst entstammt. Er kann daher als eine *Metonymie* der Eruption eingesetzt werden. Das beinhaltet, dass der Vulkanit das Gesamtgeschehen des Vulkans grundlegend anders repräsentiert als die Koralle. Der Weg von der Koralle zum Vulkanit dokumentiert also einen Übergang von der Symbolik der Farbe zur Metonymie des Materials.

11 Diese Tendenz zur Metonymie des Materials kommt in den späteren Arbeiten Hilberts zur vollen Entfaltung, in denen weitere vulkanische Materialien wie Obsidian oder Lava einen deutlichen und ausgiebigen Einsatz finden. Der alte Dualismus von Form und Farbe transformiert sich in einen Gegensatz zwischen der konischen Hohlform und der Metonymie von Festkörpern aus Vulkanstein.

Ein Beispiel dafür ist eine silberne Kegelbrosche aus dem Jahr 2009, mit mehreren Wölbungen am Kegelmantel. Neben einer der Wölbungen, die den Austritt von Dampf anzeigen, ist die Manteloberfläche mit einer großen, unregelmäßigen Kuppel aus Obsidian bestückt, deren flache Basis den Augenblick evoziert, da das Gestein aus dem Inneren der konischen Hohlform hervorbricht. Damit wird nicht nur die Fortdauer vulkanischer Aktivität angezeigt, sondern auch, dass der Austritt innerterrestrischer Materie noch im Gange ist. Der Anhänger erscheint als das eingefrorene Bild jenes vulkanischen Vorgangs, der das Innere der Erde durch die Oberfläche nach außen gelangen lässt, und funktioniert somit als die konkrete Ausformung einer *Metapher des Ausdrucks.*

Ein weiteres Beispiel für die Metonymie des Materials ist eine Reihe von Anhängern aus dem Zeitraum 2008–2010. Diese sind ausnahmslos sphärische Hohlkörper aus Silber bzw. geschwärztem Silber, die den Betrachter*innen – anhand vielfältiger latitudinaler Schnitte – kreisrunde Öffnungen zukehren und den Blick ins Innere der Hohlform weisen. Hinzu kommt, dass die Objekte teils an der Außenfläche, teils an der Innenfläche mit Obsidian- oder Lavakugeln bestückt sind. Manchen von ihnen klebt auf der Innenseite ein Schwarm von Obsidiankugeln, die von ihrer Dichte und

Positionierung her den Eindruck erwecken, als ob sie im Inneren des Hohlkörpers auf der Lauer lägen und im Begriff wären, durch die Oberfläche zu stoßen und nach außen zu gelangen. Solche Objekte fungieren als vulkanologische Metaphern der Erde, da sie die bewegte Materie im Inneren des planetarischen Hohlkörpers andeuten und die vulkanischen Prozesse als Scharen zentrifugaler Kräfte modellieren, von denen die Vulkansteinkugeln bewegt und wie ein geodynamischer Hautausschlag von innen nach außen gedrängt werden.

Man kann also Hilberts Objekte als die Endpunkte vielfältiger, von der Begegnung mit dem Vulkan ausgelöster Erfahrungswege ansehen. Damit erscheinen sie einzeln als Inkarnierungen der wohldosierten Ferne, und in ihrer Vielfalt als Variationen einer einzigen, komplexen Antwort auf eine ursprüngliche Begegnung mit dem Erhabenen.

Die Erkenntnis, schreibt Walter Benjamin, ist «nur blitzhaft. Der Text ist der langnachrollende Donner.»[3] Man kann ein solches Bild auch auf die Erfahrung im Allgemeinen anwenden, insbesondere auf die Begegnung mit dem Erhabenen, die blitzartig geschieht, Erfahrung auslöst und Ausdruck verursacht. Als der nachrollende Donner erfolgt damit der Diskurs über das Erhabene: als Wort, als Bild oder als die Verbindung beider. Man kann die einzelnen Objekte Hilberts durchaus als Benjamins Donner hören: als so viele Antworten auf die blitzhafte Begegnung mit dem Vulkan.

Doch: Was hat das alles mit Schmuck zu tun? Sicher: Man kann kaum leugnen, dass Hilberts Objekte von hoher Präzision und großem handwerklichen Können zeugen. Zudem sind sie Ausdruck einer Leidenschaft für ein Phänomen, das sein Geheimnis nur allzu zögerlich preisgibt. Der Geist, den sie atmen, ist jedenfalls von lückenloser Konsequenz. Sofern sie als die immer wiederkehrenden Antworten auf eine Begegnung mit dem Erhabenen entstanden sind, spürt man in ihnen noch die Erschütterungskraft solcher Begegnung. Dennoch stellt sich die Frage: Inwiefern ist das überhaupt Schmuck und nicht etwa Kleinskulpturen, die zu Schmuck umgemünzt wurde?

Im Unterschied zu anderen Kunstwerken, etwa der Malerei, Bildhauerei oder Fotografie, steht der Schmuck in einem zweideutigen Bezug zum menschlichen Körper, der zugleich Displayoberfläche und Objekt der Verzierung ist. Als Ausdruck eines uralten menschlichen Verlangens nach Selbstbearbeitung und Modifikation der eigenen Oberfläche hat der Schmuck mit Haut und Oberfläche eines gemein: die Ambivalenz der Grenze. Sofern er aus Materialien besteht, die traditionell der Erde entstammen, und sofern er aus dem Einsatz von Verfahren hervorgeht, die physische Kraft und objektives Können involvieren, gehört er zur Außenwelt. Sofern aber der Schmuck sich an Körper, Haut, Kleidung anschmiegt und für das betrachtende Auge vom geschmückten Menschen kaum zu trennen ist, dient er als Ausdruck des inneren Lebens des Menschen. Und doch ist er weder das eine noch das andere,

3 Benjamin, Walter, Das Passagenwerk, in ders., Gesammelte Schriften Bd. V,1, Frankfurt a. M. 1982, S. 570.

sondern ein Zeichen, das gleichzeitig in zwei gegensätzliche Richtungen weist: in die fernen, fremden Transzendenzen der Welt außerhalb des Menschen und in die ebenso fernen, fremden Leidenschaften im Inneren des Menschen.

Eine solche Zweideutigkeit gehört typischerweise auch zur Begegnung mit dem Vulkan, die, wie alle intensiven Erlebnisse, Metaphern generiert. Der Vulkan ist nicht nur die ferne Gefahr, die alles vernichten kann, was die Menschen noch vor der drohenden Katastrophe entwickelt haben, sondern auch eine Metapher für das aus Leidenschaften zusammengesetzte menschliche Wesen, dem er einen Spiegel vorhält. So erinnert die Gestalt des Feuerbergs als Wölbung an der Oberfläche der Erde mit einem Loch in der Mitte an die Wunde als Sitz der Schmerzen, in denen sich die Menschen selbst erfahren und sich an sich selbst binden. Ebenfalls erinnert der Vulkanausbruch mit seiner Plötzlichkeit und Unberechenbarkeit an die menschlichen Leidenschaften. Denn vieles ist ungeheuer, wie Sophokles seinen Chor in Antigone singen lässt, aber nichts ungeheurer als der Mensch, der die Natur bändigt und die Ordnungen des Zusammenlebens einrichtet, zugleich aber auch imstande ist, gegen diese zu freveln.[4]

Gewissermaßen befindet sich damit die menschliche Existenz zwischen zwei Vulkanen. Der eine entsteht unter den Füßen und vernichtet mit seinem Ausbruch die physische Existenz des Menschen. Der andere entsteht im Inneren und vernichtet mit seinem Ausbruch die soziale Existenz des Menschen.

15 Darin sind aber zwei Doppelungen angesprochen. Auf der einen Seite haben wir den Doppelbezug des Schmucks. Auf der anderen Seite haben wir die Doppeldeutigkeit des Vulkans. In Hilberts Auseinandersetzungen mit dem Vulkan fügen sich diese zwei Doppelungen ineinander. Der Schmuck, der daraus hervorgeht, bezieht sich im gleichen Maße auf die Explosionen des Erdfeuers wie auf das explosive Innere des Menschen. Das vermag er kraft der Doppeldeutigkeit seiner vulkanischen Erscheinung als Metapher, die in seiner Form, Farbe und Materialität zum Ausdruck kommt. Das tut er aber auch gerade in seiner Seinsweise *als Schmuck:* kraft seines zeichenhaften Doppelbezugs nach außen und innen.

16 Zu den typischen Aufgaben von Metaphern gehört, dass sie zwei Bilder verbinden. Die Schmuckobjekte Hilberts sind Ding gewordene Metaphern, die den äußeren und den inneren Vulkan zu einem einzigen Bild zusammenziehen. Als das ferne Bild der äußeren und das ebenso ferne Bild der inneren Gefahr verkörpern sie zwei unterschiedliche und unabhängige Strategien der Distanzierung und erscheinen deshalb als Variationen einer doppelten Ferne: einer wohldosierten Ferne in Bezug auf die verborgenen Leidenschaften des Menschen, und einer wohldosierten Ferne in Bezug auf die explosiven Kräfte in seiner Umwelt.

4 Antigone, in: Sophokles, Tragödien und Fragmente. Griechisch und deutsch, hg. und übers. v. Wilhelm Willige, überarbeitet v. Karl Bayer, München 1966, S. 261.

Vor diesem Hintergrund überrascht es nicht, dass Hilberts künstlerische Auseinandersetzungen mit der inneren Welt chronologisch noch ihrer Begegnung mit dem Vulkan vorausgehen. Ein Beispiel dafür sind die Arbeiten der Serie Emotionen (1991–1994). Diese Arbeiten, die älter sind als die Nea Kameni-Objekte, sind ausnahmslos Hohlformen aus Silberblech mit elliptischen oder kreisrunden Öffnungen, woraus spitze, gezackte oder zungenförmige Teile herausragen. Nicht anders als bei den Nea Kameni-Objekten entfalten diese Arbeiten ihre Reflexion im Ausgang von der Hohlform und der Explosivität der daraus hervorbrechenden Kräfte. Indem sie einer eigentümlichen Ästhetik der Eruption folgen, spielen sie auf den Vulkan als Metapher für die inneren Kräfte an – und dienen damit gewissermaßen als Vorbereitung auf eine spätere, explizitere Auseinandersetzung mit der Welt des Vulkans. Der Vulkan als Bild der Leidenschaften verweist auf die Leidenschaften als Bild des Vulkans.

17

In mythischen Gesellschaften meldet sich die Welt oft gleichzeitig in mehreren Gestalten. Die Schlange kann zugleich ein Seil, eine Wurzel, ein gezackter Blitz sein. Eine solche plurale Weltwahrnehmung, die eine offene Reihe von Parallelbildwelten auftauchen lässt, kann nur anhand einer metaphorischen Praxis organisiert werden. Der junge Nietzsche hat versucht, eine solche «Metaphorologie» für das moderne Denken zu reklamieren.[5] Er hat gezeigt, dass die Tätigkeit der Metaphern sich keineswegs auf die Sphäre der Sprache beschränkt – wie etwa in der herkömmlichen Rhetorik –, sondern unsere gesamte Sinnlichkeit durchdringt. Dadurch erst erscheint das anfängliche Chaos an Sichtbarem, Hörbarem, Tastbarem etc. – im Rahmen einer wohldosierten Ferne – als eine metaphorologische Ordnung der zusammengezogenen Bilder.

18

Auch in diesem Sinne gilt der Vulkan nicht nur als das Erhabene *außer* uns, das uns den Boden unsicher macht und die Grenzen des endlichen menschlichen Daseins aufzeigt, sondern auch als das Erhabene *in* uns, das wir nicht bändigen können, das jederzeit aus uns herausbrechen kann, vergleichbar dem *Tremendum* der alten Mystiker, das in einer bestimmten Phase der mystischen Entwicklung aus unserer eigenen Tiefe aufsteigt und uns zu sprengen droht: als das, was uns prinzipiell übersteigt und uns selbst fremd ist. Damit wird in den Schmuckarbeiten Hilberts – mit ihrer ziselierten Perfektion und der Logik ihrer Abfolge – der Prozess ablesbar, in dem die Doppelgestalt des Erhabenen systematisch auseinander- und zusammengelegt wird.

Damit erscheint aber auch Hilberts Atelier als eine Werkstatt der Metaphern, in der sie seit vielen Jahren die wohldosierte Ferne ausformt und ihre Schmuckstücke als Metaphern des Ausdrucks modelliert.

5 Nietzsche, Friedrich, «Ueber Wahrheit und Lüge im aussermoralischen Sinne», in ders., Kritische Studienausgabe in 15 Bänden, hg. v. Giorgio Colli und Mazzino Montinari, München 1980, S. 875–890.

Well-measured distance – volcanism in Therese Hilbert's jewelry

1 «Civilization exists by geological consent, subject to change without notice.»
Will Durant[1]

On the one hand, there are *forces* such as those to be perceived when a supernova explodes, a hurricane approaches, or a state or a living organism collapses. On the other hand, there are *forms* such as the orbits of heavenly bodies, the geometry of crystalline structures, the loops of recurring habits, or merely the luminous streak of a waterfall at a distance, revealing itself in its proximity as a foaming inferno. Every form turns out to be a force at close quarters, every force settles down to a form at a distance.

2 Such an interplay of proximity and distance is characteristic of our experience of a volcano. From a distance it appears as a glowing mountain of fire, but at close quarters it transforms into the explosive inner life of the earth, remaining typically unseen till it erupts at unpredictable moments to reduce to rubble the tectonic peace at the base of everything human. This is why, seen from a historical perspective, volcanoes appear as a series of collective traumata. Santorini, Mount Vesuvius, Krakatoa, Mount Pinatubo – each and every one of these eruptions had something of the finality of an untimely stop, suddenly interrupting the syntax of human history. In modern discourse, volcanoes seem to incorporate a brutal barrier, delimiting humankind's technological supremacy and donning the fearful shape of the *sublime*, which can only be lived and experienced through the filter of distance and abstraction.

3 Since many years Therese Hilbert has been grappling with the world of volcanoes, manifesting itself in her work as the sublime: taken not only as an inaccessible, external force of nature, but also as innermost recess of human nature. The sudden shifting of the ground, the smoke and sulphurous fumes escaping from the crevices, the flames erupting from the earth's interior, the red, fiery flux of molten stone, the occasional glimpse of a bottomless chasm. All these things have a deep impact on people, demolishing their trust in the foundations of their daily activities. Only when one flees to attain a certain distance, can the explosions as experienced at close quarters morph into the image of a cone of fire, which initially figures as a symbol of human frailty in Hilbert's work.

1 Durant, Will «What is Civilization?» in: Ladies' Home Journal, LXIII, January 1946.

All this is best expressed by the young Nietzsche[2]: Distance results from a practice of distancing that reins in the seething heart of things and transforms it into an Apollonian dream form. The decisive element in such a practice is the *measure* of distance. Move too far away and all that remains is the cold abstraction of knowledge. You turn into ice. But if you do not move far enough you have neither knowledge nor life. You get burnt down. A *well-measured distance* is effectively a middle ground and compromise in one. You perceive the distant image, but continue to sense something of the force, which, mitigated by the distance, no longer kills, but only transforms.

This happens in Greek tragedy, where the images on the distant stage are mobilized and the forces of the tragic drama attain the spectators to shake up their innermost emotions. The same process can also be observed in the laws of thermodynamics, where the thermal chaos of molecules, seen from the distance of sufficiently large populations, becomes a statically dispersed order. Or in jewelry art, where the body of the wearer becomes a stage for the interactions between proximity and distance: between the eroticism of proximity that unfolds as one follows the siren song of jewelry and is captivated by the charm of the bejeweled body; and an aesthetics of a distance that transforms the adorned person into a far, but visible work of art.

That said, «distance» not only denotes the span of space separating an image and an observer but also the lapse in time between the *past of formation* and the *presence of the form*. As a residual token of the process of its own emergence, the distant form is not only the outcome of the act of distancing, but also an archive of the dynamics at work in the sphere of proximity, consisting in things like brushstrokes, blows of the hammer, precipitating masses of water – all of which provide form and resulting in a form.

In this sense, Hilbert's jewelry issues from her reflections on volcanic processes as the outcome of a series of attempts at crafting a well-measured distance. Such a process consists of three stages: a rudimentary *analysis,* dividing form and color into two distinct categories; a process of *reduction,* breaking volcanism down to a small number of elementary forms and colors; and a *synthesis,* reassembling the forms and colors to jewelry objects.

The concrete application of such a method consists in the act of detaching from the inferno associated with proximity the marvel of the hollow form. This is not to be understood as a form enclosing a lifeless void, but rather a space brimming over with forces, in which hidden, incalculable energies proliferate, ready to erupt at any instant of time. The category of a well-measured distance reveals itself in the image of the hollow space: as a connection between *form* in the sense of the external shape of hollowness and force in the sense of the energies enclosed by the form.

2 Nietzsche, Friedrich, «Die Geburt der Tragödie aus dem Geiste der Musik» in ders., Kritische Studienausgabe in 15 volumes, ed. by Giorgio Colli and Mazzino Montinari, Munich 1980, vol. 1, 9–156 (Nietzsche, Friedrich, «The Birth of Tragedy from the Spirit of Music,» in: Basic Writings of Nietzsche, ed. W. Kaufmann, Modern Library: New York, 2000).

In order to enable the symbolic concentration and representation of the inferno associated with proximity, the external impression of hollowness has *first* to be reduced to clear, simple forms. Specifically, this means that the complex spaces we connect with the volcano, such as mountains, holes, bubbles, craters and calderas are evened out to elementary geometric figures such as circles, ellipses and cones. These function like the letters of an alphabet spelling out the essential features of the human experience of volcanoes. Starting out from such elementary geometric figures, Hilbert unfolds a detailed phenomenology of the orifices, through which the inner fire of the earth finds its way out. Almost unintentionally, the volcano becomes a metaphor of expression.

But as a *second* objective involved in the representation of the space of forces, the visible volcanic energies – the erupting terrestrial fire, the colored smoke of fumaroles, the glow of molten rocks – have to be broken down to basic colors like red, black and yellow.

This means that the procedure leads on the one hand to a set of *geometricized forms* as representations of the orifices of eruption, and, on the other hand, to a set of basic colors as representations of the erupting energies.

7 Such a combination of analysis, reduction and synthesis can be best discerned in the brooches of the Nea Kameni group (1996). The title of the group – which translates literally as the «Newly Burned» – refers to the youngest of the Kamenes islands in the Santorini archipelago, all of which derive from the conic orifices of eruption associated with the intense volcanism in this part of the Aegean Sea. Accordingly, the works of this group, crafted from blackened and bent silver sheet, can all be perceived as variations on the basic form of the cone. At times, the conic form ends in an apex, at other times, the apex is sliced off along a conic section to reveal a crater from which occasionally the form of a silver ignition cord or tufts of silver arrowheads emerge.

In one of these objects the crater is shaped like a gaping wound extending across the apex and revealing an overflowing mass of red coral. Another object evokes the tongue-like flames of an erupting subterranean fire through a rippled mass of blue coral emerging from a slit on the conical surface. In a further work, the surface is a network of holes shaped like variously compressed circles spreading out and expanding from the crater to the base. In another piece, directly below the crater's brim, a broad, tapering strip is cut into the cone's surface and bent into a spiral that winds its way upwards to enclose the overflowing red of a coral. As one of the colors constituting the phenomenon of volcanism, the red indicates the energies of a volcanic eruption.

Thus, what we find in these works is, *firstly*, the twin entities of *form* and *force*. There is on the one hand the hollow form as a combination of a geometricized shell with the reduced color of blackened silver. And then there is on the other hand the dynamism of volcanic forces, represented by a combination of glowing colors and

amorphous masses of appropriate materials like coral or vulcanite. The contrast between the hollow shape and the colored material masses indicates the prior *analytical distinction* between form and color mentioned above. *Secondly,* elements such as the geometricized forms or the elementary colors like red, blue and yellow derive from a prior reduction of volcanic realities. Such elements function as the letters of an evolving «alphabet» of volcanism. *Thirdly,* the jewelry object itself emerges as a re-combination or *synthesis* of the «letters» of these two groups of previously distinguished and reduced elements to yield a jewelry object, which can thus be read as a metaphor for the volcanic recesses in the depth of the individual wearer who will later be adorned with it.

Nonetheless, in these early works the concrete relationship between *color* and *form* remains pretty simple. Color bursts out of the hollow space of a grey conic form, indicating a subterranean fire.

8

In Hilbert's later works this relationship is subjected to a complex variation. Several works from the series Glut (Embers, 2004) can be taken to illustrate the point. In these pieces, the material vehicle of color is no longer an amorphous substance, but rather a two-dimensional, varnished silver sheet, cut out as clear shapes. The question at the center of this type of form-oriented research is ultimately, whether there is any specific *form* inherent to fire, *force,* color: a *form of color* for instance, depicted by a flickering red disc perforated by holes and slits, placed on the broad brim or base of a silver receptacle; or a circular, ocher-colored disc with a hole in the middle, forming a kind of chaplet around the crater opening; or a slender, yellow rectangle protruding out of a slit drawn across the cone's surface; or the straight line of a lacquered red silver strip on the surface, extending from below the tip to almost as far as the base.

Another relationship between form and color can be discerned in the later «Glowing Embers» brooches, for example from the group called Yali (2009), all of which have the form of silver hemispheres with the curved surface consisting of a mesh of elongated holes, while the inner face of the base is lacquered with volcanic colors to produce the visible effect of a subterranean glow through the net. Here, the volcanic energies shine through a *second distance* and hit the eye as an Apollonian image of their glow. The second, *vertical distance* of depth intersects with the first *lateral distance* of the gaze that normally reaches out to distant volcanoes. Such an intersection is the condition of possibility of the hollow form with its net-like surface and the glow within its entrails. Thus, the cross generated by the intersection of the two distances could be said to function like an Apollonian machine, structuring the materiality of the brooch and fashioning it into a wearable image of the original, volcanic inferno.

A further tendency of these works is to radicalize the analytical distinction between form and color by augmenting their difference to a material autonomy of separate objects. An artistic investigation of this nature, plumbing the limits and possibilities of the well-measured distance and articulating the analytical distinction between

9

form and color to recombine them to new types of objects, tends initially towards a preparatory analysis within the materiality of the materials employed and ultimately towards augmenting the analytical distinction and crossing the threshold of material autonomy of the distinctive elements. Hilbert's later works manifest such a threshold frequently, where the color of glow and the conical form of the orifices of eruption no longer allude to one other.

One example is the pendant with two component parts dating from 2007. Each of the two parts, both in close contact with each other and capable of hanging parallelly, consists of a round, perforated silver disc, lacquered red and furnished with an irregular, wavy brim. The fact that the two parts lie against each other not only produces a more complex network of perforations. In addition, the flickering, flame-like color discs unfold a new kind of depth: the terraced depth of a fiery, latticed surface – characterizable as *color transposed into form* –, visualizing volcanic energies without alluding to the orifices and events of eruptions. Two works of blackened silver created earlier in 2006 can be regarded in a sense as negatives of the said pendant. They are also pendants, but comprising a single piece each and consisting in a perforated, flame-shaped disc. The main difference, however, is that all color seems to have been drained out of these objects, which are left behind as the charred core of the igneous element, clotted and consolidated to a pure form. The relentless process of abstraction has exuded even all color, retaining only the flickering, flame-like form of energy.

However: not only color, but also form can be affected by the power of abstraction, as evidenced in the brooches of the group Schwarze Berge (Black Mountains, 2015/16) made of MDF. The pieces in question are small, black sculptures, marking a departure from the pure geometry of the conical form and returning to the irregularities of natural volcanic shapes like domes, towers, huts, cone-shaped hills, occasionally with veins carved out on their surfaces. Nonetheless, the conical form, detached from any connection with the colored materials of earlier works, remains the formal base of these small jewelry objects, presenting themselves with their irregular shapes as variations of a single basic form. In addition to the absence of color and contrast between colored materials and a conically formed silver sheet, there is a complete lack of orifices, bubbles and crater openings so that these pieces with their unbroken solidity and relentless black seem to have completely soaked up the enigma of a force-filled cavity and the vagaries of eruption. What remains is the charred core of the volcanic form: the quasi conical mountain, detached from the fire and force of eruption.

Thus, two paths of abstraction emerge in the course of Hilbert's artistic explorations: *turning away from color and turning away from the hollow form*. A prefiguration of these two options can be discerned in the early objects of the Nea Kameni group with their dualism of color and form. The eruption of color and colored material requires a cut, an opening, an interruption on the curved surface of a blackened,

conical silver sheet, manifesting the relationship between form and color as a sharp contrast and anticipating their material autonomy as a radicalization of abstraction. Materialized color is the fruit of turning away from form. Materialized form is the fruit of turning away from color.

In these early works, one can also detect the beginnings of another trend that comes into focus in the later works. In the Nea Kameni objects, the material vehicle of the colors of fire is either coral or vulcanite. In geological terms, corals have no connection to the world of volcanoes. They are neither stone, nor do they stem from an eruption. According to Darwinian theory, they can at most be said to occasionally «cooperate» with volcanoes to produce riffs, by growing on the peaks of volcanoes as they sink into the ocean. Vulcanite, by contrast, is a material that stems from the actual volcanic process. Accordingly, it can be employed as a *metonymy* of eruption. The implication is, that vulcanite represents the overall activity of the volcano in a fundamentally different manner than coral. The move from coral to vulcanite thus documents a transition from the symbolism of color to the metonymy of a material.

This trend towards the metonymy of the material is fully developed in Hilbert's later works in which we witness an unequivocal and abundant use of other volcanic materials such as obsidian or lava. The old dualism of form and color is transformed into a contrast between the conic cavity as a form and solid bodies of volcanic stone as a metonymic reference. [11]

One example is a conical brooch of silver from 2009 with several bulges on the cone's surface. Beside one of the bulges, indicating escaping steam, the surface of the cone is studded with a large irregular dome of obsidian, the flat base evoking the instant when the stone breaks through the surface of the hollow conical form and indicating not only continuous volcanic activity, but also continued discharge of subterranean matter. The pendant is thus something like a frozen image of the volcanic process, in which the interiority of the earth breaks through the surface into the open. It functions as a materially crafted *metaphor of expression.*

Another example for the metonymy of the material is a series of pendants from 2008 to 2010. These are all hollow spheres of silver or blackened silver with diverse latitudinal cuts that reveal to the eye circular openings directing the gaze into the interior of the hollow form. In addition, the inner or outer surfaces of these objects are studded with obsidian- or lava beads. In some of the pieces, a swarm of obsidian beads are placed on the inner surface, which, owing to their density and emplacement, create the impression as if they were lying low and waiting, about to thrust through the surface and break out into the open. Such objects function as volcanological metaphors of the earth, alluding to the physics of matter in motion within the cavities of the planetary sphere, and modelling the volcanic process as a throng of subterranean centrifugal forces thrusting out beads of volcanic stone like a geodynamic rash.

Well-measured distance

12 One can thus see Hilbert's objects as the points of termination of the trajectories of a wide variety of experiences triggered by volcanic encounters. They can each be taken as an incarnation of a well-measured distance, appearing in their diversity as variations on a singular and complex response to a primal encounter with the sublime.

 Knowledge, as Walter Benjamin once wrote, comes «only in flashes of lightning. The text is the long roll of thunder that follows.»[3] Such an image can be applied to experience in general, and in particular to encounters with the sublime, which occur as flashes of lightning, triggering experience and generating expression. The long roll of thunder unfolds as a discourse on the sublime: as words, as images, as combinations of both. Hilbert's objects can in a sense be listened to as Benjamin's roll of thunder: as a variety of responses to the lightning flash of encounters with volcanoes.

13 But what has all of this got to do with jewelry? Certainly, there is no denying that Hilbert's objects demonstrate great technical precision and craftsmanship. They are also expressions of a passion for a phenomenon, that is all too hesitant in disclosing its secret. The thought process that they breathe is certainly of an extraordinary, unbroken coherence. To the extent that they emerge as recurrent responses to an encounter with the sublime, one still senses in them the power of the impact of such encounters. Yet the question remains: To what extent is this jewelry at all, and not miniature sculpture for instance, reframed as jewelry?

14 Unlike other genres of art such as painting, sculpture or photography, jewelry has a dual relationship to the human body, which is simultaneously a surface of display and an object of decoration. As the expression of a primordial human drive to modify and alter one's own surface, the common trait that jewelry shares with the skin and the surface is the ambivalence of a limit. To the extent that it consists of materials traditionally originating in the earth and that its making involves physical force and objective excellence, jewelry belongs to the external world. But to the extent that it nestles on the body, skin or dress, and can hardly be distinguished from the adorned individual, jewelry is an expression of the inner life of the individual. And yet it is neither the one nor the other, but rather a sign, pointing at the same time in two opposing directions: into the distant, alien transcendence of the world outside us and into the just as distant and alien passions within us.

 Such a dualism is also typical of any encounter with volcanoes, which generates metaphors just as any intensive experience does. A volcano is not only the distant peril capable of destroying all human accomplishment up to the threshold of the disaster, but also a metaphor for human nature, composed as an assemblage of passions, to which it holds a mirror. Thus a mountain of fire, shaped as a vault on

3 Benjamin, Walter, «Das Passagenwerk,» in ibid., Gesammelte Schriften vol. V,1, (Frankfurt a. M., 1982), p. 570.

the surface of the earth with a hole in its middle, is reminiscent of a wound as the seat of human agony, in which we habitually experience ourselves and bond with ourselves. Likewise, the sudden and unpredictable nature of a volcanic eruption is reminiscent of the suddenness of human passions. For, as Sophocles has his choir sing in Antigone, there is so much that is monstrous around us, but nothing is more monstrous than humans, who tame nature and set up the laws of human coexistence, and yet are capable of violating them.[4]

Thus, in a sense, human existence finds itself placed between two volcanoes. One of them can erupt beneath our feet and destroy our physical existence. The other can erupt within us and destroy our social existence.

Such a connection evokes two sets of dualism. On the one hand, there is the dual reference of jewelry. On the other, there is the metaphorical duplication of the volcano. In Hilbert's reflections on the volcano these two sets of dualism mesh together. The jewelry that results from such a thought process alludes to volcanic explosions as well as eruptions in the depth of its human wearer. It is capable of doing this due to the dual reference of its volcanic form, functioning as a metaphor expressed in its form, color and materiality. But it is also capable of doing this by virtue of its mode of existence *as jewelry*, constituted by its dual reference to an external as well as an internal reality.

A typical function of a metaphor is to link together two images. Hilbert's jewelry objects are materialized metaphors, combining the external and the internal volcano into a single image. As the distant image of an external calamity and an equally distant image of an inner peril, they incorporate two distinct and independent strategies of distancing and are thus manifested as variations of a duplicated distance: a well-measured distance with regard to latent human passions and a well-measured distance with regard to the explosive forces populating a human environment.

Against this background it is not surprising that Hilbert's artistic trajectory, the exploration of the inner world, precedes her encounter with the volcano. An example of the former are the pieces belonging to the series Emotionen (Emotions, 1991–1994). Almost all of these works, which are older than the objects of the Nea Kameni group, are hollow forms of silver sheet with elliptical or circular openings, from which pointed, jagged or tongue-shaped parts protrude. Just as the Nea Kameni pieces, these works unfold their reflection by starting out with the hollow form and the explosive forces erupting from within it. Through a discernible aesthetics of eruption, they evoke the volcano as a metaphor for the inner forces and seem to function as a preparatory stage for a later, more explicit reflection on the world of volcanoes. The volcano as a metaphor for passion points toward passion as a metaphor for the volcano.

4 Antigone, in: Sophokles, Tragödien und Fragmente. Greek and German, ed. and translated by Wilhelm Willige, revised by Karl Bayer, (Munich, 1966), p. 261.

Well-measured distance

18 In mythical societies the world is often experienced in different forms. The snake can be a rope, a root or a jagged streak of lightning. Such a plural perception of the world as an open series of parallel visual universes can only be organized through a metaphorical practice. The young Nietzsche attempted to claim such a «metaphorology» for modern thought[5] by demonstrating that metaphors are by no means restricted to the sphere of language – as suggested by conventional rhetoric – but that they permeate our entire sensory awareness. Such a connection explains how an initial chaos of visible, audible, tactile impressions can ultimately appear as a metaphorological order of images mounted together within the bounds of a well-measured distance.

It is also in this sense that the volcano appears not only as the sublime *external* to us, rendering the ground beneath our feet unsafe and revealing the limits of a finite human existence but also as the sublime *internal* to us, that we cannot rein in and that can break out of us at any instant, comparable with the *tremendum* proclaimed by Medieval Christian mystics, rising from our own depths in a specific phase of the mystical process and threatening to blow us apart: as something within us that essentially transcends us and is alien to us. Consequently, Hilbert's jewelry objects – with their finely chased perfection and the logic of their emergence in time – can be read as the manifestation of a process, in which the twin figures of the sublime are systematically taken apart and reassembled.

In this sense, Hilbert's studio serves as a workshop of metaphors, in which she has been creating concrete forms of the well-measured distance since many years and modelling her jewelry as a metaphor of expression.

5 Nietzsche, Friedrich, «Ueber Wahrheit und Lüge im aussermoralischen Sinne», in: ibid., Kritische Studienausgabe, 15 volumes, ed. by Giorgio Colli and Mazzino Montinari, (Munich, 1980), pp. 875–890.

Nea Kameni
1995–1997

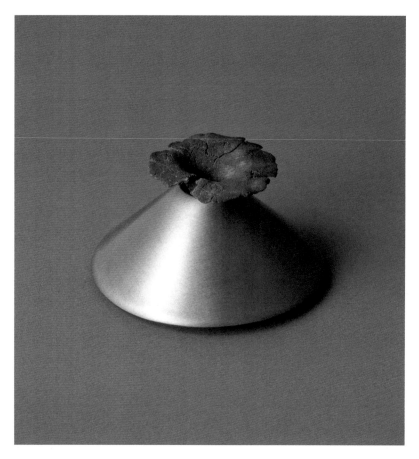

▲ Brooch, 1996, silver blackened, ø 5.7 cm, d 3.2 cm.
▶ Nea Kameni Island, Greece, 1994.

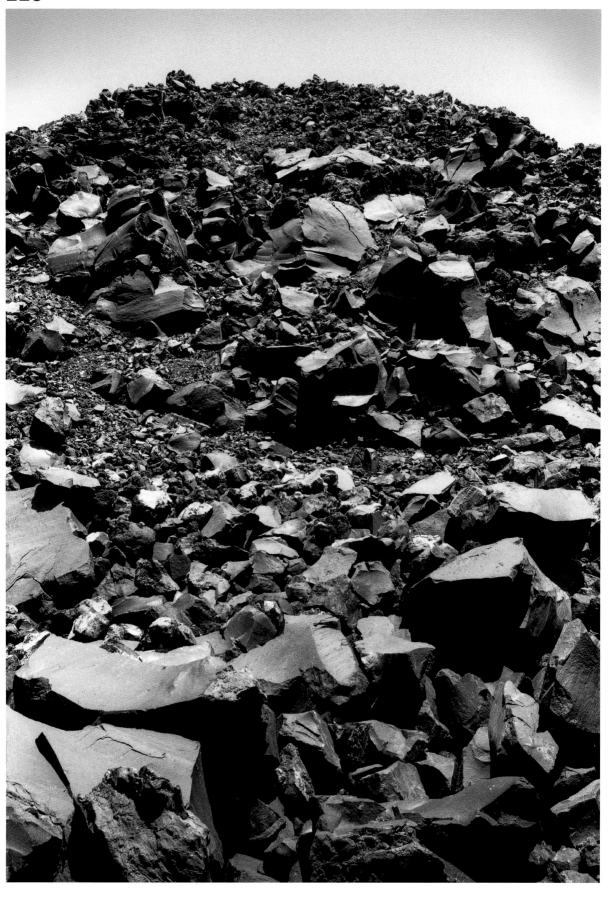

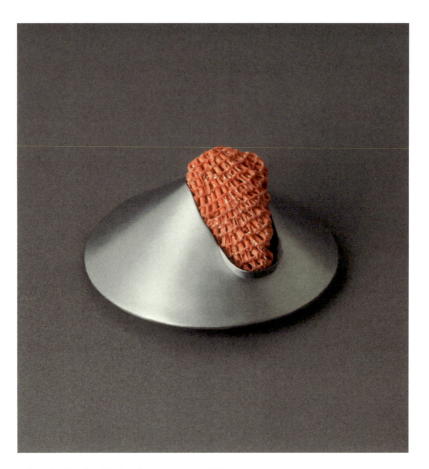

▲ Brooch, 1996, silver blackened, coral, ø 6.9 cm, d 3.0 cm.
Die Neue Sammlung – The Design Museum. Permanent
loan from the Danner Foundation, Munich, Germany.

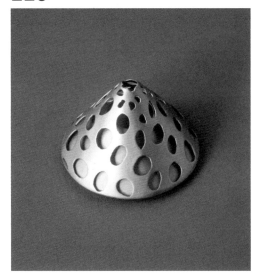

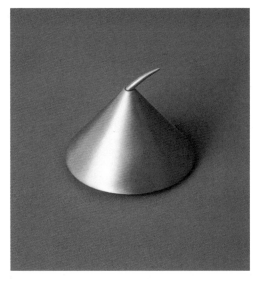

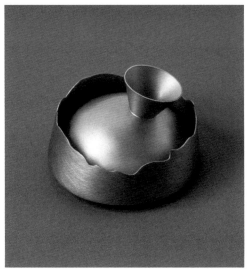

▲ Brooch, 1996, silver blackened, ø 5.7 cm, d 3.7 cm.
▲ Brooch, 1996, silver blackened, ø 5.3 cm, d 4.0 cm.
▲ Brooch, 1996, silver blackened, ø 5.4 cm, d 2.9 cm.
▶ Nea Kameni Island, Greece, 2003.

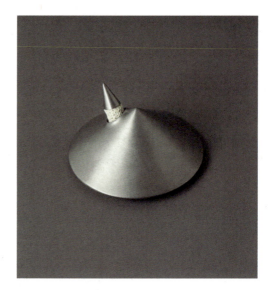

▲ Brooch, 1996, silver blackened, coral, ø 7.5 cm, d 4.2 cm.
◄ Brooch, 1996, silver blackened, coral, ø 6.1 cm, d 3.8 cm. Schmuckmuseum Pforzheim, Germany.
◄ Brooch, 1996, silver blackened, ø 5.3 cm, d 3.8 cm. Private collection, Tokyo, Japan.
► Brooch, 1996, silver blackened, ø 7.5 cm, d 2.4 cm.
► Brooch, 1996, silver blackened, opalit, 7.7 x 7.0 x 2.6 cm.

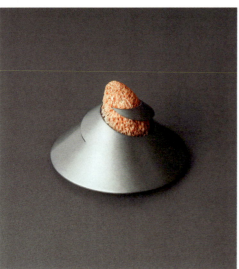

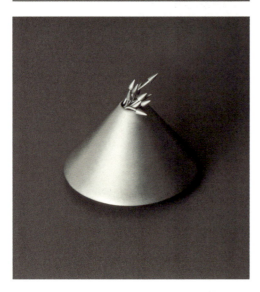

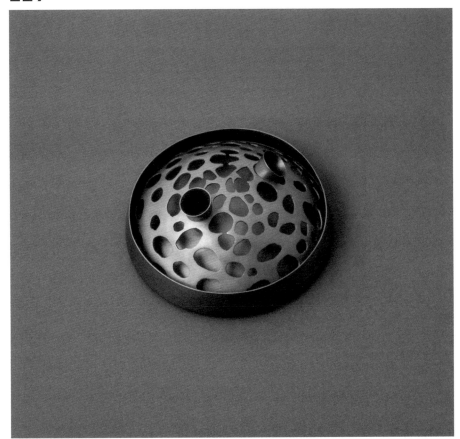
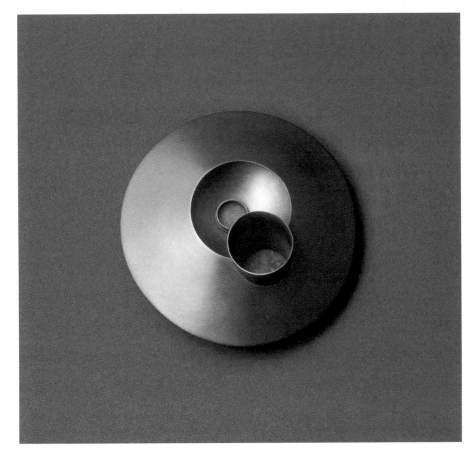

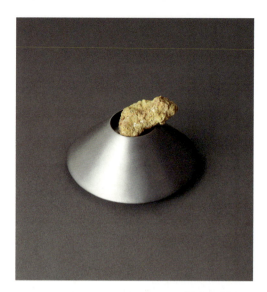

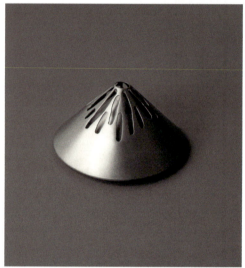

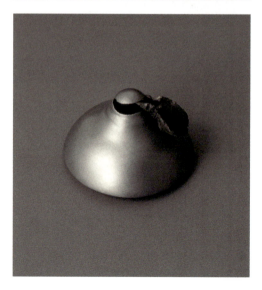

◄ Brooch, 1996, silver blackened, volcano, ø 4.9 cm, d 2.4 cm.
◄ Brooch, 1996, silver blackened, ø 5.7 cm, d 2.9 cm.
Private collection, Gmunden, Austria.
◄ Brooch, 1996, silver blackened, ø 5.1 cm, d 2.8 cm.

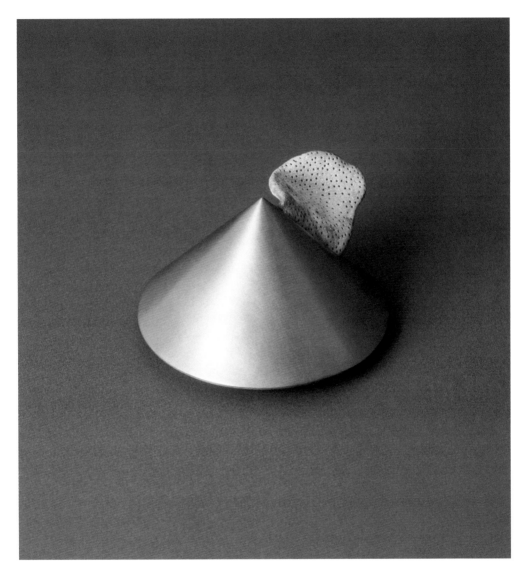

▲ Brooch, 1996, silver blackened, coral, ø 7.3 cm, d 4.2 cm.

Glut
Glow
2004–2009

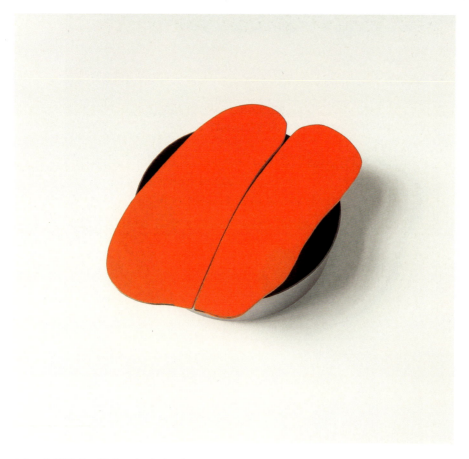

▲ Brooch, 2004, silver blackened and painted,
ø 5.8 cm, d 1.8 cm. mudac, Musée de design et d'arts
appliqués contemporains, Lausanne, Switzerland.
► Eugène Ionesco: Introduction to Maurice & Katia Krafft,
Volcano, (Paris & New York, 1975), p. 8.

Für den Augenblick existiere ich. In mir schlummern Leidenschaften, die explodieren, doch auch in Schach gehalten werden können. Ströme von Wut und Freude liegen in mir, bereit zu bersten und Feuer zu fangen. Ich bin voll von Energien, Feuer und Lava. Ich bin ein Vulkan. Meistens bin ich im Halbschlaf: Meine Krater warten, dass dieses ständige Kochen ausbricht, auftaucht, seine Instinkte befriedigt; dass meine glühenden Leidenschaften emporkommen, lodern und sich in einem Sturm über die Welt ausbreiten.

For the moment, I exist. Passions slumber in me that may explode, then be held in check again. Jets of rage or joy lie within me, ready to burst and catch fire. In myself I am energy, fire, lava. I am a volcano. Most often, I am half asleep: my craters wait for this continual boiling to rise, emerge, satisfy its instincts; for my incandescent passions to pour out, ignite, and spread forth in an assault on the world.

Eugène Ionesco

▲ View into the exhibition «&: Hilbert & Künzli», 2016, Gewerbemuseum, Winterthur, Switzerland. Here: Pendant, 2007, two-parts, silver painted, 9.4 x 9.6 cm.

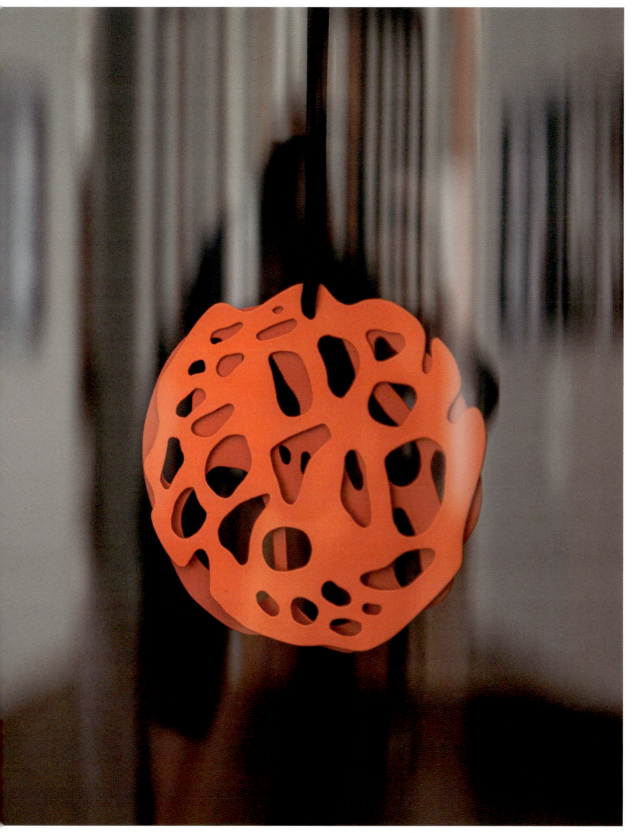

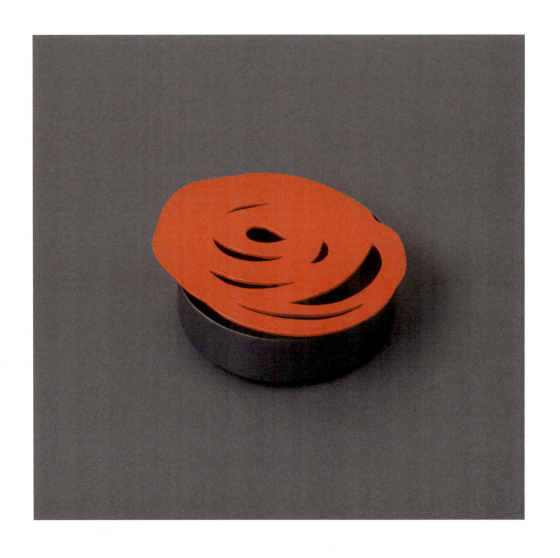

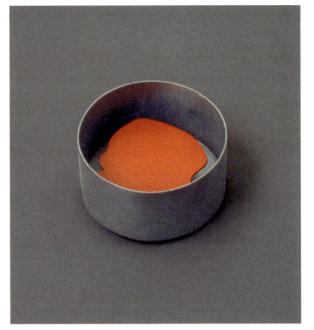
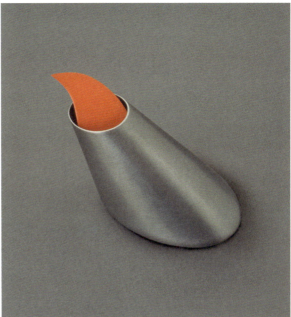
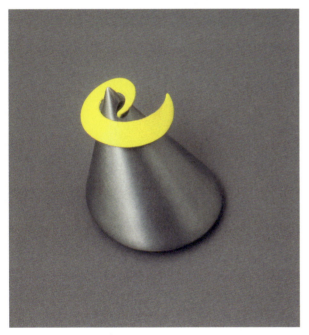
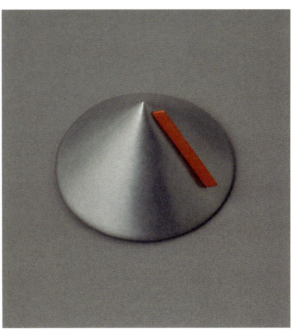

▲ Brooch, 2004, silver blackened
and painted, ø 3.7 cm, d 1.8 cm.
▲ Brooch, 2004, silver blackened
and painted, 3.6 x 4.2 x 4.6 cm.
synthetic cotton wool, ø 4 cm, h 1.6 cm.
◄ Brooch, 2004, silver blackened
and painted, ø 5.8 cm, d 1.7 cm.

▲ Brooch, 2004, silver blackened
and painted, 4.0 x 4.1 x 5.9 cm.
▲ Brooch, 2004, silver blackened
and painted, ø 6.0 cm, d 3.4 cm.

▲ Brooch, 2004, silver, 6.5 x 5.6 x 4.3 cm.
mudac, Musée de design et d'arts appliqués contemporains, Lausanne, Switzerland.
▶ Pendant, 2007, silver blackened and painted, ø 6.3 cm, d 2.3 cm.

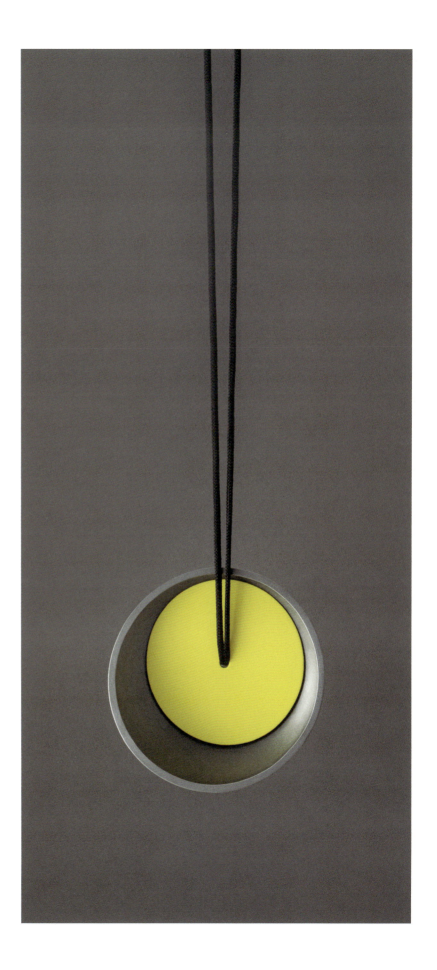

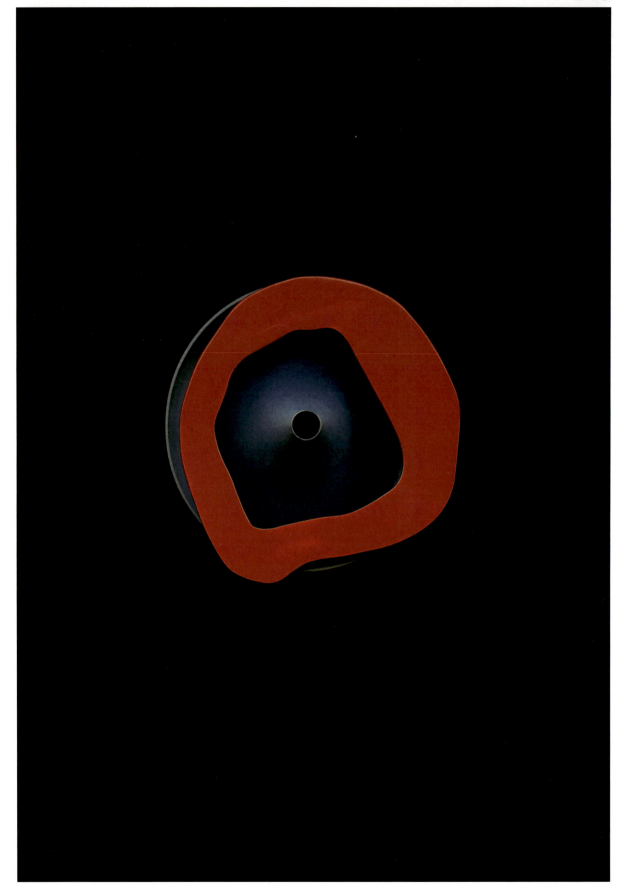

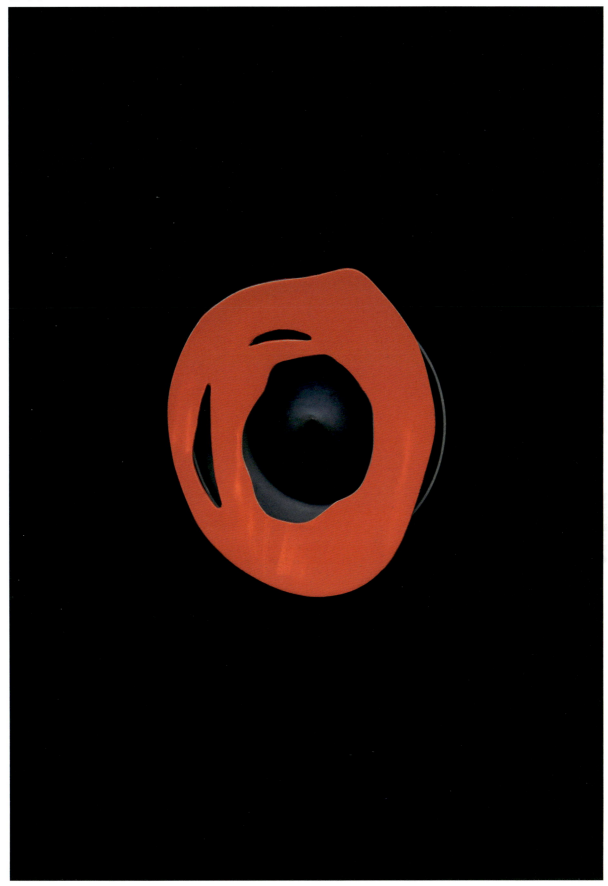

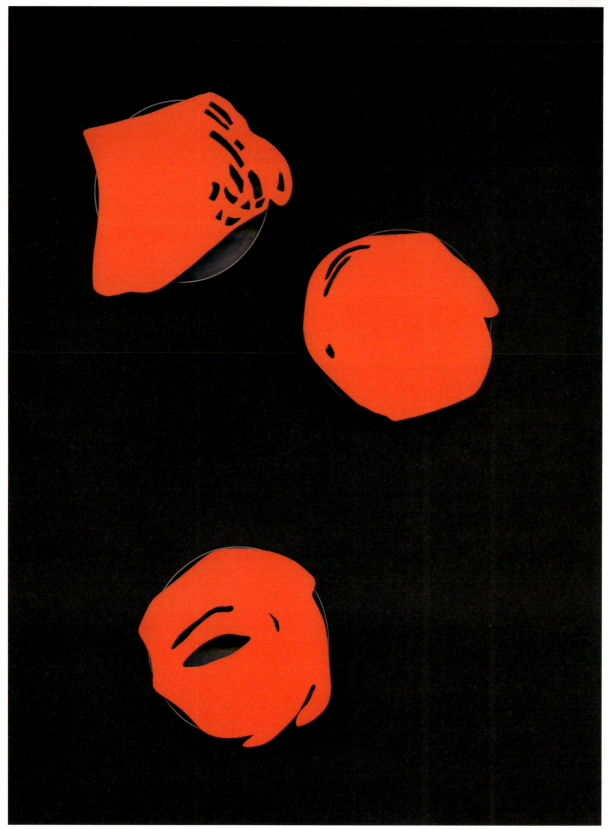

◂ Brooch, 2004, silver blackened and painted, ø 4.8 cm, d 2.4 cm (p. 240).
◂ Brooch, 2004, silver blackened and painted, ø 4.8 cm, d 2.0 cm (p. 241).

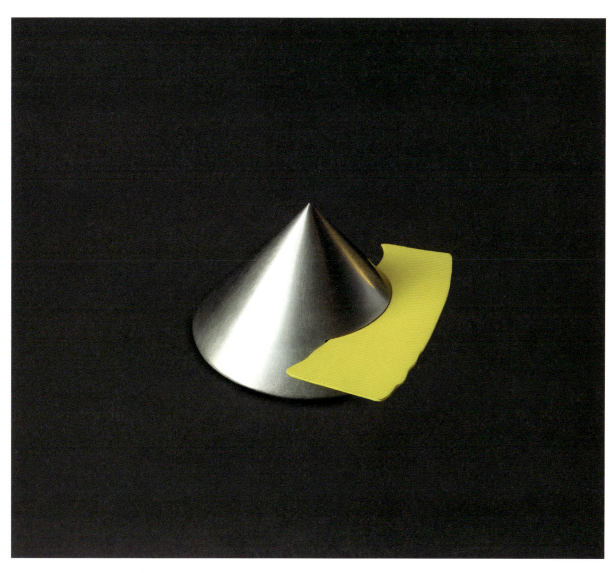

▲ Brooch, 2004, silver blackened and painted, ø 5.8 cm, d 3.5 cm.
◄ Brooches, 2004, silver blackened and painted, ø 5.8 cm, d 2.0–2.3 cm.

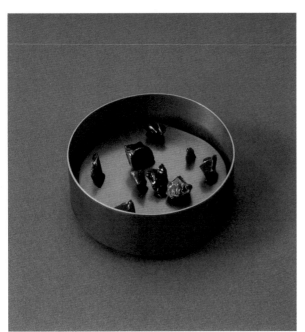 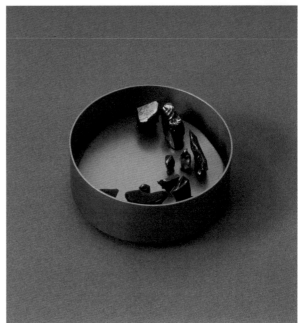

◄▲ Brooches, 2005, silver blackened, obsidian, each, ø 4.8 cm, d 1.6 cm.
► Brooch, 2005, silver blackened, obsidian, ø 4.8 cm, d 1.6 cm.
► Brooch, 2009, silver blackened, obsidian, 7.2 x 6.7 x 1.2 cm.

— 245

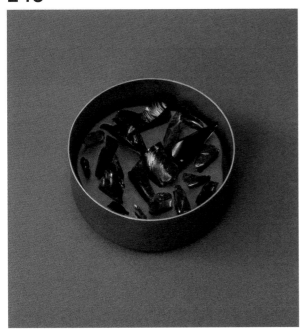

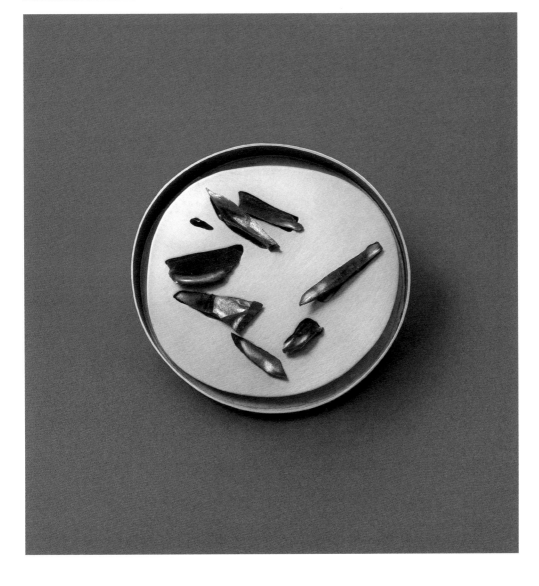

▲ See (lake), brooches, 2004, silver, silver painted, ø 4.4 cm, d 1.8 cm.
▶ Pendant, 2006, silver blackened, 16.0 x 7.0 x 0.05 cm.

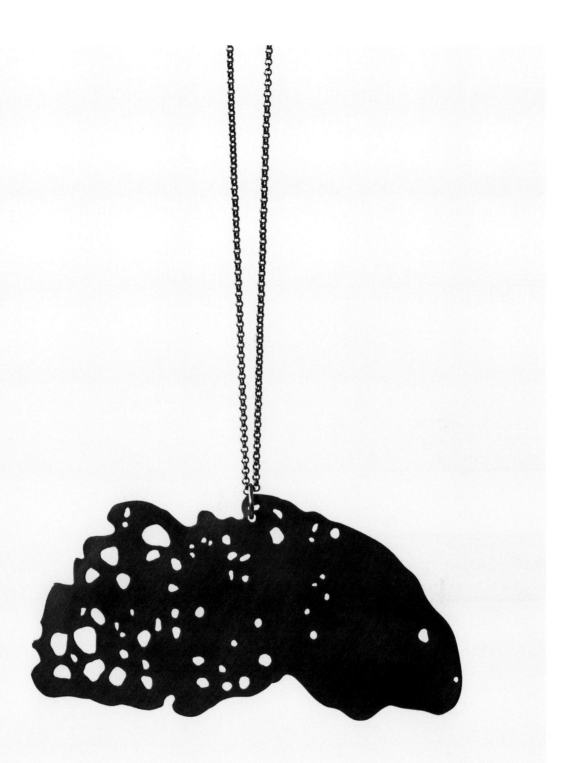

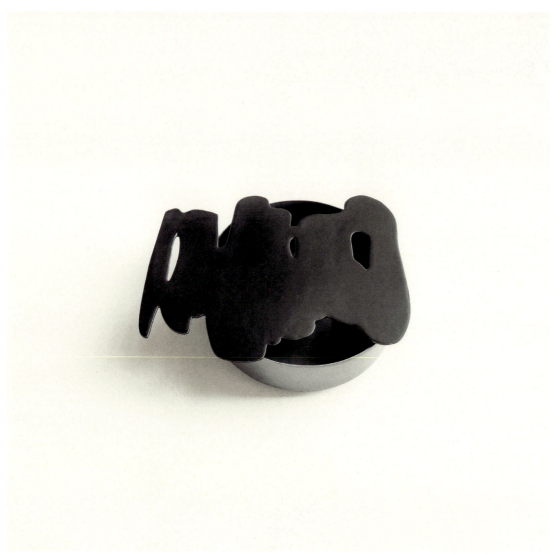

▲ Brooch, 2007, silver blackened and painted, 5.9 x 8.5 x 1.8 cm. mudac, Musée de design et d'arts appliqués contemporains, Lausanne, Switzerland.

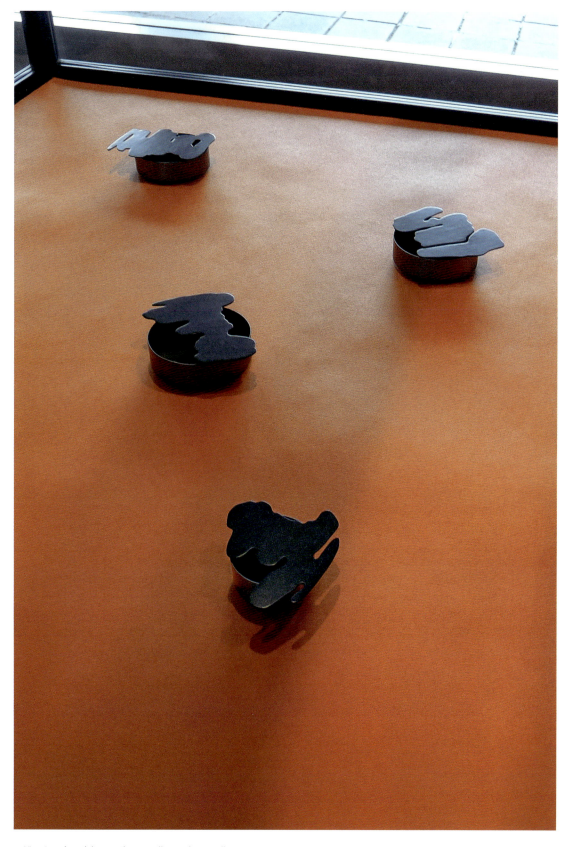

▲ View into the exhibition «Therese Hilbert, Yali», at Gallery Ra, Amsterdam, The Netherlands. Here: Brooches, 2007/2009, silver blackened and painted, different dimensions.

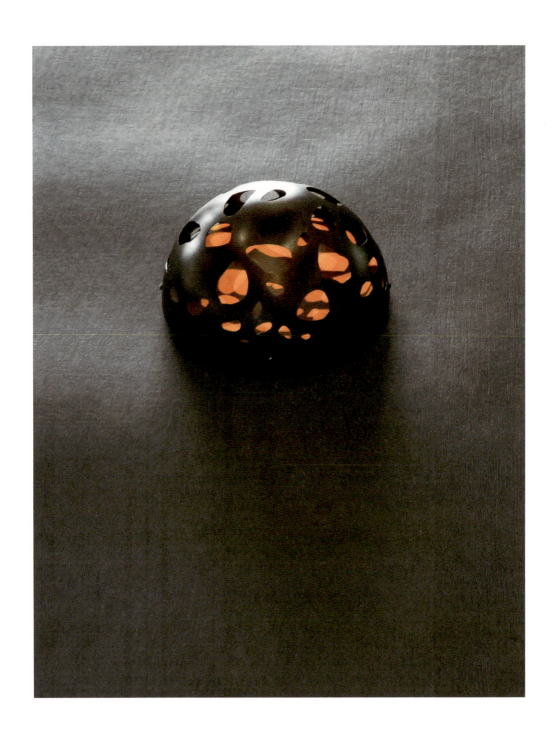

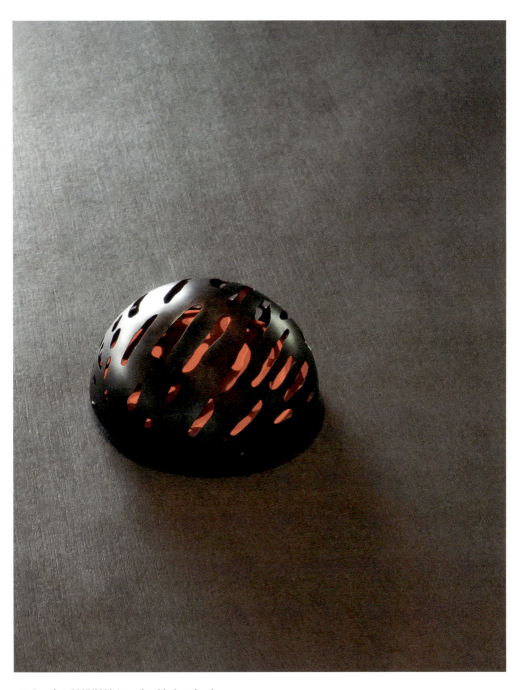

◀▲ Brooches, 2007/2009, iron, silver blackened and painted, each ø 6.8 cm, d 3.6 cm.

Die Freiheit des Vulkans

Ich war ein Berg. Brennende Steine hatte ich in die Luft geschleudert, hoch genug, dass man sie von jenseits des Himmels sah und von dort oben waren sie in rot glühenden Vorhängen zurückgefallen auf die Erde. Sie kamen aus meinem Inneren, wo es stets brodelt. Ich leitete das flüssige Gestein hinaus, durchmaß den Raum in der Vertikale, denn ich bin die Verbindung vom Mittelpunkt der Erde bis zu ihrem Äußersten. Ich reiche von dort, wo alle Masse anfängt, bis dorthin, wo sie davonfliegt, sich zerstreut und auflöst. Es ist so, dass ich im immer geltenden Gesetz der Schwerkraft wurzele und zugleich fähig bin, es aufzuheben. Ein Widerspruch und eine kleine Protzerei. Schließlich kehren meine Geschosse im Himmel um und fallen zurück. Doch ist dies das Geheimnis eines gelungenen Feuerwerks, bei dem das Hinauf so wichtig ist wie das Hinunter der glühenden Funken. Ich könnte mich selbst zerstören. Aber ich erschuf mich auch. Glühende Ströme hatte ich an meinen Flanken hinabgeschickt, kochende Flüsse, die sich einen Weg bahnten, aber kein Weg waren, denn niemand konnte auf ihnen reisen, auch wenn, wie ich hörte, manche davon träumten, sie mit einem Boot aus Titan zu befahren. An meinem Saum wurden sie gekühlt und erstarrten. Später kreisten nur noch Wolken in gelben Spiralen um meinen Gipfel wie ein giftiges Schauspiel. Gelbe Fumarolen, Schwefelgebilde, entstanden aus meinem farbigen starken Atem. Und Schwefel trat auch aus meiner Seite aus, er steckte noch halb fest in mir, als er schon ein neues Plateau formte: von mir abstammend, aus mir kommend, doch fast von mir getrennt. Nun bin ich ein schlummernder Vulkan. Menschen wagen es, auf meinem gefährlichen Haupt spazieren zu gehen. Sie hören ihre eigenen Schritte lauter, wenn sie über meine verstreut liegenden Tuffsteine streifen und meine glasigen Obsidiansteine an den Kanten ihrer Schuhe knirschen. Aber ihre Schritte erscheinen ihnen auch deshalb so laut, weil sie, sobald sie in meine Nähe kommen, wachsam hören und prüfend atmen und aufmerksam schauen. Denn sie wissen von meiner tief liegenden, für sie unsichtbaren Kammer, die eingerichtet ist wie ein warmes Herz: rot, zitternd und strömend. Darum spüren sie, was sie bei ihren Wanderungen auf anderen Bergen selten spüren. Ich bin wandelbar. Ich lebe.

Ich war eine Frau. Sowohl Körper, Oberfläche und Gefäß, abgeschlossen, in mir ruhend, abweisend und eingängig, verletzlich und mich schützend, Zeichen produzierend und sie spiegelnd. Ich kann Gaben aufnehmen, die sich mit dem in mir Vorhandenen vermengen und ich kann sie verwandeln, das Verwandelte beherbergen und wachsen lassen. Mein Körper selbst ist vulkanisch, ausbrechend, eruptiv. Er gibt rote und weiße Flüsse frei und lässt sie wieder versiegen. Die Koralle, die sich an einen Vulkankegel haftet, lässt mich an meine empfindsamsten Stellen denken. Worte wie Eruption und Nachbeben begleiten Höhepunkte meines sinnlichen Lebens, die wie Schmuckstücke sind. Denn so mit einem köperhaften Gefühl verbunden, wächst ihre Bedeutung. Ich suche nach einer nicht verschämten Sprache, ich meide das doppeldeutig Plumpe und liebe das Vieldeutige. Vielleicht ist die erotische Sprache nicht nur die erregendste, klügste und beziehungsreichste Sprache, sondern auch die allgemeinste und darum zutreffendste, die uns mit allem verbindet. Durch sie ist der feuerspuckende Berg Naturphänomen, bewundernswertes Schauspiel und Allegorie für das, was wir als Menschen erleben, wünschen und denken.

Ich war ein Mann. Man verglich meine Energie, meine Kämpfe, meine Gestaltungskraft mit dem nach außen drängenden Vulkan. Das machte mich stolz und ich fühlte mich stark, ich faszinierte mich an mir selbst und ich fürchtete mich doch vor meinem eigenen Symbol. Musste ich etwas, das Herrschaft durch Gewalt, Unwägbarkeit und Chaos idealisierte, mir zum Vorbild nehmen? Vergaß ich darüber nicht die anderen Teile meines Wesens? So wie der Vulkan vieles ist – aufstrebender Berg und umgebende Höhlung – bin ich vieles. Und so emanzipierte ich mich. Auch ich bin ein Gefäß. In mir lagern Gedanken, Worte und Samen. Manches verberge ich, manches bewahre ich und manches lasse ich frei. Ich fühle Verborgenes, Zärtliches, Gefürchtetes, Zurückgehaltenes. Ich kenne das Schöne, Spektakuläre, Zornige, den heißen Ausbruch, der Steine schmelzen lässt. Das rote Feuer, das Materie verdaut. Schwarz ist die Farbe nach dem Brand. Sie ist das Zeichen einer zuvor geschehenen Verausgabung und hinterlässt eine kantige körperliche Präsenz. Ein schwarzer Berg, eine schwarze Landschaft mag lebensfeindlich sein, aber von großer Klarheit. Ein Nullpunkt, an dem die Struktur der Dinge sichtbar wird. Schwarz ist dort, wo Farbe ist: in einem gefärbten Stück Holz. Schwarz ist dort, wo das Licht war: in der Asche, an einem rußigen Berg. Schwarz ist dort, wo das Licht nicht ist: im Universum, der Nacht, der Tiefe. Ein Holzstück kann schwarz sein wie das Weltall, eine Höhle so rau wie ein verkohlter Baum, eine Nacht so tief wie ein geheimnisumsäumtes, die Augen vernarrendes, schwarzes, anziehendes Loch im Universum.

Ich war ein Kind. «Was!» rief ich. «Werde ich aus dem weichen Dunkel hinausgeschleudert werden? Mein Schicksal hat mich auf Wochen im Inneren eines wärmenden Vulkans untergebracht und nun werde ich hinausgedrückt, hinausgepresst, hinausgespuckt. Und es ist das Beste, das mir geschehen kann?» Später, als ich längst begonnen hatte zu spielen, erinnerte ich mich nicht mehr an meine Geburt. Wenn ich spielte, baute ich Berge aus allem, was ich fand. Ich stapelte und häufte an, ich stabilisierte und ließ zusammensinken. Ich spielte verstecken und herauskommen und bohrte meine suchenden Finger in Löcher, die ich erkundete. Ich betrachtete Pudding, der auf dem Herd für mich kochte, und sah vanillefarbenes, kakaofarbenes,

Die Freiheit des Vulkans

himbeerfarbenes Blubbern und Platzen. Wenn Vulkane dies tun, darf man Schlammtopf zu ihnen sagen. In meinen Gedanken besuchte ich sie und fand dort einige ihrer Blasen in einem magischen, matten Schwarz aneinandergereiht. Es freute mich, über die buckeligen Bögen zu tasten, die sind wie kleine, schwarze, luftgefüllte Raupen. Doch so wie ich sie betastete, wollte ich auch hineinstechen, um sie zu befreien, zu entkrampfen, zu glätten, das angehaltene Kriechen durchbrechen, die Qual des Stillliegens, die Buckelplage sich entleeren lassen. Ich freute mich über die gelegentlichen Löcher. Dabei wusste ich nicht, sind sie Eingang oder Ausgang, Maul oder Hinterteil, aus dem die Bergdärme furzen, um die vulkanischen Dämpfe einer wabernden Verdauung zu entlassen?

Ich lernte zu denken. Was ich erlebte, begann ich zu sortieren, was ich sammelte, begann ich zu abstrahieren. Was ich fand, formte ich in Begriffen nach, die dem Gefundenen in Nichts ähnelten, und als ich beides so weit voneinander entfernt hatte, dass das eine im anderen nicht mehr zu erkennen war, begann ich mit den Begriffen zu formen und diese Formen in Silber und Farbe zu setzen. So machte ich aus glattem Silber einen kleinen Kegel und ließ ihn zu einem kostbaren Berg werden. Aus einer metallischen Spitze machte ich einen festen Gipfel, aus einer Spirale Dampf, aus einem Ring wurde das Umschließende, aus einem Hohlraum wurde eine Mitte, aus hellem Blau ein See, aus einem Viereck eine gefüllte Schatulle, aus einem Oval ein Amulett, aus einem Hohlraum eine Tiefe, aus einem Strich ein Weg. Durch diese Verschiebungen verband ich die außerhalb meiner selbst existierende Natur mit menschlichen Begriffen, mit Gefühlen und mit der Suche nach Schönheit.

Ich lernte zu sprechen. Mein Mund war wie eine Box, aus der Überraschendes ausbrach, was mich erlöste und befreite. Obwohl es so hitzig aus mir herausschoss, herrschte allgemeine Freude, weil Neues entstand, weil die vorgegebene enge Form verlassen wurde, weil meine Worte leuchteten, als sie sich auf den Weg machten in mitreißenden Strudeln und in glühenden Streifen, die alle Einfassungen übertraten. Sie waren so fruchtbar, als würde ich damit neues Land oder eine neue Insel erschaffen oder einen neuen Berg, der allerdings auch zerstören konnte. Denn manchmal ließ ich meine Gefühle ausströmen, ohne Rücksicht zu nehmen. Ich ließ sie über die Ränder sozialer Regeln treten. Ich war wütend und wollte es auch bleiben, schön, groß und einschüchternd. Dann lauerten Worte in meinem Inneren wie flüssige Ungeheuer und waren jederzeit bereit zu verwunden und zu verbrennen.

Und ich lernte zu schweigen.

Ich war alt. Ich war voller Geschehenem und Zeit. Das was Zeit brauchte, war entstanden. Über meiner Glut hatte ich dem Wasser erlaubt, sich zu sammeln. Ich war alt, sowie ich Erinnerungen sammelte, und ich war jung, sowie neue hinzukamen, denn meine schönen Seen sind jung, Orte aus ruhigem Wasser. Ich war wie eine Schale und in mir ein runder See, ein Kreis mit geschwungenen Buchten, eine vollkommene Form voller Eigensinn, von heller Farbe, von hellem Blau und hellem Grün, Farben, denen man ansah, dass sie sich mit anderen Farben gemischt hatten, mit einem strahlenden Weiß vor allem, wodurch meine Wasser zwar hell aber nicht

durchscheinend waren. Trüb würden jene sagen, die gern bis zum Grund schauen wollen. Opak würden jene sagen, welche die schwebenden Überlagerungen der Materie mögen. Darum erscheint diese Farbe sanft, rätselhaft und lebendig. Ganz neue Farbtöne sind das nach dem Grau, dem Braun, dem Schwarz, dem Rot und dem Gelb des Berges. Diese Seen lagerten nun am Eingang eines beruhigten Kraters. Meine Ruhe schloss alle vorangegangene Aufruhr mit ein. Sie ist wie eine Erinnerung, über der sich glattes Wasser gesammelt hat. Ich weiß, dass tief darunter ein grummelndes Brodeln lauert. Ich weiß nicht, ob es sich wieder auftürmen wird, bis die schönen Wasserflächen verdampfen und zu aufsteigenden Vorboten werden für den Rauch kommender Explosionen. Denn in mir ist beides, Ruhe und Glut. In mir lagern viele feine Darunter, die ahnbar sind, aber bedeckt, ohne einen Eingang. Es sind magische Räume, denn nur jene sind die eigentlich magischen, die man noch nicht betreten kann.

Ich bin all das.

Und darum werde ich Freiheit.

The volcano's freedom

I was a mountain. I had hurled burning stones into the air, hurled them up high enough to be seen from beyond the heavens, and from those dizzying heights they fell back to Earth in veils of glowing red. They came from deep within me, where magma seethed incessantly. I channeled the molten rock outward, cutting through space vertically, for I am the link between the center of the earth and its outermost crust. I reach from the place where all mass begins to where it flies away, disperses and dissolves. The fact is that I am rooted in the universal law of gravity while at the same time able to suspend it. A contradiction and a little vainglory. After all, my missiles U-turn in the heavens and fall back down to Earth. But this is, after all, the secret of a successful firework, in which the rise is as important as the fall of glowing sparks. I could destroy myself. But I am also my own creator. I have sent glowing streams down my flanks, boiling rivers that broke their way yet were no path, as no one was able to travel on them – despite some, as I heard, dreaming of riding them in a titanium boat. At the hem of my skirts, these rivers cooled and solidified. Later only clouds were left circling my peak in yellow spirals like some toxic spectacle. Yellow fumaroles, sulfurous structures, condensed from my strong, tinted breath. And sulfur also leaked from my side, still half embedded in me as it already formed a new plateau: originating from me, coming out of me, but almost separated from me. Now I the volcano lie dormant. Humans dare to stroll around on my dangerous head. They hear their own footsteps amplified as they pass over my scattered tuff and my glassy obsidians crunch under the edges of their shoes. But their steps also sound so loud to them because when they come close to me, they are on guard, listening intently, breathing carefully and looking about themselves keenly. This is because they know of my deep-seated chamber, far out of their sight and furnished like a warm heart: red, quivering and flowing. That's why they feel something they seldom experience during their treks to other mountain tops: I am changeable. I am alive.

I was a woman. I am at the same time a body, a surface and a vessel, complete, at peace with myself, forbidding and impressive, fragile and protective of myself, producing signs and reflecting them. I am able to receive gifts, which merge with the materials within me, and I am able to transform them, harbor the transformed substances, and allow them to grow. My body itself is of volcanic nature, eruptive. It produces red and white streams, then lets them run dry. The coral clinging to a volcanic cone reminds me of my most sensitive parts. Words such as eruption and aftershock accompany the climaxes of my sensory life that are like pieces of jewelry. By linking them to a physical sensation in this way their meaning grows. I seek a manner of speaking that is not bashful, I avoid the clumsy double entendre and love the ambiguous. Maybe erotic speech is not just the most arousing, the smartest and most suggestive speech, but also the most general and therefore the most applicable, the language that links us to everything else. It allows the fire breathing mountain to be at the same time a natural phenomenon, a spectacle to be admired and an allegory for human experience, desires and thought.

I was a man. Others compared my energy, my struggles, my creative power to the outward thrust of the volcano. This made me proud and I felt strong, I was fascinated with myself, yet feared my own symbol. Did I have to model myself on something that idealized rule through violence, uncertainty and chaos? Did this not cause me to forget the other parts of my nature? And just as the volcano is many things – towering mountain and body enveloping a cavity – I too am many things. And so I emancipated myself. I too am a vessel. I contain thoughts, words and seeds. Some things I conceal, others I safeguard, yet others I release. I feel what is secret, tender, feared, held back. I recognize what is beautiful, spectacular, furious, the hot eruption that melts stones. The red fire that digests matter. Black is the color that follows the blaze. It is the sign of a previous exertion and leaves behind an angular physical presence. A black mountain, a black landscape may be hostile to life, but it is of great clarity. A neutral point, at which the structure of things comes into view. Black occurs where you find color: in a tinted piece of wood. Black is where light used to be: in the ashes, on a sooty mountain. Black is where there is no light: in the universe, the night, the deep. A piece of wood can be as black as space, a cavern as rough as a charred tree, a night as deep as a black, sucking hole in the universe, shrouded by mystery and drawing our gaze.

I was a child. «What!» I screamed «Am I to be ejected from the soft darkness? My fate has kept me sheltered for weeks inside a warming volcano, and now I am being squeezed out, pressed out, spat out. And it is the best thing that can happen to me?» Later, when I had long since begun to play, I no longer remembered my birth. When I played, I built mountains out of everything I could find. I stacked and heaped up, steadied the result, and knocked it over. I played hide-and-seek and I stuck my searching finger into holes that I explored. I watched pudding being cooked for me on the stove and saw vanilla-colored, cocoa-colored, raspberry colored bubbling and bursting. When volcanoes do this, you are allowed to call them mud-pots. In my thoughts I visited them, finding their magical, matt black bubbles strung together in

their pools. Touching the gibbous arches delighted me; they were like small, black, air-filled caterpillars. But as I touched them, I also wanted to pierce them, free them, relax them, smooth them down and punctuate their halted creeping, their agony of lying quiet, wanted to let the plague of humps deflate. I rejoiced at the occasional holes, without knowing whether they were entrance or exit, jaws or an anus emitting farts from the mountain's intestines, releasing the volcanic vapors of a churning digestion.

I learnt to think. I began to classify what I was experiencing, to abstract from what I was collecting. What I found I reconstructed in concepts that no longer resembled the original impetus, and when I had distanced both so far from each other that one could no longer be traced in the other I began to use the concepts to create shapes and to cast these shapes in silver and color. I made a small cone in smooth silver and turned it into a precious mountain. I turned a metal spire into a solid peak, a spiral into the vapor, a ring into the enclosing element, a cavity the center, light blue became a lake, a rectangle a well-stocked jewelry box, an oval an amulet, a hollow a depth, a line became a path. Using these shifts I linked nature, existing outside of myself, to human concepts, feelings and the search for beauty.

I learnt to speak. My mouth was like a box from which surprising words sprang forth, words that released and freed me. Despite all of these words bubbling out of me in such a fiery fashion, those around me were glad to hear them because my words gave rise to something new, because the predefined, narrow mold was being left behind, because my words glowed as they departed in sweeping swirls and glowing streaks that broke through all borders. They were so fertile it was as though I were using them to create new terrain or a new island or a new mountain that nevertheless also held the power to destroy. For sometimes I allowed my feelings to flow without consideration for others. I let them violate the boundaries of social rules. I was angry and wanted to stay that way: beautiful, large and intimidating. Then my words would lie in ambush inside me like liquid monsters, always poised to wound and sear.

And I learnt to remain silent.

I was old. I was full of things that had happened and of time. What had needed time to evolve had come into being. I had allowed water to collect over my embers. I was old as I collected memories and I was young as new ones joined them, because all my beautiful lakes are young, they are places of calm water. I was like a bowl with a round lake inside me, a circle with sweeping bays, a perfect shape, perfectly tenacious, of light color, of light blue and light green, colors that had clearly become intermingled with other colors, most of all with a bright white, which made my waters appear bright but not translucent. Those wanting to see all the way to the ground might call my waters murky. Others, who enjoy the floating overlays of matter, might call them opaque. That is why this color appears mellow, mysterious and animated. These are entirely new hues after the grey, the brown, the black, the

red and the yellow of the mountain. These lakes now sit at the entrance of a pacified crater. My calm has incorporated all preceding turmoil. It is like a memory on which flat water has collected. I know that a grumbling source lurks deep beneath it. I don't know if it will surge up once again, causing the beautiful bodies of water to evaporate and become rising harbingers of the smoke of coming explosions. For I include both calm and fire. I contain many delicate lower layers that may be intuited but remain covered, without entrance. These are magical spaces, because only the spaces we are not able to enter yet remain truly magical.

I am all of this.

And that is why I am becoming freedom.

Yali
2008–2009

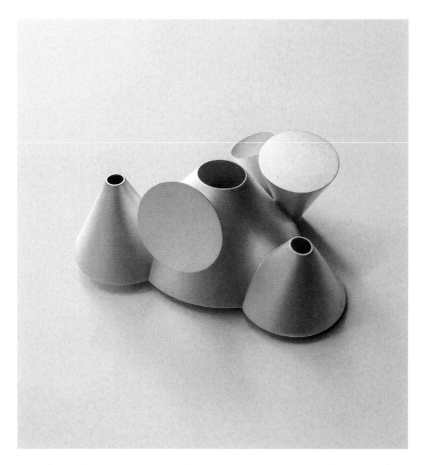

▲ Brooch, 2008, silver, 6.4 x 8.4 x 3.6 cm. mudac, Musée de design et d'arts appliqués contemporains, Lausanne, Switzerland.
▶ Pendant, 2008, silver, partly blackened, 8.5 x 4.3 cm, ø 4.2 cm (sphere). Gallery SO, Solothurn, Switzerland.

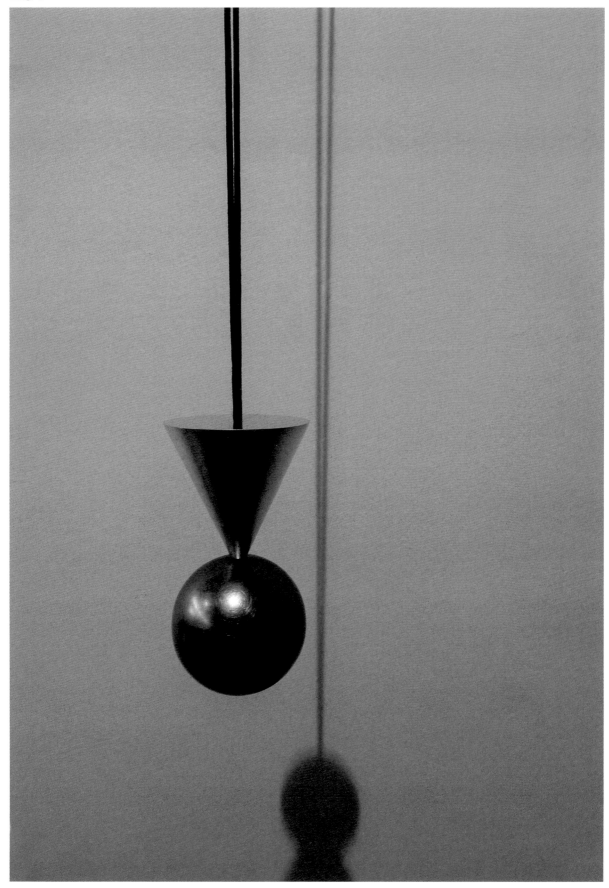

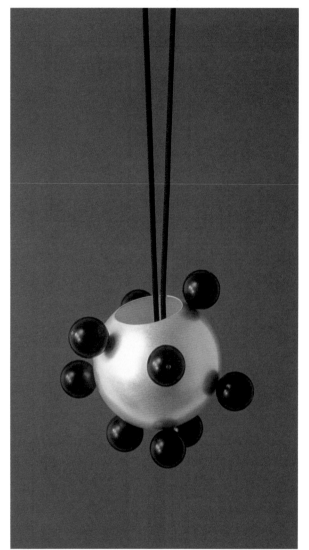
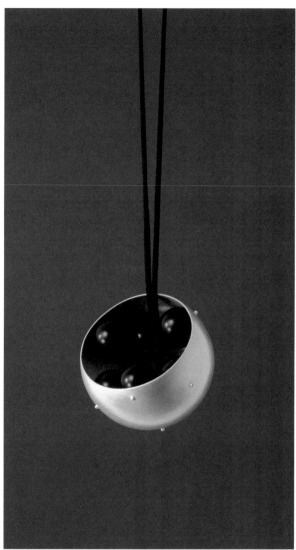

▲ Pendant, 2008, silver, obsidian, ø 4.7 cm. Private collection, Padua, Italy.
◄ Pendant, 2008, silver, obsidian, ø 4.8 cm.

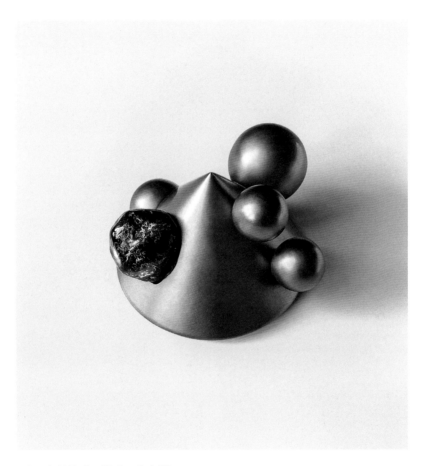

▲ Brooch, 2009, silver blackened, obsidian,
ø 6.4 cm, d 4.4 cm. mudac, Musée de design et d'arts
appliqués contemporains, Lausanne, Switzerland.

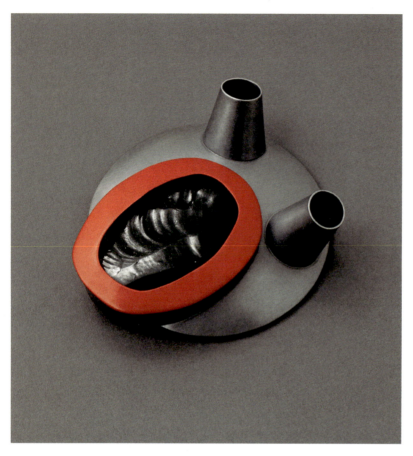

▲ Brooch, 2009, silver blackened and painted, obsidian, ø 6.6 cm, d 2.5 cm. Private collection, Padua, Italy.

▲ Fumarole I, brooch, 2009, silver blackened and painted, ø 7.4 cm, d 1.3 cm.
▲ Brooch, 2009, silver blackened, 8.4 x 6.6 x 1.0 cm.
Private collection, Amsterdam, The Netherlands.

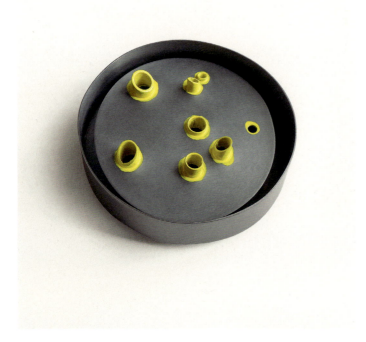

▲ Hot Spot, brooch, 2009, silver blackened and painted, ø 7.2 cm, d 1.2 cm.
▲ Fumarole II, brooch, 2009, silver blackened and painted, 6.6 x 6.2 x 1.5 cm.
▶ Milos Island, Greece, 2013.

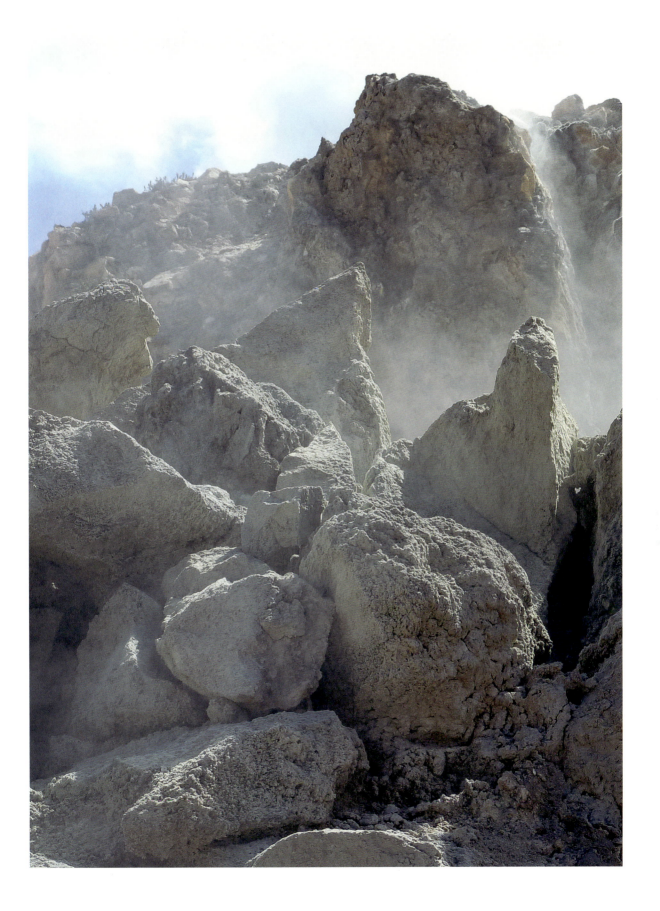

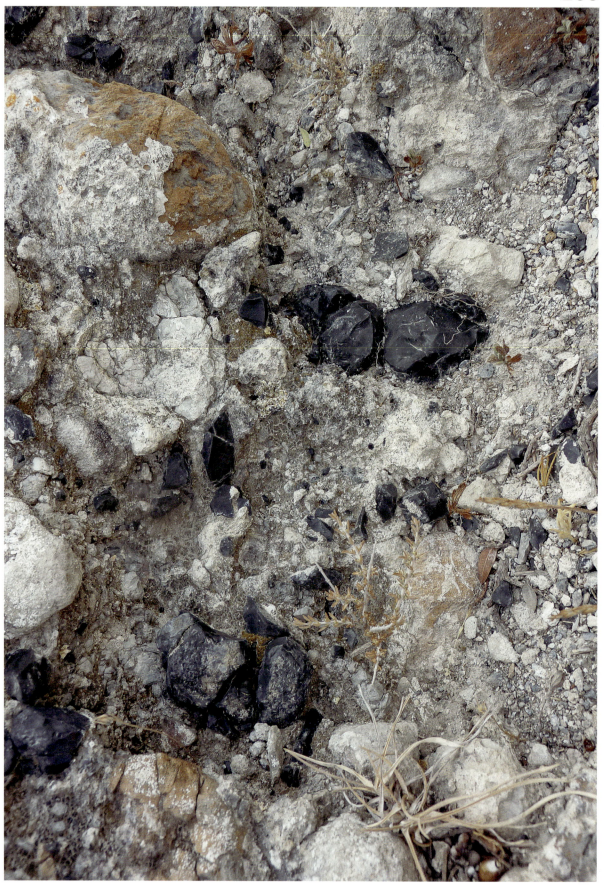

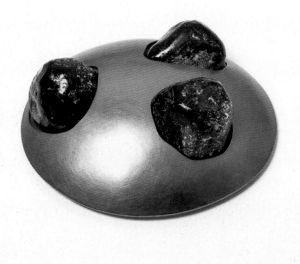

▲ Brooch, 2009, silver blackened, obsidian, 9.1 x 8.0 x 2.9 cm.
◄ Milos Island, Greece, 2013.

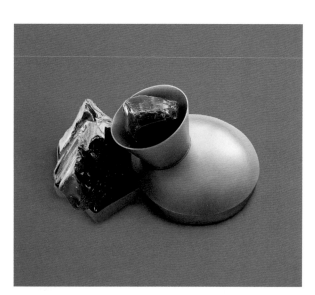

◀ Brooch, 2008, silver blackened, obsidian, 7.6 x 3.8 x 4.9 cm.

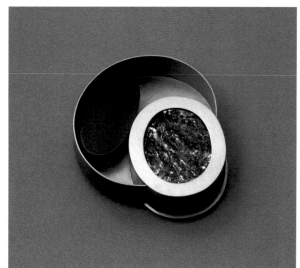

◀ Brooch, 2009, silver blackened and painted, obsidian, 5.6 x 5.9 x 1.3 cm. Private collection, Oslo, Norway.

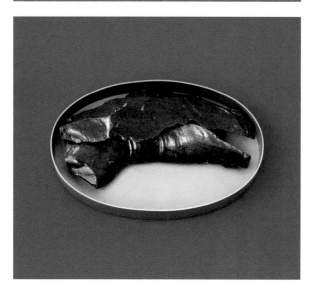

◀ Milos I, brooch, 2009, silver blackened, obsidian, 8.0 x 4.9 x 1.2 cm.

▲ Pendant, 2009, silver blackened, lava stone, ø 4.8 cm.

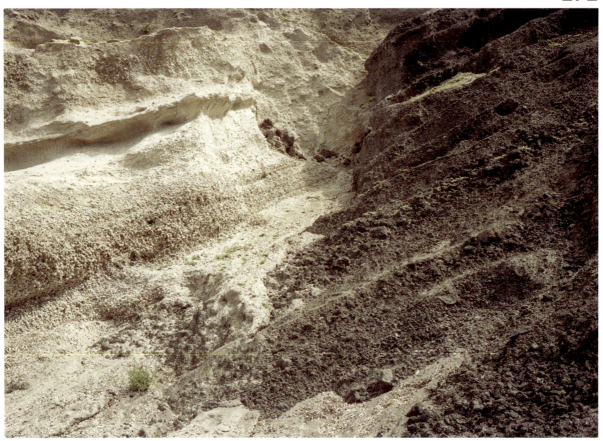

▲ Brooch, 2009, silver, ø 4.3 cm, d 1.7 cm.
◄ Santorin Island, Greece, 2003.

Erwandern – Therese Hilbert

Immer wieder und unermüdlich zieht es mich in den griechischen Archipel.
Einige der Inseln sind vulkanisch.
Die einen sind erloschen, harmlos und still.
Andere sind aktiv und unberechenbar, sie spucken nicht, sie schlafen.
Man traut ihnen nichts Böses zu.
Das Innere ist unsichtbar.

Ich abstrahiere und artikuliere Formen, eine Reflektion über Vorstellung,
Wirklichkeit und Erinnerung.
Eine Referenz an geologisch–vulkanische Formationen, an Farben und
Landschaften und die Spuren früherer Ausbrüche.
Interpretationen der spürbaren Kräfte, die neuen Eruptionen vorausgehen.

Frühling 2010

► Santorin Island, Greece, 2003.

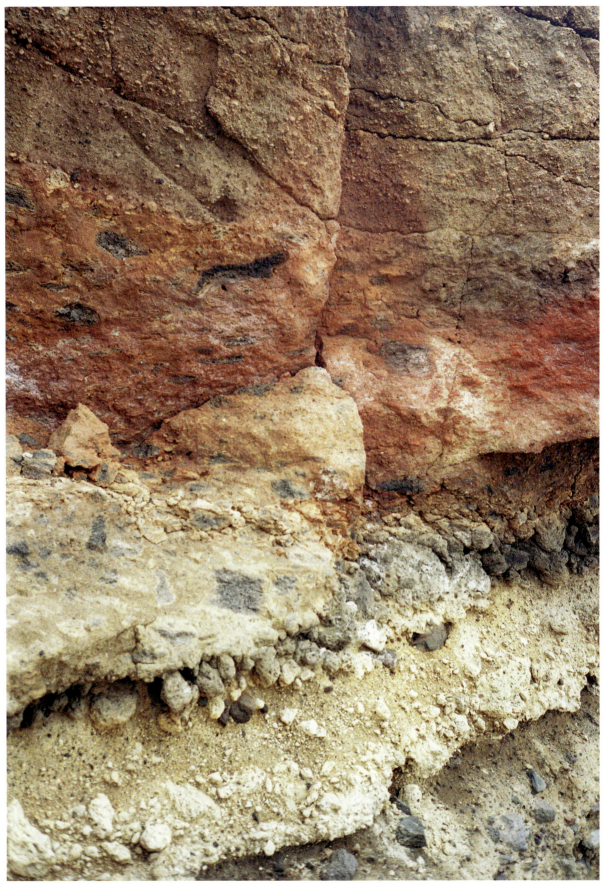

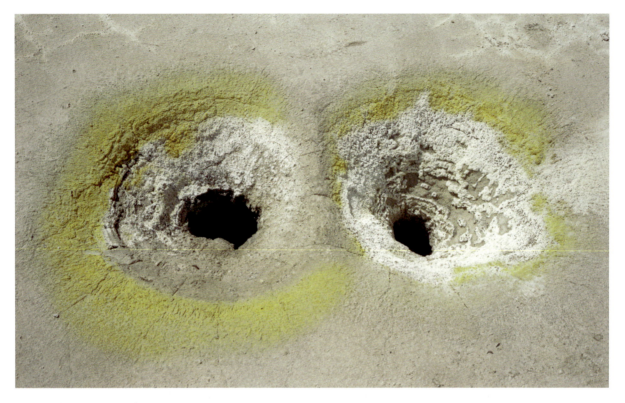

▲ Nisyros Island, Greece, 2008.
▶ Milos Island, Greece, 2013.

Exploring by foot – Therese Hilbert

I am repeatedly and tirelessly drawn to the Greek archipelago.
Some of the islands are of volcanic origin.
The one set of them is long since extinct, harmless and silent.
The other is active and unpredictable, they don't eject, they are sleeping.
Hard to imagine they could do harm.
Their insides are invisible.

I abstract and articulate shapes, a reflection on imagination, reality,
and memory. A reference to geological-volcanic formations, to colors and
landscapes, and to the traces of former eruptions.
Interpretations of the preceding tangible powers of new eruptions.

Spring 2010

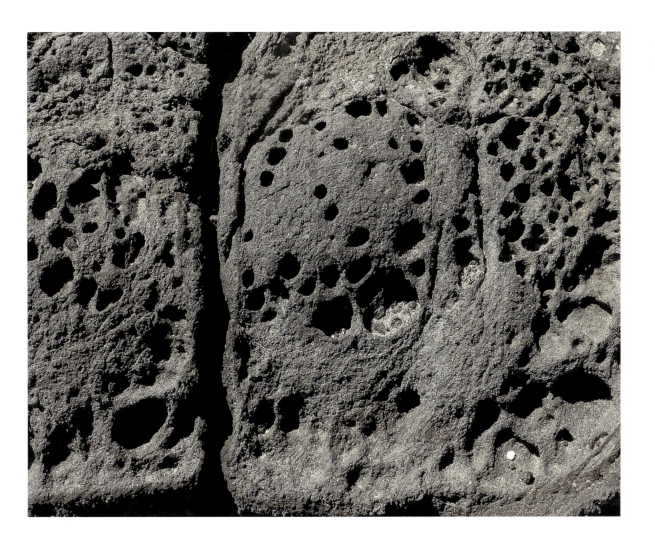

Durch den Sinn gefahren
Flashed through the Mind
2010–2013

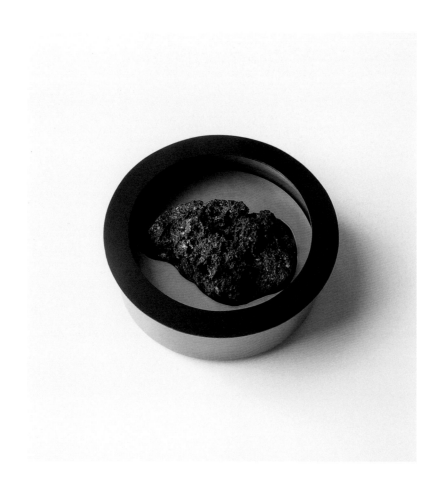

▲ Pendant, 2012, silver blackened and painted,
ø 4.8 cm, d 3.9 cm. Private collection, Munich, Germany.
◄ Brooch, 2012, silver blackened and painted,
volcano, stone, ø 6.6 cm, d 2.0 cm.

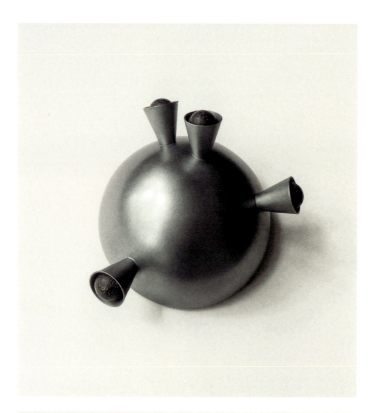
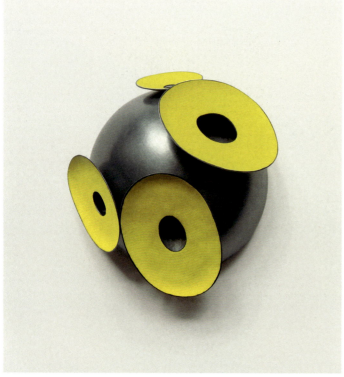

▲ Strogyli, brooch, 2010, silver blackened, lava stone, ø 6.6 cm, d 4.5 cm.
▲ Fumarole III, brooch, 2010, silver blackened and painted, ø 6.7 cm, d 4.9 cm. Private collection, Melbourne, Australia.

▲ Brooch, 2013, silver blackened, volcano stone, 5.0 x 4.2 x 2.8 cm.

▲ Brooch, 2013, silver blackened and painted, 9.8 x 7.7 x 0.7 cm.

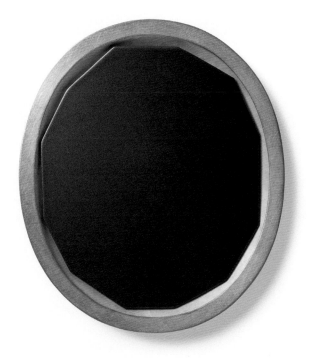

▲ Brooch, 2013, silver blackened and painted, 9.5 x 8.3 x 0.8 cm.
Schmuckmuseum Pforzheim, Germany.

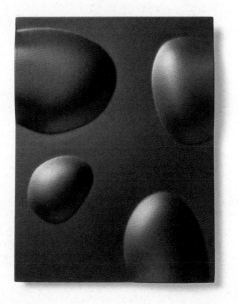
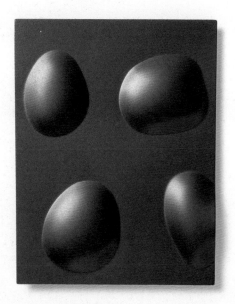
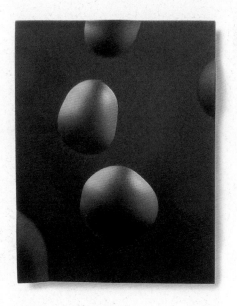
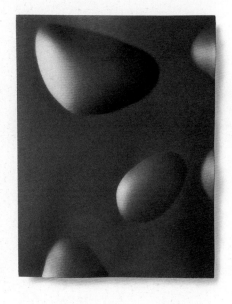

▲ Brooch, 2012, silver painted, 8.3 x 6.5 x 0.4 cm.
▲ Brooch, 2012, silver painted, 8.4 x 6.5 x 0.4 cm.

▲ Brooch, 2012, silver painted, 8.3 x 6.5 x 0.4 cm.
▲ Brooch, 2012, silver painted, 8.2 x 6.6 x 0.4 cm.

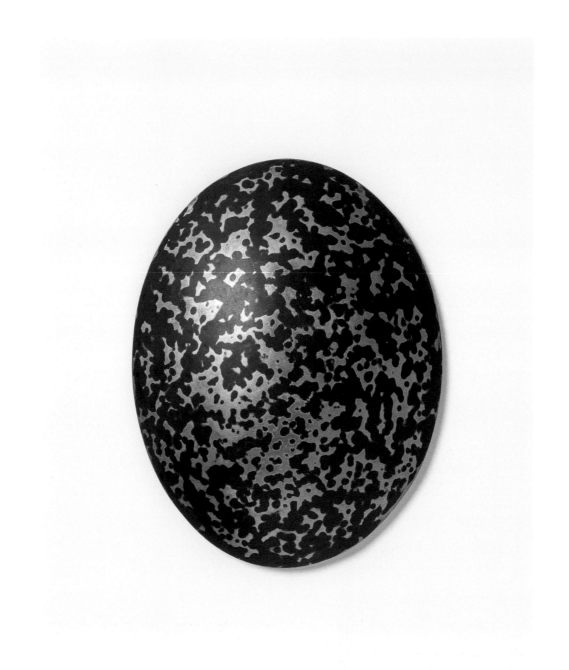

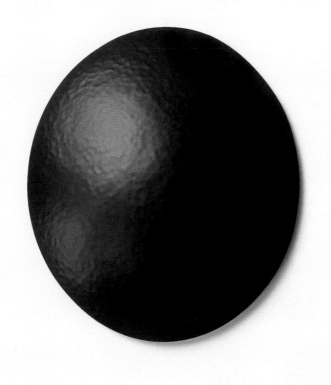

▲ Brooch, 2013, silver blackened and painted, 8.9 x 7.9 x 1.2 cm.
◄ Brooch, 2013, silver blackened and painted, 10.2 x 8.0 x 1.2 cm.
LACMA, Los Angeles County Museum of Art, The Lois Boardman
Collection, USA.

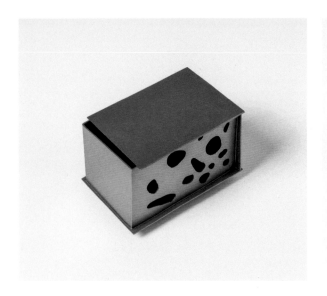
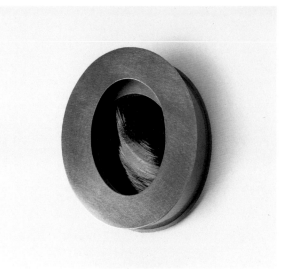

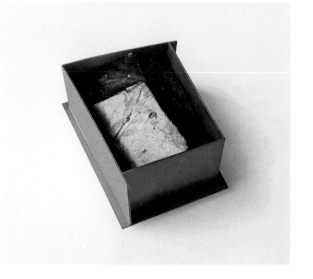
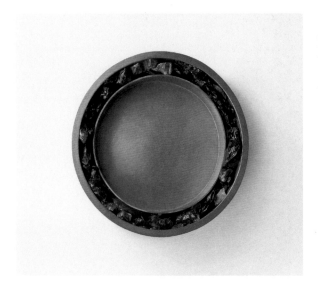
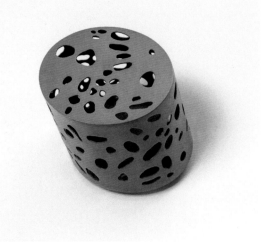

▲ Brooch, 2013, silver blackened, 6.2 x 3.6 x 3.1 cm.
▲ Brooch, 2012, silver blackened, obsidian, ø 6.5 cm, d 2.4 cm.
▲ Brooch, 2011, silver blackened, obsidian, ø 6.9 cm, d 1.4 cm.
Private collection, Munich, Germany.

▲ Brooch, 2013, silver blackened, obsidian, 6.2 x 5.0 x 2.3 cm.
Private collection, Munich, Germany.
▲ Brooch, 2013, silver blackened, obsidian, 5.0 x 4.5 x 2.8 cm.
▲ Brooch, 2013, silver blackened, 5.3 x 5.1 x 3.3 cm.

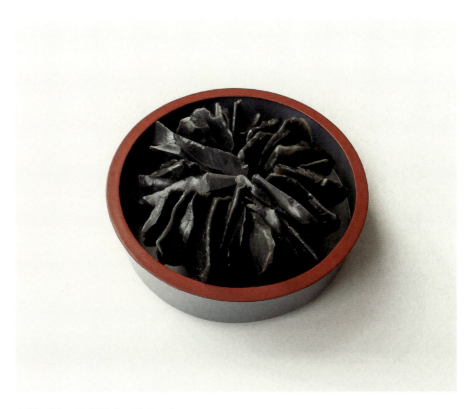

▲ Milos II, brooch, 2010, silver blackened and painted, obsidian, ø 6.9 cm, d 2.6 cm.

Schwarze Berge
Black Mountains
2015–2018

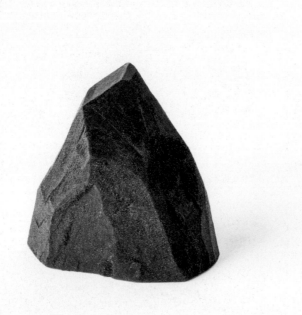

▲ Berg, brooch, 2016, MDF, steel, 6.2 x 5.7 x 2.2 cm.
▶ Berge, brooches, 2015/16, MDF, steel, different dimensions.

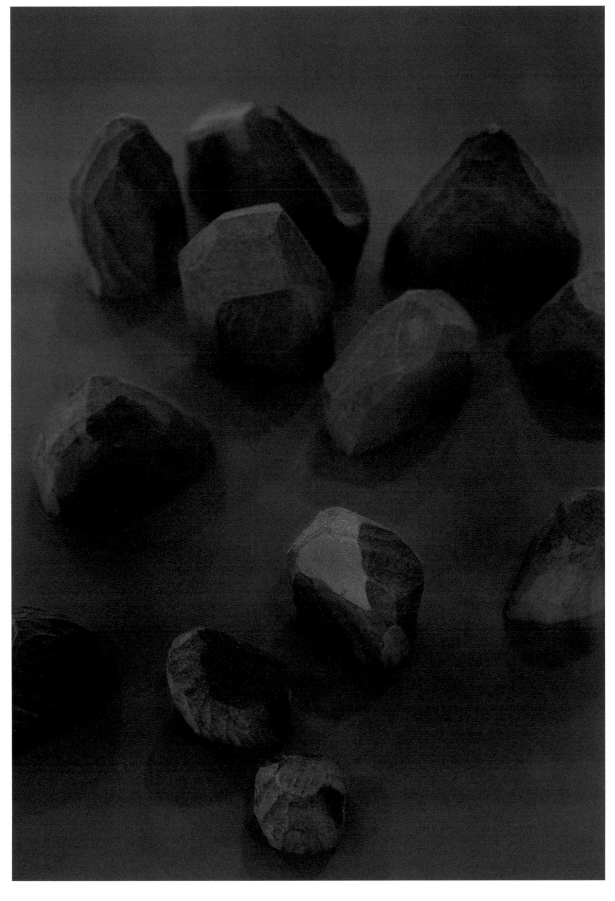

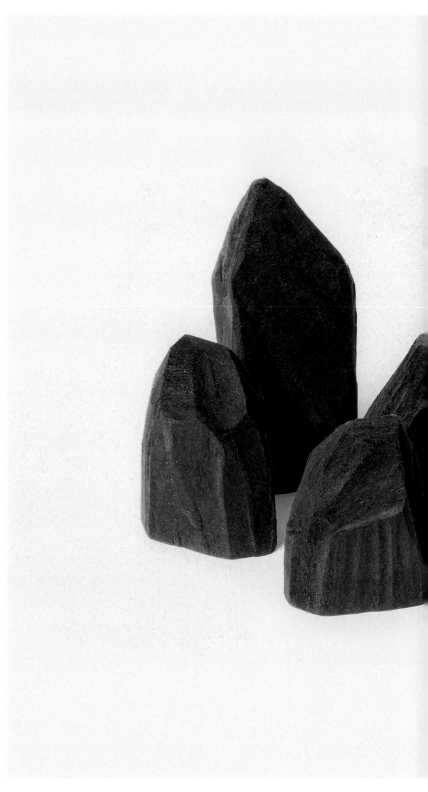

▲ Berge, brooches, 2015/16, MDF, steel, different dimensions.

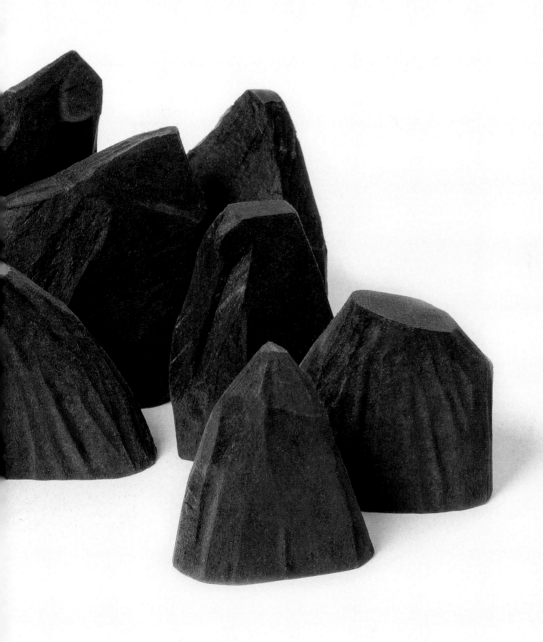

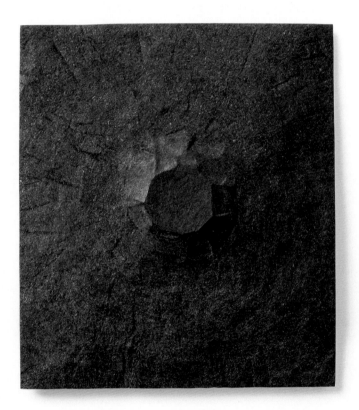

▲ Landschaft, brooch, 2015/16, MDF, steel, 9.0 x 8.0 x 1.6 cm.
◀ Landschaft, brooch, 2015/16, MDF, steel, 9.0 x 8.0 x 1.6 cm.

Rūaumoko, hörst du mich?

Die größte Stadt Neuseelands liegt auf einem aktiven Vulkanfeld, das in den vergangenen 250.000 Jahren über 53 Ausbrüche zu verzeichnen hatte. Katastrophale Feuersbrünste haben ganze Wälder vernichtet und die Landenge von Auckland lichterloh brennen lassen. Wissenschaftler stellen sich nicht die Frage, ob es wieder passieren wird, sondern wann.[1]

Auch wenn ich natürlich keinesfalls möchte, dass meine Stadt und ihre Einwohner zu Schaden kommen, so würde ich mir wünschen, dass Auckland seinem geologischen Ruf mit der Bildung eines neuen Vulkans gerecht wird. Einer, der möglichst noch zu meinen Lebzeiten entsteht. Ich weiß zwar nicht, an wen ich eine solche Bitte richten könnte, doch ist sie nicht so ungewöhnlich, wie sie sich vielleicht anhört. Von Wissenschaftlern erhobene Daten der jüngsten seismographischen Untersuchungen der Erdkruste unter Auckland zeigen, dass sich unter der Stadt eine elliptische, brodelnde Magmablase mit einer Ausdehnung von fünfzig mal zwanzig Kilometern befindet. Sie gehen davon aus, dass sich das Magma irgendwann in naher Zukunft trotz der 53 existierenden verschlossenen Schlote seinen Weg durch die Erdkruste bahnen und Vulkan Nr. 54 entstehen wird.

Sollte es so sein, wünsche ich mir, dass Vulkan Nr. 54 von der Veranda meines Hauses zu sehen, aber gleichzeitig hoffentlich weit genug entfernt ist, dass mir Asche und Lavaströme nichts anhaben können. Und doch wiederum nah genug, um seine Aktivitäten prüfen und beobachten zu können, wie sich am Horizont allmählich ein perfekter Kegel formt.

Bereits jetzt kann ich von meiner Veranda den niedrigen Kegel des großen Schildvulkans[2] Rangitoto sehen. Er ist der jüngste und größte der verbliebenen Vulkane von Auckland, der erstmals vor 1000, zuletzt vor 600 Jahren ausgebrochen ist. Der Küste vorgelagert, ist seine sehr flache, sanft ansteigende Form von den meisten Plätzen in Auckland zu sehen. Er ist zu einem Symbol der Stadt geworden. Der deutsche Geologe Ferdinand von Hochstetter schrieb nach seinem Besuch der Stadt im

1 Geoff Chapple, «The Fire beneath Us», in: New Zealand Geographic, Nr. 131, Januar–Februar 2015, online https://www.nzgeo.com/stories/the-fire-beneath-us/, aufgerufen am 14.12.2021.

2 Durch wiederholte, dünnflüssige Lavaströme gebildete Vulkane mit flachen, weitausladenden Flanken.

Jahre 1859, dass der Rangitoto «für den Hafen von Auckland so bestimmend sei wie der Vesuv für den Golf von Neapel.»[3]

Hochstetter war der erste Europäer, der das Vulkangebiet von Auckland eingehend kartografierte. Auf seiner Karte, sie ist eines meiner Lieblingsbilder meiner Stadt, erscheint der Isthmus von Auckland, der Tāmaki, mit den 53 in feurig roter Tinte dargestellten Vulkanen wie die pickelige Haut eines Teenagers.[4]

Zu der Zeit als Hochstetter in den Hafen von Auckland segelte, zeichneten sich die Vulkane der Stadt als ständige Kulisse am Horizont ab. Die Māori, die ersten Bewohner des Isthmus, haben den letzten Ausbruch des Rangitoto noch erlebt. Für die Beobachter des Vulkans war der Rangitoto das Werk von Rūaumoko. Unter den vielen Gottheiten, die die Welt der neuseeländischen Ureinwohner erklären, ist der Rūaumoko der Māori-Vulkan, der Gott der Erdbeben und Vulkane. Nach ihrem Schöpfungsmythos wurden der Himmelsvater Rangi (Ranginui) und die Erdmutter Papa (Papatūānuku) von ihren eigenen Kindern voneinander getrennt. In dieser Zeit bekamen sie ein ungeborenes Kind, das sie Rūaumoko nannten. Als Papa von ihren Söhnen auf das Gesicht gelegt wurde, damit sie Rangi nicht länger sehen konnte, blieb Rūaumoko im Leib seiner Mutter. Nach der Trennung von Rangi wurde Papa durch das brodelnde Magma von Rūaumoko gewärmt und getröstet.

Der Name Rangitoto bedeutet so viel wie ‹blutiger Himmel›, eine ausgesprochen bildhafte Namensgebung, die die Weltsicht der Māori widerspiegelt (rangi = Himmel, toto = Blut). Das Magma ist das Blut der Erdmutter Papa und quillt als flüssiges Gestein aus ihrer aufgerissenen Haut hervor, Funken in den Himmel speiend.

Viele Jahrhunderte später sinnierte Hochstetter aus einem anderen Blickwinkel und mit den Augen der westlichen Wissenschaft: «wie lange die vulkanische Aktivität im Isthmus angedauert hat und ob sie nochmals zurückkehren wird kann natürlich nicht beantwortet werden».[5] Im 21. Jahrhundert kennen Hochstetters Kollegen bei der Beantwortung dieser Frage kaum noch Zweifel. Sie sagen schlichtweg: Es wird passieren.

Liegen die Auckländer oder ich in der Nacht wach und machen uns diesbezüglich Sorgen? Nein, das bezweifle ich – ich jedenfalls tue es nicht.

Aber so wie das eine gewisse Leugnung der Gefahr von mir fordert, gebe ich mich auch gerne der Illusion hin, dass der von mir herbeigewünschte neue Ausbruch nicht so explosiv und zerstörerisch sein möge, wie das im Allgemeinen bei Vulkaneruptionen der Fall ist. Ich hoffe vielmehr, dass die Entstehung von Vulkan Nr. 54 eine wesentlich ruhigere Angelegenheit wird, ohne verheerende Brände und

[3] Ferdinand von Hochstetter, Geologie von Neu-Seeland. Beiträge zur Geologie der Provinzen Auckland und Nelson, Wien 1864.

[4] Ferdinand von Hochstetter, Der Isthmus von Auckland mit seinen erloschenen Vulkankegeln (engl. Erstausgabe o.O. 1859, dte. Erstausgabe: Geologisch-topographischer Atlas von Neu-Seeland, Gotha 1865).

[5] Ferdinand von Hochstetter, Geologie von Neu-Seeland. Beiträge zur Geologie der Provinzen Auckland und Nelson, Wien 1864.

Rūaumoko, hörst du mich?

Ascheregen für die Bewohner Aucklands.

Obwohl die vulkanischen Ursprünge von Tāmaki heutzutage größtenteils von der Stadt verdeckt sind, die sich mehr und mehr an den Flanken der verbliebenen Kegel ausbreitet, ragen einige grasgrün bewachsene Spitzen noch auf markante Weise aus dem städtischen Umfeld heraus.

 Seit der Ankunft der Menschen auf dem Tāmaki wurde die vulkanische Landschaft genutzt und die Stadt auf den verbliebenen Gesteinsschichten errichtet. Die Kegel wurden für Befestigungen abgestuft und untertunnelt. Die verschiedenen Formen der von den Vulkanen stammenden, basaltischen Lava nutzte man für unterschiedlichste Zwecke. Ich habe sogar Schmuck daraus gemacht.

Während sich mein Verbrauch an vulkanischem Gestein für die Schmuckherstellung eher in Grenzen hält, wurden die Vulkankegel in einigen Fällen bis auf Bodenniveau abgetragen, um dem Bedarf an Baumaterial nachzukommen.

 Vor dem Hintergrund der Geschichte und dem damit einhergehenden Verlust plädiere ich daher im Rahmen einer durchaus sinnvollen Ersatzstrategie für einen Vulkan Nr. 54.

Rūaumoko, hörst du mich?

Can you hear me Rūaumoko?

Warwick Freeman

Can you hear me Rūaumoko?

New Zealand's largest city sits atop an active volcanic field that has erupted at least 53 times in the past 250,000 years. The catastrophic blasts felled forests and set the Auckland isthmus alight. Scientists are not wondering if it will happen again … but when.[1]

While not wishing my city or its citizens any harm, I would like to put in a request that Auckland live up to its geological reputation and add to the above record, another volcano please. One that appears in my lifetime. Not sure who I should petition for such a requisition but it's not untimely, because going by the data that scientists have collected from recent seismographic surveys of the crust under Auckland, there exists beneath the city a fifty by twenty kilometre oval ball of boiling magma. They speculate at some stage in our future the magma will ignore the existing 53 blocked vents and find a way up through the crust and create Volcano No. 54.

When it does, I hope that Volcano No. 54 is visible from the veranda of my house, far enough away so I'm not worried by its ash or lava flows but close enough so I can check its mood and progress each day as I watch it form a perfect cone on my horizon.

Already from my veranda, I can see the low cone of a large shield volcano called Rangitoto.[2] Rangitoto, the most recent and the biggest of Auckland's remaining volcanoes, erupted for the first time 1000 years ago and most recently 600 years ago. Sitting just off the coast and visible from most points of Auckland, the low spread form of Rangitoto is an enduring and defining symbol of the city. Visiting in 1859, German geologist Ferdinand von Hochstetter wrote that Rangitoto: «is for Auckland Harbour what Vesuvius is for the Bay of Naples.»[3]

[1] Geoff Chapple, «The Fire beneath Us», in: New Zealand Geographic, vol. 131, January-February 2015, online https://www.nzgeo.com/stories/the-fire-beneath-us/, last retrieved December 14, 2021.

[2] Volcanoes formed by repeated, thin lava flows with flat, wide-arching flanks

[3] Ferdinand von Hochstetter, Geologie von Neu-Seeland, Beiträge zur Geologie der Provinzen Auckland und Nelson, Vienna 1864.

Can you hear me Rūaumoko?

Hochstetter was the first European to thoroughly map Auckland's volcanic field; his map, one of my favourite images of my city, has the Auckland isthmus, Tamaki, pimpled like a teenager's bad skin, with the 53 volcanoes depicted in angry red ink.[4]

By the time Hochstetter sailed into the harbour, Auckland's volcanoes would have been a settled presence on the skyline. But Rangitoto's last eruption would have been witnessed by Māori, the first inhabitants of the isthmus. For those volcano watchers Rangitoto was the work of Rūaumoko. Amongst the many deities that explain their world, Rūaumoko is the Māori Vulcan, the God of earthquakes and volcanoes. In their creation myth, when the sky father Rangi (Ranginui) and the earth mother Papa (Papatūānuku) were separated by their children, they had an unborn child, Rūaumoko. When Papa was turned face down by her sons, so that she could no longer see Rangi, Rūaumoko stayed in his mother's womb; his boiling magma keeping her warm and comforting her after the separation.

The name Rangitoto can be translated as ‹bloody sky›, a descriptive naming reflecting the Māori world view (rangi = sky, toto = blood); magma is the Earth Mother's blood and the molten rock escapes when her skin is ruptured, spewing fire into the sky.

Centuries later, in another world view being visited on Auckland's volcanoes – the inquiring eye of Western science – Hochstetter reflected: «how long volcanic activity lasted on the isthmus and whether it could return once more naturally cannot be answered.»[5] In the 21st century, Hochstetter's scientific colleagues aren't so unsure about answering that question, they say simply: it will happen.

Do I and other Aucklanders lie awake at night worrying about it? I don't think so – I certainly don't.

But just as that requires some denial on my part, I'm also happy to delude myself that the generally explosive and destructive behaviour of volcanoes won't be in the nature of the new eruption I'm ordering up. I expect the formation of Volcano No. 54 to be a much quieter affair, no wreaking fire and ash havoc on Auckland's inhabitants.

Although the volcanic origins of Tamaki are now largely obscured by the city that has spread across the flanks of the remaining cones, the ones that clear their heads of the built landscape are still very visible and mostly coloured a pleasant grassy green.
 Since the arrival of humans on Tamaki, the volcanic landscape has been put to use – the city has been built on and with the remnant volcanic rock strata; the cones have been stepped and tunnelled for fortifications and the various types of basaltic lava produced by the volcanoes have been used in myriad ways. I have even made jewelry with it.

[4] Ferdinand von Hochstetter, Der Isthmus von Auckland mit seinen erloschenen Vulkankegeln (first edition in English: 1859. First edition in German: Geologisch-topographischer Atlas von Neu-Seeland, Gotha 1865).

[5] Ferdinand von Hochstetter, Geologie von Neu-Seeland, Vienna 1864.

While my consumption of volcanic stone for jewelry making is very slight, in some extreme cases the volcanic cones have been quarried to ground level to supply the demand for material. Reflecting on this history makes me think in light of this loss, at the least, this makes my petition for Volcano No.54 just part of a sensible replacement strategy.

Can you hear me Rūaumoko?

Aus der Tiefe
From the Depth
2014–2019

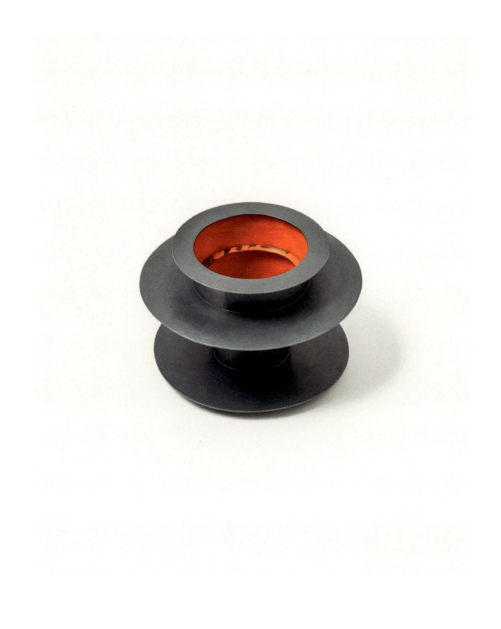

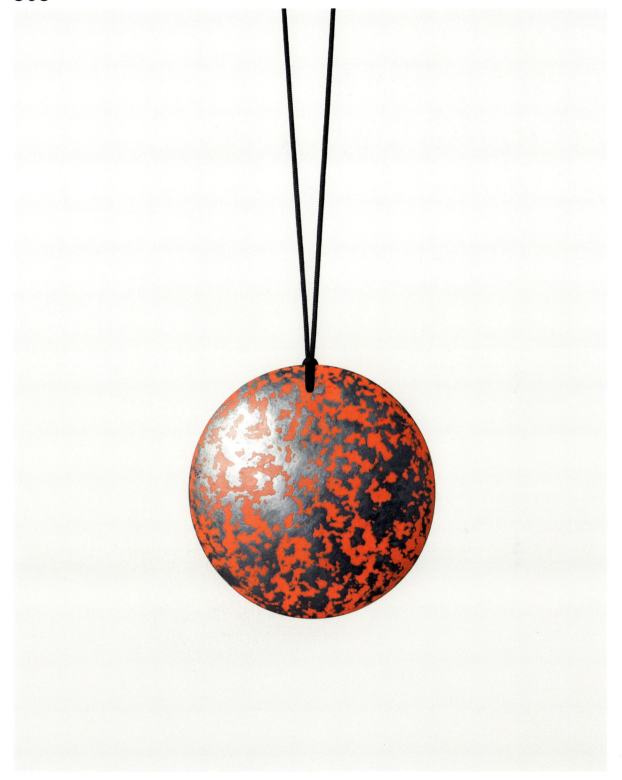

▲ Pendant, 2018, silver blackened and painted, ø 10.5 cm, d 2.0 cm.
◄ Brooch, 2018, silver blackened and painted, ø 6.6 cm, d 3.7 cm.

▲ Brooch, 2018, silver blackened and painted, ø 7.0 cm, d 5.0 cm.
▶ Brooch, 2018, silver blackened and painted, ø 8.4 cm, d 5.0 cm.

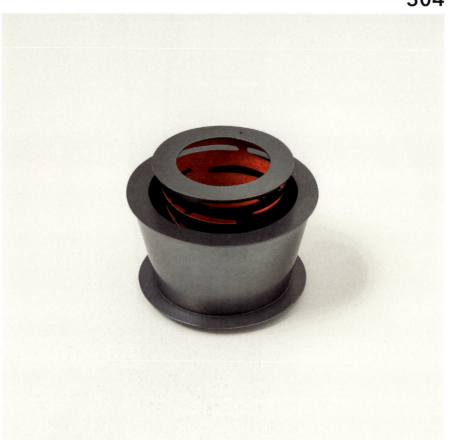

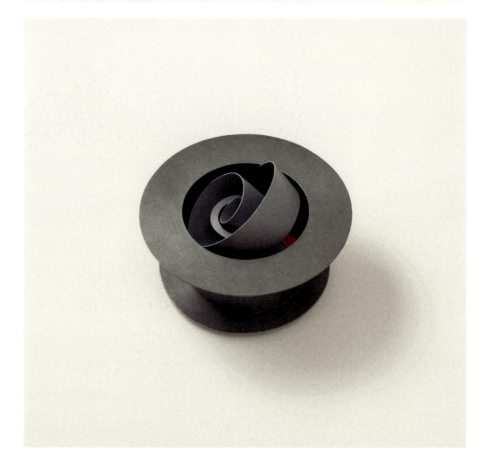

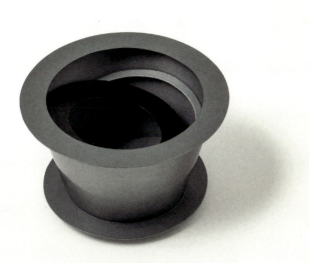

▲ Brooch, 2018, silver blackened and painted, ø 7.9 cm, d 5.0 cm. Private collection, Hanau, Germany.
◄ Brooch, 2018, silver blackened and painted, ø 7.5 cm, d 4.2 cm.

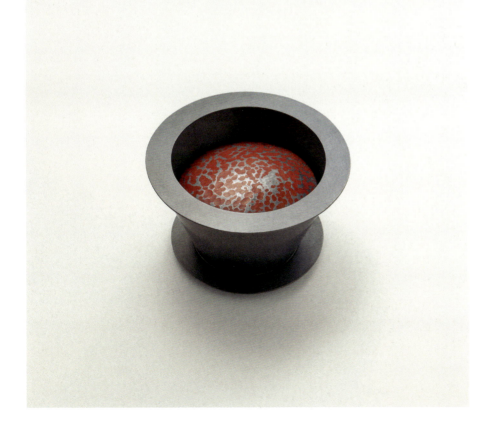

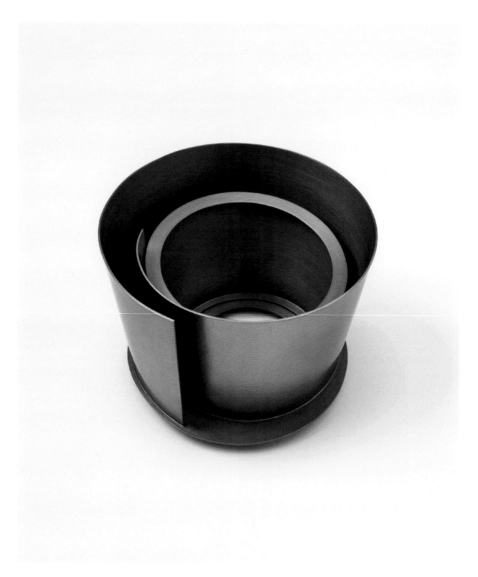

▲ Brooch, 2018, silver blackened, 7.1 x 6.1 x 4.2 cm.

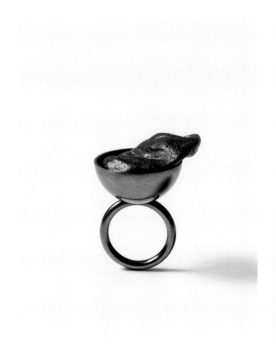

▲ Ring, 2012, silver blackened, lava stone, ø 2.6 cm, d 3.6 cm. Private collection, Munich, Germany.

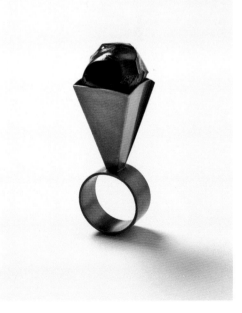

▲ Ring, 2016, silver blackened, obsidian, 3.8 x 2.0 x 2.2 cm. Private collection, Philadelphia, USA.

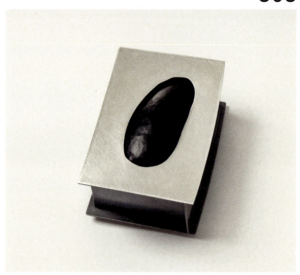

▶ Brooch, 2016, silver partly blackened and painted, 5.5 x 3.9 x 2.5 cm.
▶ Brooch, 2016, silver blackened, obsidian, 7.1 x 3.9 x 2.6 cm.
▶ Brooch, 2017, silver blackened and painted, 5.7 x 4.2 x 2.6 cm. Private collection, Sydney, Australia.

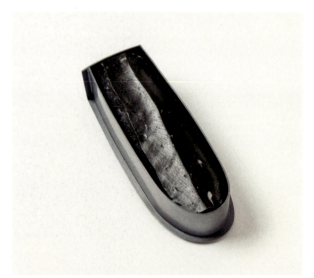

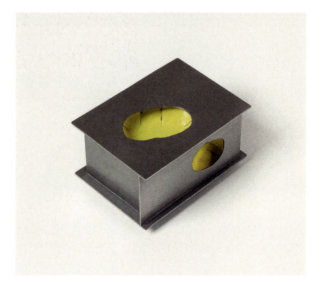

▶ Brooch, 2017, silver painted, 8.7 x 6.4 x 0.5 cm.

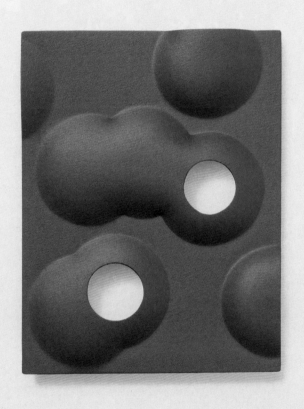

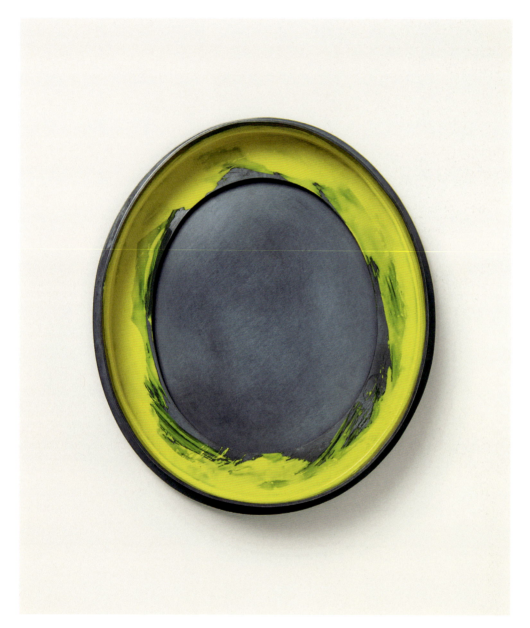

▲ Brooch, 2016, silver blackened and painted, 9.4 x 8.4 x 1.5 cm.
GRASSI Museum für Angewandte Kunst, Leipzig, Germany.
▶ Brooch, 2018, silver blackened and painted, 9.6 x 7.1 x 1.5 cm.
▶ Brooch, 2018, silver blackened and painted, 10.6 x 7.0 x 1.5 cm.

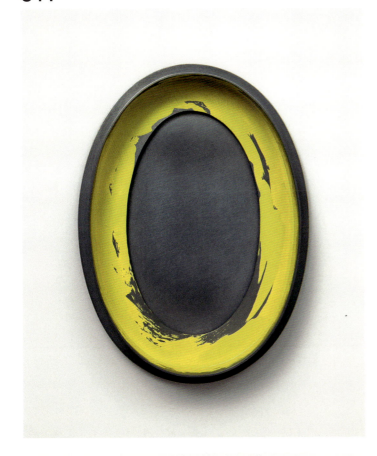
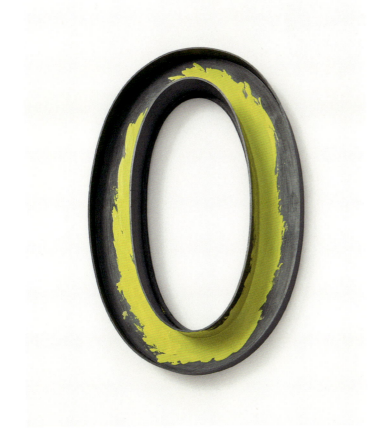

▲ Brooch, 2018, silver blackened, 7.8 x 7.7 x 4.8 cm.
◀ Brooch, 2018, silver blackened, 10.5 x 10.2 x 4.0 cm.

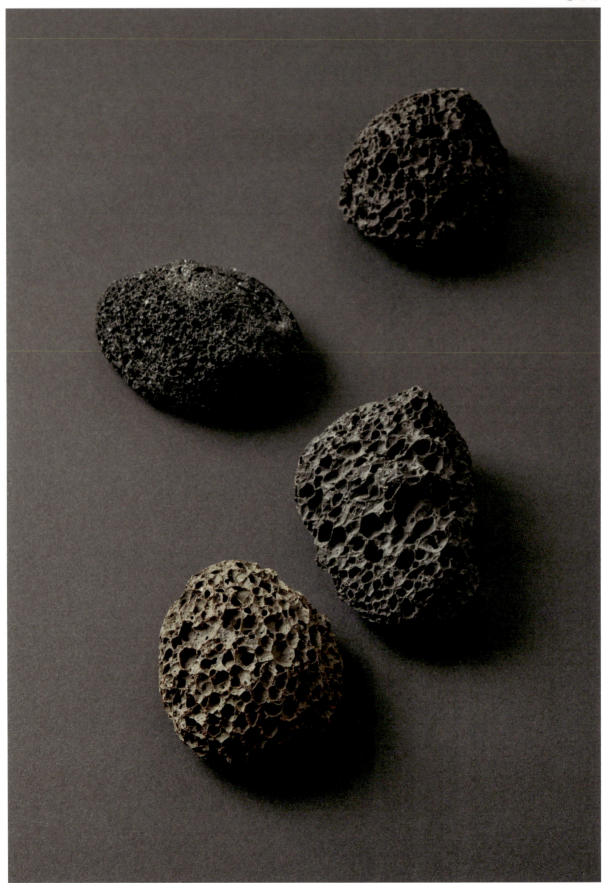

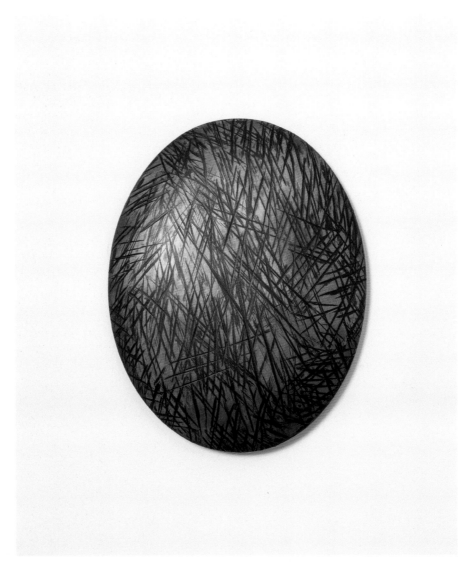

▲ Brooch, 2018, silver blackened and painted,
9.8 x 7.8 x 1.0 cm. Private collection, Munich, Germany.
◄ Brooches, 2016–2019, volcano stones, silver,
different dimensions.

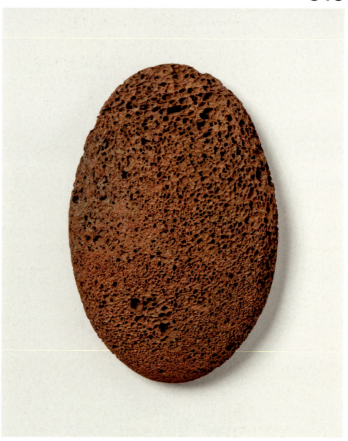

▲ Brooch, 2019, volcano stone, silver, 9.4 x 6.4 x 2.3 cm.
▶ Brooch, 2019, pumice, silver, 8.0 x 5.2 x 1.9 cm.
▶ Milos Island, Greece, 2017 (p. 317).

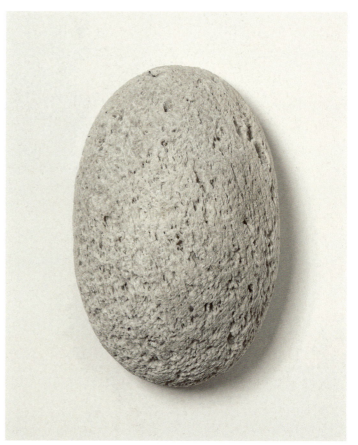

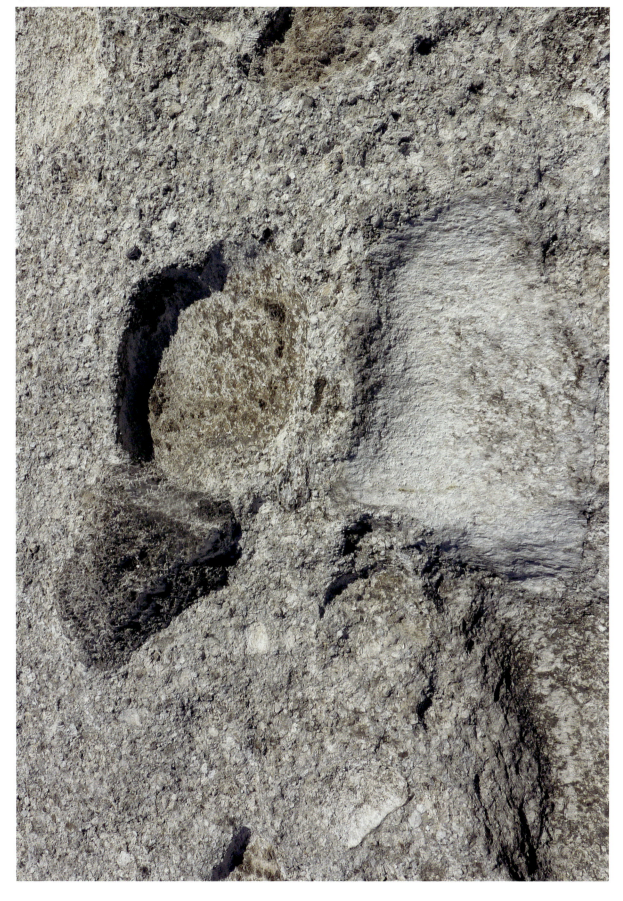

Funke
Spark
2019–2020

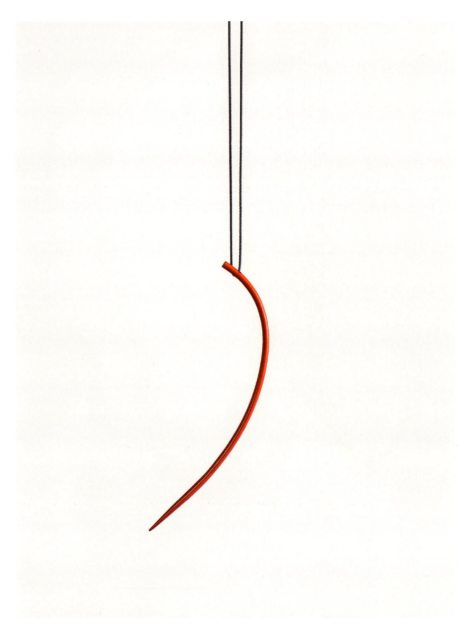

▲ Pendant, 2020, silver painted, 7.2 x 0.3 cm.
▶ Group of pendants, 2020, silver painted, different dimensions.

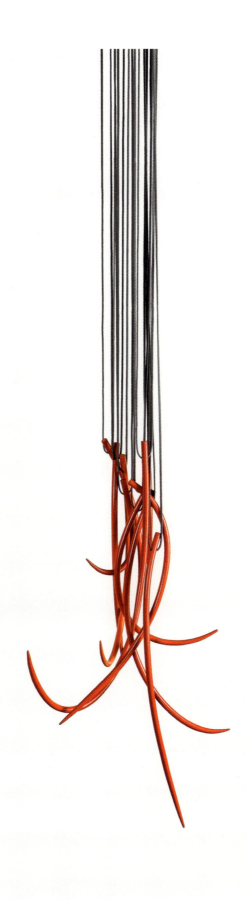

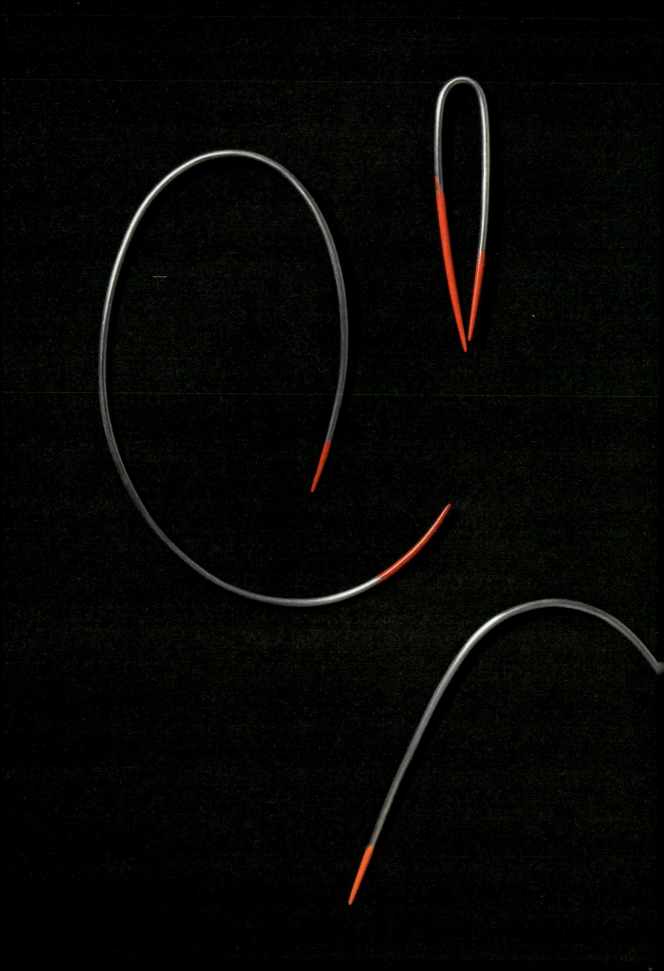

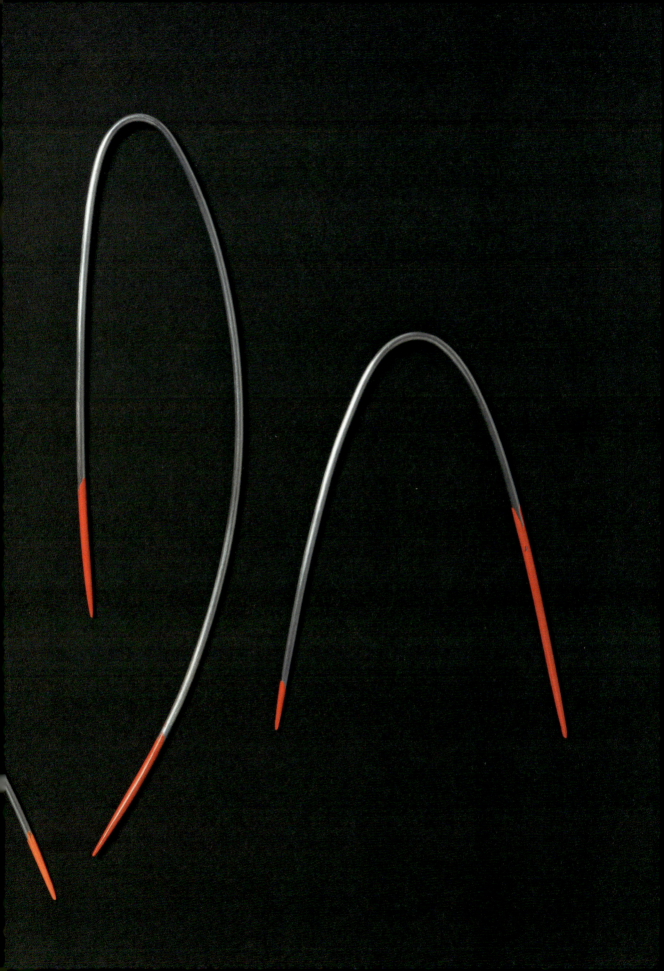

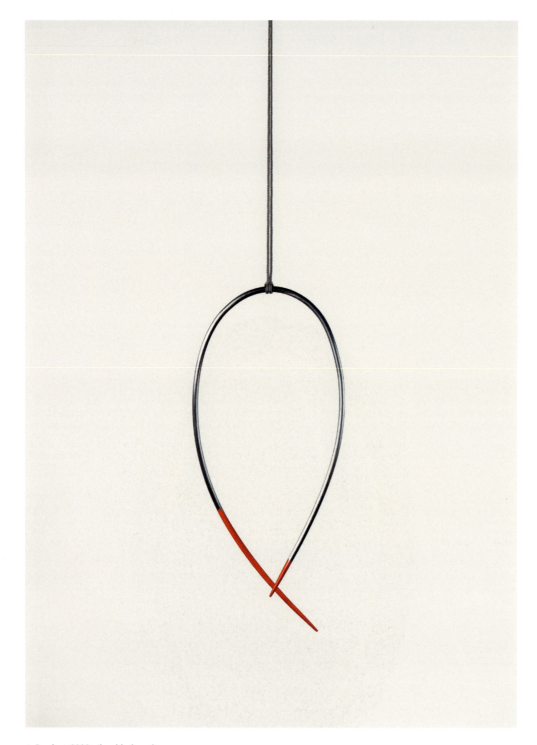

▲ Pendant, 2020, silver blackened and painted, 14.7 x 6.6 x 0.2 cm.
▶ Brooch, 2019, silver blackened and painted, 10.9 x 6.9 x 0.9 cm.
◀ Pendants, 2020, silver blackened and painted, different dimensions.

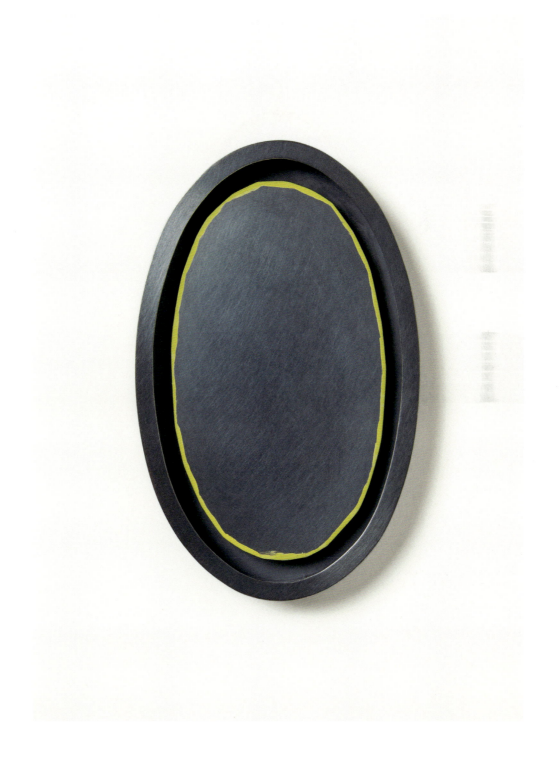

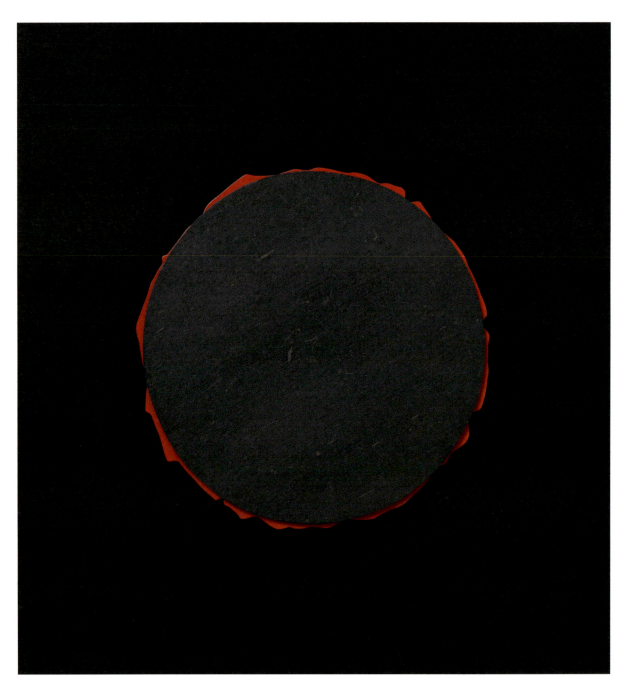

▲ Brooch, 2020, slate, silver blackened and painted, ø 9.0 cm, d 0.4 cm.

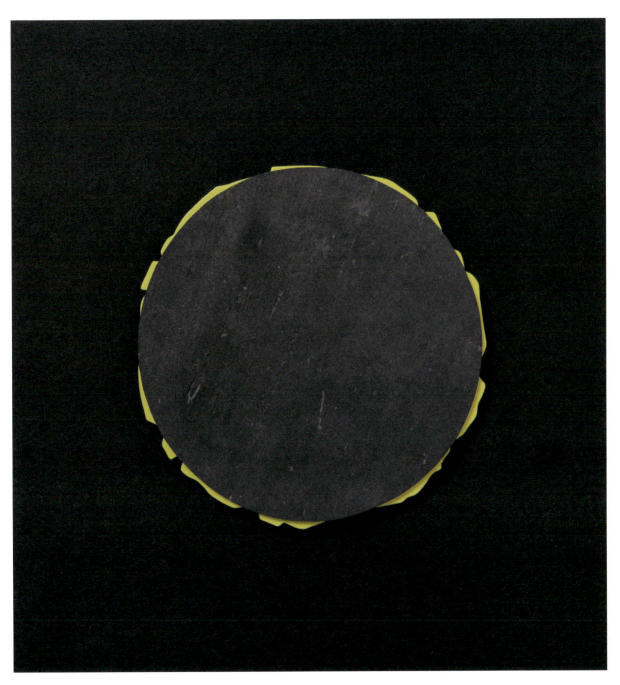

▲ Brooch, 2020, slate, silver blackened and painted, ø 9.0 cm, d 0.4 cm.

Wenn der Berg vom Feuer träumt.

Wer nachts schläft, träumt im Dunkeln.

Wie sehr, wie außergewöhnlich Therese den Schlaf liebt, fast über alles, das berührt mich immer wieder.
So wie ihr Kopf in das Kissen sinkt, begibt sie sich mit Leib und Seele auf eine Reise in tiefere Schichten, neue Landschaften, fremde Regionen, die auf sie warten, in eine Welt, die sich nur ihr erschließt.
Früher hatte sie sich manchmal von dort gemeldet, fing an zu reden, in fremder, unverständlicher Zunge, hatte sich aufgesetzt, die Arme in die Luft geworfen, mit nach innen gerichtetem Blick etwas gesucht, vielleicht auch gesehen und ist dann beruhigt zurück gesunken in ihren Schlaf.

Sie sagt, dass sie kaum mehr träumt. Doch ich kenne sie, die schlummernde Therese. Stille Wasser gründen tief.

Die Fumarolen von Kalamos. Der trockene Meltemi bringt der Ägäis klare Sicht und heiteres Wetter und kühlt uns beim Wandern auf Milos so gut es im Sommer eben geht. Salbei, Oregano, Thymian. Huschende Eidechsen, eine Haubenlerche lockt mit ihrem Ruf. Kurz rüttelt ein Falke. Dann zieht er weiter. Eine Zikade zirpt. Langsam und zögerlich. Setzt kurz aus. Eine zweite fällt ein. Tausende folgen. Schnell und schrill wird nun gesägt. Bis irgendwann das Crescendo stockt, ausfranst und verstummt. Die fruchtbare, flache Kaldera-Senke des Tsingrado hinter uns lassend, erreichen wir die vulkanisch aktivste Region der Insel. Der zarte Geruch von faulen

Eiern wird streng, der Boden bricht auf, ein Labyrinth von Ziegenpfaden zwischen forschen, zackigen Felsformationen. Rot, Weiß, ein fahles Grün. Giftig gelb leuchtet der Schwefel rund um die kleinen, tiefen Löcher, aus denen die Erde raucht. Wir versichern uns noch gegenseitig, den Rucksack auf keinen Fall auf den Boden zu stellen, nicht dass uns der ätzende Grund wieder ein Loch frisst. Dann geht jeder seiner Wege. Man muss alleine sein mit dem Vulkan. Erst recht wenn dieser schläft und schlummert. Und Therese sowieso.

Und dann vergisst sie den Rest der Welt.

Sie sieht, riecht, berührt, schmeckt, hört, fühlt, spürt, empfindet, denkt. Sie tut, was man tut, wenn man seine Sinne öffnet und ihnen vertraut.

Lebensfeindlich und karg sind solche Landschaften. Kleine Flechten, ein dorniges Gestrüpp halten die Stellung. Dampfende Aschen hier, heiße schrundige Brocken dort. Lapilli, ausgespuckte, im Flug erstarrte Magmafetzen, Brotkrustenbomben, krude Laibe, bizarr gekringelte, poröse Schlacken, Bims, die schwimmenden Steine, Tuff, von weiß und grau zu gelb, braun bis kräftig rot, strickförmige Lavastränge, Pyroklaste ohne Ende, kompakte Schichten, auskristallisierte Basaltsäulen, eng aneinander geschmiegt türmen sie sich auf, schwarzes, schweres Ergussgestein. Und Obsidian, das vulkanische Glas, tiefschwarz, amorph, muschelig im Bruch. Hart und scharf. Bis in die Bronzezeit das Material für Schaber, Klingen, Dolche, Speerspitzen. Diese zähe, schnell abgekühlte Lava, reich an Silikat, an Wasser arm, hat Milos als «Werkzeug- und Waffenschmiede» bekannt und reich gemacht. Auch auf dem Parkplatz vor dem Supermarkt kannst Du es finden, das kleine schwarzglänzende Fragment eines neolithischen Messerchens.

130 Seemeilen gen Ost. Eine kleine Insel am Rande der Ägäis. Ein flacher Kegel, die Spitze, verwandelt, nun ein Trichter. Die Form erzählt ihre Geschichte. Sagt, was man schon von weitem sieht: Ich bin ein Vulkan. Im Zentrum eine Caldera deren Rand sich bis auf 580 Meter erhebt. Die Senke wird von riesigen Bimssteinfeldern und einem aktiven Geothermalgebiet mit Schlammkratern und Fumarolen dominiert. Wie des Teufels große, stinkende Bratpfanne liegt der runde Stefanoskrater auf dem Grund der Caldera. Durchmesser dreihundert Meter, dreißig Meter tief. Betreten auf eigene Gefahr. Es drohen ernsthafte Verbrennungen und Verätzungen. In kleinen und größeren Löchern brodelt graues, lehmiges Wasser, heißer, saurer Schlamm wirft Blasen, es blubbert unter dem dünnen Vlies aus Bimsmehl, Asche, Staub. Mager, fragil und fiebrig ist hier die Kruste, die Membrane, die Haut der Erde. Die Schuhsohlen werden heiß. Qualmende, gelbe Schwefelfelder. Es kratzt im Hals. Später Nachmittag. Die Tagesausflügler haben die Insel verlassen. Nach sechsstündiger Wanderung sind wir zu zweit, alleine, gemeinsam, ein jeder für sich. Die Pfanne nur für Therese, und auch ein klein wenig für mich.

Jede Insel, jeder Ort, jeder Vulkan, jeder Stein, ist eigen.

Wenn der Berg vom Feuer träumt. Otto Künzli

Wie wird daraus Schmuck? Und weshalb?
 Ich weiß es nicht, warum und wie Therese das macht, was sie macht. Und ich brauche dafür auch keine Erklärung. Denn ihre Objekte sprechen sehr wohl für sich. Auf ihre eigene, reduzierte und konzentrierte Art sogar sehr deutlich.
 Das von Therese geliebte Zitat von Eugène Ionesco auf Seite 233, öffnet ein Fenster, zeigt einen Weg, ohne den Blick auf andere Sichtweisen und einen eigenen, individuellen Zugang zu verstellen: «Ich bin ein Vulkan». In sechs kurzen, kraftvollen Sätzen geht es in dem Sinnbild um Verwandschaften, die Ionesco zwischen den Feuerbergen und seiner eigenen Innenwelt erkennt.

Nicht immer, doch auch im Atelier ist Therese gerne alleine. Sie braucht keine Zuschauer, die sie beobachten. Das wäre keine gute Idee. Wenn ihr jemand über die Schulter schaut, wird der Fluss ihres Tuns irritiert, gestört, unterbrochen. Sie legt dann oft die Arbeit weg. Manchmal, selten, für immer.

Sie liebt und leidet. Sie ist impulsiv, expressiv, offensiv.
Sie lacht. Sie tanzt. Sie kann auch laut und wild.

Sie sägt, feilt und lötet. Sie schmiedet.
Manchmal bis tief in die Nacht.

Therese macht, was sie machen will, was sie machen muss.
Und das ist nie etwas Halbes.
Und wenn sie dazu etwas sagt, dann zum Beispiel:

Schmuck trägt mich.

When the mountain dreams of fire. — Otto Künzli

When the mountain dreams of fire.

Those that sleep at night dream in the dark.

Just how much Therese loves sleep with such an unusual intensity is something that never fails to move me.
 As soon as her head sinks into the pillow, she embarks body and soul on a journey into deeper levels, new landscapes, alien regions that await her in a world that only reveals itself to her.
 There was a time when she would occasionally get in touch from there, began to speak in a strange, incomprehensible tongue, sat upright, threw up her arms, searched for something with an inward-looking gaze, perhaps also saw it and then, reassured, would sink back into sleep. Just how much Therese loves sleep with such an unusual intensity is something that never fails to move me.

She says that she hardly dreams any more. But I know her, the slumbering Therese. Still waters run deep.

The fumaroles of Kalamos. The dry Meltemi brings clear visibility and fine weather to the Aegean and cools us during our hike on Milos, to the extent that this is possible in the summer. Sage, oregano, thyme. Scuttling lizards, a crested lark declaiming a mating call. A falcon hovers briefly, then moves on. A cicada chirps. Slowly and hesitantly. Pauses briefly. A second cicada joins in. Thousands follow. They produce a shrill, rapid sawing sound. Until at some point the crescendo falters, becomes ragged and ceases. Leaving behind us the fertile, flat caldera depression we reach the most volcanically active region of the island. The delicate aroma of rotten eggs becomes acrid, the ground is crusted and cracked, a labyrinth of goat tracks between

When the mountain dreams of fire.

rough, jagged rock formations. Red, white, a wan green. The sulfur glows a toxic yellow around the small, deep holes from which the earth smokes. We reassure each other that we won't under any circumstances set down our rucksacks, so that the caustic earth eats a hole in them again. Then each of us goes their own way. You have to be alone with your volcano. All the more so, when it sleeps and slumbers. That goes for Therese at any rate.

And then she forgets the rest of the world.

She sees, smells, touches, tastes, listens, feels, senses, experiences, thinks. She does what you do when you open up your senses and trust in them.

Such landscapes are barren and hostile to life. No thriving lichens, thorny undergrowth alone survives. Steaming ashes here, hot, creviced lumps there. Lapilli, spewed magma shreds that solidified in mid-air, volcanic bombs, crude lumps, strangely curled, porous clinkers, pumice, the floating stones, tuff, from white and gray to yellow, brown to bright red, string-like strands of lava, never-ending pyroclasts, compact layers, crystallized basalt columns, nestled close together tower up, heavy, black extrusive rock. And obsidian, volcanic glass, jet black, amorphous, conchoidal when it fractures. Hard and sharp. Through into the Bronze Age the material used for scrapers, blades, daggers, arrow tips. This tough, quickly cooled lava, rich in silicate and with scant water content made Milos rich and famous as a «center for making tools and weapons». You can also find it on the car park in front of the supermarket, small, shiny black fragment of a Neolithic implement.

130 sea miles east. A small island on the periphery of the Aegean. A flat cone, the apex transformed and now a funnel. Its form tells its story. Relates what is already apparent from a distance: I am a volcano. At the center a caldera whose rim rises up to a height of 580 meters. The depression is dominated by expansive areas of strewn pumice stone and an active geothermal area with mud craters and fumaroles. Like the devil's large, stinking frying pan the round Stefanos crater lies on the base of the caldera. Diameter three hundred meters, thirty meters deep. Entry the area at your own risk. There is a danger of serious burns and acid burns. In large and small holes muddy gray water seethes, hot acidic mud forms bubbles, it blubbers beneath the sparse covering of pumice powder, ash and dust. Here the crust is thin, fragile and feverish, the membrane, the skin of the earth. Our shoes soles get hot. Smoking yellow areas of sulfur. There is a scratchy feeling in the throat.
 Late afternoon. The day-trippers have left the island. After a six-hour hike there is just the two of us, alone, together, each for themselves. The pan for Therese alone and just a little of it for me.

Every island, every volcano, every stone is special, individual.

Otto Künzli

How does it become jewelry? And why?
 I don't know why and how Therese does what she does. And I don't need an explanation for it. After all, her objects speak very well for themselves. Loud and very clear in their special, reduced and concentrated manner.
The quote by Eugène Ionesco on page 233 that Therese so loves opens a window, reveals a route, without obscuring the view of other perspectives and one's own individual interpretation: «I am a volcano». In six, short, powerful sentences Ionesco explores the connections that he identifies between volcanoes and his own inner world.

Therese likes being alone, but not always and that goes for the studio, too. She doesn't need any spectators watching her. That would not be a good idea. When someone looks over her shoulder the flow of her work is irritated, interrupted, disturbed. Often, she then puts her work aside. Sometimes, though rarely forever.

She loves and suffers. She is impulsive, expressive, direct.
She laughs. She dances. She can also be loud and wild.

She saws, files and solders. She forges.
Sometimes until the early hours.

Therese does what she wants, what she feels compelled to do.
And she never does things by halves.
And if she comments on it, then to say something like:

Schmuck trägt mich.[1]

1 Engl.: For me, jewelry is the backbone of everything.

Biografie / Biography

1948	Born on 19th July in Zurich, Switzerland.
1964–1969	Schule für Gestaltung Zurich. Foundation course with Karl Schmid, Metal class with Max Fröhlich and Fritz Loosli.
1969	Final apprenticeship examination as a goldsmith.
1969–1972	Work in the workshops of Fritz Suter, Zurich, and Othmar Zschaler, Bern, Switzerland.
1972	Marriage to the goldsmith Otto Künzli and move from Switzerland to Germany.
1972–1978	Akademie der Bildenden Künste München, Munich, class for goldsmiths' art and holloware with Prof. Hermann Jünger, Germany.
1973–1975	Work in the studio of Hermann Jünger.
1976	Birth of daughter Miriam.
1978	Diploma at the Akademie der Bildenden Künste München, Munich, class for goldsmiths' art.
since 1975	Workshop and residence in Munich, Germany.

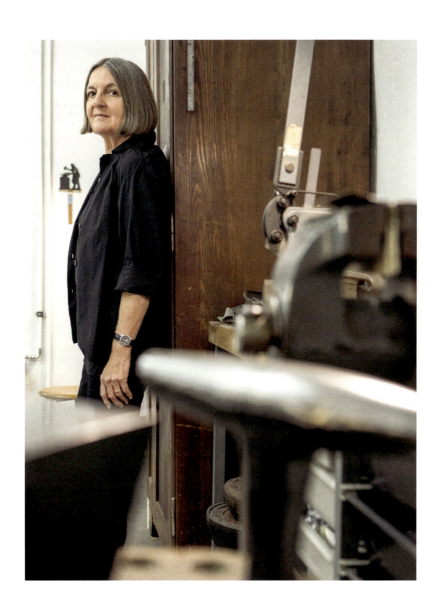

Anerkennungen und Preise Awards and Prizes 334

1972	Eidgenössisches Stipendium für angewandte Kunst des Departement des Innern, Bern, Switzerland.
1973	1. Preis, Modeschmuck – Wettbewerb, Arbeitskreis Form + Farbe, Neugablonz, Germany.
1974	Eidgenössisches Stipendium für angewandte Kunst des Departement des Innern, Bern, Switzerland.
1974	Herbert-Hoffmann-Gedächtnis-Preis, Internationale Handwerksmesse Munich, Germany.
1975	Leistungspreis der Schule für Gestaltung, Zurich, Switzerland.
1975	Eidgenössisches Stipendium für angewandte Kunst des Departement des Innern, Bern, Switzerland.
1985	Prinzregent-Luitpold-Stiftung, Munich, Germany.
1986	Förderpreis für angewandte Kunst der Landeshauptstadt München, Germany.
2001	Bayerischer Staatspreis, Munich, Germany.

Arbeiten in öffentlichen Sammlungen — Works in Public Collections

Bundesamt für Kultur, Bern, Switzerland — Bröhan Design Foundation, Berlin, Germany — Collection de la Ville de Cagnes-sur-Mer, France — Deutsches Goldschmiedehaus, Hanau, Germany — Design Museum Den Bosch, Netherlands — Die Neue Sammlung – The Design Museum. Permanent Loan from the Danner Foundation Munich, Germany — Die Neue Sammlung – The Design Museum, Germany — Gewerbemuseum, Winterthur, Switzerland — GRASSI Museum für Angewandte Kunst, Leipzig, Germany — Institut für Auslandsbeziehungen, Stuttgart, permanent loan in the Reuchlinhaus, Pforzheim Germany — The Israel Museum, Jerusalem, Israel — Knapp Collection, New York, USA — LACMA, Los Angeles County Museum of Art, The Lois Boardman Collection, Los Angeles, USA — Alice and Louis Koch Collection, Schweizerisches Nationalmuseum, Zurich, Switzerland — Kunstgewerbemuseum, Staatliche Museen zu Berlin, Germany — Metropolitan Museum of Art, The Donna Schneier Collection, New York, USA — The Museum of Fine Arts Houston (MFAH), The Helen Williams Drutt Collection, USA — mudac, Musée de design et d'arts appliqués contemporains, Lausanne, Switzerland — Museum of Arts and Design (MAD), The Sandy Grotta Jewelry Collection, New York, USA — Museum Angewandte Kunst, Frankfurt am Main, Germany — Museum of Fine Arts (MFA), The Daphne Farago Collection, Boston, USA — National Gallery of Victoria (NGV), Melbourne, Australia — Powerhouse Museum of Applied Arts & Sciences, Sydney, Australia — Schmuckmuseum im Reuchlinhaus, Pforzheim, Germany — Münchner Stadtmuseum, Munich, Germany — Stedelijkmuseum, Amsterdam, Netherlands — The Dallas Museum of Arts, The Edward W. and Deedie Potter Rose Collection (former Inge Asenbaum Collection, Vienna, Austria), Dallas, USA — The Hiko Mizuno Collection, Tokyo, Japan

Einzelausstellungen

1979–1980	Therese Hilbert. Schmuckmuseum im Reuchlinhaus, Pforzheim; Deutsches Goldschmiedehaus, Hanau, Germany, and Galerie Alberstraße, Graz, Loft Wien, Austria (with Otto Künzli)
1981	Schmuck, Galerie Academia, Salzburg, Austria (with Otto Künzli)
1982	Therese Hilbert. Galerie Ra, Amsterdam, Netherlands
1983	Therese Hilbert. Schaufenster Nr. 34, Maximilianstraße, Munich, Germany
1984	Gioielli di Therese Hilbert. Galleria Cubo, Lugano, Switzerland
1985	Therese Hilbert. Schmuck. Cada, Munich, Germany, Galerie V&V, Vienna, Galerie Droschl, Graz, Austria
1986	Fragments. Therese Hilbert – Otto Künzli. Helen Drutt Gallery, Philadelphia, USA
1986	Eröffnungsausstellung. Opening Exhibition. Galerie Louise Smit, Amsterdam, Netherlands
1987	Therese Hilbert. Vitrine, Maximilianstraße 30, Munich, Germany
1987	Gioielli di Therese Hilbert. Galleria Cubo, Lugano, Switzerland
1989	Therese Hilbert. Sieraden. Galerie Louise Smit, Amsterdam, Netherlands
1989	Therese Hilbert. Galerie Spektrum, Munich, Germany
1989	Therese Hilbert. Schmuck. Galerie Michèle Zeller, Bern, Switzerland
1990	Therese Hilbert. One person exhibition. Rezac Gallery, Chicago, USA
1990	Galerie für modernen Schmuck, Frankfurt a. M., Germany
1991	Therese Hilbert. Contemporary Jewellery. Galerie Louise Smit, Amsterdam, Netherlands
1992	Therese Hilbert. Schmuckausstellung. Galerie Michèle Zeller, Bern, Switzerland
1992	Therese Hilbert. Schmuck. Galerie Slavik, Vienna, Austria
1994	Therese Hilbert. Jewelers' Werk Gallery, Washington D.C., USA
1996	Weiss und Schwarz. Schmuck von Therese Hilbert. Galerie für angewandte Kunst – Bayerischer Kunstgewerbeverein, Munich, Germany
1996	Nea Kameni. Galerie Michèle Zeller, Bern, Switzerland
1997	Hier und Jetzt. Galerie Ra, Amsterdam, Netherlands
1998	Insight – Inside. Jewelers' Werk Gallery, Washington D.C., USA
1999	Hollow but not empty. Gallery Funaki, Melbourne, Australia
1999	Therese Hilbert. Schmuck. Galerie 422, Gmunden, Austria
2002	Hollow but not empty. Galerie Ra, Amsterdam, Netherlands
2003	Geheime Orte. Galerie Michèle Zeller, Bern, Switzerland
2004	Glow. Therese Hilbert. Gallery Funaki, Melbourne, Australia
2005	Therese Hilbert. Glow. Jewelers' Werk Gallery, Washington D.C., USA

Solo Exhibitions

2006	Therese Hilbert. Glow. Galerie Ra, Amsterdam, Netherlands
2007	Wie Du mir – so ich Dir. Ecke Galerie, Augsburg, Germany (with Otto Künzli)
2007	Ardore. Therese Hilbert – Gioielli. Galleria Maurer Zilioli, Desenzano del Garda, Italy
2009	Therese Hilbert «durch den Sinn gefahren». Galerie SO, Solothurn, Switzerland
2009	Therese Hilbert. Yali. Galerie Ra, Amsterdam, Netherlands
2010	Leonids and Fumarols. Gallery Funaki, Melbourne, Australia (with Otto Künzli)
2013	Therese Hilbert zu Gast bei Kunstbüro reillplast, Maurer Zilioli Contemporary Arts, Munich, Germany
2016	&: Hilbert & Künzli. Gewerbemuseum, Winterthur, Switzerland (with Otto Künzli)
2016	Evil and I. Gallery Funaki, Melbourne, Australia (with Otto Künzli)
2017	Nukleus. Galerie Rosemarie Jäger, Hochheim, Germany (with Otto Künzli)
2018	Therese Hilbert. Aus der Tiefe. Maurer Zilioli Contemporary Arts, Munich, Germany
2018	Therese Hilbert. Eruption. Patrícia Domingues. Erosion. Galerie Ra, Amsterdam, Netherlands
2018	Day and Night. Hannah Gallery, Barcelona, Spain (with Otto Künzli)

Ausstellungsbeteiligungen

1969	Kunstgewerbemuseum Zurich, Switzerland
1972	Stipendiatenausstellung. Gewerbemuseum Bern, Switzerland
1973	Modeschmuck '73. Neugablonz, Germany
1973	Schmuck und Gerät. Akademie der Bildenden Künste München, Germany
1973–1978	Schmuck-Sonderschau. Internationale Handwerksmesse, Munich, Germany
1974	Stipendiatenausstellung. Gewerbemuseum Bern, Switzerland
1974/76	Galerie Poggi, Oberstdorf, Germany
1974	Kreativer Schmuck. Sonderschau an der europäischen Uhren- und Schmuckmesse, Schweizer Mustermesse Basel. Basle, Switzerland
1975	Stipendiatenausstellung. Gewerbemuseum Bern, Switzerland
1975	Eröffnungsausstellung. Klaus Olligs Galerie, Oldenburg, Germany
1975	Hermann Jünger and Rüdiger Lorenzen and their Students. Electrum Gallery, London, UK
1975	6 Goldschmiede der Akademie der Bildenden Künste München. Der Kunstladen, Neubeuern, Germany
1975	5ème Exposition Internationale de Bijoux d'Art Contemporain. Galerie at home, Toulouse, France
1975	6. Weihnachtsausstellung. Galerie Lalique, Berlin, Germany
1975	Schmuck und Gerät. Goldschmiede der Akademie der Bildenden Künste München. Galerie Rehklau, Augsburg, Germany
1976	Jahresausstellung der Akademie der Bildenden Künste München, Germany
1976	Goldschmiedearbeiten. Galerie Alberstraße, Graz, Austria
1976	Thema Schmuck. Sonderschau Schweizer Mustermesse in der Europäischen Uhren- und Schmuckmesse oder Schmuck heute. Schweizer Mustermesse Basel, Basle, Switzerland
1976	7. Weihnachtsausstellung. 5 Goldschmiede. Galerie Lalique, Berlin, Germany
1977	Schmuck und Gerät. Goldschmiede der Akademie der Bildenden Künste München, and Galerie Rehklau, Augsburg, Germany
1977	Schmuck 77 – Tendenzen. Schmuckmuseum im Reuchlinhaus, Pforzheim, Germany
1977	Arbeiten aus der Goldschmiedeklasse der Akademie der Bildenden Künste München. Kunstzentrum No. 66. Munich-Neuperlach, Germany
1977	Artist Craftsmen and their vocational training in the Federal Republic of Germany. Wanderausstellung der Arbeitsgemeinschaft des deutschen Kunsthandwerks. USA, Canada (trav. exh.)
1977	8. Weihnachtsausstellung. 4 Goldschmiede. Galerie Lalique, Berlin, Germany
1978	Stipendiatenausstellung. Gewerbemuseum Bern, Switzerland
1978	Kunst – Schmuck. 26 Goldschmiede. Galerie Thomas, Munich, Germany
1978	Die Brosche. Galerie Alberstraße, Graz, Austria

Group Exhibitions

1978	Schweizer Schmuck 78. Heimatwerk, Zurich, Switzerland
1978	Schmuck und Gerät. Goldschmiede der Akademie der Bildenden Künste München, Munich, and Galerie Rehklau, Augsburg, Germany
1978	10 Goldschmiedinnen. Galerie Lalique, Berlin, Germany
1979	Körper – Zeichen. Goldschmiedearbeiten. Städtische Galerie im Lenbachhaus, Munich, Germany
1979	Goldschmiede dieser Zeit. Körper – Schmuck – Zeichen – Raum. Kestner Gesellschaft, Hannover, Germany (1979), and Museum für Gestaltung, Zurich, Switzerland (1981)
1980	Schmuck International 1900–1980. Künstlerhaus, Vienna, Austria
1980	8 orafi. Galerie Albrecht, Oberplanitzing/Kaltern near Bolzano, Italy
1981	Schmuck. Studio f, Ulm, Germany
1982	Material. Schmuck und Gerät. Sonderschau der Internationalen Handwerksmesse, Munich, Germany
1982	Zwitserse Avantgarde. Galerie Nouvelles Images, Den Haag, Netherlands
1982	1+8 Wanderausstellung durch Australien und USA. College Art Gallery, State University of New York (SUNY), New Paltz, USA (trav. exh.)
1982	Vieses op Sieraden 1965–1982. Stedelijk Museum, Amsterdam, and Gemeentemuseum Arnhem, Netherlands (trav. exh.)
1982	Jewellery Redefined. The 1st International Exhibition of Multi-Media Non-Precious Jewellery. British Crafts Centre, London, UK, among others (trav. exh. until 1984)
1982	Schmuck '82 – Tendenzen? Schmuckmuseum im Reuchlinhaus, Pforzheim, Germany
1982	Schmuck. Schaufenster Nr. 34, Munich, Germany
1983	Material. Schmuck und Gerät. Sonderschau der Internationalen Handwerksmesse, Munich, Germany
1983	Eröffnungsausstellung. Opening Exhibition. Cada, Munich, Germany
1983	Schmuck. Galerie Traude Näke, Nuremberg, Germany
1983	Moderner Schmuck – Neue Arbeiten. Galerie Hermanns, Munich, Germany
1983	De Plastic Tas. Rotterdamse Kunststichting, Rotterdam, Netherlands
1983	Ohrschmuck. Schaufenster Nr. 34, Munich, Germany
1983	Bijou'terrible. Schmuckforum, Zurich, Switzerland
1984	Zeitgenössische Deutsche Goldschmiede Kunst. Goethe-Institut Tokyo, Japan
1984	Jewellery International. American Craft Museum II, New York, USA
1984	Contemporary Jewellery – The Americas, Australia, Europe and Japan. The National Museum of Modern Art, Kyoto, and The National Museum of Modern Art, Tokyo, Japan
1984	Razionale e fantastico nel decoro del corpo. Lanaro, Padua, Italy
1984	Cross Currents. Jewellery from Australia, Britain, Germany, Holland. Power House Museum, Sydney, Australia, among others (trav. exh. until 1986 in Australia and New Zealand)

Ausstellungsbeteiligungen

1984	Künstler der Galerie. Cada, Munich, Germany
1984	Artisti Orafi Svizzeri. Galleria Cubo, Lugano, Switzerland
1985	Bijou frontal. Neue Tendenzen der Schmuckgestaltung in der Schweiz. Museum für Gestaltung Basel, Basle, Switzerland
1985	Attitudes. Jewellery from Britain, Schmuck aus Deutschland, Sieraden uit Nederland, Juwelen uit Vlaandern. International Cultureel Centrum, Antwerpen, and Museum voor Sierkunst, Ghent, Belgium (trav. exh.)
1985	Kunstformen jetzt! Galerie Susi Wassibauer, Salzburg, Austria
1985	hart – weich oder schnell – langsam. Schweizer Schmuckkünstler. Heimatwerk, St. Gallen, Switzerland
1985	Schmuck und Gerät. Cada, Munich, Germany
1986	1001 Karat. Sonderschau Schmuck und Gerät der Heim + Handwerk, Munich, Germany
1986	Kunstenaars van de Galerie. Galerie Louise Smit, Amsterdam, Netherlands
1986	Kunstpreisträger 1986 [here: Therese Hilbert – Stern]. Künstlerwerkstatt Lothringerstraße 13, Munich, Germany
1986	Ohrschmuck. Internationale Sommer-Ausstellung. Galerie Michèle Zeller, Bern, Switzerland
1986	Jahresgaben 86. Kunstverein München, Munich, Germany
1986	Ohr du Fröhliches. Galerie Lalique, Berlin, Germany
1987	Joieria Europea Contemerània. Fundació Caixa de Pensions, Barcelona, Spain
1987	Bijoux – Nouvelles Tendences. Nouveaux Matériaux. Centre Culturel Suisse, Paris, France
1987	Malerei und Schmuck. Kunstkreis Gräfelfing, Rathaus Gräfelfing, Germany
1988	Biennale Svizzera del gioiello d'arte contemporaneo. Swiss Biennale of Contemporary Art Jewellery. Villa Malpensata, Lugano, Switzerland
1988	10 Goldsmiths. Rezac Gallery, Chicago, USA
1988	Schweizer Schmuckkünstler. Galerie Bild + Schmuck, Zug, Switzerland
1988	Seven Contemporary Goldsmiths from Munich. Helen Drutt Gallery, Philadelphia, USA
1988	Geburtstagsschmuckausstellung. Galerie Michèle Zeller, Bern, Switzerland
1988	Künstler der Galerie. Galerie Spektrum, Munich, Germany
1988	Jahresgaben 88. Kunstverein München, Munich, Germany
1989	British Jewellery – German Jewellery. Crafts Council Gallery, London, UK
1989	Rites of Spring. Rezac Gallery, Chicago, USA
1989	Neue Tendenzen Schweiz. Galerie Michèle Zeller, Bern, Switzerland
1989	Strange Attractors: The spectacle of chaos. Kaos Foundation, Chicago, USA

Group Exhibitions

1989	European Metal – Jewellery and Objects. The Art Gallery of Western Australia, Perth, Australia
1989	Function-Non-Function. Rezac Gallery, Chicago, USA
1989	Zeitgenössische Schmuckkunst aus der Bundesrepublik Deutschland: eine Ausstellung des Instituts für Auslandsbeziehungen e.V. (ifa), Stuttgart. Konzeption und Zusammenstellung: Jens-Rüdiger Lorenzen; Polytechnic Gallery, Newcastle, UK; Harbourfront, Toronto, Canada; Musée des Arts Décoratifs, Montreal, Canada; GI Gallery, Chicago, USA; Cartwright Gallery – The Canadian Craft Museum, Vancouver, Canada; California Museum of Science and Industry, Los Angeles, USA; Civic Center Art Gallery, Mississauga, Canada; Triangle Gallery, Calgary, Canada; Edificio Chiado, Coimbra, Portugal; Gulbenkian-Stiftung, Lisbon, Portugal; Arsenal, Metz, France; Cultural Centre, Kowloon, Hong Kong, China; Kunstakademie, Canton, China; Walker Hill Art Center, Seoul, South Korea; Shoto Museum, Tokyo, Japan; Design Centre, Singapore; Jakarta, Indonesia; Bangkok, Thailand; and Manila, the Philippines (trav. exh. until 1994)
1990	Ketten. Galerie Spektrum, Munich, Germany
1990	European Metal – Jewellery and Objects. Powerhouse Museum, Sydney, Australia
1990	Ohrschmuck. Galerie für modernen Schmuck, Frankfurt a. M., Germany
1990	Weihnachtsausstellung. Galerie Spektrum, Munich, Germany
1991	Ohrschmuck. Galerie Michèle Zeller, Bern, Switzerland
1991	Eröffnungsausstellung. Galerie Treykorn, Berlin, Germany
1991	Schmuck und Gerät. Schloss Wertingen, Wertingen, Germany
1991	10 Schweizer Schmuckkünstler im Ausland. Galerie für Gebrauchskunst «Das da», Zug, Switzerland
1991	Artist Couples Exhibition. The Society for Contemporary Crafts, Pittsburgh, USA
1991	Neoteric Jewelry. Snug Harbor Cultural Center, Staten Island, Society for Contemporary Crafts, Pittsburgh and Museum of Art, Rhode Island School of Design, Providence, USA (trav. exh.)
1992	Schmuck. Centrum Beeldende Kunst, Groningen, Netherlands
1992	Schmuck und Gerät. Schmuckforum, Zurich, Switzerland
1992	Der Stamm des Tannenbaumes ist das Herz des Schmuckes (von Innen nach Aussen). K- Raum Daxer, Munich, Germany
1992	Sieraden. Centrum Beeldende Kunst, Groningen, Netherlands
1992	Weihnachtsausstellung. Galerie Treykorn, Berlin, Germany
1993	Schmuck. Die Sammlung der Danner-Stiftung. Galerie für angewandte Kunst – Bayerischer Kunstgewerbeverein, Munich; Deutsches Goldschmiedehaus, Hanau; Schmuckmuseum im Reuchlinhaus, Pforzheim; Augustinermuseum, Freiburg im Breisgau, Germany (trav. exh. until 1995)

Ausstellungsbeteiligungen

1993	Münchner Goldschmiede. Schmuck und Gerät. Münchner Stadtmuseum, Germany
1993	10 Jahre. Jubiläumsausstellung. Galerie Michèle Zeller, Bern, Switzerland
1993	Schmuck und Gerät. Galerie Knauth & Hagen, Bonn, Germany
1993	Fetische, Talismane und andere Glücksbringer. Galerie Michèle Zeller, Bern, Switzerland
1994	6. Triennale. Zeitgenössisches Kunsthandwerk. Museum für Kunsthandwerk, Frankfurt a. M., and GRASSI Museum für Angewandte Kunst, Leipzig, Germany
1994	Ohrschmuck. Galerie Michèle Zeller, Bern, Switzerland
1994	Schmuck unserer Zeit 1964–1993. Sammlung Helen Williams Drutt, USA, Museum Bellerive, Zurich, Switzerland
1994	Gold und Silber. Städtische Galerie im Rathausfletz, Neuburg an der Donau, Germany
1994	Weihnacht '94. Galerie Slavik, Vienna, Austria
1995	Weihnachtsausstellung. Galerie Treykorn, Berlin, Germany
1995	Silberstreif. Neckarwerke, Göppingen, Germany
1995	Tragbare Düfte. Schmuckforum, Zurich, Switzerland and Gallery V&V, Vienna, Austria (until 1996)
1995	Japan Contemporary Craft. Art Association Annual Exhibition. Metropolitan Museum, Tokyo, Japan
1995	The Best in Contemporary Jewellery. Villa de Bondt, Ghent, Belgium
1995	Weihnacht '95. Galerie Slavik, Vienna, Austria
1996	Munich to Sarajevo. Collegium Artisticum, Sarajevo, Bosnia and Herzegovina
1996	Koreanisch-Deutsche Zeitgenössische Schmuck und Gerät Ausstellung. Walker Hill Art Center, Seoul, South Korea
1996	Weihnachtsgeschenke. Galerie Wittenbrink, Munich, Germany
1997	Broschen. Kunstforum, Kirchberg/Bern, Switzerland
1997	Als wär's ein Stück von mir. Galerie Profil, Regensburg, Germany
1998	Halsschmuck. Kunstforum, Kirchberg/Bern, Switzerland
1999	Hommage an Herbert Hofmann. Galerie Handwerk, Munich, Germany
1999	Augenlust. Zeitgenössisches Kunsthandwerk in Deutschland mit europäischen Gastbeiträgen. Kunsthalle Erfurt – Haus zum Roten Ochsen, Germany
1999	Galerie Stühler, Berlin, Germany
2000	Schönmachen – Zeitgenössischer Schmuck aus München. Kunsthaus Kaufbeuren, Germany
2000	Prototyp und Produkt. Positionen angewandter Kunst. Spiegel. Künstlerwerkstatt Lothringerstraße 13, Munich, Germany
2000	Het Versierde Ego. Het Kunstjuweel in de 20ste Eeuw. The Ego Adorned. 20th-Century Artists' Jewellery. Konigin Fabiolazaal, Antwerp, Belgium

Group Exhibitions

2000	Alles Schmuck. Sammlung Inge und Elisabeth Asenbaum. Museum für Gestaltung, Zurich, Switzerland
2000	Parures d'ailleurs, parures d'ici: incidences, coïncidences. mudac, Musée de design et d'arts appliqués contemporains, Lausanne, and Gewerbemuseum Winterthur, Switzerland (trav. exh.)
2000	Kunst Schmuck Kunst. Malerei – Arbeiten auf Papier. Schmuckkunst. Galerie Stühler, Berlin, Germany
2000	Le Diamant. Galerie Viceversa, Lausanne, Switzerland
2001	Preiswürdig. Internationale Handwerksmesse, Munich, Germany
2001	Bayerische Staatspreise. Bayerischer Kunstgewerbeverein, Munich, Germany
2001	Einblick. Galerie Silvia Kirsch, Bremen, Germany
2001	Mikromegas. Galerie für angewandte Kunst, Munich, Germany; American Craft Museum, New York, USA; Musée de l'horlogerie et de l'émaillerie, Geneva, Switzerland; Gallery YU, Tokyo, Japan; Powerhouse Museum, Sydney, Australia; John Curtin Gallery, Perth, Australia; Oratorio di San Rocco, Padua, Italy (trav. exh. until 2004)
2001	Von wegen. Schmuck aus München. Deutsches Goldschmiedehaus, Hanau, Germany
2001	Maskerade. Contemporary Masks by Fifty Artists. Galerie Ra, Amsterdam, Netherlands; Cleveland Crafts Centre, Middlesbrough, UK; Ilias Lalaounis Jewelry Museum, Athens, Greece (trav. exh. until 2004)
2001	7 Schmuckkünstler. Galerie Michèle Zeller, Bern, Switzerland
2001	schön und gut. 150 Jahre Bayerischer Kunstgewerbe-Verein. Münchner Stadtmuseum, Munich, Germany
2001	bijou noir. Galerie Hélène Porée, Paris, France
2001	10 ans de Galerie Viceversa, Lausanne, Switzerland
2001	Schmuck hier, Schmuck anderswo: Verwandtschaft oder Zufall? Gewerbemuseum Winterthur, Switzerland
2001	Ringe von 33 Schmuckkünstlern. Galerie Stühler, Berlin, Germany
2002	Pièce a conviction. Galerie Tactile, Geneva, Switzerland
2002	L'ornement est-il toujours un crime? Le bijou d'auteur en Suisse au XXe siècle. Musée d'art et d'histoire, Geneva, Switzerland
2002	Schmuck Kunst Schmuck. Internationale Schmuckkunst und Malerei im Dialog. Galerie Stühler, Berlin, Germany
2002	Bloemensieraden. Galerie Ra, Kunst RAI, Amsterdam, Netherlands
2002	Weihnachtsausstellung. Galerie Michèle Zeller, Bern, Switzerland
2003	Schweizer Schmuck im 20. Jh. Schweizerisches Nationalmuseum im Schweizer Landesmuseum, Zurich, Switzerland
2003	Gioielli d'Arte in Svizzera nel 20 secolo. Museo Vela, Ligornetto, Switzerland
2003	Corporal Identity – Körpersprache. 9. Triennale für Form und Inhalte. Museum für angewandte Kunst, Frankfurt a. M., Germany, and Museum of Arts & Design (MAD), New York, USA (2004)

Ausstellungsbeteiligungen

2004	ohne Schmuck keine Heimat!? Fünf Goldschmiede aus München. Maierhof im Kloster Benediktbeuern, Benediktbeuern, Germany
2004	Die Danner-Rotunde. Schmuck in der Pinakothek der Moderne – Ersteinrichtung von Hermann Jünger und Otto Künzli. Die Neue Sammlung – The International Design Museum, Munich, Germany
2004	Pensieri Preziosi: differenze, incidenze, coincidenze in alcuni gioielli europei. Oratorio di San Rocco, Padua, Italy
2005	10 – 2005. 10th Anniversary. Gallery Funaki 10th Anniversary, Melbourne, Australia
2005	Pensieri Preziosi: Kostbare Gedanken. Deutsches Goldschmiedehaus, Hanau, Germany
2005	Gioielleria Contemporanea, Minimal Art. Studio GR.20, Padua, Italy
2006	Connect. Gallery Funaki International Jewellery Award 2006, Melbourne, Australia
2006	Radiant. 30 years Ra. Galerie Ra, Amsterdam, Netherlands
2006	Ausstellung zur Wiedereröffnung des Schmuckmuseums Pforzheim, Germany
2007	Jewelry by Artists: The Daphne Farago Collection. Museum of Fine Arts, Boston, USA
2007	Ornament as Art: Avant-Garde Jewelry from the Helen Williams Drutt Collection. Museum of Fine Arts, Houston; Renwick Gallery of the Smithsonian American Art Museum, Washington D.C.; Mint Museum of Craft + Design, Charlotte; Tacoma Museum of Art, Tacoma, USA (trav. exh.)
2007	Radiant. 30 years Ra. Stedelijk Museum, Roermond, Netherlands
2007	Künstlerinnen und Künstler der Galerie. Galerie SO, Solothurn, Switzerland
2007	GlassWear. Toledo Museum of Art, Toledo, USA; Schmuckmuseum im Reuchlinhaus, Pforzheim, Germany; Memorial Art Gallery of the University of Rochester, Rochester, USA; Museum of Arts and Design (MAD), New York, USA; Mobile Museum of Art, Mobile, USA; Art Museum of South Texas, Corpus Christi, USA (trav. exh. until 2010)
2008	Gioielleria Contemporanea, Collezionismo a Padova. Studio GR.20, Padua, Italy
2008	Just Must. Estonian History Museum, The Great Guild House, Tallinn, Estonia
2009	Schmuck – Extreme. Maurer Zilioli – Contemporary Arts, Brescia, im Kunstbüro reillplast, Munich, Germany
2010	Nicht dass Du mir von der Bluse fällst. Broschen von Volker Atrops, Peter Bauhuis, Waltraud Erlacher, Therese Hilbert, Otto Künzli, Karen Pontoppidan, Bettina Speckner. Galerie für angewandte Kunst – Bayerischer Kunstgewerbeverein, Munich, Germany
2010	Danner-Rotunde. Der Schmuckraum in der Pinakothek der Moderne. Neukuratiert von Karl Fritsch. Die Neue Sammlung – The International Design Museum, Munich, Germany

Group Exhibitions

2010	Contemporary Collection. New Work from Gallery SO. Glynn Vivienne Art Gallery, Swansea, UK
2010	Nishijin. K-Studio, Tokyo, and HOSOO, Kyoto, Japan (trav. exh.)
2010	Wunderwerk. Selected works from Australia and Germany 1970–2010. Philadelphia Art Alliance, Philadelphia, USA
2010	Multiples between Art and Design. Gallery SO, London, UK
2011	Ladies Boxes. Maurer Zilioli – Contemporary Arts, Brescia, Kunstbüro reillplast, Munich, Germany
2011	Multiples. Galerie SO, Solothurn, Switzerland
2011	Material Revisited. 10. Triennale für Form und Inhalte. Museum für angewandte Kunst, Frankfurt a.M., and Klingspor-Museum, Offenbach, Germany (trav. exh.)
2011	Das Kleine Format. 40 Jahre Ecke Galerie. Ecke Galerie, Augsburg, Germany
2011	22 bricks at a time. Contemporary metalwork and jewellery by 22 international artists. Gallery SO, London, UK
2011	Ra Present. 35 jaar Galerie Ra, Amsterdam, Netherlands
2011	Piccole Sculture. Maurer Zilioli Contemporary Arts, Brescia, Italy
2012	Campagne-sans-Mer. Cinq artistes suisses. Espace Solidor, Cagnes-sur-Mer, France
2012	Unexpected Pleasures. The Art and Design of Contemporary Jewellery. The National Gallery of Victoria, Melbourne, Australia, and Design Museum, London, UK (trav. exh.)
2012	Entfesselt – Schmuck ohne Grenzen. Museum Bellerive, Zurich, Switzerland
2012	Bijou Contemporain – Collection de la Ville. Espace Solidor, Cagnes-sur-Mer, France
2012	mudac, Musée de design et d'arts appliqués contemporains. Lausanne, Switzerland (permanent exhibition)
2012	Chamber of Wonder. International Art Jewellery Exhibition. Gallery SO, London, UK
2013	New Edition. Gallery Funaki, Melbourne, Australia
2013	Design Bijou Suisse. Fondation Suisse / Pavillon Corbusier, Paris, France
2013	papallona – mariposa – butterfly. La metàfora de la vida a la joieria contemporània. Museu de Ciències Naturals de Granollers, Granollers, Spain
2014	Danner-Rotunde. Re-defined und neukuratiert von Otto Künzli. Der Schmuckraum in der Pinakothek der Moderne. Die Neue Sammlung – The Design Museum, Munich, Germany
2014	Ebbe Weiss-Weingart & Wegbegleiter. Deutsches Goldschmiedehaus, Hanau, Germany
2014	Mari Funaki Award for Contemporary Jewellery. Gallery Funaki, Melbourne, Australia
2015	20th Anniversary. Gallery Funaki, Melbourne, Australia

Ausstellungsbeteiligungen — Group Exhibitions

2015	Autorenschmuck und noch mehr – Sammlung Basiner. Künstlerhaus, Munich, Germany
2015	Bijoux en jeu – Collections du mudac et de la Confédération Suisse. Barcelona Disseny Hub, Spain
2015	I am here, portable art, wearable objects, jewellery since 1970. A Crafts Council Touring Exhibition. Upper Gulbenkian Gallery, Royal College of Art, London, UK
2016	From A to Z. Maurer Zilioli – Contemporary Arts, Kunstbüro reillplast, Munich, Germany
2016	Bijoux en jeu – Collections du mudac et de la Confédération Suisse. Art Basel, Switzerland
2016	Dierbaar – Cherished. 40 Jaar Galerie Ra, Amsterdam, Netherlands
2016	Wilde Mischung. Neue Schmuckstücke aus der Sammlung. Schmuckmuseum im Reuchlinhaus, Pforzheim, Germany
2016	Beyond Bling: Jewelry from the Lois Boardman Collection. LACMA, The Los Angeles County Museum of Art, USA
2016	Chain. Gallery SO, London, UK
2017	Die Sammlung Bollmann. Schmuck von 1970–2015. Museum für angewandte Kunst, Vienna, Austria; Deutsches Goldschmiedehaus, Hanau, Germany; Oratorio di San Rocco, Padua, Italy (trav. exh. until 2019)
2017	Die Münchner Zeit – The Munich Times. Galerie Spektrum, Munich, Germany
2017	Schmuck – Material. Handwerk. Kunst. Schweizerisches Nationalmuseum, Zurich, Switzerland
2017	Bijoux en jeu: Swiss Contemporary Jewelry Design. Power Station of Art – psD, Shanghai, China
2018	Collection by Klimt02. 26 Artists & 300 Pieces for you. Hannah Gallery, Barcelona, Spain
2018	To Have and to Hold. The Daalder Collection of Contemporary Jewellery. Art Gallery of South Australia, Adelaide, Australia
2018	Alles Rund – Punkt Kreis Kugel. Galerie Handwerk, Munich, Germany
2018	50 Jahre – 50 Years. Galerie Handwerk, Munich, Germany
2019	Bijoux en jeu: Swiss Contemporary Jewellery Design. Habitat et Jardin, Lausanne, Switzerland; Gallery MUN, DDP, Seoul, South Korea; Power Station of Art – psD, Shanghai, China (trav. exh.)
2019	Welcome to enter … AUTOR Bukarest, Halucinarium, Bukarest, Romania
2019	FINAL PARADE. Galerie Ra, Amsterdam, Netherlands
2020	Die Danner-Rotunde. Der Schmuckraum der Pinakothek der Moderne. Neukuratiert von Mikiko Minewaki, Alexander Blank und Hans Stofer. Die Neue Sammlung – The Design Museum. Munich, Germany
2020	Love. Nomiya, Munich, Germany
2021	Rings! The Galleries at Moore College of Art and Design, Philadelphia, USA

Literaturverzeichnis — Selected Bibliography

1972	Zimmermann Marie-Louise, Frau testet Berufe. VXIII. Goldene Berufe (archive Therese Hilbert).
1973	Blumen eines Sommers. Modeschmuckwettbewerb 1973 des Arbeitskreises Form + Farbe. In: Goldschmiede Zeitung, no. 8, Stuttgart, Germany, pp. 30–32.
1973	Modeschmuck 73. Arbeitskreis Form und Farbe. Kaufbeuren-Neugablonz, Germany (exh. cat.).
1974	Kreativer Schmuck. Sonderschau an der europäischen Uhren und Schmuckmesse im Rahmen der Schweizer Mustermesse Basel, Switzerland (exh. cat.), pp. 46–47.
1974	Schollmayer Karl, Leitsätze Schmuck. In: Gold + Silber, Uhren + Schmuck, no. 4, Leinfelden, Germany (archive Therese Hilbert).
1976	Goldschmiedearbeiten. Galerie Alberstraße, Graz, Austria (exh. cat.).
1976	Schmuck heute. Le bijou actuel. Jewelry today. Publiziert von der Schweizer Mustermesse Basel. Eidgenössisches zum Thema Schmuck. Departement des Innern, Bern/Basle, Switzerland (exh. cat.).
1977	Schmuck 77 – Tendenzen. Schmuckmuseum im Reuchlinhaus, Pforzheim, Germany (exh. cat.), no. 35.
1978	Kunst – Schmuck. 26 Goldschmiede. Galerie Thomas, Munich, Germany (exh. cat.).
1978	Schöner Hans (ed.), Reiling Reinhold, Goldschmiedekunst. Arbeiten von 32 europäischen Goldschmieden. Königsbach-Pforzheim, Germany, pp. 91–93.
1978	Schweizer Schmuck 78. In: Heimatwerk. Blätter für Volkskunst und Handwerk, no. 3, Zurich, Switzerland, pp. 10, 17.
1979	Friedel Helmut, (ohne Titel). In: Therese Hilbert. Ed. by Schmuckmuseum im Reuchlinhaus, Pforzheim, Deutsches Goldschmiedehaus Hanau, Germany, Galerie Alberstr. Graz, Austria, Munich, Germany (exh. cat.), pp. 38–39.
1979	Therese Hilbert. Ed. by Schmuckmuseum im Reuchlinhaus Pforzheim, Deutsches Goldschmiedehaus Hanau, Germany, Galerie Alberstrasse, Graz, Austria, Munich, Germany (exh. cat.).
1979	Schmager Silvia M., Gemeinsam auf verschiedenen Wegen. In: Schmuck und Uhren, no. 18, Ulm, Germany, pp. 8–10.
1979	Wunderlich Wolfgang, (ohne Titel). In: Therese Hilbert. Ed. by. Schmuckmuseum im Reuchlinhaus, Pforzheim, Deutsches Goldschmiedehaus Hanau, Germany, Galerie Alberstr. Graz, Austria, Munich, Germany (exh. cat.), pp. 2–3.
1980	m-e, Hilbert + Künzli. In: Goldschmiede Zeitung, no. 4, Stuttgart, Germany, pp. 125–127.
1980	Schmuck international 1900–1980. Künstlerhaus, Vienna, Austria (exh. cat.), pp. 88, 212.
1980	World Craft Council Vienna 1980. Schmuck international 1900–1980. In: Four Seasons of Jewelry, no. 33, Tokyo, Japan, p. 67.

Literaturverzeichnis

1982	British Crafts Centre (ed.), Jewellery Redefined. The 1st International Exhibition of Multi-Media, Non-Precious Jewellery, London, Great Britain (exh. cat.), p. 31.
1982	Schmuck 82 – Tendenzen. Internationale Ausstellung zeitgenössisch-individuellen Schmucks. Schmuckmuseum im Reuchlinhaus, Pforzheim, Germany (exh. cat.).
1982	Zwitserse Avant-Garde. Text by Tom Berneds. Galerie Nouvelles Images, Den Haag, Netherlands (exh. cat.), p. 20.
1983	Bijou terrible: Ulrich Bruppacher, Carol Guinard, Johanna Hess, Therese Hilbert, Andreas Schaub, Urs Wagner, Zurich, Switzerland (exh. cat.).
1983	International Jewellery Art Exhibition. The 5th Tokyo Triennial. Isetan Art Museum, Tokyo, Japan (exh. cat.), no. 58/3.
1983	Norden Linda, Hermann Jünger. In: American Craft, no. 2, New York, USA, p. 14.
1983	Schmuck und Gerät. Sonderschau der Internationalen Handwerksmesse, Munich, Germany (exh. cat.).
1984	Cross Currents. In: Gold + Silber, Uhren + Schmuck, no. 12, Leinfelden, Germany (archive Therese Hilbert).
1984	Ildebrando Renzo and Brigitte Moser, Artisti orafi svizzeri. Galleria Cubo, Lugano, Switzerland (exh. cat.).
1984	Jewelry International. American Craft Museum, New York, NY, USA (exh. cat.).
1984	Künzli Otto. In: Cross Currents. Jewellery from Australia, Britain, Germany, Holland. Power House Museum, Sydney, Australia (exh. cat.), pp. 66–69.
1984	Weiss Rainer, Therese Hilbert. In: Gold + Silber, Uhren + Schmuck, no. 7, Leinfelden, Germany, pp. 24–25.
1984	Zeitgenössische Deutsche Goldschmiedekunst. In: Four Seasons of Jewelry, no. 55, Tokyo, Japan, p. 66.
1985	Almhofer Edith, Schmuck der Zeichen setzt. Ausstellung. Therese Hilbert in der Galerie V&V. In: Die Presse, 16.07.1985, Vienna, Austria, p. 6.
1985	Bijou frontal. Neue Tendenzen der Schmuckgestaltung in der Schweiz. Concept by Bruno Halder. Gewerbemuseum Basel / Museum für Gestaltung. Basle, Switzerland (exh. cat.), pp. 43, 49.
1985	Bode Peter M., Schmuck, Mode, Plastik. In: Abendzeitung, Feuilleton, 15.04.1985, Munich, Germany, p. 10.
1985	Cartlidge Barbara, Tweentieth-Century Jewelry. New York, USA.
1985	Dormer Peter and Ralph Turner, The New Jewelry – Trends and Traditions. London, Great Britain, pp. 30, 59, 69, 204.
1985	Künzli Otto, Kristall, Nase. In: Therese Hilbert. Schmuck. Galerie Cada, Munich, Germany; Galerie V&V, Vienna, and Galerie Droschl, Graz, Austria (exh. cat.).
1985	Kuhn Albert, Therese Hilbert + Otto Künzli. Die Menschen-Dekorateure. In: Magma, no. 4, Zurich, Switzerland, pp. 54–63.

1985	Schmid Karlheinz, Schmuck der nicht nur schmückt. In: ART, Das Kunstmagazin, no. 1, Hamburg, Germany, p. 97.
1985	Therese Hilbert. Schmuck. Galerie Cada, Munich, Germany; Galerie V&V, Vienna, and Galerie Droschl, Graz, Austria (exh. cat.).
1986	Avantgarde – Schmuck sprengt alle Ketten. In: Cosmopolitan, no. 4, Munich, Germany, p. 7.
1986	Czöppan Gabi, Stern – Medaillen. Kunstpreisträger '86 (archive Therese Hilbert).
1986	Gold Franz G., Interview. In: Fragments. Therese Hilbert – Otto Künzli Jewellery 1976–1986. Helen Drutt Gallery, Philadelphia, USA (exh. cat.), pp. 7–11, 17–20.
1986	Karcher Eva, Kunterbunt ist der Sommer. In: Süddeutsche Zeitung, no. 173, Munich, Germany, p. 34.
1986	Kulturreferat München (ed.), Therese Hilbert. Stern. Kunstpreisträger '86. Monographienreihe hrsg. anläßlich der Verleihung der Förderpreise und Stipendien für Bildende und Angewandte Kunst durch die Landeshauptstadt München, Munich, Germany (exh. cat.).
1986	M. R. and M. O., Therese Hilbert in der Galerie Louise Smit. In: Bijvoorbeeld, no. 9, Amsterdam, Netherlands, pp. 22–23.
1986	Müller Elisabeth, Individualität im Kollektiv. Förderpreisträger der Stadt München in der Künstlerwerkstatt Lothringerstraße. In: Abendzeitung, Feuilleton, Munich, Germany, 29.07.1986.
1986	Ohrschmuck. Galerie Michèle Zeller, Bern, Switzerland (exh. cat.).
1986	Reinwald Chris, Kunst als Ambacht. In: tableau – Fine Arts Magazine, no. 5, Amsterdam, Netherlands, p. 75.
1986	Wolf Deborah, Draagbare Kunst. In: Avenue, Maandblad, no. 9, Amsterdam, Netherlands, p. 169.
1987	Fundació Caixa de Pensions (ed.), Joieria Europea Contemporània. Barcelona, Spain (exh. cat.), p. 95.
1988	Bijou nouvelles tendances, nouveaux materiaux. Centre Culturel Suisse, Paris, France (exh. cat.).
1988	Eickhoff Jürgen, Poesie, Geometrie und neue Dimensionen. In: Die Waage, no. 3, Band 27, Aachen, Germany, pp. 126–132.
1988	Hildenbrand Renzo and Paola, Gioielli d'Arte. Biennale Svizzera del Gioiello d'Arte Contemporaneo. Villa Malpensata, Lugano, Switzerland (exh. cat.), pp. 61–67.
1988	Künzli Otto, Un celato al dolore (about Therese Hilbert). In: Hildenbrand Renzo and Paola, Gioielli d'Arte. Biennale Svizzera del Gioiello d'Arte Contemporaneo. Lugano, Switzerland (exh. cat.), p. 62.
1988	Meier Irene, Schmuck – Zeichen am Körper. In: DU, no. 4, Zurich, Switzerland, p. 84.
1988	Philipp Ulrike, Dada ist tot – es lebe der Dadaismus. In: Art Aurea, no. 2, Ulm, Germany, p. 72.
1988	10 Goldsmiths. Text by Ian Wardropper. Rezac Gallery, Chicago, USA (exh. cat.), p. 6.

Literaturverzeichnis

1989	Bell Robert, Perth International Crafts Triennial. Art Gallery of Western Australia, Perth, Australia (exh. cat.).
1989	Bode Peter M., Die starke stille Kunst der Dornen. Therese Hilbert's Schmuckausstellung in der Galerie Spektrum. In: Abendzeitung, Feuilleton, 20.10.1989, Munich, Germany, p.12.
1989	Erlhoff Michael, Fritz Falk, Jens-Rüdiger Lorenzen, Wilhelm Mattar and Sabine Strobel (eds.), Ornamenta 1, Internationale Schmuckkunst. Schmuckmuseum im Reuchlinhaus, Pforzheim, Germany (exh. cat.), p. 26.
1989	Jünger Hermann, Therese Hilbert. Vertraut und doch ganz neu. In: Art Aurea, no. 3, Ulm, Germany, pp. 76–78.
1989	Zeitgenössischer Schmuck. Schmuckgestalterin Therese Hilbert bei Michèle Zeller. In: Der Bund, 18.11.1989, Bern, Switzerland.
1989	Zeitgenössische Schmuckkunst aus der Bundesrepublik Deutschland. Concept by Jens Rüdiger Lorenzen. ifa (Institut für Auslandsbeziehungen), Stuttgart, Germany (exh. cat.), pp. 48–49.
1991	Abgereist. 10 Schweizer Schmuckgestalter im Ausland. In: Gold + Silber, Uhren + Schmuck, no. 12, Leinfelden-Stuttgart, Germany, p. 20.
1992	Der Stamm des Tannenbaumes ist das Herz des Schmuckes (von innen nach außen). K- Raum Daxer, Munich, Germany (exh. cat.).
1992	Lucas Felix, Therese Hilbert. Klarheit des Designs. In: Goldschmiede und Uhrmacher Zeitung, no. 4, Stuttgart, Germany, p. 120.
1992	Neoteric Jewelry. Curated by Louis Muller. Snug Harbor Cultural Center, Staten Island, New York, NY, USA (exh. cat.).
1993	Bauer Helmut (ed.), Münchner Goldschmiede. Schmuck und Gerät der Gegenwart. Stadtmuseum, Munich, Germany (exh. cat.), pp. 27, 35, 45, 54, 126, 188–189.
1993	Hilbert and Künzli. Gold and Silver. Symbols of Life and Divinity. In: Italia Orafa International, no. 3, Milan, Italy, p. 68.
1993	Nicola Carl-Günter, München – Zentrum des modernen Schmucks. In: Kunsthandwerk und Design, no. 4, Frechen, Germany, pp. 9, 15.
1993	Schmuck: Die Sammlung der Danner-Stiftung, Bestandskatalog. Schriftenreihe des Bayerischen Kunstgewerbe-Vereins e.V., Bd. 4. Galerie für Angewandte Kunst, Munich, Germany (exh. cat.), pp. 56–57.
1993	Watkins David, The Best in Contemporary Jewellery. London, Great Britain, pp. 76–77, 212.
1994	Chadour Anna Beatriz, Ringe. Die Alice und Louis Koch Sammlung. Vierzig Jahrhunderte durch vier Generationen gesehen. Leeds, Great Britain, Bd. II, p. 561.
1994	Gold und Silber. Städtische Galerie im Rathausfletz, Neuburg an der Donau, Germany (exh. cat.).
1994	Richter Andrea, Schmuck + Gerät. Zeitgenössisches deutsches Kunsthandwerk. 6. Triennale 1994, Frankfurt a. M., Germany (exh. cat.).

1994	Zeitgenössische Schmuckkunst. Contemporary Jewelry. ifa (Institut für Auslandsbeziehungen), Stuttgart, Germany, and Tokyo, Japan (exh. cat.).
1995	Benno und Therese Danner'sche Kunstgewerbestiftung (ed.), Danner-Stiftung. Tätigkeitsbericht 1995. Text by Ellen Maurer, Munich, p. 83.
1995	Drutt English Helen W. and Peter Dormer, Jewelry of our Time. Art, Ornament and Obsession. London, Great Britain, p. 237.
1995	Runde Sabine, Sinnliches zwischen Körper, Hülle und Gefäß. In: Art Aurea, no. 2, Ulm, Germany, p. 63.
1995	Silberstreif. Eine Kunstausstellung. Neckarwerke, Esslingen, Germany (exh. cat.).
1996	Königer Maribel, Kraterwanderung. Emotionen, Gefäße, Vulkane – Zu den Schmuckarbeiten von Therese Hilbert. In: Weiss und Schwarz – Therese Hilbert. Schmuck. Galerie für angewandte Kunst e.V., Schriftenreihe des Bayerischen Kunstgewerbe-Vereins e.V., Bd. 19, Munich, Germany (exh. cat.), p. 7–11.
1996	Koreanisch – Deutsche Zeitgenössische Schmuck und Gerät Ausstellung. Concept by Jens-Rüdiger Lorenzen. Walker Hill Art Center, Seoul, South Korea (exh. cat.).
1996	Weiss und Schwarz – Therese Hilbert. Schmuck. Galerie für angewandte Kunst e.V., Schriftenreihe des Bayerischen Kunstgewerbe-Vereins e.V., Bd. 19. Munich, Germany (exh. cat.).
1996	Für Sarajevo, za Sarajevo. Rudolf Bott, Bettina Dittlmann, Karl Fritsch, Therese Hilbert, Hermann Jünger, Hubertus von Skal. Anläßlich der Ausstellung im Collegium Artisticum Sarajevo 1996. Organisation: Gordana Anđelić-Galić and Olga Zobel. Sarajevo, Bosnia Herzegovina (exh.cat.).
1997	Broschen. Kunstforum Kirchberg Desinfarkt. Kirchberg, Switzerland (exh. cat.).
1997	Lehmann Franziska, Schmuck wird zum Kunstobjekt. In: Burgdorfer Tagblatt, Burgdorf, Switzerland, 22.05.1997.
1998	Therese Hilbert. In: Dictionaire International du Bijou. Editions du Regard, Paris, France, pp. 273–274.
1999	Bundesverband Kunsthandwerk (ed.), Augenlust. Zeitgenössisches Kunsthandwerk in Deutschland mit europäischen Gastbeiträgen. The Eye's Delight. Contemporary Arts and Crafts in Germany with Contributions from other European Countries. Frankfurt a. M., Germany (exh. cat.), p. 84.
1999	Falk Fritz and Cornelie Holzach, Schmuck der Moderne 1960–1998. Bestandskatalog der modernen Sammlung des Schmuckmuseum im Reuchlinhaus. Modern Jewellery. Catalogue of the Modern Collection in the Schmuckmuseum Pforzheim. Stuttgart, Germany, pp. 156f., 201, 227.

Literaturverzeichnis

1999	Keltz Ursula, Schmuckgestaltung an der Akademie der Bildenden Künste München. Die Klasse für Goldschmiedekunst 1946–1991. Weimar, Germany, pp. 126, 171, 178–179, no. 129–132.
1999	Maas Barbara, Vulkanische Broschen. Ringe aus Meteoritgestein. In: Süddeutsche Zeitung, no. 256, Munich, Germany, p. 48.
1999	Ricklin-Schelbert Antoinette, Schmuckzeichen Schweiz 20. Jahrhundert. 20th Century Swiss Art Jewellery, St. Gallen, Switzerland, pp. 48, 53, 89, 91, 93, 99, 102, 127, 135, 168.
1999	Selenitsch Alex, Hollow but not empty. Jewellery by Therese Hilbert at Funaki Gallery, Melbourne. In: Object/lemel, Contemporary Craft + Design + 3D Art, no. 3, Sydney, Australia, pp. 32–33.
2000	Alamir Marie and Carole Guinard, Parures d'ailleurs, parures d'ici: incidences, coïncidences? Schmuck hier, Schmuck anderswo: Verwandschaft oder Zufall? mudac, Musée de design et d'arts appliqués contemporains, Lausanne, Switzerland (exh. cat.), pp. 32, 123.
2000	Dosch Stefan, Schmuck, der nicht nur schmückt. Goldschmiedearbeiten im Kunsthaus Kaufbeuren. In: Allgäuer Zeitung, April 2000, Kaufbeuren, Germany (archive Therese Hilbert).
2000	Felderer Brigitte, Herbert Lachmayer and Erika Keil (eds.), Alles Schmuck. Eine Ausstellung mit Schmuckstücken aus der Sammlung Inge und Elisabeth Asenbaum, Schweizer Ateliers und den Hochschulen Linz, Pforzheim und Zürich. Exhibition architecture by Zaha Hadid. Museum für Gestaltung, Zurich. Baden, Switzerland (exh. cat.), p. 131.
2000	Walgrave Jan, Het Versierde Ego. Het Kunstjuweel in de 20ste Eeuw / The Ego Adorned. 20th Century Artists' Jewellery. Koningin Fabiolazaal, Antwerp, Belgium (exh. cat.), pp. 48, 49, 60, 68, 316, G 22, 39, 61.
2001	Derrez Paul, Maskerade. Contemporary Masks by Fifty Artists. Galerie Ra, Amsterdam, Netherlands (exh. cat.), pp. 106, 107.
2001	Mikromegas. 150 Jahre Bayerischer Kunstgewerbe-Verein München 1851–2001. Dritte Ausstellung der Jubiläumsreihe 2001. Eine Ausstellung von Otto Künzli. Schriftenreihe des Bayerischen Kunstgewerbe-Vereins e.V., Bd. 27, Galerie für angewandte Kunst e.V., Munich, Germany (exh. cat.), no. 74.
2001	Von wegen – Schmuck aus München. Publication accompanying the exhibition «Schön machen – zeitgenössischer Schmuck aus München». Concept by Karl Fritsch and Hilke Gesine Möller for Kunsthaus Kaufbeuren. Presentation by Bettina Speckner and Karen Pontoppidan for Deutsches Goldschmiedehaus. Hanau, Germany (exh. cat.).
2002	Le Bijou Suisse au 20e siecle. Art jewellery in Switzerland in the 20th century. Schweizer Schmuck im 20. Jahrhundert. Gioielli d'arte in Svizzera nel 20o secolo. Musée d'art et de'histoire, Genève, Schweizerisches Landesmuseum, Zurich, Museo Vela, Ligornetto, Switzerland. St. Gallen, Switzerland (exh. cat.), pp. 126–127.

Selected Bibliography

2003	Arch Gregory, Minimal Rings. Waynesville, USA, p. 152.
2003	Runde Sabine, Corporal Identity – Körpersprache. 9. Triennale für Form und Inhalte. USA und Deutschland. Museum für angewandte Kunst, Frankfurt a. M., Germany (exh. cat.).
2004	Cisotto Nalon Mirella, Pensieri Preziosi. Differenze, incidenze, coincidenze in alcuni gioielli – Kostbare Gedanken. Verschiedenheiten, Zufälligkeiten und Gemeinsamkeiten im europäischen Schmuck. Oratorio di San Rocco, Padua, Italy (exh. cat.), pp. 54–59.
2004	Le Van Marthe (ed.), 1000 Rings: Inspiring Adorments for the Hand. Introduction by Robert W. Ebendorf. New York, USA, pp. 104, 230.
2004	Webb Penny, Munich maker quietly reaches peak. In: The Age. A3, Arts. Melbourne, Australia, 17.11.2004.
2004	Zobel Olga and Stefan Hirsch, Ohne Schmuck keine Heimat !? Fünf Goldschmiede aus München. Benediktbeuern, Germany (exh. cat.).
2005	Benno und Therese Danner'sche Kunstgewerbestiftung (ed.), Danner Stiftung. Tätigkeitsbericht 2005. Bruno und Therese Danner'sche Kunstgewerbestiftung, Munich, Germany, pp. 116–119, 156.
2005	Folchini Grassetto Graziella, Gioelleria Contemporanea – Minimal Art. Studio GR 20. Graziella Folchini Grassetto, Padua, Italy (exh. cat.), pp. 28–31.
2005	Le Van Marthe (ed.), 500 Brooches: Inspiring Adornments for the Body. New York, USA.
2006	Derrez Paul, Radiant. 30 jaar Ra – 30 Years Ra. Amsterdam, Netherlands (exh. cat.), pp. 136–137.
2006	Le Van Marthe (ed.), 500 Necklaces: contemporary interpretations of a timeless form. New York, USA.
2007	Bachmair Angelika, Schmuck ist Kunst. Die Goldschmiede Hilbert und Künzli in der Ecke Galerie. In: Augsburger Allgemeine, Feuilleton regional, no. 35, Augsburg, Germany, 02.02.2007.
2007	Ilse-Neuman Ursula, Cornelie Holzach and Jutta-Annette Page, GlassWear. Glass in Contemporary Jewelry / Glas im zeitgenössischen Schmuck. Glass Pavillion, Toledo Museum of Art, Toledo, Ohio, USA, Schmuckmuseum Pforzheim, Germany, Memorial Art Gallery of the University of Rochester, Rochester NY, Museum of Arts and Design, New York, NY, Mobile Museum of Art, Mobile, Alabama, all USA. Stuttgart, Germany (exh. cat.), pp. 118–119, 201.
2007	Maurer Zilioli Ellen, Therese Hilbert. Gioiello. In: Qui Brescia, no. 31, Brescia, Italy, p. 150.
2007	Maurer Zilioli Ellen, Glut – Glow – Ardore. Therese Hilbert – Gioielli. In: Archimagazine Academy, no. 107, Desenzano di Garda, Italy, pp. 1–3.
2007	Maurer Zilioli Ellen, Glut – Glow – Ardore. Schmuck von Therese Hilbert. In: GZ Goldschmiedezeitung, 105. Jg., Stuttgart, Germany, p. 14.
2007	Mizuno Takahiko, Contemporary Jewelry. Tokyo, Japan, Bd. 2, pp. 83–93.

Literaturverzeichnis

2007	Strauss Cindi, Ornament as Art. Avant-Garde Jewelry from the Helen Williams Drutt Collection. The Museum of Fine Arts, Houston. Stuttgart, Germany, p. 376 (no. 279–284).
2008	Mälk Kadri (ed.), Just Must. Cosmic empathic contract conducted between 58 artists. It is a creative contract written in blood … International jewellery art exhibition. Estonian History Museum, The Great Guild House, Tallinn. Stuttgart, Germany (exh. cat.), pp. 162–163.
2009	Herbert-Hofmann Preis / Herbert Hofmann Award 1973–2008. Concept by Wolfgang Lösche. Ed. by GHM Gesellschaft für Handwerksmessen mbH. Munich, Germany (exh. cat.), p. 108.
2009	Maurer Zilioli, Ellen, Schmuck-Extreme. In: Cult, no. 2, Munich, Germany (archive Therese Hilbert).
2009	Mizuno Takahiko, Hiko Mizuno presents 14 Jewelry Artists on Earth. Tokyo, Japan, pp. 82–93.
2010	Nishijn Brocade. Kyoto and Tokyo, Japan (exh. cat.).
2010	Weskott Hanne, Kostbares auf dem Prüfstand. In: Süddeutsche Zeitung, Münchner Kultur, Munich, Germany, 10.03.2010.
2011	Besten Liesbeth den, On Jewellery. A compendium of international contemporary art jewellery. Stuttgart, Germany, p. 199.
2011	Derrez Paul. 35 Years Ra Gallery. Amsterdam, Netherlands (exh. cat.).
2011	Runde Sabine, Materials Revisited. 10. Triennale für Form und Inhalte. Museum für angewandte Kunst, Frankfurt a. M., Berlin, Germany (exh. cat.), p. 48.
2012	Cohn Susan (ed.), Unexpected Pleasures. The Art and Design of Contemporary Jewellery. National Gallery of Victoria, Melbourne, Australia. New York, USA (exh. cat.), pp. 132, 144, 170.
2012	Zobel Olga, Campagne-sans-Mer*. David Bielander. Kiko Gianocca. Andi Gut. Therese Hilbert. Otto Künzli. Espace Solidor. Cagnes-sur-Mer, France (exh. cat.).
2013	Cummins Susan, Interview with Therese Hilbert. 11/25/2013, In: https://artjewelleryforum.org/therese hilbert; on view 28.05.2020.
2013	Maurer Zilioli Ellen, Therese Hilbert. Vom Gehäuse. Munich, Germany (exh. folder).
2013	Skinner Damian (ed. in association with Art Jewelry Forum), Contemporary Jewelry in Perspective. New York, USA, pp. 104, 107.
2014	Garcia Grego, Philip Sajet and Julia Wild, Papallona – Mariposa – Butterfly. The metaphor of life in contemporary jewelry. Museu Naturals de Granollers, Granollers, Spain (exh. cat.).
2014	Guinard Carole and Isabelle Chassot, Bijou en jeu. Collections du mudac et de la Confédération Suisse. Lausanne, Switzerland (exh. cat.), pp. 80–81, 96–97, 156–157.
2015	Autorenschmuck und noch mehr. Sammlung Katrin Basiner. Ed. by Paul und Katrin Basiner Stiftung. Munich, Germany, pp. 82–83.
2016	Derrez Paul, Dierbar, Cherished. 40 Jaar Galerie Ra Gallery 40 years. Amsterdam, Netherlands (exh. cat.), pp. 68, 83, 93, 101, 103.

2016	&: Hilbert & Künzli. Salz & Pfeffer. Gestalten im Dialog. Therese Hilbert & Otto Künzli. Ausstellung im Gewerbemuseum, Winterthur, Switzerland (exh. folder).
2016	&: Hilbert und Künzli. Schmuckkünstler im Gewerbemuseum Winterthur. In: Der Landbote, Winterthur, Switzerland, 25.08.2016.
2016	Ludwig Reinhold, Review. Therese Hilbert und Otto Künzli. In: Art Aurea, no. 3, Ulm, Berlin, Germany, pp. 74–75.
2016	Maass Angelika, Die Lust am Objekt. In: Der Landbote, Winterthur, Switzerland, 22.07.2016.
2017	Mostra Povera. All you need for an exhibition. In: https//klimt02.net/forum/articles/mostra-povera-allyou-need...; on view 24.05.2017.
2019	Beatriz Chadour-Sampson, Rings of the 20th and 21st centuries. The Alice and Louis Koch Collection. Ringe des 20. und 21. Jahrhunderts. Die Sammlung Alice und Louis Koch. Stuttgart, Germany, p. 342 (no. 449).
2020	Danner-Stiftung / Die Neue Sammlung (ed.), Schmuck – Jewelry. Text by Petra Hölscher. Stuttgart, Germany, pp. 209–213 (no. 304–316), 298 (no. 523).
2020	Mazumdar Pravu, What is a brooch? In: Dongchun Lee (ed.),100 Brooches. Korean Contemporary Jewelry Chronicle. Seoul, South Korea, pp. 93–101, here p. 100.

Ich danke

Ich danke,
Angelika Nollert und Petra Hölscher, dass sie mich eingeladen haben, meine Arbeiten in der Neuen Sammlung – The Design Museum zu zeigen.
 Petra Hölscher für ihre großzügige Unterstützung und wunderbare Zusammenarbeit bei der Konzeption dieser Publikation und der Ausstellung.
 Allen Autorinnen und Autoren, die sich präzise und einfühlsam auf mich und meine Arbeit eingelassen haben.
 Den privaten und öffentlichen Leihgebern, die sich bereit erklärten ihre Stücke für die Ausstellung zur Verfügung zu stellen.
 Dirk Allgaier und Greta Garle von arnoldsche Art Publishers für die freundschaftliche verlegerische Begleitung dieses Buches.

Frederik Linke für seine klare grafische Linie und seine Geduld, meine Vorstellungen auf's Papier zu bringen. Genial die Umsetzung des Titels in • – • • – • • und • – • – – – –!
 Miriam Künzli für ihren fotografischen Beitrag, ihre starken, frischen Bilder.
Und allen andern die zur Entstehung der Publikation und der Ausstellung beigetragen haben.

Er hat mich und meine Arbeit über 5 Jahrzehnte aus nächster Nähe begleitet, von Beginn an meine Arbeiten fotografiert, von s/w, über Dias, zu digital. Wir haben uns auf Augenhöhe ergänzt, wir teilten und teilen die Leidenschaft für Schmuck, das Atelier, das Leben, danke Otto.

Therese Hilbert 2021

Thank you,
Angelika Nollert and Petra Hölscher for inviting me to show my work at Die Neue Sammlung – The Design Museum.

Petra Hölscher for her generous support and wonderful cooperation with the concept for this publication and the exhibition.

All the authors who have, with sensitivity and precision, engaged with me and my work.

The private and public lenders who have agreed to make their pieces available for the exhibition.

Dirk Allgaier and Greta Garle for their cordial support in the publication of this book.

Frederik Linke for his clear line in terms of graphics and his patience in transferring my visions to paper. Genial – the way he has transformed the title in • – • – – – – and • – • • – • •!

Miriam Künzli for her photographic contribution, her strong, fresh images.
And all those other people who have contributed to the genesis of the publication and that of the exhibition.

He has closely accompanied my works for over five decades. He has photographed my work from the outset, from black-and-white to slides to the digital era. We have complemented each other on an equal footing, we have shared and still share a passion for jewelry, our studio, our lives. Thank you, Otto.

Therese Hilbert 2021

Impressum

Die vorliegende Publikation erscheint anlässlich der Ausstellung / This book is published to mark the exhibition «Therese Hilbert ROT», Die Neue Sammlung – The Design Museum, Pinakothek der Moderne, München / Munich.

© 2023 Die Neue Sammlung – The Design Museum, München / Munich: die Künstlerin / the artist, die Autor*innen / the authors und / and arnoldsche Art Publishers

Alle Rechte vorbehalten. Vervielfältigung und Wiedergabe auf jegliche Weise (grafisch, elektronisch und fotomechanisch sowie der Gebrauch von Systemen zur Datenrückgewinnung) – auch in Auszügen – nur mit schriftlicher Genehmigung der Copyright-Inhaber.
www.arnoldsche.com

All rights reserved. No part of this work may be reproduced or used in any form or by any means (graphic, electronic or mechanical, including photocopying or information storage and retrieval systems) without written permission from the copyright holders.
www.arnoldsche.com

Herausgeberin — Editor
Angelika Nollert

Konzept — Concept
Therese Hilbert

Autor*innen — Authors
Heike Endter, Warwik Freeman, Therese Hilbert, Petra Hölscher, Eugène Ionesco, Otto Künzli, Ellen Maurer Zilioli, Pravu Mazumdar, Angelika Nollert, Rainer Weiss

Fotograf*innen — Photographers
Ingrid Amslinger, Therese Hilbert, Miriam Künzli, Otto Künzli, George Meister, Regina Relang

Bildnachweis — Photo credits
© VG Bild-Kunst, Bonn 2021: Therese Hilbert
Wenn nicht anders vermerkt, alle Aufnahmen / If not indicated otherwise, all photos: Otto Künzli

Ingrid Amslinger, p. 83
Therese Hilbert, pp. 226–227, 267–268, 272, 274–277, 317
Archiv Therese Hilbert, p. 139
Miriam Künzli, pp. 81, 182, 187, 134–135, 291, 333
George Meister, pp. 73, 74
Regina Relang, p. 22, Landeshauptstadt München: Archiv Münchner Stadtmuseum
Museum für Gestaltung, Zürich: Archiv ZHdK, p. 4

Übersetzung — Translation
Jeremy Gaines, Frankfurt a. M.

Redaktion — Editorial staff
Therese Hilbert, Petra Hölscher

Lektorat — Copy editing
Petra Hölscher, Oliver Krug

Grafische Gestaltung Layout — Graphic design
Frederik Linke

Bildbearbeitung — Image editing
Miriam Künzli, Otto Künzli, Schwabenrepro, Fellbach

Druck — Printed by
Schleunungdruck, Marktheidenfeld

Schrift — Type
Avenir Next Demi Bold / Demi Bold Italic

Papier — Paper
Magno Volume 135 g/m^2

Imprint

Bibliografische Information der Deutschen Nationalbibliothek
Die Deutsche Nationalbibliothek verzeichnet diese Publikation in der Deutschen Nationalbibliografie; detaillierte bibliografische Daten sind über www.dnb.de abrufbar

Bibliographic information published by the Deutsche Nationalbibliothek
The Deutsche Nationalbibliothek lists this publication in the Deutsche Nationalbibliografie; detailed bibliographic data are available at www.dnb.de

ISBN 978-3-89790-623-5

Made in Germany, 2022

Eine Ausstellung der Neuen Sammlung – The Design Museum, München
An exhibition of Die Neue Sammlung –The Design Museum, Munich

Kuratorin — Curator
Petra Hölscher

Ausstellungsidee und Konzept — Exhibition idea and conception
Therese Hilbert, Petra Hölscher

Restauratorische Betreuung — Conservation departement
Tim Bechthold, Helena Ernst, Julia Demeter, Christian Huber

Museumstechnik — Technical departement
Michel Daume, Cornelius von Heyking, Florian Westphal

Registrar
Waltraud Wiedenbauer

Mitarbeit — Assistance
Rainer Schmitzberger

Presse- und Öffentlichkeitsarbeit — Press and public relations
Tine Nehler, Jette Elixmann, Sarah Stratenwerth, Pressestelle der Pinakotheken
Eric Dietenmeier, Leitung Kommunikation, Presse- und Öffentlichkeitsarbeit, Pinakothek der Moderne (Kunst | Graphik | Architektur | Design)

Leihgeber — Lenders
Öffentliche Sammlungen – Public Collections
mudac, Musée de design et d'arts appliqués contemporains, Lausanne, Switzerland
National Gallery Victoria, Melbourne, Australia
Schmuckmuseum Pforzheim, Germany
Privatsammlungen – Private Collections
Amsterdam, Graz, Hanau, München, Padua

Alle nicht extra gekennzeichneten Objekte sind Eigentum der Künstlerin / All not specially marked objects are the property oft the artist

▶ Otto Künzli, Therese Hilbert, Miriam Künzli, Frederik Linke
Brescia, Italy 2008.

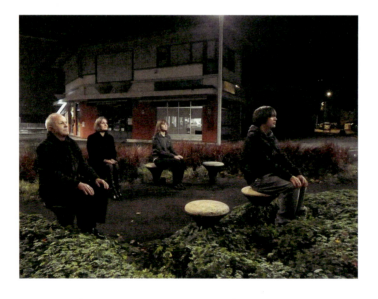